FIFTY KEY WRITERS ON PHOTOGRAPHY

Edited by
Mark Durden

Routledge
Taylor & Francis Group

LONDON AND NEW YORK

First published 2013
by Routledge
2 Park Square, Milton Park, Abingdon, Oxon OX14 4RN

Simultaneously published in the USA and Canada
by Routledge
711 Third Avenue, New York, NY 10017

Routledge is an imprint of the Taylor & Francis Group, an informa business

© 2013 Mark Durden, selection and editorial material; individual chapters, the contributors.

The right of the editor to be identified as the author of the editorial material, and of the authors for their individual chapters, has been asserted in accordance with sections 77 and 78 of the Copyright, Designs and Patents Act 1988.

All rights reserved. No part of this book may be reprinted or reproduced or utilised in any form or by any electronic, mechanical, or other means, now known or hereafter invented, including photocopying and recording, or in any information storage or retrieval system, without permission in writing from the publishers.

Trademark notice: Product or corporate names may be trademarks or registered trademarks, and are used only for identification and explanation without intent to infringe.

British Library Cataloguing in Publication Data
A catalogue record for this book is available from the British Library

Library of Congress Cataloging in Publication Data
Fifty key writers on photography / [compiled by] Mark Durden.
pages cm. – (Routledge key guides)
Includes bibliographical references and index.
1. Photography. 2. Photography literature. 3. Technology writers–Biography.
4. Photographers–Biography. I. Durden, Mark. II. Title: 50 key writers on photography.
TR185.F54 2013
770.92'2–dc23
2012026136

ISBN: 978-0-415-54944-8 (hbk)
ISBN: 978-0-415-54945-5 (pbk)
ISBN: 978-0-203-07495-4 (ebk)

Typeset in Bembo
by Taylor & Francis Books

Printed and bound in Great Britain by the MPG Books Group

Fifty Key Writers on Photography introduces some of the most significant writers on photography who have played a major part in defining and influencing our understanding of the medium. It provides a succinct overview of writing on photography from a diverse range of disciplines and perspectives, and examines the shifting perception of the medium over the course of its 170-year history. Key writers discussed include:

- Roland Barthes
- Susan Sontag
- Jacques Derrida
- Henri Cartier-Bresson
- Geoffrey Batchen.

Fully cross-referenced and in an A–Z format, this is an accessible and engaging introductory guide.

Mark Durden is Professor of Photography at the University of Wales, Newport.

ALSO AVAILABLE FROM ROUTLEDGE

CONTENTS

ALPHABETICAL LIST OF ENTRIES

CONTRIBUTORS

Jan Baetens is Professor of Cultural and Literary Studies at the University of Leuven, Belgium. He has published widely on word and image studies, mainly in so-called minor genres such as the photonovel and the comics. He is currently co-directing a research programme on the historiography of modernist literature (see www.mdrn.be). Among his recent publications are *The Unwanted Self: Photography from the Low Countries*, co-edited with David Green (2008), and a special issue of *History of Photography* on 'glocalization' (vol 35, no 2, 2011).

Malcolm Barnard is Senior Lecturer in Visual Culture at Loughborough University, UK, where he teaches the history and theory of art and design. His interests lie in the theories and philosophies of fashion and graphic design, and they are turning increasingly to photographic theory. His background is in recent French philosophy and he is the author of *Graphic Design as Communication* (2005), *Fashion as Communication* (2002), *Approaches to Understanding Visual Culture* (2001) and *Art, Design and Visual Culture* (1998). He is also the editor of *Fashion* (2011) and *Fashion Theory* (2007).

Geoffrey Batchen is the author of *Burning with Desire: The Conception of Photography* (1997, with subsequent translations into Spanish, Korean and Japanese), *Each Wild Idea: Writing, Photography, History* (2001), *Forget Me Not: Photography and Remembrance* (2004), *William Henry Fox Talbot* (2008), *What of Shoes: Van Gogh and Art History* (2009, in German and English), and *Suspending Time: Life, Photography, Death* (2010, in Japanese and English). He has also edited an anthology of essays entitled *Photography Degree Zero: Reflections on Roland Barthes's Camera Lucida* (2009) and co-edited another entitled *Picturing Atrocity: Photography in Crisis* (2012). He is currently working on a book for Yale University Press on the first 20 years of photography in the UK. Batchen is currently Professor of Art History at Victoria University of Wellington in New Zealand.

David Bate is a photo-artist, writer and teacher. Recent works include *Australian Picnic*, *Bungled Memories* and *Zone*. His books include *Photography and Surrealism: Sexuality, Colonialism and Social Dissent* (2004) and *Photography: Key Concepts* (2009). He studied film and photographic arts at the Polytechnic of Central London and art history in the Fine Art Department of the University of Leeds. He was a founder member of Accident Gallery in London, is a co-editor of *Photographies* journal and currently is Professor of Photography and Course Leader of the MA Photographic Studies programme at the University of Westminster, London, UK.

Caroline Blinder is Senior Lecturer in American Literature at Goldsmiths, University of London. Recent publications include *New Critical Essays on James Agee and Walker Evans: Perspectives on Let us now Praise Famous Men* (2010); 'Brassaï's Chair, Henry Miller and The Eye of Paris' in *Text and Image Relations in Modern European Culture* (2011); 'Sitting Pretty: Modernism and the Municipal Chair in the Work of Kertész and Doisneau' in *Regarding the Popular: High and Low Culture in the Avant Garde and Modernism* (2011); 'The Bachelor's Drawer: Art and Artefact in the Work of Wright Morris' in *Writing With Light: Words and Photographs in American Texts* (2009); 'Not so Innocent: Vision and Culpability in Weegee's Photographs of Children' in *Photographs, Histories, and Meanings* (2009).

Jane Blocker is Professor of Art History at the University of Minnesota, US. She is author of *Seeing Witness: Visuality and the Ethics of Testimony*; *What the Body Cost: Desire, History, and Performance*; and *Where Is Ana Mendieta? Identity, Performativity, and Exile*. She has published articles in *Performance Research*, *Grey Room*, *Art Journal*, *Camera Obscura*, *Cultural Studies*, *Visual Resources* and *Performing Arts Journal*, and contributed essays to a number of anthologies: *Perform, Repeat, Record: Live Art in History*; *The Aesthetics of Risk*, *After Criticism: New Responses to Art and Performance*; *An Introduction to Women's Studies: Gender in a Transnational World*; and *The Ends of Performance*.

Henry Bond is a British writer and photographer; he is Senior Lecturer in Photography in the School of Fine Art at Kingston University, London. His Lacan-inspired reading of forensic photography and the crime scene, *Lacan at the Scene*, was published in 2009; a monograph of his photographs, *Henry Bond: Point and Shoot*, was published in 2000. Examples of his work have been exhibited at the Tate Modern in London; the Contemporary Arts Museum in Houston; the Walker Art Center in Minneapolis; and Fotomuseum in Winterthur, among other venues.

Matthew Bowman is an art theorist and curator based at the School of Philosophy and Art History at the University of Essex, UK, and also lectures in contextual studies at the Colchester School of Art. In 2008 he completed his PhD at Essex with a dissertation on the *October* journal and concepts of medium specificity. He has curated exhibitions in England and Austria, and has published numerous essays, including 'The New Critical Historians of Art?' in James Elkins and Michael Newman (eds) *The State of Art Criticism* (2007). At present he is researching collaborative art practice, materiality and post-Fordist society.

Wolfgang Brückle is a Guest Professor at the Art History Department, University of Zürich. He submitted his PhD thesis on the influence of political Aristotelianism on the royal promotion of art in fourteenth-century France at Hamburg University in 2001 and worked as an assistant curator at the Staatsgalerie Stuttgart prior to becoming an assistant professor at the Universities of Stuttgart and Bern. From 2007 to 2010, he was a Senior Research Fellow at the University of Essex. Brückle's research interests cover medieval art, contemporary art and the history of photography. Currently, he is preparing a book on authenticity claims in documentary art practices.

Stephen Bull is a writer, artist and lecturer. He is the author of *Photography* (2010) and the editor of the forthcoming *Companion to Photography*, published by Blackwell, and writes for magazines including *Source: The Photographic Review*. His work as an artist has been exhibited in Tate Britain and The Photographers' Gallery, London, and he has published two books of photographs, *A Meeting with a Celebrity* (2004) and *Meeting Hazel Stokes* (2006). He is Course Leader for Photography at University for the Creative Arts, Farnham, UK.

David Campany is a writer, curator and artist. His publications include *Photography and Cinema* (2008), *Jeff Wall: Picture for Women* (2011), *Walker Evans: The Magazine Work* (2012) and the artist's book *Rich and Strange* (2012). In 2010 he co-curated *Anonymes: Unnamed America in Photography and Film* for Le Bal, Paris. He is a Reader in Photography at the University of Westminster, London.

David Chandler is a writer, curator and editor. He was Assistant Curator of Photography at the National Portrait Gallery, London (1982–1989); Head of Exhibitions at The Photographers' Gallery, London (1991–1995); Projects Manager at the Institute of International Visual Arts (inIVA) (1995–1997); and, from 1997 to 2010,

Director of Photoworks, Brighton. He has written widely on photography and the visual arts for many books and journals, including recent essays for monographs on Paul Graham, Rinko Kawauchi, Helen Sear and Peter Fraser (forthcoming in 2013). He is currently Professor of Photography at the University of Plymouth, UK.

Sean Cubitt is Professor of Film and Television at Goldsmiths, University of London, UK; Professorial Fellow in Media and Communications at the University of Melbourne, Australia; and Honorary Professor of the University of Dundee, Scotland. His publications include *Timeshift: On Video Culture*; *Videography: Video Media as Art and Culture*; *Digital Aesthetics*; *Simulation and Social Theory*; *The Cinema Effect*; and *EcoMedia*. He is the series editor for Leonardo Books at MIT Press. His current research is on the history and philosophy of visual technologies, on media art history and eco-criticism and mediation.

Patrizia Di Bello lectures on the history and theory of photography in the Department of the History of Art and Screen Media at Birkbeck, University of London. Her publications include *Women's Albums and Photography in Victorian Britain: Ladies, Mothers and Flirts* (2007); *Art, History and the Senses: 1830 to the Present* (2009), edited with Gabriel Koureas; and *The Photobook from Talbot to Ruscha* (2012), edited with Colette Wilson and Shamoon Zamir. She is currently working on a monograph on photography and sculpture.

Erina Duganne is an Associate Professor of Art History at Texas State University, US, where she teaches courses on the history of photography, race and representation, and American art and visual culture. In addition to numerous book chapters, articles and reviews, she is the author of *The Self in Black and White: Race and Subjectivity in Postwar American Photography* (2010), as well as a co-editor of *Beautiful Suffering: Photography and the Traffic in Pain* (2007).

Mark Durden is Professor of Photography at University of Wales, Newport, UK. He has published over 150 reviews and essays on contemporary art and photography. In 2000, with C. Richardson, he co-edited and co-curated *Face On: Photography as Social Exchange*. His 2001 book on *Dorothea Lange* is currently in its third edition. Durden contributed essays on John Szarkowski, Victor Burgin and Brian O'Doherty for Routledge's *Fifty Key Texts in Art History* (2012). He co-authored (with D. Campbell) the book *Variable Capital: Art and Consumer Culture* in 2007. Durden is also an artist, exhibiting regularly as part of the artists' group Common Culture.

Paul Edwards is a literary photographer, a founder member of the Ouphopo, and is also Reader in English at Paris VII, specializing in photoliterature and translation. He has recently edited *Rock Photography* and *L'Élixir du R. P. Gaucher* (both 2011). Publications include *Soleil noir: Photographie et littérature* (2008), as well as an anthology, *Je hais les photographes! Textes clés d'une polémique de l'image 1850–1916* (2006), and a photographically illustrated novel, *Mademoiselle de Phocas: Gothic-Industrial Photographer* (2008). Translations include Alfred Jarry for Atlas Press, and Marcel Duchamp for the Philadelphia Museum of Art. His websites are www.ouphopo.org and www.phlit.org.

David Evans has contributed to international exhibitions on John Heartfield and photomontage, and has published widely on *avant-garde* uses of photography. Books include *John Heartfield: AIZ/VI 1930–38* (1992), *Appropriation* (2009) and *Moholy-Nagy: 60 Fotos* (2010). He teaches the history and theory of photography at the Arts University College at Bournemouth, UK.

Jane Fletcher's critical practice revolves around photography: archival research, photographic theory, blogging and the creation of lens-based imagery. She writes regularly for the photographic press and has contributed to various anthologies and exhibition catalogues. Recent publications include '"An Embarras de Richesses": Making the Most of the Royal Photographic Society Collection 1970–1980' in *Photography and Culture* (2010) and 'Stand Before the World' in *John Blakemore: 1955–2010* (2011). She is currently collaborating on a series of life-sized video portraits entitled *Quickening*. Using the latest digital imaging technology, these images destabilize the boundaries between the animate and inanimate, the past and the 'passed away'.

Jonathan Friday is a Senior Lecturer in the History and Philosophy of Art Department, and Head of the School of Arts, at the University of Kent, UK. He has published widely on the aesthetics of photography, including the book *Aesthetics and Photography*, published in 2002. Among his writings on photography is a study of Bazin's theory of photography, 'André Bazin's Ontology of Photographic and Film Imagery', that appeared in the *Journal of Aesthetics and Art Criticism* in 2005. His other field of study is eighteenth-century British aesthetics.

Elizabeth Howie is Assistant Professor of Art History at Coastal Carolina University in Conway, South Carolina, US. Her research focuses on modern and contemporary art with an emphasis on the history and theory of photography. Her publications include 'Seeing

Stars: Reading Melancholy and Power at Madame Tussauds through the Lens of Hiroshi Sugimoto' in *Colloquy* (vol 15, 2008) and 'Proof of the Forgotten: A Benjaminian Reading of Daguerre's Two Views of the Boulevard du Temple' in *Walter Benjamin and the Aesthetics of Change: An Interdisciplinary Approach*, edited by Anca M. Pusca (2010).

Ian Jeffrey taught art history at Goldsmith's College, UK, from 1970, where he became an influential figure for the generation of young British artists, including Damien Hirst, who studied there during the 1980s. Jeffrey contributed an essay to the catalogue of the Young British Artists' (YBA's) ground-breaking exhibition *Freeze* (1988). His books on photography include *Photography: A Concise History* (1981), *Revisions* (1999) and *How To Read a Photograph* (2008). A book of his own photographs, *Universal Pictures*, was published in 2003. He lives and works in Suffolk, UK.

Yoshiaki Kai is an art historian based in Tokyo, Japan. He earned a PhD from the City University of New York and is currently an adjunct lecturer at Tokyo Zokei University, where he teaches the history of photography.

Hope Kingsley is Curator for Education and Collections at the Wilson Centre for Photography. Her publications include *Seduced by Art: Photography Past and Present* (2012).

Joanna Lowry writes about contemporary photography and video and fine art. She is the Academic Programme Leader for Photography Moving Image and Sound at the University of Brighton, UK, and is Course Leader for the MA Photography programme. Her research focuses upon the way in which fine art practices have prompted a re-engagement with our understanding of photography as a medium, and the phenomenology of space, time and the everyday. Recent publications include 'Projecting Symptoms' in *Screen/Space*, edited by Tamara Trodd (2010); 'Modern Time: Photography and the Contemporary Tableau' in *Time and Photography*, edited by Hilde Van Gelder (2010); 'Photography, Cinema and Medium as Social Practice', with David Green, in *Visual Studies* (vol 24, no 2, 2009); and 'An Imaginary Place' in *Theatres of the Real* (2009).

Amna Malik is Lecturer in Art History and Theory at the Slade School of Fine Art, University College London, and has published a number of articles examining contemporary art practice from the perspective of diaspora. She is currently researching two book projects:

Art and the Post-Colonial Imaginary examines the work of diaspora artists who have disappeared from mainstream narratives and post-colonial accounts of art history; *Proximity* is a study of documentary film and the politics of affect in contemporary art. She is also a member of the editorial board of *Third Text*.

Carol Mavor is Professor of Art History and Visual Studies at the University of Manchester, UK. Mavor was named the Northrop Frye Chair in Literary Theory at the University of Toronto for 2010–2011. Her books include *Black and Blue: The Bruising Passion of Camera Lucida, La Jetée, Sans Soleil and Hiroshima mon amour* (2012); *Reading Boyishly: Roland Barthes, J. M. Barrie, Jacques Henri Lartigue, Marcel Proust, and D. W. Winnicott* (2007); *Becoming: The Photographs of Clementina, Viscountess Hawarden* (1999); and *Pleasures Taken: Performances of Sexuality and Loss in Victorian Photographs* (1995), all published by Duke University Press. Her latest book is *Blue Mythologies: Reflection on a Colour* (Reaktion, 2013).

Jessica S. McDonald is Assistant Curator of Photography at the San Francisco Museum of Modern Art and a doctoral candidate in the Visual and Cultural Studies programme at the University of Rochester, New York. She is the US reviews editor for the journal *Photography & Culture* and editor of *Nathan Lyons: Selected Essays, Lectures, and Interviews*, published in 2012.

Nikos Papastergiadis is Professor at the School of Culture and Communication at the University of Melbourne, Australia. His current research focuses on the investigation of the historical transformation of contemporary art and cultural institutions by digital technology. His publications include *Modernity as Exile* (1993), *Dialogues in the Diaspora* (1998), *The Turbulence of Migration* (2000), *Metaphor and Tension* (2004) and *Spatial Aesthetics: Art Place and the Everyday* (2006), as well as being the author of numerous essays which have appeared in major catalogues, such as Sydney, Liverpool, Istanbul, Gwanju, Taipei and Lyon Biennales.

Grant Pooke is a Senior Lecturer at the University of Kent, UK, and a Fellow of the Higher Education Academy. He studied at the University of St Andrews and undertook a PhD at the Winchester School of Art. His research and teaching interests include post-conceptual art practice, aspects of Cold War visual culture and biography, and extending the audiences for art history. He is the co-author of *Teach Yourself Art History* (2003, 2008), *Art History: The Basics* (2008) and the author of *Francis Klingender 1907–1955:*

A Marxist Art Historian Out of Time (2008) and *Contemporary British Art: An Introduction* (2011).

Olivier Richon was born in Lausanne and studied at the Polytechnic of Central London, where he was taught by Victor Burgin, and graduated with a BA (Hons) in Film and Photographic Arts in 1980. In 1988 he completed a Master's of Philosophy on Exoticism and Representation. In 1991, he received the Camera Austria Award for Contemporary Photography. He is currently Professor at the Royal College of Art, where he is Head of Photography. A monograph of his photographic work, *Real Allegories*, was published in 2006. He was guest editor of *Photographies* (2011) for a special issue on photography and literature. He is represented by Ibid Projects, London.

Russell Roberts is Reader in Photography at the European Centre for Photographic Research at the University of Wales, Newport. He has curated many exhibitions on different aspects of photographic history and practice.

Adair Rounthwaite is a PhD candidate in Art History at the University of Minnesota, US, specializing in contemporary art. She is writing a dissertation about group material and Martha Rosler's participatory projects at the Dia Art Foundation in New York in 1988–1989. Her articles have appeared in various journals including *Representations*, *Camera Obscura* and *Performance Research*.

Katia Schneller is Professor of Art History at ESAD–Grenoble–Valence. Her PhD dissertation, *'Some Splashes in the Ebb Tide': Constructions and Deconstructions of Artistic Categories, New York, 1966–1973*, defended at Paris I–Panthéon–Sorbonne University in 2009, will be published by Macula Éditions. Her research deals with American art and criticism, trans-Atlantic artistic exchanges, and such notions as *avant-garde*, modernism and postmodernism. She has co-organized several international symposia on these topics at the INHA in Paris and the ENS-LSH in Lyon. She is a member of the reading committees of the French journals *Études photographiques* and *Images Re-vues*.

Nancy M. Shawcross teaches at the University of Pennsylvania, US, where she also serves as Curator of Manuscripts. She is the author of *Roland Barthes on Photography* (1997) and several articles on photography, literature and theory.

Jane Tormey lectures in critical and historical studies at Loughborough University School of the Arts. Her research explores the exchange

of ideas between art practice and other disciplines and the ways in which conceptual and aesthetic traditions can be disturbed by and through photographic/filmic practices. She is co-editor of the *Radical Aesthetics–Radical Art* book series (I. B. Tauris), which addresses contemporary themes within art practice, such as 'eco-aesthetics', 'indigenous aesthetics' and 'socio-political aesthetics'. She is currently completing two books for publication in 2012: *Photographic Realism: Late Twentieth-Century Aesthetics* (Manchester University Press) and *Cities and Photography* for the Routledge series Urbanism and the City.

Hilde Van Gelder is Associate Professor of Modern and Contemporary Art History at the University of Leuven, Belgium. She is Director of the Lieven Gevaert Research Centre for Photography. She is editor of the Lieven Gevaert Series (University Press Leuven), and editor of the e-journal *Image [&] Narrative* (Open Humanities Press). She has published in various journals, including *History of Photography*, *Semiotic Inquiry*, *Visual Studies* and *Philosophy of Photography*. In 2011, she was invited blogger for *Le Magazine du Jeu de Paume*. In June and July 2012, she was invited blogger for Fotomuseum Winterthur, investigating the topic 'What Can Photography Do?'

Shamoon Zamir is Associate Professor of Literature and Visual Studies at New York University, Abu Dhabi. His work focuses primarily on the literature, photography and intellectual history of the US. He is the author of *W.E.B. Du Bois and American Thought* (1995), co-editor of *The Photobook: From Talbot to Ruscha and Beyond* (2012) and has recently completed a book on photography, portraiture and time focused on the work of Edward S. Curtis. He has also published on the interactions of Native American photography and literature. Shamoon Zamir previously taught at the universities of Chicago, York and London.

PREFACE

Introducing selected essays on photography in his 1980 anthology (ranging from Joseph Nicéphore Niépce to John Berger), Alan Trachtenberg said that photography lacked 'a critical tradition, a tradition of serious writing' (Trachtenberg 1980: vii). 'There has been,' he said, 'little notable effort to address the medium itself, to examine its evolving character, its social and cultural properties, its complex relations with other media and the great variety of roles it performs' (Trachtenberg 1980: vii). Over three decades later we can now speak about both a critical tradition and a community of serious writers on photography, a community attested to by the contributors to this very anthology, some of whom are also included as its key writers.

Trachtenberg's anthology came out at the cusp of the emergence of a new critical body of writing that has in many ways radically altered our relationship and understanding of photography. He pointed to the future at the close of his introduction by stressing the beginning of 'a new seriousness of discussion' of photography that could be found in the work of 'cultural critics' such as Walter Benjamin, Roland Barthes and Susan Sontag. The future of photography criticism was felt to 'require that critics take into account the communicative power of the photographic image, its "language", its "meaning", and the relevance of that meaning to our world' (Trachtenberg 1980: xiii).

Sabine T. Kriebel's rich and detailed introduction to a recent book on photographic theory, picking upon Trachtenberg's sense of impoverishment of critical writing on photography during the 1980s, suggests that since then 'while there has been a great deal of focus on the social, political, cultural and psychological resonances of the photographic medium, it does seem that the actual physical characteristics of the medium and how they signify have gotten short thrift' (Elkins 2007: 42). She suggests that the questions we now need to be addressing concern the ways in which 'politics and culture are imbricated in its very form', questions that become ever more pressing and

urgent '[g]iven the increasing authority and omnipresence of digitality and virtuality' (Elkins 2007: 43).

Kriebel is suggesting a new path for photographic writing. It is, in fact, one that has already been defined by a number of key writers in this book. But before considering them, we should just further clarify the characteristics and issues of the writing dominant in the 1980s. Broad terms of classification and identification often simplify and distort, and are certainly very often opposed by those who are categorized by them; but for convenience the kind of writing Trachtenberg notes that is emergent in 1980 is best defined as postmodern.

Postmodernism opened up the context of photography and exposed the limits of an aesthetic and formalist approach to the medium as fine art. Photography was seen and understood as an integral part of mass culture, and it was ideological through and through. Photography had a habit of appearing to disguise ideology, make it appear natural – as, among others, Roland Barthes in *Mythologies* (1957) and Malek Alloula in his later *The Colonial Harem* (1981) have both so brilliantly shown us.

Postmodern writing on photography has led to some serious questions being asked. One of the strongest criticisms is voiced by Susie Linfield as she addresses the question: 'Why do photography critics hate photography?' in her 2010 book *The Cruel Radiance*. The question forms part of the title of her polemical first chapter in which Linfield defends photojournalism from its theoretical detractors and argues for the ethical importance of looking and thinking about images of political violence. For her, Susan Sontag's essays that began appearing and making an impact in 1973, and were published as *On Photography* in 1977, set a certain tone for photography criticism, continuing with such writers as Allan Sekula, Abigail Solomon-Godeau, Martha Rosler, John Tagg and Victor Burgin. What united this criticism was how it appeared not to have empathy for photography and how it viewed emotional responses not as 'something to be experienced and understood but, rather, as an enemy to be vigilantly guarded against' (Linfield 2010: 4).

Linfield represents a new turn in photography writing – it is signalled in this book by the writings, in particular, of David Levi Strauss, Carol Mavor, Elizabeth Edwards, Geoffrey Batchen, Kobena Mercer and bell hooks. One could also add to this list Max Kozloff, someone who has been writing on photography since the mid-1970s. All offer a much more emotionally engaged response to photographs, and start to make us think about the interrelationship between aesthetics and politics. John Berger and the Roland Barthes of *Camera Lucida*, in many senses, can also be associated with this new approach.

One could then divide photography writing into two camps in terms of those who write about photography 'with empathy and insight' and those who appear not to like it (Linfield 2010:9). Writing since the 1990s has certainly entailed a closer attachment and emotive engagement with the photographic image; at the same time it has also drawn upon the politicized perspectives opened up by postmodernism.

The purpose of an anthology like this is to allow us to find patterns and strands of common ways of thinking about photography, for us to try and find continuities and connections from among the often bewildering array of contesting and differing voices that make up photography writing – but also to take up some of the polemics that have emerged around photography, especially within the last three decades, and to interrogate them. The recourse to the alphabetical structure of the A–Z for this book is intended to help all this, on one hand, reflecting the difficulty of fitting photography writing into a chronology, and, on the other, enabling an ease of use and cross-referencing that may help to facilitate and guide us through the field, no matter how messy it is.

William Henry Fox Talbot's writings on photography are significant because, as the English inventor of photography, he is very often shaping for the first time a language to describe what photography is and does. He is exploring its very identity and distinction from painting and drawing. Talbot's definition of the photograph as 'Impressed by Nature's Hand' resonates throughout photography's 170-year history.

Such nineteenth-century writers as Lady Eastlake and Oliver Wendell Holmes are fascinating because they, like Talbot, are also seeking to define what photography is. Both are aware very early on of the import given to ordinary and humble details in photography. This valuing of the commonplace and everyday was to become integral to many subsequent writers on photography and is especially important to John Szarkowski's aesthetic account of photography and its distinction from painting.

Writing by photographers offers one key strand running through this book. It could and has been said that writers who are photographers write about the medium differently than those who are not. Photographers' understanding of photography can often be quite original, refreshing and insightful because it is written from a position of close engagement and involves a practical knowledge. This is why Henri Cartier-Bresson is included here as a key writer. The identity of the photographer as writer changed considerably with the emergence of such theorist-practitioners as Allan Sekula, Victor Burgin and Martha Rosler. Interestingly, their engagement with photography as artists

did not prevent Susie Linfield from claiming that they were still hostile to photography in what they said about it. What all three certainly opposed were more naïve responses to documentary and aesthetic Fine Art uses of the medium: photography was neither a window onto the world nor an expressive manifestation of an artist's unique sensibility.

Literature remains another key strand of writing on photography in this anthology. That the photographer Brassaï should write a book on Marcel Proust is fascinating, attesting to the close affinity between literature and photography, as well as Proust's value as a writer on photography. Proust has two key presences in this anthology, both through Brassaï and Carol Mavor's reflections upon the ways in which his long modernist novel *In Search of Lost Time* (1913–1927) is photographic.

James Agee considered photography through and in relationship to literature. His essays on Walker Evans and Helen Levitt, and especially his extraordinary 1941 book *Let us now Praise Famous Men* – arguably one of the most significant modernist texts within the twentieth century – offer an impassioned and valuable engagement with both documentary photography's problems and virtues. We can still learn from Agee.

This anthology also responds to philosophers and theorists who have had an impact upon our understandings of photography. Their inclusion might appear rather unconventional, but their influence and value is often disproportionate to what little they may have written about photography – see especially the essays on George Bataille, Vilém Flusser, Jacques Derrida, Jacques Rancière, Jean Baudrillard and Henri Van Lier. With some of them, one senses that the full repercussions of their ideas have yet to take full effect.

And then there is, of course, art history and its impact; it becomes a meta-narrative here, one that can and has framed photography in particular ways. While photography does not really fit well within art history, it has nevertheless been written about by major figures from within the discipline – if one can still call it a discipline. This is why Clement Greenberg is important. Integral to shaping modernist art criticism in his defence and advocation of abstract painting, the few essays he wrote on photography value content and referentiality as its integral characteristics. Photography should not aspire to but remain distinct from painting. Both Rosalind Krauss and Michael Fried in their very different engagements with art photography work through the influence of Greenbergian modernism and his medium-specific concerns with both painting and photography.

Alan Trachtenberg was writing at the point of an emergent post-modern criticism, away from what he identified as art historical 'connoisseurship'. As I close this introduction, there is the sense of a growing new body of writing attentive to the ways in which photography becomes integral to the global flow of digital information. As a selection of key writers from Talbot to the present, there is inevitably a domination of writers addressing the analogue identity of photography in this book. The question of digitality does, of course, arise – especially among the more recent philosophical reflections on photography. However, there is such a growing and expanding body of writing about new media, where photography circulates as an image on the screen and as part of social media alongside text and in relationship to moving images and sound, that it is a field that remains somewhat beyond the scope of this book and would perhaps require a publication of its own to begin to do it justice.

I'd like to thank all the contributors for their texts and for the care and precision in elucidating the often complex ideas of their key writer and with so few words at their own disposal. Also, thank you all for keeping within the tight word length you were set. I would also like to thank all the staff at Routledge who worked on this book, especially Rebecca Shillabeer: her patience and attention to detail throughout this project has been much appreciated. And, finally, thanks to Tom Wood for his generosity in allowing us to reproduce his brilliant photograph on the cover, *gratis*: an artist who really understands photography and from whom I have learned and still learn so much.

References

Elkins, J. (ed) (2007) *Photography Theory*, New York and London: Routledge.

Hand, M. (2012) *Ubiquitous Photography*, Cambridge, UK: Polity Press.

Linfield, S. (2010) *The Cruel Radiance: Photography and Political Violence*, Chicago, IL: University of Chicago Press.

Trachtenberg, A. (1980) *Classic Essays on Photography*, New Haven, CT: Leet's Island Books.

Wood, T. (1998) *All Zones Off Peak*, Stockport, UK: Dewi Lewis.

FIFTY KEY WRITERS ON PHOTOGRAPHY

JAMES AGEE (1909–1955)

James Agee's reputation as a writer on photography is predominantly based on his long-term collaborative work with the photographer Walker Evans, the result of which, *Let us now Praise Famous Men* (1941), remains one of the most complex investigations into the ethical implications of documentary practice to come out of the 1930s. As stated in its introduction, the book was meant to take as its subject 'North American Cotton tenantry as examined in the daily living of three representative white tenant families' (Agee and Evans 1941: xiv), and yet, couched within its 500-plus pages of prose, poetry and photographs lay also a commentary on and critique of the idea of photography as an undisputed instrument of progress, on photography as a straightforward method of documentation.

While Agee famously decreed 'the camera seems to me, next to unassisted and weaponless consciousness, the central instrument of our time' (Agee and Evans 1941: 11), his observations on the potentially voyeuristic aspects of documentary practice and the ways in which this voyeurism has to be negotiated remain a remarkably prescient rumination on photographic practice, in general. Coming in the wake of both Margaret Bourke White and Erskine Caldwell's *You Have Seen Their Faces* (1936) and Dorothea Lange and Paul Taylor's *American Exodus* (1939), *Let us now Praise Famous Men*, was partly constructed as a response to the perceived stereotyping of the South in Bourke White's photographs of an apparently backwards people. For Agee, such attempts proved the near impossibility of a genuine document of abject poverty that did not in the end demean the subjects portrayed. Rather than a series of case studies, the three families with whom he lived during the summer of 1936 thus became a springboard for an investigation into the philosophical ramifications of documentary representation itself. For Agee, the fact that his subjects, as he put it, 'exist, in actual being, as you do and as I do' meant that it was the obligation of the documentary project to render both the emotional and psychological landscape, as well as the reality of the existence of the subjects, in as truthful terms as possible (Agee and Evans 1941: 12).

Agee's background as a lyricist (his collection of poems *Permit Me Voyage* was published in 1934) as well as a staff writer for *Fortune* and, later, *Time* Magazine, undoubtedly added to the lyrical tone of *Let us now Praise Famous Men*; but it also – more crucially – allowed him to define Evans's photography as able to render 'those individual existences ... where each carries in the postures of his body, in his hands, in his face, in the eyes, the signatures of a time and a place in

the world' (Agee 2004: 15). This later comment, from Agee's intro-
duction to Evans's photographs of commuters on the New York
Subway, *Many Are Called*, indicates the way in which Agee stresses
the individuality of the subjects, making the photograph's ability to
capture the uniqueness of a time and place paramount.

Agee's writing on Walker Evans's photography as a way to sanctify
human individuality is echoed in his later collaborative work with the
New York-based photographer Helen Levitt during the 1940s. Like
Evans's images of the 1930s sharecroppers, Levitt's photographs of
children on the streets of Harlem and Manhattan were, for Agee,
clear manifestations of the importance of an ethical documentary per-
spective, a perspective in which the presence of both the photographer
and the subject photographed could co-exist without the stigma of an
overtly journalistic agenda. In Levitt's lyrical portrayal of the movements
and play of children, Agee finally found proof of photography's abil-
ity to combine realist representation with an emotive and distinctly
lyrical quality. The beauty of Levitt's 'ordinary metropolitan soil', as
Agee put it, was that it finally proved without subterfuge the presence
of 'reality in its unmasked vigour and grace' (Agee 1965: 8). This is
another version of the 'time and a place in the world' that Agee felt
Walker Evans's subway photos so irrevocably caught in the faces of
the passengers photographed (Agee 2004: 14).

In *A Way of Seeing*, an introduction to Levitt's first collected book
of photographs, posthumously printed in 1965, Agee defines a
distinctly American visual vernacular as instrumental in creating this
sense of truthfulness, of 'unmasked vigour and grace'. In 1944 Agee and
Levitt collaborated on a short art film, *In the Street*; a cross between
American *cinema verité* and live photography, the 14-minute black-
and-white film was shot by Agee, Janice Loeb and Helen Levitt in
East Harlem. Silent, save for a piano accompaniment by Arthur
Kleiner, the film likewise exemplifies Agee's concept of the lyrical
photograph, 'filled with movement, fluid and so transient' it is able to
capture the most illuminating moment in which 'the simplest and most
direct way of seeing the everyday world is ... the most subjective way in
which we ordinarily look around us' (Agee 1965: 8).

In the Street, among other things, sets out to define the photographic
process as also operating in some ways between two genres: photo-
graphy and film. A devotee of silent movies, Agee used cinema as an
entry into a reconsideration of how gestures within photography can
be read as a visual language in themselves. In *A Way of Seeing*, two
modes of documentary photography are distinguished: the static and
meditative gaze (found in Walker Evans's photographs, for example)

in which 'the actual is not at all transformed; it is reflected and recorded, within the limits of the camera with all possible accuracy', and the lyrical and emotional gaze (evident in Levitt's street photography) in which 'the most illuminating moment' is that 'faithful record of the instant in which this movement of creativeness achieves its most expressive crystallization' (Agee 1965: 8).

As in the case of Evans, Agee's impulse was to both universalize and Americanize Levitt. This was not simply because of the unmistakable urbanity of Levitt's images and the unmistakeable rural quality of Evans', but because Agee considered their collective ability to capture the sacred in the everyday a decidedly American characteristic. As Agee put it: 'The artist's task is not to alter the world as the eye sees it into a world of aesthetic reality, but to perceive the aesthetic reality within the actual world' (Agee 1965: 8).

Just as Evans's photographs of the sharecroppers in *Let us now Praise Famous Men* were partly about the illuminative potential of a lost pastoral dream during 1930s America, Agee's desire to use Levitt's work as proof of the magnetism of street photography also reflects 1940s concerns with environment and social behaviour. The issue is one of community or 'how we all powerfully inter-depend upon and enhance one another, reverberating like mirrors locked face to face' (Agee 1965: 8). Always gravitating towards the communal, the vision of togetherness in Levitt's images allowed Agee to concretize what he had signalled in *Let us now Praise Famous Men* – namely, the importance of photography as a form of shared intimacy as well as a communicative device. The children in Levitt's photographs, for instance, rather than being seen as victims of social forces beyond their control, are complex ciphers for an innocence that has as much to do with photography's ability to capture the purity of an instant as with their actual social circumstances, an 'innocence, not as the word has come to be misunderstood and debased, but in its full original wildness, fierceness, and instinct for grace and form' (Agee 1965: 13).

This mix of intimacy and form is what Agee wanted photography to render. It lies in the gestural qualities of Levitt's work because, more than anything else, they intimate the continuum of lived life, making photography both still and moving collide with something beyond the surface. In the end, the external gesture is also what attaches value to interior life and, for Agee, Levitt's ability to infer such attachments proves the link between street photography and the lyrical quality he so ardently desired. What Agee recognized was essentially that in order to have relevance, street photography would have to signal its own ability to capture more than simply a place and situation at hand.

In effect, by capturing the lyricism of the street and the external world we live in, untold interior regions could also be intimated and explored. Agee's elevation of photography into something more complex than simply a method of documentation was a crucial step in a longer process of allowing what we now take for granted – namely, the blurring between art and documentary photography, between fiction and reportage. For Agee, photography simply unearthed those underlying signals and signs that were part of our culture all along, proving 'that the actual world constantly brings to the surface its own signals, and mysteries' (Agee 2004: 10).

Biography

James Rufus Agee was born on 27 November 1909 in Knoxville, Tennessee. He studied at Harvard University in Cambridge, Massachusetts, where he edited the *Harvard Advocate* (1928–1932). He was a reporter and staff writer for *Fortune* (1932–1939). From 1939 he was a book reviewer and from 1941 to 1948 both a feature writer and film reviewer for *Time* magazine. He was film columnist for the *Nation* from 1942 to 1948. In 1948 he was co-director of the film *In the Street*. He received a posthumous Pulitzer Prize in 1957 for *A Death in the Family*. He died of a heart attack in New York on 16 May 1955.

Primary texts

Agee, J. (1965) *A Way of Seeing: Photographs by Helen Levitt*, New York, NY: Viking Press, pp7–15.
——(2004) *Many Are Called*, New York, NY: Metropolitan Museum of Art.
Agee, J. and Evans, W. (1941) *Let us now Praise Famous Men: Three Tenant Families*, Boston, MA: Houghton Mifflin.

Secondary texts

Bergreen, L. (1984) *James Agee: A Life*, New York, NY: Dutton.
Blinder, C. (ed) (2010) *New Critical Essays on James Agee and Walker Evans: Perspectives on Let us now Praise Famous Men*, New York, NY: Palgrave Macmillan.
Lofaro, M. A. (ed) (1992) *James Agee: Reconsiderations*, Knoxville, TN: University of Tennessee Press.
Lofaro, M. A. and Davis, H. (eds) (2005) *James Agee Rediscovered: The Journals of Let us now Praise Famous Men and Other New Manuscripts*, Knoxville, TN: University of Tennessee Press.
Madden, D. (ed) (1974) *Remembering James Agee*, Baton Rouge, LA: Louisiana State University Press.

Maharidge, D. and Williamson, M. (1989) *And Their Children After Them: The Legacy of Let us now Praise Famous Men, James Agee, Walker Evans, and the Rise and Fall of Cotton in the South*, New York, NY: Pantheon.

Stott, W. (1974) *Documentary Expression and 1930s America*, Chicago, IL: University of Chicago Press.

Trachtenberg, A. (1989) *Reading American Photographs: Images as History, Mathew Brady to Walker Evans*, New York, NY: Hill and Wang.

Caroline Blinder

MALEK ALLOULA (1937–)

Malek Alloula is an Algerian writer and poet, based in Paris since 1967. He has a keen interest in photography about his home country, and has written for a range of books covering topics such as photographs of nineteenth-century Algiers (Alloula 2001b) and photographs of the moment of national independence following the Franco-Algerian War (1954–1962) (Alloula 2009). All of Alloula's writings on photography and Algeria are of note, but his reputation as a photo-theorist is primarily based on one book: *Le Harem Colonial: Images d'un sous-érotisme* (*The Colonial Harem: Images of a Suberoticism*), originally published in France and Switzerland in 1981, and appearing as a new edition in France with an afterword by the author in 2001. In 1986 an English-language version with the shorter title *The Colonial Harem* was published simultaneously in the US and the UK as a volume in the prestigious series *Theory and History of Literature*, edited by Wlad Godzich and Jochen Schulte-Sasse, under the auspices of the University of Minnesota Press. Basically, it was Alloula's inclusion in this series, and the ensuing exposure to large audiences beyond the Francophone world, that resulted in international interest in him as a significant post-colonial photo-theorist.

The Colonial Harem contains reproductions of 90 postcards plus critical commentary. Most of the images were created in photographic studios in Algiers between 1900 and 1930, mainly to be sent as postcards to metropolitan France. All show Algerian women veiled and – more often – unveiled. The postcards often have the generic title *Scenes and Types*, implying that what is being represented has some ethnographic value. Rarely so, Alloula insists, for the postcards are generally staged studio shots. Models, often prostitutes, use a stock of costumes, jewellery and elementary props to act out a limited repertory of themes, oscillating between pseudo-ethnography and the vulgarized iconography of Orientalist painting. The fictional nature of the 'Scenes' and 'Types' is

vividly conveyed when Alloula presents three postcards showing the same model, wearing the same outfit, in the same studio, but with different titles: 'Young Beduin woman', 'Young woman from the South' and 'Young Kabyl woman' (Alloula 1986: 62, 63, 65). This explains the author's use of the lowercase word *algérienne* to describe a role-playing female model, to be clearly distinguished from the actual uppercase *Algérienne*.

The *Algérienne* is often veiled and this poses problems. The photographer is supposed to provide a comprehensive inventory for the French colonial masters who want clear, unimpeded views of all of their property. But a disturbing opacity remains as long as women conceal themselves. Moreover, they can see without being seen, and in a particularly inspired passage, Alloula imagines the veiled woman as a mimic, aggressing and frustrating the male photographer by acting like a human camera:

> These veiled women are not only an embarrassing enigma to the photographer but an outright attack upon him. It must be believed that the feminine gaze that filters through the veil is a gaze of a particular kind: concentrated by the tiny orifice for the eye, this womanly gaze is a little like the eye of a camera, like the photographic lens that takes aim at everything.
>
> The photographer makes no mistake about it: he knows this gaze well; it resembles his own when it is extended by the dark chamber or the viewfinder. Thrust in the presence of a veiled woman, the photographer feels photographed; having himself become an object-to-be-seen, he loses initiative: *he is dispossessed of his own gaze.*
>
> (Alloula 1986: 14)

The photographer's response, Alloula suggests, is a 'double violation: he will unveil the veiled and give figural representation to the forbidden' (Alloula 1986: 14).

Significantly, the second chapter concludes with a postcard of a studio set-up in which the face behind the veil is revealed. And the rest of the book – Chapters 3 to 10 – presents thematic variations of a 'double violation', primarily involving images of an imagined harem with its inmates usually unveiled, undressed and seemingly available. Alloula's 90 postcards are thematically distributed across the nine chapters, preceded by an opening chapter that offers a framework for the book as a whole. In Chapter 1, the author acknowledges that Orientalist thinking, often focusing upon the harem as a source of fear

and fascination, pre-dates modern colonialism. Nevertheless, the early decades of the twentieth century are significant, simultaneously the 'Golden Age' of French colonialism and postcard culture. At this moment, then, the old Western myths surrounding the harem take on a new lease of life, as widely circulated pseudo-ethnographic erotic postcards of the unveiled Arab woman – the 'poor man's phantasm' (Alloula 1986: 4) – become a metaphor for colonial possession, in general.

The Colonial Harem works on more than one level. Most obviously, Alloula is the outraged Algerian male who takes it for granted that his little collection of postcards reveals more about metropolitan 'phantasms' than about the *Algérienne* –hence his attempt, 'lagging far behind History, to return this immense postcard to its sender' (Alloula 1986: 5). But on a second level, Alloula makes it clear that he is doing more than retrospectively defending the honour of the *Algérienne* when he describes his text as a personal 'exorcism' (Alloula 1986: 5). In other words, the book is a way of dealing with the fact that he, too, has grown up in colonial Algeria and has been a victim of the colonizer's gaze. And on a third level, Alloula's engagement becomes more complex when he occasionally admits that, despite the norms of sordid fakery, certain postcards appeal to him – for example, 'Moorish women in their quarters', produced in the Algiers studio of Jean-Théophile Geiser, which is used on the front or back cover of all of the various editions. It is also reproduced in the book where it is described as a 'sort of masterpiece of the genre', a 'kind of photographic synthesis of Delacroix's *Women of Algiers* and of Ingres's *Turkish Bath*' (Alloula 1986: 35). In short, the author has a complex personal involvement with the postcards, veering between avowal and disavowal, attraction and repulsion. These tensions are signalled through the use of Roland Barthes, to whom the *The Colonial Harem* is dedicated. Note that Alloula makes no reference to the young left-leaning author of *Mythologies* (1957), a book published during the Franco-Algerian War and marked by a clear sympathy for contemporary colonial revolt. Rather, he draws on the mature, openly hedonistic author of *Camera Lucida* (1981), whose main preoccupation is why only a very small number of photographs move him profoundly. *Camera Lucida* is a very personal book that Alloula continuously cites and which provides him with epigraphs for three of his chapters.

The broader context for Alloula's pioneering book is contemporary appropriation art. Appropriation means taking without authority and is at the core of all imperial projects, including French involvement in Algeria for over a century. The idea of using the term to describe certain types of contemporary art is relatively recent and is usually

associated with the artists who emerged in New York during the late 1970s and who are surveyed for the first time in the exhibition and catalogue *Endgame: Reference and Simulation in Recent Painting and Sculpture* (Boston: 1986). Significantly, this overview took place in the same year that *The Colonial Harem* was published in the US and there is a link, for Alloula's book can be understood as a pioneering instance of post-colonial appropriation, 'the re-taking of that which was possessed without authority' (Evans 2009: 19).

Biography

Malek Alloula was born in Oran in 1937. He lived in Algeria throughout the Franco-Algerian War (1954–1962) and in the first years of independence. In 1967 he moved to Paris, where he pursued postgraduate studies in French literature at the École Normale Supérieure. He is a widely published writer and poet, based in Paris.

Primary texts

Alloula, M. (1981) *Le Harem Colonial: Images d'un sous-érotisme*, Geneva and Paris: Éditions Slatkine.
——(1986) *The Colonial Harem*, Minneapolis, MN: University of Minnesota Press.
——(2001a) *Le Harem Colonial: Images d'un sous-érotisme*, Paris: Éditions Séguier (new edition with an afterword by the author).
——(2001b) *Alger photographiée au XIXe siècle*, Paris: Éditions Marval.
——(2001c) *Belles Algériennes de Geiser*, Paris: Éditions Marval.
——(2009) 'Les instantanés éphémères de l'éternité', in M. Riboud (ed) *Algérie indépendance*, Paris: Le Bec en l'air, pp161–168.

Secondary texts

Beaulieu, J. and Roberts, M. (eds) (2002) *Orientalism's Interlocutors: Painting, Architecture, Photography*, Durham and London: Duke University Press.
Enwezor, O. (2008) *Archive Fever: Uses of the Document in Contemporary Art*, New York, NY: International Center of Photography; Göttingen: Steidl.
Evans, D. (ed) (2009) *Appropriation*, London: Whitechapel Gallery; Cambridge, MA: MIT Press.
Hassan, S. (1997) '"Nothing Romantic About It!" A Critique of Orientalist Representation in the Installations of Houria Niati', in S. Hassan (ed) *Gendered Visions: The Art of Contemporary African Women Artists*, Trenton, NJ, and Asmata, Eritrea: Africa World Press, Inc., pp9–18.
Merewether, C. (ed) (2006) *The Archive*, London: Whitechapel Gallery; Cambridge, MA: MIT Press.

David Evans

ROLAND BARTHES (1915-1980)

Roland Barthes was a literary and cultural theorist, active in France
during the second half of the twentieth century. He was associated
with Marxism, the structuralism of Claude Lévi-Strauss, the semiology
of Ferdinand de Saussure, as well as the post-structuralism of the late
1960s and the 1970s. During the 1950s, several of Barthes's essays
relating to photography were compiled in a book entitled *Mythologies*.
His Marxist leaning in these articles can be seen in his critique of
capitalism and the use of photography in advertising. In particular,
Barthes focuses on how photography supports consumerism while
masking capitalism's exploitation of the masses; he offers incisive cri-
tiques on the use or misuse of photographs for propaganda, whether
political or commercial. Barthes's review of New York's Museum of
Modern Art exhibition *The Family of Man*, (in Paris) curated by Edward
Steichen, is unusual for the time. In 1955 Steichen displayed 503
photographs in an attempt to reveal 'the essential oneness of mankind
throughout the world'; the show is considered the most successful
photographic exhibition in history. Barthes challenges Steichen's
installation, which includes aphorisms and quotations from literature;
Barthes argues that the individual subjects and their unique lives are
effaced in order to promote universal human kinship, while responsibility
for human suffering and injustice is obscured.

Beginning in the late 1950s and continuing into the 1960s, Barthes
adapts the methodologies of structuralism and semiology in his analyses
of literature and other cultural phenomena. He argues at first for
the structure of the sign; using the example of the myth (which he
presents as a system of communication), Barthes states that a 'sign'
comprises a 'signifier' and a 'signified'. The signifier is the object,
whether a word or a story or an image, and the signified is the
meaning that an individual or a group associates with the signifier.
Key to his terminology is that the signifier is arbitrary. It doesn't
matter, for example, what combination of letters is used to suggest a
feline animal; whether society agrees on the letter combination 'cat'
or some other combination such as 'tac', the association is arbitrary
and not natural or God-given. In the 1961 essay 'The Photographic
Message', Barthes claims that the photograph is unique among 'signs':
because the photograph carries its referent with it (the reflected light
of the photographic subject), the signifier can never be completely
erased. In other words, the signifier is not arbitrary in the way that
the word 'cat' is. Barthes posits that the photograph is a signifier
without a signified or a message without code.

The 1980 publication of *La Chambre claire*, just two months before the author's death, dominates all that has been written about Barthes and photography during the last dozen or more years. Perhaps because Barthes was so closely associated with the analysis of writing, academic art historians were slow to integrate his essays on photography and art within their canon. In his lifetime, however, Barthes caught the attention of some who published on photography, a medium experiencing a resurgence of critical interest. On the strength of Barthes's previous essays on still and moving images (e.g. 'The Photographic Message', 'The Rhetoric of the Image' and 'The Third Meaning'), Cahiers du cinéma commissioned the treatise that became *La Chambre claire* (*Camera Lucida*, 1981). As Barthes undertook this assignment, he was also mourning the death of his mother. Some critics have argued that the work is not so much a treatise on photography but rather a eulogy or lament for his mother and that the photograph represents death or, at the very least, is a *memento mori*.

Looking at *Camera Lucida* as a text on photography, readers are presented with two neologisms that are frequently cited and debated by subsequent writers on photography. The elusive term *'punctum'* appears for the first and only time in *Camera Lucida* and is juxtaposed with the term *'studium'*, the cultural and intellectual ground on which one evaluates photographic content and composition. The *punctum*, on the other hand, involuntarily exceeds or pierces the analysable world of the photograph's *studium*, a detail that the photographer did not know was there. The former speaks to desire, the latter to interest. For Barthes the realm of the *studium* encompasses the photographer's intentions and any critical assessment of his or her work, but it keeps Barthes a spectator, neither delighted nor pained – and frequently bored – by the image. The *punctum*, as defined in Part I, is the photographic accident that bruises or stings Barthes and is poignant to him. By proposing this binary set, he finds a way to explore a particular kind of response, a dynamic that escapes codification and repetition. The concept has proved intriguing for some but infuriating for others, yielding no consensus about whether Barthes presents a theory on which to build or a paradox that offers little to no critical utility.

The introduction of the term *punctum* enhances Barthes's discussion of selected photographs (mostly portraits) in *Camera Lucida*, a fact that speaks to the term's rhetorical value. His pronouncement, however, in the final quarter of the book that the photographic *punctum* is time is often overlooked when invoking his nomenclature. From the 1961 essay 'The Photographic Message' to his final work, Barthes associates the medium's essence with its property of being an analogon – a reduction in

proportion, perspective and colour but not a 'transformation (in the mathematical sense)' (Barthes 1985b: 5). In his essays from the 1960s Barthes expresses awe that the photographic subject was once in front of the analogue camera lens; he emphatically returns to this sentiment ('that-has-been') in Part II of *Camera Lucida*. Barthes states that the photographic subject is not the optionally real thing but rather the undeniably real thing: no one can argue that in an analogue photograph the thing has not been there (short of obvious photographic tricks). He revises his concept of the *punctum* by emphasizing the photograph's intense relationship to time: 'the lacerating emphasis of the *noeme* ("that-has-been"), its pure representation' (Barthes 1981: 96). Once the *punctum* is linked with 'that-has-been' and with time, the remainder of *Camera Lucida* becomes vertiginous. Alexander Gardner's portrait, for example, of Lewis Payne in handcuffs is confounding for the simultaneity of Payne as someone dead and someone about to die, and a 1928 photograph by André Kertész of a child and his puppy induces a sense of going mad for pity's sake because of the reality of the boy and his dog and the knowledge that the dog, at least, is dead. The final section of the work offers the reader a choice: to tame the photograph's madness either by making it an art or by generalizing it and making it banal. It is not surprising that most bypass the notion of the *punctum* as time, for to confront in the photograph the awakening of intractable reality is the way of madness.

An immediate commercial success, *Camera Lucida* disappointed some photography critics who took issue with an approach that failed to consider the role of the photographer. For literary scholars the text confirmed the post-structural development of Barthes's writings of the 1970s (the so-called 'late' Barthes) and suggested new theoretical pathways privileging the concepts of desire, loss and subjectivity; for some the photograph was simply a means by which to examine the death of his mother two years earlier. The most spectacular example is Diana Knight's essay in which she posits that the 'Winter Garden' image – written but not printed in Part II of *Camera Lucida* – is an invention, a psychological displacement complicated not only by mourning but also by Barthes's homosexuality (Rabaté 1997: 138). In 2005 *Critical Inquiry* published 'Barthes's Punctum', in which Michael Fried co-opts the neologism, situating it 'in relation to the all-important current of antitheatrical critical thought and pictorial practice' (Batchen 2009: 145) – that is, seeing rather than being shown – from Denis Diderot to Édouard Manet. In response, James Elkins contends that 'the reading in "Barthes's Punctum" is necessary' (Batchen 2009: 172) and 'exemplary of modernism and for modernism' (Batchen 2009: 182).

Fried's article, however, prompts Elkins to interrogate more critically the value of *Camera Lucida* to photographic theory. In counterpoint to Fried's interpretation of the *punctum*, Rosalind E. Krauss locates its origin in 'The Third Meaning: Research Notes on Some Eisenstein Stills', in which Barthes postulates an obtuse meaning – 'a signifier without a signified' – that disturbs or sterilizes meta-language.

Roland Barthes endures as a worthy and seductive essayist on the medium of photography. He was also an innovator in his use of image and text: *Empire of Signs* and *Roland Barthes* give equivalence to both forms of expression. His writings on photography are an important witness to a medium in the full maturity of its analogical life, but they offer no discussion about or prediction regarding the new age of digital photography. On the other hand, Barthes's insistence on the photograph as an emanation of the necessarily real thing can engender some interesting dialogues *vis-à-vis* digital files and prints, and his study of the manipulation, exploitation and ubiquity of photographic images is as trenchant today as it was in his lifetime.

Biography

Roland Barthes was born in Cherbourg, France, on 12 November 1915 and attended the University of Paris, where he received degrees in classical letters (1939) and grammar and philosophy (1943). From 1939 to 1952 he taught at *lycées* in Biarritz (1939), Bayonne (1939–1940) and Paris (1942–1946); at the French Institute in Bucharest, Romania (1948–1949); at the University of Alexandria in Egypt (1949–1950); and at the Direction Générale des Affaires Culturelles in Paris (1950–1952). He held research appointments in Paris with the Centre National de la Recherche Scientifique from 1952 to 1959 and was director of studies at the École Practique des Hautes Études from 1960 to 1976. During 1967 to 1968 he was a visiting professor at Johns Hopkins University, Baltimore. Barthes served as chair of literary semiology at the Collège de France from 1976 until his death in Paris on 26 March 1980.

Primary texts

Barthes, R. (1976) *Mythologies* (selected and translated by A. Lavers), New York, NY: Hill and Wang,
——(1977) *Roland Barthes* (translated by R. Howard), New York, NY: Hill and Wang.
——(1981) *Camera Lucida: Reflections on Photography* (translated by R. Howard), New York, NY: Hill and Wang.

——(1983) *Empire of Signs* (translated by R. Howard), New York, NY: Hill and Wang.
——(1985a) *The Grain of the Voice: Interviews 1962–1980* (translated by L. Coverdale), New York, NY: Hill and Wang.
——(1985b) *The Responsibility of Forms: Critical Essays on Music, Art, and Representation* (translated by R. Howard), New York, NY: Hill and Wang.

Secondary texts

Alpert, A. (2010) 'Overcome by Photography: *Camera Lucida* in an International Frame', *Third Text: Critical Perspectives on Contemporary Art & Culture*, vol 24, no 3, pp331–339.
Batchen, G. (ed) (2009) *Photography Degree Zero: Reflections on Roland Barthes's 'Camera Lucida'*, Cambridge, MA: MIT Press.
Derrida, J. (2001) 'The Deaths of Roland Barthes', in P. A. Brault and M. Naas (eds) *The Work of Mourning*, Chicago, IL: University of Chicago Press, pp34–67.
Guittard, J. (2006) 'Impressions photographiques: les Mythologies de Roland Barthes', *Littérature*, vol 143, pp114–134.
Mavor, C. (2007) *Reading Boyishly: Roland Barthes, J. M. Barrie, Jacques Henri Lartigue, Marcel Proust, and D. W. Winnicott*, Durham, NC: Duke University Press, pp129–161.
Meek, A. (2010) *Trauma and Media: Theories, Histories, and Images*, New York, NY: Routledge.
Rabaté, J.-M. (ed) (1997) *Writing the Image after Roland Barthes*, Philadelphia, PA: University of Pennsylvania Press.
Shawcross, N. M. (1997) *Roland Barthes on Photography: The Critical Tradition in Perspective*, Gainesville, FL: University Press of Florida.
Taminiaux, P. (2009) *The Paradox of Photography*, Amsterdam: Rodopi.

Nancy M. Shawcross

GEORGES BATAILLE (1897–1962)

The inclusion of French writer Georges Bataille in an anthology devoted to theorists of photography is mainly due to his writing and picture editing for *Documents* (Paris, 1929–1930), a short-lived, eclectic academic journal that also became an outlet for dissident Surrealists. He was actively involved in choosing and editing photographs for the journal, but he rarely wrote explicitly about photographers and photography. Significantly, the most substantial piece of writing dealing directly with the subject was a short review of a photographic exhibition, originally intended for *Documents*, but only coming to light in the posthumously published second volume of his *Oeuvres complètes* (Paris, 1972).

He writes:

> After the photographs of Atget and the odd endeavours of Man
> Ray, it seems as if specialist art photographers can produce
> nothing more than rather tedious technical acrobatics. Press
> photographs or film stills are much more pleasurable to look
> at and much livelier than the majority of masterpieces that are
> presented for the public's admiration. The exception that must
> be made is the admirable photography of J.-A. Boiffard.
>
> (Bataille 1972: 122)

In many ways, Bataille is expressing views that align him to André
Breton and mainstream Surrealism, at least in matters photographic.
The veteran jobbing photographer Eugène Atget was a Surrealist
discovery and, prior to his death in 1927, the only *avant-garde* journal
that published his work was *La Révolution Surréaliste*, edited by Breton;
Man Ray was the nearest thing to an official chronicler of Surrealism;
and before becoming a regular contributor to *Documents*, Jacques-André
Boiffard supplied some of the photographs of Parisian streets that were a
distinctive feature of Breton's novel *Nadja* (1928). Finally, even
Bataille's declared preference for press photographs or film stills rather
than so-called art photography was a widely held perspective that
informed the picture editing of a range of Surrealist publications.
Bataille's note is of historical interest, then, but is insufficient to
account for his presence in this book.

In fact, Bataille's credibility as a theorist of photography rests on
one paragraph for *Documents* 7 (December 1929) barely much longer
than the draft review cited above:

> A dictionary begins when it no longer gives the meaning of
> words, but their tasks. Thus *formless* is not only an adjective
> having a given meaning, but a term that serves to bring things
> down in the world, generally requiring that each thing have its
> form. What it designates has no rights in any sense and gets itself
> squashed everywhere, like a spider or an earthworm. In fact, for
> academic men to be happy, the universe would have to take
> shape. All of philosophy has no other goal: it is a matter of giving
> a frock coat to what is, a mathematical frock coat. On the other
> hand, affirming that the universe resembles nothing and is only
> *formless* amounts to saying that the universe is something like a
> spider or spit.
>
> (Bataille 1993: 31)

The text is called 'Formless' and was part of a mock dictionary (often illustrated with photographs) that was a regular feature of the journal involving a range of contributors. 'Formless' is a central notion in a complex of ideas and techniques that cumulatively constitute what Bataille termed base materialism, at odds with all forms of idealism. In the quotation above, Bataille declares an interest in a dictionary that gives words jobs to do. Therefore, rather than attempting to define 'formless', it is probably more appropriate to proceed by examining the various ways in which theorists have sought to set the notion to work in relation to photography from 1970 to date.

Example one: Roland Barthes. 'The Third Meaning: *Research Notes on Some Eisenstein Stills*' (1970) was his contribution to a special issue of the film journal *Cahiers du Cinéma* devoted to the Soviet director Sergei Eisenstein. The essay title references a famous formulation by Eisenstein related to film editing – one plus one equals three – that would have been familiar to readers of *Cahiers*. In the essay, though, Barthes provocatively gives the term a different sense: the *first* meaning relates to the basic information contained in clothing, gestures, objects, settings and so on found in most photographs; the *second* meaning refers to a level of interpretation beyond the informational that might draw on the theoretical ideas of a figure such as Saussure that informs the early writing of Barthes; and the *third* meaning refers to elusive aspects of some images that appear to resist conventional ana- lysis. He calls this third meaning 'obtuse' and he finds it in certain stills from Eisenstein. Barthes states that 'one of the possible regions of obtuse meaning' is to be found in 'The Big Toe' (Barthes 1970: 60). This cryptic remark relates to an article by Bataille, published in *Documents* in 1929, that Barthes considered in more detail in a conference paper called 'Outcomes of the Text' (1972) (note that Bataille's text is accompanied by Boiffard's now famous photographs, but Barthes does not refer to them). In the spirit of Bataille, he offers fragments that do not add up to any systematic commentary, arranged alphabeti- cally. Of particular relevance here is his citing of the opening sentence of 'Formless', and his insistence that Bataille's reference to the 'tasks' of words means far more than the straightforward functionalism of Saussure and mainstream linguistics (Barthes 1972: 248–249).

Example two: Rosalind Krauss. In 1981 Krauss published an article called 'Corpus Delecti' that received wider circulation when it was included in the catalogue of *L'Amour Fou*, an internationally touring exhibition on Surrealist photography that was shown at the Hayward Gallery, London, in 1986. The exhibition was doubly challenging. First, it proposed that photography was an important, but hitherto

overlooked, dimension of Surrealist activities. Second, it audaciously approached this work 'through the grid of Bataille's thought', especially 'Formless', 'the category that would allow all categories to be unthought' (Krauss 1986: 64). She adds:

> Allergic to the notion of definitions, then, Bataille does not give *informe* a meaning; rather he posits for it a job: to undo formal categories, to deny that each thing has its 'proper' form, to imagine meaning as gone shapeless, as though it were a spider or an earthworm crushed underfoot.
>
> (Krauss 1986: 64–65)

The main examples she gives relate to photographs of the female nude in which the 'formless' is produced by axial rotation, converting conventional verticals into disorientating horizontals; by inversion, with, say, a photograph of a big toe by Boiffard also containing hints of a face; or the various techniques that play with man-as-beast like Man Ray's photograph of a male in which torso and arms suggest the head and horns of a bull. But she also identifies the 'formless' in chemical experiments such as the *brulages* of Ubac or solarizations by Man Ray.

Example three: James Clifford. His essay 'On Ethnographic Surrealism' was originally published in 1981, but is better known in its revised form in the book *The Predicament of Culture: Twentieth-Century Ethnography, Literature, and Art* (1988). He considers *Documents* as an exemplar of the convergence of radical ethnography and Surrealism, expansively defined, in Paris during the 1920s. Unlike Barthes (1970, 1972) and Krauss (1986), Clifford is interested in the editing of diverse visual material in *Documents* to create a 'playful museum that simultaneously collects and reclassifies its specimens' (Clifford 1988: 132). He notes that the use of photographs, especially, generates something like an 'unfin-ished collage' rather than a 'unified organism', resulting in an 'odd museum' that 'merely documents, juxtaposes, relativizes'. In short, *Documents* is a 'perverse collection' (Clifford 1988: 133–134). Clifford's brief remarks are highly suggestive, but the generalizations about Surrealist collage tend to block reflections on the ways in which the ideas of Bataille informed a distinctive approach to picture editing in *Documents*, a relationship that has been investigated at length by my next case study.

Example four: Georges Didi-Huberman. La Ressemblance Informe ou Le Gai Savoir visuel selon Georges Bataille (Formless Resemblance or The Visual Gay Science according to Georges Bataille, Paris, 1995) is a book-length

study by French critic and art historian Didi-Huberman that con-centrates on picture editing in *Documents*. He notes that decisions about page layout were almost certainly collaborative, and Bataille's precise role is impossible to determine. Nevertheless, he is confident that the outcomes are clearly marked by the ideas of Bataille and merit the term 'ressemblance informe' – that is, formless resemblance. For the author, *Documents* aimed to create 'stupéfiants passages, ou *rapports*, entre des objets différents par leur statut, des objets "hauts" et des objets "bas" [astonishing transitions, or connections, between differ-ent objects according to their 'high' or 'low' status]' or 'un certain *art des ressemblances* – un certain art des rapprochements, des montages, des frottements, des attractions d'images, bref un certain style de pensée figurale double d'un certain style de penser les figures [a certain kind of art of resemblances – a certain kind of art involving comparisons, montages, frictions, attractions between images, in short, a certain style of figurative thinking combined with a certain style of thinking about the figure]' (Didi-Huberman 1995: 18). A recurring phrase is 'montage figuratif' (figurative montage) and the concluding sections of the book seek to identify complex relations between the picture editing of *Documents* and the film editing of Sergei Eisenstein.

Example five: Yve-Alain Bois and Rosalind Krauss. Their book *Formless: A User's Guide* (1997) is the English language version of the French catalogue that accompanied their exhibition *L'Informe: Mode d'emploi* at the Pompidou Centre, Paris, in 1996. Overall, the project was an ambitious attempt to rethink twentieth-century art via the ideas of Bataille. Particularly relevant in this context is their sharp disagreement with the interpretation offered by Didi-Huberman, summarized above, expounded most explicitly in the sections by Bois called 'Dialectic' and 'Figure'. In 'Dialectic', there is a rejection of Didi-Huberman's extended comparison between Bataille and Eisenstein, although there is sympathy for Barthes's 1970 essay in which he draws on Bataille to identify dimensions of Eisenstein that offer a 'counterpoint' to his 'formal dialectics and revolutionary semantics (that is, to the "obvious" meaning)' (Bois and Krauss 1997: 72). In 'Figure' Bois emphatically takes issue with the interpretation of Bataille's text 'Formless' that traverses the writing of Didi-Huberman: 'Generating the oxymoron "*ressemblance informe*" (formless resemblance), Didi-Huberman reintro-duces wholesale everything the concept of *informe*, such as we under-stand it, wants to get rid of' (Bois and Krauss 1997: 80). In contrast, Bois suggests that 'Metaphor, figure, theme, morphology, meaning – everything that resembles something, everything that is gathered into the unity of a concept – that is what the *informe* operation crushes,

sets aside with an irreverent wink: this is nothing but rubbish' (Bois and Krauss, 1997: 79).

Example six: Dawn Ades and Simon Baker. Their co-edited catalogue *Undercover Surrealism: Georges Bataille and DOCUMENTS* accompanied an exhibition at the Hayward Gallery, London, in 2006. 'DOCTRINES [The Appearance of Things]' is the opening essay by Simon Baker that offers useful adjudication of the various ways in which scholars have drawn on 'formless'. He notes critically that the influential writing of Krauss especially, linking formless to a range of fields – including abstract painting, photography and curatorial strategy – has distracted from the fact that *Documents*'s 'heterogeneous challenge to accepted ideas is most readily apparent in its attitude to (and use of) images' (Ades and Baker 2006: 35). Yet he also has serious reservations about Didi-Huberman's interpretation of the picture editing of *Documents* via the notion of 'formless resemblance', and endorses the critique of Bois and Krauss, noted above. Unlike Didi-Huberman or Bois and Krauss, Baker seeks to consider *Documents* within the context of an international photographic culture that 'rejoiced in games of juxtaposition and the dissemblance of resemblance by which anything could be shown to be "something like" anything else' (Ades and Baker 2006: 35).

Biography

Georges Bataille (1897–1962) was born in the Auvergne in Central France, but lived most of his life in Paris. He trained in Paris as a medievalist and worked as a librarian for much of his professional life, mainly in the Bibliothèque Nationale. His interests were wide ranging and his posthumously published *Oeuvres complètes* (Paris, 1970–1988) extend to 12 volumes. His hostility to all forms of systematic thought has made him a regular reference point in post-structuralism.

Primary texts

Bataille, G. (1972) *Oeuvres complètes*, vol 2, Paris: Gallimard.
——(1985) *Visions of Excess: Selected Writings, 1927–1939*, Minneapolis, MN: University of Minnesota Press.
——(1993) *Documents vols 1 and 2* (1929–1930), Paris: Jean-Michel Place, (facsimile edition, introduced by D. Hollier).

Secondary texts

Ades, D and Baker, S. (eds) (2006) *Undercover Surrealism: Georges Bataille and DOCUMENTS*, London: Hayward Gallery Publishing; Cambridge, MA: MIT Press.

Barthes, R. (1970) 'The Third Meaning: *Research Notes on Some Eisenstein stills*', in *Image Music Text*, 1977, London: Fontana Press, pp52–68.

——(1972) 'Outcomes of the Text' in *The Rustle of Language*, 1989, Berkeley and Los Angeles: University of California Press, pp238–249.

Bois, Y.-A. and Krauss, R. E. (1997) *Formless: A User's Guide*, New York, NY: Zone Books.

Clifford J. (1988) 'Ethnographic Surrealism', in *The Predicament of Culture: Twentieth-Century Ethnography, Literature, and Art*, Cambridge, MA, and London: Harvard University Press, pp117–151.

Didi-Huberman, G. (1995) *La Ressemblance Informe ou Le Gai Savoir visuel selon Georges Bataille*, Paris: Éditions Macula.

Krauss, R. E. (1986) 'Corpus Delecti', in R. E. Krauss and J. Livington (eds) *L'Amour fou: Photography and Surrealism*, London: Arts Council of Great Britain, pp57–112.

Surya, M. (2002) *Georges Bataille: An Intellectual Biography*, London and New York: Verso Books.

David Evans

GEOFFREY BATCHEN (1956–)

The beleaguered question of what kind of an object photography actually is, and therefore what kind of a history it actually deserves, has been a persistent one. Writers have struggled with the problem of whether they are dealing primarily with a technology, a set of social practices or an artistic medium, and the theoretical problems posed by this perennial ambivalence haunt every attempt to tell photography's story or to establish coherent parameters for a theory of critical judgement or evaluation. This wider sphere of 'the photographic' troubles key concepts of authorship, originality, uniqueness, aesthetics and value that lie at the heart of the way in which we think about art and visual communication.

Geoffrey Batchen's writing has consistently attempted to deal with these issues, all of his work being underpinned by the ontological question of how a theoretical practice constructs its object. What we think of as photography comes into being through the way in which we talk about it, the objects we choose to look at, the discursive spaces we allow it to inhabit. The question at the heart of all his writing is always an abstract one: how is an idea of the photographic formed? But the method he uses to approach this question is pragmatic, painstaking, historical, rooted in a description of the material world.

His first major publication, *Burning with Desire* (1997), appeared at a key moment in the history of contemporary photographic thought.

The modernist art historical model of photography espoused by John Szarkowski, which supported the idea that it was a medium in its own right, with its own historical and aesthetic integrity, had been eclipsed by the radical theoretical light of postmodern theory and practice. The writings of Douglas Crimp, Rosalind Krauss, Hal Foster, John Tagg and Abigail Solomon-Godeau had proposed a complete dismantling of the concept of a photographic medium with an essential set of qualities that could be called its own. Photography was always, for these writers, plural, part of many histories, many social contexts, determined by its position at the centre of competing political and social ideologies.

Batchen saw himself as offering an alternative perspective to both of these implacably opposed camps. Neither wanting to assume that we know in advance what 'photography' is, nor wanting to completely dismantle it like some of the postmodern theorists were attempting to do, he chose instead to attempt to map the space it occupied through a form of materialist history, looking at how photography was used and how it was written about. He rejected the idea that there was one simple history that could be traced back to a moment of invention and suggested instead that photography had multiple origins, and that what needed to be accounted for was not the emergence of a single technology, but the emergence of a widespread desire for it at a particular moment in the development of modern industrial society. In a subtle blending of historical research and philosophical argument he suggested that the complex metaphysical questions that the technology seemed to propose were fundamental to the visual culture of modernity and are still vital to our understanding of that culture today.

In taking this route Batchen was influenced by the work of Michel Foucault and Jacques Derrida. Foucault provided the model for a historical methodology based upon the mapping of actual social practices, and exploring how they produced what he called 'discursive spaces', spaces of cultural production articulated through the operations of power and desire. Derrida's deconstructionist philosophy, which suggested that there could be no fixed entities in the world, meanwhile offered Batchen the theoretical tools he needed for proposing a model of photography that would always be unstable, provisional and paradoxical. Batchen's mapping of photography's origins demonstrated that photography was always hybrid, embedded in a variety of social and cultural spaces and activities, never pure. A deconstructionist approach enabled him to find a model for thinking about the relationship between a modernist concept of photographic practice and those other vernacular practices of the family snapshot, the memorial image,

the album, that continually threatened its sense of self-possession. It offered a useful theoretical solution to the vexed problem of defining photography's essence by suggesting that it was always in the process of being challenged and redefined by those practices that were at its margins and by its location in real social contexts. This was as much a methodical position as a historical one, and it is one that has come to define his contribution to photography theory.

Much of Batchen's writing since *Burning with Desire* has been based, therefore, on the investigation of more marginal vernacular photographic practices, and his preoccupation with these types of objects puts a further distance between him and those postmodern critics who had initially prompted the development of his philosophical position. Ironically, those theorists who had critiqued the dominance of the museum and had argued photography out of any essentialist existence had become engaged with a dialogue with contemporary art practices which effectively wedded them to the art gallery and the concept of an *avant-garde* practice. Theoretical discourse around photography in the wake of this moment shifted dramatically from the space of cultural analysis towards an engagement with art criticism and the development of a symbiotic relationship with post–conceptualist art practice (Krauss 1999). Batchen, by contrast, pursued his interest primarily in those practices that were definitely not art. His most important contributions were concerned with the photographic memorial objects, the vernacular snapshot and digital culture.

One specific narrative of origin associated with photography can be traced back to the Daguerreotype, and one of Batchen's contributions has been to remind us of the fact that early forms of portraiture were as much objects as images. In a number of significant essays he has traced the history of those forms of vernacular photography that were important primarily as material objects. Writing about forms of memorial culture that often included photographs as part of larger collages made up of embroidery, waxed flowers, lace and hair (forms of remembrance often associated with women and the domestic space) (Batchen 2003, 2004), he relocates the theory of photography's relationship to memory by considering its haptic qualities. He suggests that photography often exists in a multi-sensorial space that invokes the body and not just the eye.

In developing this set of ideas, Batchen shifts the emphasis of a photographic analysis away from the producer (who in these instances is often anonymous) and towards the point of use and reception. A similar sensibility pervades his analysis of the snapshot (Batchen 2008c). Arguing the necessity of developing a theory of photography that can

incorporate an understanding of the 'boring' generic snapshot, Batchen aligns himself with the proponents of 'Visual Culture', alongside writers associated with ethnographic perspectives such as Elizabeth Edwards (Edwards and Hart 2004) and Christopher Pinney (Pinney and Peterson 2003). He suggests that we need to understand the context within which such images come to mean something to people, considering their material presence in people's lives, the way they are handled and written on: the way they literally embody a practice of working through the relationship between life and death, the present and the past. It is in this context that Batchen finds a sympathy with the writings of Roland Barthes, seeing *Camera Lucida*, with its preoccupation with the photograph's relationship to mourning and death, as an example of writing that uses a reflection upon our actual engagement with photographs to reflect upon our sense of what it actually is (Batchen 2008a).

This is where Batchen stands slightly to the side of the theorists of 'Visual Culture'. For although he is committed to opening up the scope of photographic studies, and to countering the dominant hegemony of the history of the fine arts, and although he is trenchant in his dismissal of theories of the medium based on an assumption that we know in advance what 'photography' is, he is ultimately committed to an 'ontological project' – to finding an alternative model for understanding what it is. To this end he has developed an historical analysis of the ways in which we use, handle and think about photographs that begins to map the discursive space occupied by photography. This approach is his most important contribution. He asks us to reconsider how the histories we write contribute to the making of the object itself, pleading with us to keep that kind of open sensibility to those peripheral practices that throw into relief the powerful desires to which photography responds.

For the same reasons, in his writing about the impact of digital culture, he has argued against the kind of polarized oppositional thinking between analogue and digital technologies that has dominated the field, suggesting instead an emphasis upon the patterns of continuity and discontinuity that hold the idea of photography together (Batchen 2001). From this perspective, he suggests, we see the digital image and the analogue image as responding to a similar set of questions and issues, both bound into a structure of desire that premises a kind of homology between them.

Batchen's theory of art history is a Foucauldian one: it proposes that photography exists within a 'discursive space' and is produced through the way we use it, talk about it and imagine it. Discursive

spaces can change, can be subject to moments of rupture and discontinuity: it may be that one day we will suddenly realize that 'photography' really does no longer exist, that the constellation of ideas that gave birth to these technologies has been eroded and worn away. But in order to recognize such a moment we need to be alert to the wider sense of the photographic as it operates within our culture, 'something always caught in a process of becoming', an unstable spacing of the forces of desire, a space in which high art and the vernacular are both equally engaged 'subject to the continuous play of history, culture and power' (Batchen 2003: 29).

Biography

Born in Australia in 1956, Batchen received his PhD from the University of Sydney in 1991. He taught at the University of California, San Diego and the University of New Mexico, going on to become Professor of Photography and History of Art at the Graduate Center of City University New York (CUNY). In 2010 he took up the post of Professor of Art History at the Victoria University of Wellington, New Zealand. As well as lecturing and writing about photography, he has curated a number of exhibitions, including *Forget Me Not*, an exhibition of vernacular photographs for the Van Gogh Museum in Amsterdam, with a subsequent tour to the National Museum of Iceland, the National Museum of Photography, Film and Television in the UK and the International Center of Photography in New York.

Primary texts

Batchen, G. (1997) *Burning with Desire: The Conception of Photography*, Cambridge, MA, London: MIT Press.

——(2001) *Each Wild Idea: Writing, Photography, History*, Cambridge, MA, London: MIT Press.

——(2003) '"fearful ghost of former bloom": What Photography Is', in D. Green (ed) *Where Is the Photograph?*, Brighton, UK: Photoforum and Photoworks, pp15–30.

——(2004) *Forget Me Not: Photography and Remembrance*, Princeton, NJ: Van Gogh Museum and Princeton Architectural Press.

——(2005) 'A Latticed Window', in S. Howarth (ed) *Singular Images: Essays on Remarkable Photographs*, London: Tate Modern, pp15–21.

——(2006) 'Electricity Made Visible', in W. H. K. Chun and T. Keenan (eds) *New Media, Old Media: A History and Theory Reader*, New York, NY: Routledge, pp27–44.

——(2008a) '*Camera Lucida*: Another Little History of Photography,' in R. Kelsey and B. Stimson (eds) *The Meaning of Photography*, Williamstown, MA: Clark Studies in the Visual Arts, pp76–91.

——(2008b) *William Henry Fox Talbot*, London: Phaidon.

——(2008c) 'Snapshots', *Photographies*, vol 1, no 2, pp121–142.

——(2009) 'Dreams of Ordinary Life: *Cartes-de-visite* and the Bourgeois Imagination', in J. J. Long, A. Noble and E. Welch (eds) *Photography: Theoretical Snapshots*, London: Routledge, pp80–97.

——(ed) (2010) *Photography Degree Zero: Reflections on Roland Barthes's Camera Lucida*, Cambridge, MA: MIT Press.

Secondary texts

Edwards, E. and Hart, J. (eds) (2004) *Photographs Objects Histories: On the Materiality of Images*, London: Routedge.

Kelsey, R. and Stimson, B. (eds) (2008) *The Meaning of Photography*, Williamstown, MA: Clark Studies in the Visual Arts.

Krauss, R. E. (1999) 'Reinventing the Medium', *Critical Inquiry*, vol 25, no 2, Winter, pp289–305.

Pinney, C. and Peterson, N. (eds) (2003) *Photography's Other Histories*, Durham, NC, London: Duke University.

Joanna Lowry

CHARLES BAUDELAIRE (1821–1867)

In 1855 in the Parisian house of the photographer Nadar, Charles Baudelaire wrote in his friend's guest album the poem 'Le Reniement de saint Pierre'. Published two years later in *Les Fleurs du mal*, the verse concludes: 'Myself, I shall be satisfied to quit/a world where action is no kin to dreams'. For Baudelaire the concept of photography as art is an oxymoron: art is action conjoined with dreams, but photography is a mechanical operation, in which 'the exact reproduction of Nature' may engender wonder but not the happiness associated with reverie.

Baudelaire's writing career begins with art criticism: exhibition reviews in which he expounds on aesthetics and lays out a philosophy of art. The imperious Salon, the official show of the Académie Royale des Beaux-Arts in Paris, refused to include photographs until 1859, and even then the prints – exclusively portraits – were hung in an antechamber with its own entrance. Although Baudelaire had reviewed many exhibitions of paintings, drawings and sculpture, his first assignment that included photographs displayed as art occurred just eight years before his death. The review of the Salon of 1859 is his only published commentary on photography to appear in his lifetime. Yet, the relatively brief section, entitled 'The Modern Public and Photography', is one of the most cited essays from the nineteenth century concerning the medium.

Baudelaire does not equivocate in print. He attacks, in particular, the masses who embrace the 20-year-old invention and equate it with art. He gives strong voice to a sensibility that existed from the beginning of the public's encounter with photography and can be summarized in the quotation attributed to artist Paul Delaroche: 'From today painting is dead!' In fact, Delaroche understood that photography could be a useful tool for an artist, a time-saver: 'The painter ... will find this technique a rapid way of making collections of studies he could otherwise obtain only with much time and trouble and, whatever his talents might be, in a far less perfect manner' (quoted in Rudisill 1971: 41). By 1859 the question of photography as an art form is more intense: 15 to 20 years earlier the medium was a novelty, and none knew with certainty what lay ahead for the photograph and the traditional fine arts. The next score of years not only saw technical and aesthetic advancements in photography, but also new art trends and controversial ideas regarding the painted canvas, in particular. Baudelaire's dear friend Édouard Manet, for example, leads painting away from realism and towards impressionism and modern art. The academy, however, is slow to change. Baudelaire not only witnesses the turmoil but also lives and works amid the arts community in Paris. Much is at stake, then, as he writes his review of the Salon of 1859.

Baudelaire takes an unusual approach to his critique of what is exhibited. Rather than assess the artists, he indicts the audience. Although that indictment appears at times to be simply a rant against the cultural mediocrity of the bourgeoisie, it can also be seen as a telling analysis of the commerce of art. As the Industrial Revolution and the ideology of progress grow and become dominant in a politically tumultuous France, the value of art takes on the transactional quality of a commodity, a negative association for Baudelaire. Photography affords a particularly stinging example of the new reality, and he decries: 'A revengeful God has given ears to this multitude. Daguerre was his Messiah. And now the faithful says to himself: "Since Photography gives us every guarantee of exactitude that we could desire (they really believe that, the mad fools!), then Photography and Art are the same thing." From that moment our squalid society rushed, Narcissus to a man, to gaze at its trivial image on a scrap of metal' (Baudelaire 1981: 152–153). Baudelaire is spot-on when he specifically invokes the Daguerreotype. It is not just a scrap of metal; rather, it's a highly polished plate that returns the sitter's image twofold: once as the imprint developed and fixed on the silver-coated copper, and again as the viewer's image reflected on the mirror-like surface that comes into play when a Daguerreotype is held at a certain angle.

'The Modern Public and Photography' ends with several declarations about the medium and its contribution 'to the impoverishment of the French artistic genius' (Baudelaire 1981: 153). Baudelaire argues that photography is the mortal enemy of art. It should know its place as servant of the sciences and the arts, 'but the very humble servant, like printing or shorthand, which have neither created nor supplemented literature' (Baudelaire 1981: 154). He recognizes photography's value as memory aide, capable of rescuing from oblivion 'those tumbling ruins, those books, prints and manuscripts which time is devouring, precious things whose form is dissolving and which demand a place in the archives of our memory' (Baudelaire 1981: 154). In private Baudelaire sits for his photographic portrait several times – with Nadar, Nadar's son Paul, Étienne Carjet and Charles Neyt – and in 1865 he becomes obsessed by the idea of having a photographic portrait of his mother, although he cautions in dramatic terms that he must accompany her because 'all photographers, even the best, have ridiculous mannerisms' (Baudelaire 1971: 275).

Some have explained Baudelaire's diatribe against photography by integrating it within his theory of art and individual genius. While such an analysis is valid, the message of 'The Modern Public and Photography' haunts the work of many who have later written on the subject. Walter Benjamin, for example, takes up Baudelaire's cause in 'The Work of Art in the Age of Mechanical Reproduction' and 'Some Motifs in Baudelaire'. In the latter Benjamin states: 'The perpetual readiness of volitional, discursive memory, encouraged by the technique of mechanical reproduction, reduces the scope of imagination' (Benjamin 1969: 186). Benjamin even concludes that the Second Empire's unreflective belief in progress – a notion that he links 'with the disintegration of the aura in the experience of shock' (Benjamin 1969: 194) – is responsible for a kind of melancholia of expression around the words 'eyes' and 'look' in Baudelaire's late poetry.

In his review of Edward Steichen's exhibition, *The Family of Man*, Roland Barthes shares Baudelaire's animus against an uncritical public and its consumption of photographs. In addition, Barthes echoes Baudelaire's observation regarding the insipid titles of the paintings in the Salon of 1859, where he derides 'all the ridiculous titles and preposterous subjects', such as 'the sentimental title (which lacks only an exclamation point)' and 'the profound and philosophical title' (Baudelaire 1981: 150). In Steichen's exhibition, Barthes denounces the captions that accompany the images, berating the discourse that 'aims to suppress the determining weight of History' and that 'prevent[s] precisely by sentimentality' access to photography's special relationship

to reality (Barthes 1976: 101). In *Camera Lucida* Barthes takes on at times a Baudelairean voice, one that speaks appreciatively about the medium as an archive of the precious things that are decaying or have ceased to exist. He also declines to consider the art photograph, a twist on Baudelaire's argument that photography is not an art. And when Barthes turns over his book to a discussion of a photograph of his mother, one is reminded of Baudelaire's entreaty to his own mother for not just a photograph but a *just* photograph of her.

In *The Paradox of Photography* Pierre Taminiaux concludes his chapter on Baudelaire as an apologist for him, suggesting that his discourse came too early (Taminiaux 2009: 57) and that he lacked the benefit of seeing the full potential of the medium as an art form. Taminiaux emphasizes that 'The Modern Public and Photography' reflects the zeitgeist of France's Second Empire but fails to offer a far-reaching insight into photography itself. It is possible, however, to see beyond Baudelaire's negative critique of the medium as a legitimate form of art and assess the validity of his broader concern for works of genius and the quality of art in his age as well as our own. Consider, for example, the development of new programming in mass-market outlets as well as the explosion of new forms of communication in today's world. On television, reality shows dominate, eschewing trained actors for common citizens, presenting the conceit that reality is at the very least entertainment and a suitable replacement for the art of fictional series or teleplays. Social media such as Facebook have created and continue to expand the technology for self-publication, a vanity press in electronic form. Could not Baudelaire justifiably contend that these trends are descendants of the Daguerreotype and make Narcissuses of us all?

Biography

Charles Pierre Baudelaire was born in Paris, France, on 9 April 1821. His mother remarried 18 months after his father, a civil servant, died in February 1827; her second husband was a general in the French army, the French ambassador to the Ottomon Empire and Spain, and a senator. Baudelaire's formal education began in the Collège Royal in Lyon and continued at the Lycée Louis-de-Grand in Paris: in 1839 he was expelled, although afterwards he studied law for a short time. Around 1840 he contacted syphilis and by 1843 had spent half of the inheritance he received in 1841. Baudelaire's first art reviews appeared in 1845 for the Salon, followed by reviews of the Salons of 1846 and 1859, as well as the Exposition Universelle of 1855. The short story

'La Fanfarlo' was his first published literary work in 1847, followed the next year by a translation of works by Edgar Allan Poe; he published his first poem in 1851. His most famous book, *Les Fleurs du mal*, was first published in 1857, with an expanded second edition issued in 1861. Poor health and poor finances plagued Baudelaire throughout his adult life; he suffered a stroke in 1866 and spent the remainder of his life in a nursing home, where he died on 31 August 1867.

Primary texts

Baudelaire, C. P. (1971) *The Letters of Charles Baudelaire to His Mother, 1833–1866,* translated by A. Symons, New York, NY: Haskell House Publishers.
——(1981) *Art in Paris, 1845–1862: Salons and Other Exhibitions,* translated and edited by J. Mayne, Ithaca, NY: Cornell University Press.

Secondary texts

Barthes, R. (1976) *Mythologies,* selected and translated by A. Lavers, New York, NY: Hill and Wang.
Benjamin, W. (1969) *Illuminations,* edited by H. Arendt, translated by H. Zohn, New York, NY: Schocken Books.
Rudisill, R. (1971) *Mirror Image: The Influence of the Daguerreotype on American Society,* Albuquerque, NY: University of New Mexico Press.
Taminiaux, P. (2009) *The Paradox of Photography,* Amsterdam: Rodopi.

Nancy M. Shawcross

JEAN BAUDRILLARD (1929–2007)

Simulacrum, simulation, seduction, sex and signs. The sinuosity of the letter 's' is typical of this Baudrillardian vocabulary. It produces an enchanted alliteration that has had a lasting effect on practices and theories of the image. The appeal of the Baudrillard effect was instantaneous for many artists addressing the culture of the image. The simulacrum is another name for the image. In English, this Latin-sounding name has some decorum and resonance that grants a particular importance to the regime of the visual. The film *Blade Runner* (1982) told the story of replicants affected by the implanted memories of events that never took place and of snapshots of families that never existed. It resonated with Baudrillard's tropes of simulacra and simulation. Artists working within practices of appropriation, montage and quotations using film and photography found an affinity with a critique of the

sign that was also a critique of the real, use value and reference. We may think of the early works of Richard Prince, his re-photography of advertisements during the late 1970s, as well as Cindy Sherman's *Untitled Film Stills*, James Welling's photographs of drapery that unsettle the question of the referent, or John Stezaker's montage and cutting strategies of the same period. Yet, Baudrillard is rather disenchanted about contemporary art's *avant-garde* gestures, apart from the early Warhol, who is 'lucky enough to be just a machine' (Baudrillard 1995).

At the end of the 1970s, the sociologist Jacques Donzelot, author of *La Police Des Familles*, held a weekly course at Nanterre with Jean Baudrillard. It was based upon a dialogue between the two thinkers, a teaching form very different from the expected delivery of knowledge at the university and its protocols of authority. Donzelot recalled that the course was a form of Patasociology, very close to '*Pataphysics*, this science of the particular, of the exception and of imaginary solutions proposed by Alfred Jarry, the author of *Ubu Roi* (Baudrillard 2004: 59). Indeed, Baudrillard has always been attached to this science of imaginary solutions, especially when apprehending the photographic image and the photographic act, which for him bears witness to 'the pataphysical refinement of the world' (Baudrillard 1999: 129). 'Pataphysics is like the action of piercing a tyre: reality shrivels up like a leaking balloon. It deflates the world. Photography as a 'pataphysical' activity would then subvert the putative realism attached to the medium.

Baudrillard's critique of the sign and of the object is also a critique of the image. Specific references to photography are few, apart from some late texts and interviews devoted to photography. Yet the impact of his thinking is significant and symptomatic of an interest in the value of objects as signs caught in a process of reproduction.

Photography is also briefly mentioned within the context of the 'Industrial Simulacrum' in *Symbolic Exchange and Death* (Baudrillard 1993). The argument takes on Walter Benjamin's analysis of reproducibility. When art, cinema and photography are placed under the regime of reproduction, the very notion of production is altered. Forms are now conceived so that they can be reproduced. The technique of mechanical and optical reproduction for Benjamin enables a particular type of test. The camera tests its object and asks questions that already contain a response which is determined by the technical apparatus itself. Baudrillard here refers to the example that Benjamin gives of the actor in front of the camera. Unlike the theatre, where the performance is continuous, the cinema actor is tested by the camera – thus the well-known expression 'screen test'. The

performance undergoes a series of discontinuous takes which are then edited together. These optical tests demand that the actor performs for the camera, and not for an audience. The audience is the camera and therefore we take the point of view of the camera when watching the film. Just as the camera was testing the actor, we in turn are testing the performance. Testing is like touching and intervening. The lens is like a surgeon's knife. Reality is tested, touched, manipulated by an apparatus that shapes what it reproduces visually. Commenting on this economy of production and reproduction, Baudrillard writes:

> [...] reality has been analysed into simple elements which have been recomposed into scenarios of stable oppositions, just as the photographer imposes his own contrasts, lighting and angles upon his subjects (any photographer will tell you that no matter what you do it is enough to catch the original from a good angle at the moment or inflection that turns it into the exact response to the instantaneous test of the apparatus and its code).
>
> (Baudrillard 1993: 63)

The question devours the answer just as the questioning lens assimilates its object. The media of reproduction introduce a cannibalism of the sign in a manner that recalls some novels of J. G. Ballard, such as *High Rise* where the camera is a weapon used for a duel among the inhabitants who trash their luxury apartments. Baudrillard devotes a whole chapter to Ballard's *Crash* (Baudrillard 1984). Vaughan, the novel's protagonist, seeks fresh car crashes in order to photograph them, constructing an archive that enables him to stage convincingly his own car crashes that he performs for the camera: an example where the performance of the event coincides with its reproduction. The crash is like a test, and the tactility of the bruised cars and bodies trapped in them unexpectedly recalls Benjamin's understanding of the camera as a testing apparatus.

Baudrillard also positions photography within a different regime of the image that precedes that of reproducibility. It is that of the *trompe l'oeil*, a simulacrum that complicates the relation between reality and its representation, and celebrates the charm of appearances. This form, for Baudrillard, has survived historical transformations and is still with us. He proposes a short genealogy of the visual, where the image is first a good semblance that reflects faithfully a reality that precedes it. A second position considers that the image masks or distorts a profound reality and misrepresents the model that it attempts to depict. Both

JEAN BAUDRILLARD (1929-2007)

attitudes share the belief in the dogma that the model pre-exist its representation. The third aspect of the image is that it neither reflects nor distorts a profound reality. What the image does instead is to mask the absence of a profound reality (Baudrillard 1988a: 170). This is where we can locate the *trompe l'oeil*. This seductive proposition puts an end to the theology of the image without renouncing the depth of the image. Like the Baroque fold, like mirrors that reflect no one but themselves, the *trompe l'oeil* plays upon the oscillation between depth and surface. When it comes to images, it is the surface that creates depth and not the pathos of the Model or the Divine. If anything, the *trompe l'oeil* is as much an art of appearance as it is an art of disappearance. The *trompe l'oeil* is more false than false. It is a parody of the theatre of social life. There is nothing to see beyond the surface of things, and the things are now looking at us (Richon 2006: 164). The simulacrum of the *trompe l'oeil* includes me as a being that is looked at by an image that expects my presence. The phenomenological experience of the *trompe l'oeil* is such that it is reality that begins to look like an image.

Photography, for Baudrillard, can be a form of *trompe l'oeil*. André Bazin already noticed this continuity between baroque artefacts and photography and mentions the folds made of stone or marble that produce an effect of frozen immobility. Baudrillard also describes the photograph as an imprint in the manner of a fossil, an image made by an invisible hand. It is 'the primal scene of a ghostlike inscription away from human intervention' (Baudrillard 2004: 231). This is also a Bazinian theme, that of the mechanical image 'in the making of which man plays no part' (Bazin 1967: 12) Only unlike Bazin, Baudrillard does not have any desire to preserve anything with photography. There is no Mummy Complex here. Photography is not an art of preserving but an art of disappearing − disappearing as object and appearing as image. About the photographs that Sophie Calle took of a stranger she is following in Venice, he writes: 'photography is itself an art of disappearance, which captures the other vanished in front of the lens, which preserves him vanished on film, which, unlike a gaze, saves nothing of the other but his vanished presence' (Baudrillard 1988b: 86).

This is why he praises the analogical at the moment it is in the process of being eclipsed by the digital. With the analogical and 'the suspense of the negative', 'the photograph retains the moment of disappearance … . This slight displacement gives the object the magic, the discrete charm of a previous existence' (Baudrillard 1997: 30). With the digital image, the real has no manner of disappearing because it has already disappeared. Baudrillard places the digital and technical

perfection on the side of *La Bêtise* (Baudrillard 2004: 232) in as much as stupidity enjoys realistic technical perfection. Virtuosity here only increases 'the technical harassment of images'. And 'the more we approach absolute definition, or the realistic perfection of the image, the more the image's power of illusion is lost' (Baudrillard 1997: 8). This argument is like a repeat of Baudelaire's contempt for photography, this art, he thought, that was so fatuously proud of claiming to be able to reproduce nature faithfully.

Although Baudrillard is not in the least interested in linking photography and text, he nevertheless sees a convergence between his process of writing and the photographic act. Both propose to analyse an object without interpreting it. Analysis is here a process of isolating, fragmenting, detailing and depleting the object. This depletion and reduction occurs each time an object is turned into a photograph. It is the discontinuous aspect of the photograph that interests Baudrillard, where chance plays its part and where there is no plan – thus his dislike for staging or retouching, activities of repentance that 'appear abominably aesthetic' (Baudrillard 1997: 30).

Subjectivity repels him for being too naïve and objectivity is hopelessly ideological, as it pretends to be neutral. As a subject, Baudrillard strives to become an object, to acquire the immutable and silent characteristic of a thing. And when taking a picture, one becomes immobile, frozen like the object that is being photographed. Thus, for him, photography must be obsessional, problematic, ecstatic and narcissistic. It is the narcissism of an unselfconscious object that does not care, that refuses to mean anything. To photograph is to become an object, holding one's breath and remaining immobile. Narcissism triumphs. Here Baudrillard follows Freud: the charm of the image/object is its silence and inaccessibility, like 'the charm of certain animals which seem not to concern themselves about us, such as cats and the large beasts of prey', as Freud wrote. Other narcissistic types would include 'women, especially if they grow up with good looks', and 'even great criminals and humorists' (Freud 1984: 83). Would the Baudrillardian photographer be an addition to this list?

Baudrillard, as is well known, also takes his own photographs. As he said in an interview: 'they are taken according to my caprice or my pleasure' (Baudrillard 1997: 35). His photographic activity has also informed his remarks on photography, producing a contagious '*Pataphysics* of appearances that undermines any theology of the image: appearances are therefore ironic constructions that subvert the belief that images can reveal the true nature of things.

Biography

Jean Baudrillard was born in 1929, the same year as the Wall Street Crash, to parents of peasant origins, in Reims. At the lycée of the same town, his professor of philosophy introduced him to 'pataphysics. He studied at the École des Hautes Études in Paris, where he received a PhD for his thesis on the System of Objects in 1966. The jury included Bourdieu, Barthes and Lefebvre. He submitted his *Habilitation* (a postdoctoral professorial thesis), 'The Other by Himself', at the Sorbonne in 1986. Baudrillard worked as a translator (of Brecht, Marx and Hölderlin) and as an editor of journals such as *Utopiques* and *Traverses*. Since the 1970s, he was visiting professor at the University of California in Los Angeles and Santa Barbara. He also taught sociology at Nanterre. He was not a career academic and published in excess of 50 books. One of his first published texts, *Les Allemands*, ran alongside documentary photographs by René Burri from his book of the same name, published by Delpire in 1963. In 1981 he was given a camera in Japan. He became and remained a photographer. In 2001, he was raised to the dignity of *Satrape Transcendental* by the *Collège de 'Pataphysique*, an honour also conferred to Marcel Duchamp and the Marx Brothers. He died on 6 March 2007.

Primary texts

Baudrillard, J. (1981) *For a Critique of the Political Economy of the Sign*, St Louis, MO: Telos Press.

——(1984) *Simulations*, New York, NY: Semiotext(e) Inc.

——(1988a) *Selected Writing*, Stanford, CA: Stanford University Press.

——(1988b) *Please Follow Me*, Seattle, WA: Bay Press.

——(1993) *Symbolic Exchange and Death*, New York, NY: Sage.

——(1995) *The Perfect Crime*, London: Verso.

——(1997) *Art and Artefact*, edited by N. Zurbrugg, New York, NY: Sage.

——(1999) 'For Illusion is not the Opposite of Reality', in *Photographies 1985–1998,* Ostfildern: Hatje Cantz.

——(2004) *Baudrillard*, Paris: Éditions de L'Herne.

Secondary texts

Bazin, A. (1967) *What Is Cinema?* Berkeley, CA: University of California Press.

Freud, S. (1984 [1914]) *On Narcissism*, The Penguin Freud Library, vol 11, *On Metapsychology*, Harmondsworth, UK: Penguin.

Richon, O. (2006) 'Thinking Things', in *Real Allegories*, Gottingen: Steidl.

Olivier Richon

ANDRÉ BAZIN (1918–1958)

André Bazin was a film critic, theorist and champion of cinematic realism. His writings on photography are limited to a single short essay, 'The Ontology of the Photographic Image' (hereafter OPI), and a few scattered remarks within his writings on cinema. Nevertheless, OPI has a central place within Bazin's writing because, like many early film theorists, he conceived of the photograph as the basic element in a strip of cinema film, and his account of photography underpins his theory of cinematic realism. Although what he writes about photography has value independently of the context in which it is embedded, the scope of Bazin's reflections do not extend beyond that variety of photographic practice often called 'straight photography'. Nevertheless, what he writes about such photography has had a powerful influence upon theorists of photography, particularly those concerned with the medium's capacity for realist representation.

Bazin's concern in OPI is with the nature of photographs, or what in the most fundamental sense they are. There are various approaches to ontological investigations, but Bazin employs the phenomenological method of Jean-Paul Sartre, investigating the nature of photography through careful description of how photographs present themselves to us in experience, including our understanding and attitudes regarding them. At the same time, Bazin draws heavily upon André Malraux's psychological theory of art, not least in his use of Malraux's idea that the history of art reflects an underlying human need to address the effects of time. For Bazin, this human need shapes the responses and attitudes to photography that reveal its fundamental nature. Bazin's approach to explaining the fundamental nature of photography is therefore properly seen as a psychology of the photographic image, or an explanation of photography resting upon an account of our experience of, and attitudes towards, a particular kind of picture that are shaped by an underlying psychological need.

Bazin opens OPI with the thought that the representational arts have their origin in ancient practices, such as Egyptian mummification of the dead, undertaken to secure existence in an afterlife. The Egyptians believed the soul needed a material body to reside within in the afterlife; but having discovered their embalming techniques provided insufficient security against decay, they began placing statues of the dead in the tomb to serve as substitute bodies. Sculpture and the representational arts, in general, have their origin, Bazin concludes, in a deep psychological need to 'have the last word in the argument with death', or more generally to preserve being from the effects of time,

by means of representation or a 'form that endures' (Bazin 1967: 10). Although the advance of civilization and culture mean that we no longer believe that representational art constitutes a vehicle for survival after death, nevertheless the connection between art and the desire for immortality remains with us in the belief that representations help us to remember, and thus 'preserve' things 'from a second spiritual death' (Bazin 1967:10). As Bazin observes: 'Louis XIV did not have himself embalmed. He was content to survive in his portrait by Le Brun' (Bazin 1967: 10). With the invention of photography, however, a more powerful means of satisfying this psychological need was discovered.

To see why, consider how this psychological perspective upon the history of the arts gives a central role to the creation of resemblance (or realism) in the explanation of artistic endeavour. To achieve what Bazin calls 'true realism', artists need to combine and balance a concern for the appearance of what they seek to represent with a concern for the 'spiritual realities', or authentic nature of their subject matter. With the rediscovery of artificial perspective in the fifteenth century, however, painters gave ever increasing emphasis to the reproduction of appearance at the expense of the 'spiritual realities'. Although Bazin is clear that the greatest painters were able to combine and balance these elements of realism, he sees the concern of painters since the Renaissance to merely reproduce appearances to have resulted in a 'pseudo-realism' that rests content with fooling the eye. What is lacking from such works is the aesthetic dimension of realism where the arts 'give significant expression to the world both concretely and in its essence' (Bazin 1967: 12). Without this latter, realism as an artistic value is debased and vulnerable to the arguments levelled against it in the nineteenth century. The invention of photography, Bazin argues, not only liberates painting from its concern with the accurate reproduction of appearances, it also provides the means by which we can satisfy 'once and for all and in its very essence our obsession with realism' (Bazin 1967: 12)

Photography is the redeemer of realism and the liberator of painting because the process by which photographs are made results in pictures with a deeper connection with what they represent than mere resemblance. For Bazin, it is a 'psychological fact' about human beings that they are aware of this connection and that it is this, rather than the way photographs reproduce appearances, which explains why photography fully satisfies the psychological need for representations that preserve their subject matter. The need is satisfied, that is, because photographs are the product of a particular 'mechanical' or 'automatic' process where the world reproduces itself, without recourse to the

kind of the subjective mediation inevitable with painting. 'This pro-duction by automatic means,' Bazin observes, 'has radically affected our psychology of the image' (Bazin 1967: 13), which is to say that awareness of the distinctive process by which photographs are made has radically affected understanding and attitudes regarding photography.

It is important to be clear about what Bazin means by saying that photography is an automatic process. The claim rests upon the con-trasting ways in which paintings and photographs are made, and by implication the relationship they have to their subject matter. With both media it is a person who selects the subject matter to be pictured in line with whatever purposes they have in making the picture; but in constructing a picture through the application of paint the painter is a mediating agent between subject matter and image. By contrast, photographers do not construct their images in this sense, employing instead a causally governed photochemical process in which reflected light is focused through the lens of a camera into an image that is recorded and reproduced. Photographers use this process to create their imagery, but the relationship between photographic image and subject matter has a directness that stands in stark contrast to the necessarily mediated relationship between a painting and its subject. The world impresses itself by means of reflected light directly onto the film, and this process of production – rather than anything to do with the appearance of the resulting image – means that photographs have a relationship to the world that Bazin sees as the source of their distinctive nature and value.

It is because of this relationship of the photographic image to the world, Bazin argues, that photography is capable of decisively satisfying mankind's psychological need for identity substitutes of people and objects that are capable of surviving the effects of time. For a photograph is not merely a resembling representation of its subject matter; it is also a 'trace' or 'transfer' of its subject in the sense that a death-mask, fingerprint or the lipstick impression of lips upon a love letter are traces of their origin. This distinctive way in which photographs stand to their subject matter acts upon us psychologically in a number of ways. We are 'forced to accept as real the existence of the object repro-duced' (Bazin 1967: 13); but more importantly we treat photographs as sharing the being of their subject matter, or having 'a kind of identity' with it. Bazin uses the example of the psychological effect (among believers) of the Shroud of Turin to illustrate this point, with the image of Christ being treated more as a manifestation than a mere pic-ture of Him. Likewise, we treat photographs as if in some respects they are their subject matter, freed from the ordinary conditions of time and

space and '*re*-presented' to us in pictorial form. It is important to emphasize that Bazin is making a claim about the psychological effects of our awareness of how photographs are made. He does not think we *believe* the photograph to be its subject matter ('No one believes anymore in the ontological identity of model and image': Bazin 1967: 10), but that a combination of our deep psychological need for identity substitutes and our awareness of how photographs are made combine to cause us to treat photographs as sharing something of the being of their subject matter.

Because these psychological effects are not the result of how photographs appear, but rather because of the connection they have to the world as a result of the process by which they are made, photography constitutes a return to a 'true realism' that represents the world both 'concretely and in its essence'. Since photography is a medium capable of restoring realism, Bazin argues that its aesthetic qualities are to be found in its capacity to 'lay bare the realities' (Bazin 1967: 15) and present the world to us 'objectively', stripped 'of all those ways of seeing it, those piled up preconceptions, that spiritual dust and grime with which my eyes have covered it' (Bazin 1967: 15). Enabling us to encounter the world in a pictorial form shorn of subjective mediation, photography presents the world to us with a kind of purity that reconciles us to it and makes it an object of love. Since it is frequently a particular photographer's 'vision' that we value, this is a less compelling aspect of Bazin's thought than his explanation of the origins of photographic realism.

Biography

André Bazin (1918–1958) was born in Angers, France, and died in Paris. He began writing about film in 1943 and went on to co-found the influential journal *Cahiers du Cinéma* in 1951, which he edited until his death. A four-volume collection of his writings on film entitled *Qu'est-ce que le Cinema?* was published after his death, only a portion of which has been translated into English.

Primary texts

Bazin, A. (1945) 'Ontologie de L'Image Photographique', in *Problèmes de la Peinture*, reprinted in A. Bazin (1958) *Qu'est ce que le Cinéma?*, Paris: Les Editions du Cerf, translated by H. Gray as 'The Ontology of the Photographic Image', in A. Bazin (1967) *What Is Cinema?, Volume 1*, Berkeley, CA: University of California Press.

Secondary texts

Brubaker, D. (1993) 'André Bazin on Automatically Made Images', *Journal of Aesthetics and Art Criticism*, vol 51, no 1, pp59–67.

Friday, J. (2005) 'André Bazin's Ontology of Photographic and Film Imagery', *The Journal of Aesthetics and Art Criticism*, vol 63, no 4, pp339–350.

Malraux, A. (1949) *The Psychology of Art*, 3 vols, translated by S. Gilbert, New York, NY: Pantheon.

Morgan, D. (2006) 'Rethinking Bazin: Ontology and Realist Aesthetics', *Critical Inquiry*, vol 32, pp443–455.

Sartre, J.-P. (2004) *The Imaginary: A Phenomenological Psychology of the Imagination*, translated by J. Webber, London: Routledge.

Jonathan Friday

WALTER BENJAMIN (1892–1940)

It is hard to imagine a text more influential in the history of photography than Walter Benjamin's 'The Work of Art in the Age of its Technological Reproducibility', first published in 1936. Its paradigmatic status is all the more remarkable as Benjamin had rarely considered photography during the first half of his professional career. It was only when the publication of several German photographic picture books marked a new public interest in lens-based image-making that he profited from the opportunity of a group review to outline his ideas about how photography shook the identity of art as people knew it. In the context of the radicalized discussions of the later 1930s, Benjamin went on to make photography the medium that had prepared the ground for the social and aesthetic missions of film, in which according to him 'all problems of contemporary art find their definitive formulation' (Benjamin 1927–40: 394). Yet, the ideas exemplified in his earlier review, which was published in the guise of a 'Little History of Photography', reverberate in Benjamin's theoretical concepts until his death. This earlier text's appraisal of photography is also much more subtle than that of the artwork essay, which is partly structured by Benjamin's wish to establish a political frontline in aesthetics.

Benjamin's photography-related thoughts are all connected to a concept he famously calls the aura of visible phenomena. As he avoids a conclusive definition and keeps changing his focus on the phenomenon, its meaning is difficult to grasp. It is not without roots in theosophical concepts, and when Benjamin mentions aura in texts of the 1920s, he seems to think that all things and people possess it, though it is only revealed in moments of attentive perception. In his concept of photography, however, he makes aura a property of traditional artworks,

testifying to their remote origin in religious cult and, as bourgeois aesthetics retain a ritualistic response to art, to their mystery, uniqueness and authenticity (Benjamin 1939a: 272). Photography's historical mission was to destroy this auratic 'appearance or semblance of distance' exhibited by artworks (Benjamin 1931: 518). Though he refers in this context to photographer Eugène Atget's uncanny images of city streets, it is clear that it is mainly the reproductive technique of the medium which he understands photography to have triggered a 'perception whose sense for the sameness of things has grown to the point where even the singular, the unique, is divested of its uniqueness – by means of its reproduction' (Benjamin 1931: 519). Being the product of changing social habits and values, this effect did not impose itself from the start. In fact, aura still lends a 'magical value' (Benjamin 1931: 510) to early photography. Benjamin argues that long exposure times and imperfectly nuanced light sensitivity had a beneficial effect on the appearance of sitters in portrait photography, the medium allowing them to assert their full personality. Yet, the apparatus was only one side of the coin. Later clients, he goes on to say, were not in the position to present their personal aura to the lens because they had lost it in the course of degenerating capitalist society. Hence, photography is as much a detector of aura lost as a tool for the destruction of the aura. It has not escaped critics' attention that Benjamin admires aura where he finds it in old photographs, and it seems some of his writings' undiminished authority rests in this admiration shared by so many of us. He makes it clear enough, however, that whatever the charms of these testimonies to the first generation's sensible practices, photography became the nemesis of traditional values in art and that it is to be praised for the 'peeling away of the object's shell, the destruction of the aura' (Benjamin 1931: 519; cf. Benjamin 1939a: 255–256). Benjamin is convinced that photography has fundamentally changed the nature of art.

Is aura an inducement to or a product of contemplation? There is evidence for both in Benjamin's texts. It is clear, however, that for him contemplation is a bourgeois attitude and is bound to disappear together with bourgeois art institutions. True, he comes to see the disadvantages of his claims towards the end of his life (Costello 2005: 175). But where he embarks on critical appraisals of contemporary photography, he says that it should bypass any resemblance to traditional art genres and that responses to photography should avoid contemplation. In an era where shock experiences have become the norm of collective city life, Benjamin refers to montage as the strategy that fits the mission of the medium best (Benjamin 1934: 775). In this vein, he prefers constructed reality over the plain realism that photography is

usually expected to provide, and he argues that details of structures are more native to the camera than 'soulful portraits' (Benjamin 1931: 512). In his first photography-related text, a Karl Blossfeldt review, Benjamin insists on the medium's ability to see differently from the unequipped eye, thus providing us with 'new image-worlds' and a 'horde of analogies' (Benjamin 1928: 156). This observation is pursued in the 'Little History of Photography', where Benjamin claims that an optical-unconscious is made visible through time lapses and enlargements. The alleged kinship of the apparatus with psychoanalysis, made explicit in Benjamin's essay (Benjamin 1931: 512), is rather superficial; but the physiognomic aspect of a world hidden from contemplative sight is crucial for Benjamin's concept: it is on these grounds that he establishes photography's task to confront us with unveiled reality. At the same time, photographs have to meet the demands of societies experiencing a 'literarisation of the conditions of life' (Benjamin 1931: 527; cf. Benjamin 1934: 776; 1936: 241). Only if photographs are combined with captions, thus preventing vagueness and stereotypes from dominating their representation of reality, can they become revealing tools in a visual struggle for the identification of social conditions and the enemies of progress. Benjamin insists that photography, thus used, should reciprocally become a paradigm for other forms of communication, literature included (Benjamin 1934: 775). Yet, photography is to some extent a thing of the past for Benjamin who elsewhere ruminates upon whether photography, as a revolutionary tool, will only survive within film (Benjamin 1932: 599).

While Benjamin hails montage and caption-based communication in lens-based art and makes shock effects the mantra of his perception theory, he does not seem to be personally intrigued by modernist artistic photography (Molderings 2004: 445–446). His bias for old and old-fashioned images, so obvious in his 'Little History of Photography', also prevails in most of his other literary encounters with the medium. In an evocative childhood memory, Benjamin recounts the visit to a studio photographer where he felt the impossibility of becoming identical to a self imposed upon him by the lens (Benjamin 1938: 391). This instance of estrangement allows a strange identity shift: in a description of what he wants his reader to imagine as his own likeness, he actually relies on a portrait of young Franz Kafka, thus inscribing his private experience into collective history. The text confirms both the aura's persistence and decay (Duttlinger 2008: 87). In the last instance, aura is a product of Benjamin's own gaze rather than of the people depicted or the medium's erstwhile technical impediments. This is most evident where, in a rather opaque sentence, his approach is epistemologically

charged with an historical perspective. Having made the point that readability will decide photography's role in the modern culture, Benjamin refers to the 90 years that separate him from the age of Daguerreotypes, and speaks of the historical tensions discharged in that interval. It is, according to him, in this momentary light that 'the first photographs emerge, beautiful and unapproachable, from the darkness of our grandfathers' day' (Benjamin 1931: 527). Aura here turns out to be an historical effect, appreciated only by those beholders who, living in the days of its decline, allow for it to unfold. A photograph in itself cannot be a true image for Benjamin. In the *Arcades Project*, he defines a dialectical, hence genuine, image that 'wherein what has been comes together in a flash with the now to form a constellation' (Benjamin 1927–1940: 462). Benjamin will return to this concept in his essay on Baudelaire where he says that experiencing the aura of an object and investing it 'with the ability to look back' (Benjamin 1939b: 338) are one and the same thing. In this context, Benjamin reiterates the idea that photography lead to a decline of the aura, saying that the medium does not return the gaze of the subjects. But in so many old photographs a return of the gaze is precisely what he seems to have encountered, and he sports fascination with the traces of accidental reality in them. Benjamin's frequently cited 'tiny spark of contingency' which marks photography's indexical character has found an unacknowledged echo in Roland Barthes's *Camera Lucida* (Barthes 1981: 27, 41). Seeing this correspondence has become a critical commonplace (Dant and Gilloch 2002: 19, and countless others). Yet when Benjamin goes on to say that in the photographically conserved bygone moment 'the future nests so eloquently that we, looking back, may rediscover it' (Benjamin 1931: 510), he is less concerned with a traumatic experience of death than, again, with the dialectical image of the past.

Benjamin's syncretism is difficult to come to terms with empirically and theoretically. Just as his history of photography suffers from various errors (Gunthert 1997: 50, 52), his concept of the apparatus is over-determined and contradictory. In one text, the camera helps to preserve the aura by long exposure times, but its technical nature precludes the aura in another; it even fragments reality to the point of shocks by freezing time in yet another argument (Benjamin 1939b: 338, 328). Benjamin also mingles different notions of reproducibility (Frizot 2000: 119). Photography's key role in Benjamin's thinking rests on the assumption that technical revolutions precede any important pro-gress in art; but his attempt to transfer Marx's theory of how productive forces affect relations of production on medium history does not go beyond mere analogies (Bürger 1984: 30). It is also not entirely clear

how Benjamin can encounter an aura long decayed. All of this does not invalidate Benjamin's basic question as to whether, since the advent of photography, the very idea of art has changed (Benjamin 1936: 240; 1939a: 258). His related thoughts are at the roots of contemporary medium critique, and his many observations on how the aesthetical and political implications of photography challenged the institutions of the artworld have stimulated generations of writers. Postmodernism's key positions emanate from this critical perspective (Crimp 1980: 94), while Benjamin's emphasis on medium specificity provoked a recent attempt to reclaim it 'from the deadening embrace of the general' (Krauss 1999: 305). Yet, Benjamin was not interested in aesthetics proper and might not have agreed on this claim with Krauss. In many of his most pertinent observations, Benjamin tends to bridge the gulf between progressive tendencies and ideologies of the past. What makes photographs most interesting for him, however, is the little something 'that cannot be silenced' in our encounter with those who once lived, are 'still real' and 'will never consent to be absorbed in art' (Benjamin 1931: 510). It is in remarks such as this, idiosyncratic as many of them sound, that Benjamin's arguments fuel thinking about photography to date.

Biography

Born in 1892 into a wealthy Jewish Berlin family, Walter Benjamin studied philosophy, literature and psychology and received his PhD in 1919, his thesis discussing *The Concept of Art Criticism in German Romanticism*. Aiming for an academic career, he failed to see his second major work, *The Origins of German Tragic Drama*, accepted as a *Habilitation* thesis at the University of Frankfurt, and went on to work as a freelance writer instead. Benjamin had started early to publish translations as well as book reviews and essays on various subjects, and he was convinced he would become Germany's foremost critic. In 1933, however, he left Germany for Paris, where he focused on his ambitious *Arcades Project*. It was to discuss nineteenth-century culture in the French capital against the background of rising high capitalism; a torso as it is, it mirrors Benjamin's enormous ability to draw on very diverse aspects of cultural life. It also testifies to his intellectual shift towards dialectics and Marxism, long prepared by intensive contacts with major left-wing intellectuals and reflected by his several travels to the Soviet Union from 1926 onwards. On his flight from the Nazis, Benjamin took his own life in 1940 after an unsuccessful attempt to cross the border to Spain.

Primary texts

Benjamin, W. (1927–1940 [1999]) *The Arcades Project*, Cambridge, MA, and London: Belknap Press.

——(1928 [1999]) 'News About Flowers', in H. Eiland, M. W. Jennings and G. Smith (eds) *Selected Writings 2, Part 1, 1927–1930*, Cambridge, MA, and London: Belknap Press, pp155–157.

——(1931 [1999]) 'Little History of Photography', in H. Eiland, M. W. Jennings and G. Smith (eds) *Selected Writings 2, Part 2, 1931–1934*, Cambridge, MA, and London: Belknap Press, pp507–530.

——(1932 [1999]) 'A Berlin Chronicle', in H. Eiland, M. W. Jennings and G. Smith (eds) *Selected Writings 2, Part 2, 1931–1934*, Cambridge, MA, and London: Belknap Press, pp595–636.

——(1934 [1999]) 'The Author as Producer' in H. Eiland, M. W. Jennings and G. Smith (eds) *Selected Writings 2, Part 2, 1931–1934*, Cambridge, MA, and London: Belknap Press, pp768–782.

——(1936 [2002]) 'Letter from Paris, 2: Painting and Photography', in H. Eiland, M. W. Jennings and G. Smith (eds) *Selected Writings 3, 1935–1938*, Cambridge, MA, and London: Belknap Press, pp236–248.

——(1938 [2002]) 'Berlin Childhood around 1900', in H. Eiland, M. W. Jennings and G. Smith (eds) *Selected Writings 3, 1935–1938*, Cambridge, MA, and London: Belknap Press, pp344–413.

——(1939a [2003]) 'The Work of Art in the Age of Its Technological Reproducibility', third version, in H. Eiland and M. W. Jennings (eds) *Selected Writings 4, 1938–1940*, Cambridge, MA, and London: Belknap Press, pp101–136.

——(1939b [2003]) 'On Some Motifs in Baudelaire', in H. Eiland and M. W. Jennings (eds) *Selected Writings 4, 1938–1940*, Cambridge, MA, and London: Belknap Press, pp313–355.

Secondary texts

Barthes, R. (1981 [1980]) *Camera Lucida: Reflections on Photography*, New York, NY: Hill and Wang.

Bürger, P. (1984 [1974]) *Theory of the Avant-Garde*, Manchester, UK: Manchester University Press.

Costello, D. (2005) 'Aura, Face, Photography: Re-Reading Benjamin Today', in A. Benjamin (ed) *Walter Benjamin and Art*, London and New York: Continuum, pp164–184, 275–279.

Crimp, D. (1980) 'The Photographic Activity of Postmodernism', *October*, vol 15, pp91–101.

Dant, T. and Gilloch, G. (2002) 'Pictures of the Past: Benjamin and Barthes on Photography and History', *European Journal of Cultural Studies*, vol 5, no 1, pp5–23.

Duttlinger, C. (2008) 'Imaginary Encounters: Walter Benjamin and the Aura of Photography', *Poetics Today*, vol 29, no 1, pp79–101.

Frizot, M. (2000), 'La modernité instrumentale: Note sur Walter Benjamin', *Études photographiques*, vol 8, pp111–123.

Gunthert, A. (1997) 'Le temps retrouvé: Walter Benjamin et la photographie', in M.-D. Garnier (ed) *Jardins d'hiver: Littérature et photographie*, Paris: Presse de l'ENS, pp43–54.

Krauss, R. E. (1999) 'Reinventing the Medium', *Critical Inquiry*, vol 25, no 2, pp289–305.

Molderings, H. (2004) 'Fotogeschichte aus dem Geist des Konstruktivismus: Gedanken zu Walter Benjamins "Kleiner Geschichte der Fotografie"', in M. Kern, T. Kirchner and H. Kohle (eds) *Geschichte und Ästhetik: Festschrift für Werner Busch zum 60. Geburtstag*, Munich: Deutscher Kunstverlag, pp443–460.

Wolfgang Brückle

JOHN BERGER (1926–)

I am sure that I was not the first undergraduate and will certainly not be the last to have opened John Berger's *Ways of Seeing*, read it in one sitting, and then sighed with the relief that I had finally read something from deep inside me and also found a language for articulating a collective hope. All of Berger's writing does that: it hits you in the most intimate space and simultaneously throws you forward to claim the future.

Ways of Seeing was not a book by John Berger; it was a collaboration with four other partners, Sven Blomberg (collage artist), Michael Dibb (BBC producer), Richard Hollis (graphic designer) and Chris Fox ('critical' friend). The book was originally a four-part TV series that was broadcast by BBC in 1972. The chapter on photography in *Ways of Seeing* drew heavily on Walter Benjamin's seminal essay 'The Work of Art in the Age of Mechanical Reproduction'; but it was also pinned closely to a phenomenological approach on perception and time. However, the book also crystallizes more than three decades of writing and thinking about art and politics that appeared in the weekly magazines *New Statesman* and *New Society*. Since then Berger has continued to write both fiction and criticism.

Berger's reflections on photography have appeared throughout his long and still active writing career. From the collection of critical essays in *About Looking* (1980) to the recent collaboration with Selcuk Demirel, *Cataract* (2011), in which he pondered the fate of losing his vision, Berger has explored the sense and sensuality of sight. Perhaps his most epigrammatic and elegiac essay on photography appears in *And Our Faces, My Heart, Brief As Photos* (1984). A rare glimpse of his own early practice as photographer can be found in *Pages of the Wound* (1994). And his masterpiece photo-narrative collaborations with photographer Jean Mohr, *A Fortunate Man* (1967) and *A Seventh*

Man (1975), also resulted in another poetic-philosophical rumination over the meaning and affect of photography, *Another Way of Telling* (1982). This represents one of the most significant and diverse bodies of writing on photography.

Berger's writing on photography is primarily in response to the analogue format. However, his commentary on the 'radial effects' of visual images in contemporary culture and his more general thinking on the conditions of spectatorship anticipates many of the features of 'camera consciousness' that have now become more explicit in the digital age. In the opening sentence to *Ways of Seeing*, Berger posited: 'Seeing comes before words. The child looks and recognizes before it speaks' (Berger et al 1972: 7). Throughout life the camera now serves not only as a prosthetic extension of the eye, in that a zoom lens can either widen perception beyond the immediate spheres of the horizon or reveal microscopic details that are otherwise imperceptible, but it also becomes a conceptual toolbox with which the visual process of the imaginary can produce new forms. The camera has not only facilitated the multiplication *of* images, but it also invented new means *through* which images are created and disseminated.

Berger was quick to recognize that we are not only surrounded by what he called personal and public photography, but that we also construct our life narratives, or what he calls 'the bricolage of the soul', through a process of montage and assemblage of visual images. Public photography refers to the myriad images that are projected at us. They are the images that seek to either lure desire or provoke reactions. As this image is severed from the tendrils of its own time and space, the public photograph becomes complicit in the more general process through which culture is homogenized and social relations commodified. However, photography also enables a more personal space for reflection and introspection. In this zone, the private use of photography creates a context that activates memory and redeems hope, and Berger claims that this is a form of resistance against the structures of domination. It is a characteristic feature of Berger's writing that he defines emergent features by making sharp and apparently strident differentiations. These are invariably useful devices; but the point is not to remain in the binary or uphold an opposition as an inevitable or insurmountable opposition. To do so would only result in new hierarchies. On the contrary, Berger's use of these distinctions is tactical. They declare historical departures and conceptual breaks, but they also invoke new points of crossing and transgression. He uses them in order to make new connections.

For Berger, the ambivalence of photography always oscillates between the jagged points of alienation and the tender veins of experience. Berger also cuts across the neat divide between public and private photographs when he refers to 'expressive' photographs. In such an image 'the viewer can read into it a duration extending beyond itself' (Berger and Mohr 1982: 89). The photograph becomes meaningful because it reaches across space and time. It speaks to the future even as it summons the past. It arrives in one place, even though it is derived from another (McQuire 1998: 59). Hence, this ambivalence of photography in Berger's writing revolves around and spins into a deeper exploration of the relationship between the function of the image and its capacity to stimulate the human quest for self-understanding and freedom (Papastergiadis 1993: 17).

Berger was always aware of the close link between the invention of photography and the regimes of empirical documentation, instrumental reason and political regulation. However, he also claimed that photography had the mysterious power to do more than simply reflect and record what is already out there. While the camera is a 'box for transporting appearances', every photograph is an interpretation. It is a selection even though it operates as a 'quotation of reality'. The photographer takes his shot rather than makes the image, and yet there is an 'abyss between the moment recorded and the moment of looking' (Berger and Mohr 1982: 92–96). These are the paradoxical maxims with which Berger pursues the ways in which photography is a reflection of reality, and also, as Jean-Luc Godard noted, the 'reality of that reflection'. Photography both documents what is real and creates an image of what is possible. In this light Berger has never lost faith in photography as one of the creative forces for producing a new symbolic language that cuts across both the personal and public realm of experience.

Across the wide terrain of Berger's writing on photography, two key spatio-temporal thematics recur. First there is the experience of simultaneity – events are captured in the instance of their action and they are also transferred into parallel or disjunctive alien life worlds. The image always has an uncertain destiny. 'It is because the photographs carry no certain meaning in themselves, because they are like images in the memory of a total stranger, that they lend themselves to any use' (Berger 1980: 53). Second, the effect of displacement carries with it the counter force of redemption and home-making. He sees all forms of art as a response to a primal exile, a struggle between the infinity of the cosmos and the emptiness of the void, an effort to give form to being through subtle but crucial gestures and traces.

Hence, he claims that the function of art is comparable to the need to distinguish a place from the boundlessness of space:

> Place is more than area. A place surrounds something. A place is the extension of a presence or the consequence of an action. A place is the opposite of an empty space. A place is where an event has taken or is taking place … . When a place is found it is found somewhere on the frontier between nature and art. It is like a hollow in the sand within which the frontier has been wiped out. The place of the painting begins in this hollow. Begins with a practice, with something being done by the hands, and the hands then seeking approval of the eye, until the whole body is involved in the hollow.
>
> (Berger 2001: 28–29)

This is the same point that Berger also made when he described August Sander's photographic method as 'translucently documentary', while also repeating Benjamin's appraisal: 'It was indeed unprejudiced observation, bold and at the same time delicate, very much in the spirit of Goethe's remark: "There is a delicate mode of the empirical which identifies itself so intimately with its object that it thereby becomes theory"' (Berger 1980: 28).

For Berger, photography is a key force in the transformation of consciousness and the reconfiguration of knowledge. In Berger's major essay the 'Moment of Cubism', he outlined the revolutionary shifts in modern visual perspective and the intimations of social transformation (Berger 1969). The potential that he saw in the break with classical perspective was transposed and magnified in relation to photography. The camera was for him the democratic device that decoupled the link between the visible and the real from a centralized imperious gaze. It ushered new opportunities for unique perspectives and individual constructions of reality. However, it also exposed a chasm between the fragmentary and the unified, and thereby exposed everyone to a condition that Berger regards as unbearable as it is ineffable. Hence, he believed that the private use of photography has the capacity to be a 'memento from a life being lived' (Berger 1980: 52). This interpretation of photography is embedded in a radical under-standing of memory and experience as it stresses that the 'moment of looking' teems with associations and can unfurl new desires:

> The remembered is not like a terminus at the end of a line. Numerous approaches or stimuli converge upon it and lead to it. Words, comparisons, signs need to create a context for a printed

> photograph in a comparable way: that is to say, they must mark and leave open diverse approaches. A radial system has to be constructed around the photograph so that it may be seen in terms which are simultaneously personal, political, economic, dramatic, everyday and historic.
>
> (Berger 1980: 63)

By offering new forms with which to grasp, represent and experience time and space, photography has fundamentally altered our 'ways of seeing'. Benjamin suggested that the 'camera introduces us to unconscious optics as does psychoanalysis to unconscious impulses' (Benjamin 1973: 238). Berger saw this link but resisted the temptation to trace its origin back to the transformation of the individual psyche. Meaning, in its most exquisite 'subjective revelations', is always forged through the metaphoric process of connecting the disconnected instances and flashes of life. Hence, throughout Berger's writing, fascination with the techne of photography occurs at the frontiers of memory and identity in a hyper-visual culture.

Biography

John Berger was born in London in 1926. He began his career as a painter and started to work as a critic for *The New Statesman* in 1951. In 1958 he published his first novel, *A Painter of Our Time*, about an exiled Hungarian painter. His novel *G* won the Booker prize in 1972 and this was the same year that his four-part television series *Ways of Seeing* was screened on the BBC. He settled in a small village in the Haute-Savoie and wrote the trilogy *Into Their Labours* on the transformation of the European peasantry. He still rides a motorbike and his most recent book is *Bento's Sketchbook* (2011).

Primary texts

Berger, J. (1969) *The Moment of Cubism*, London: Weidenfeld and Nicholson.
——(1980) *About Looking*, New York, NY: Pantheon.
——(2001) *The Shape of a Pocket*, London: Bloomsbury.
Berger, J. and Mohr, J. (1982) *Another Way of Telling*, London: Writers and Readers.
Berger, J., Blomberg, S., Fox, C., Dibb, M. and Hollis, R. (1972) *Ways of Seeing*, London: BBC and Penguin Books.

Secondary texts

Benjamin, W. (1973) 'The Work of Art in the Age of Mechanical Reproduction', *Illuminations*, translated by H. Zohn, London: Fontana.

McQuire, S. (1998) *Visions of Modernity*, London: Sage.
Papastergiadis, N. (1993) *Modernity as Exile: The Stranger in John Berger's Writing*, Manchester, UK: Manchester University Press.

Nikos Papastergiadis

PIERRE BOURDIEU (1930–2002)

With the following subjects, is a photographer more likely to produce a beautiful, interesting, meaningless or ugly photo?: a landscape; a car crash; a little girl playing with a cat; a pregnant woman; a still life; a woman breastfeeding; a metal structure; tramps quarrelling; cabbages; a sunset over the sea; a weaver at his loom; a folk dance; a rope; a butcher's stall; the bark of a tree; a famous monument; a scrapyard; a first communion; a wounded man; a snake; an 'old master'.

(Bourdieu 2010: 518–519)

This enquiry and eclectic list form question number 26 in a survey conducted in 1963 amongst a sample of 692 people in Paris, Lille and 'a small provincial town in France' (Bourdieu 2010: 503). The survey was preceded by interviews with the subjects, which included a discussion of specific photographs illustrating the generalized categories named above (most of the photographs used were taken from the 1955 book of *The Family of Man* – 'a pregnant woman', for example, was an image by Manuel Álvarez Bravo). The survey, along with the interviews and information from a range of further sources, was used as the basis for Pierre Bourdieu's book *Photography: A Middle-Brow Art* (Bourdieu 1990).

Pierre Bourdieu was a key French sociologist whose work remains highly influential. Unusually in the field of sociology, Bourdieu combined traditional forms of empirical evidence with aesthetic theories. Central to Bourdieu's analyses of art and visual media are ideas from the work of eighteenth-century philosopher Immanuel Kant, particularly Kant's 1790 *Critique of Judgement*, where he considers taste in an attempt to determine why certain things may be judged to be beautiful: a likely influence on the phrasing of question 26 in the 1963 survey (Kant 2005). The two main texts in which Bourdieu discusses photography are *Photography: A Middle-Brow Art* and the later book *Distinction: A Social Critique of the Judgement of Taste* (its subtitle clearly inspired by Kant's writings).

Photography: A Middle-Brow Art was first published in France as *Un Art Moyen* in 1965. Twenty-five years later it was translated into

English. With middle-brow's meaning of something that is accessible to all, the English title of the book is perhaps as close a translation from the French as possible. However, 'middle-brow' does not do the contents of the book full justice. Michel Frizot, for example, has noted that *art moyen* has a double-sense, meaning both 'average art' and 'art-medium' (Frizot 1998: 719). Rosalind Krauss was more expansive about this point in her 1981 essay 'A Note on Photography and the Simulacral':

> [The book's] title uses the notion of *moyen*, or middle, to invoke the aesthetic dimension of middling or fair as a stage between good and bad, and to mean midway between high art and popular culture; it also employs *moyen* to call up the sociological dimensions of middle class as well as distributed mean or average.
>
> (Krauss 1990: 15)

The sociological use of the word is vital, as it suggests the links between culture and class, a point addressed in more detail below. The idea of mean or average neatly connects the idea of photography as an average and accessible form of culture with the statistical averages drawn from the research methods used by Bourdieu. Beyond this (as the references here to Frizot and Krauss suggest), Bourdieu's 1965 book has, especially since its English translation, gone on to become the average reference point when popular forms of photography are critically debated – although his ideas are usually only briefly discussed (for recent examples see Bate 2009: 28; Wells 2009: 165).

Photography: A Middle-Brow Art is divided into two parts. The first part of the book asks why photography is such a widespread medium and what its main role is. Bourdieu's argument is that photography in its mass form as snapshots performs a vital social function. On the basis of evidence gathered from the sources discussed above, Bourdieu makes the case that snapshots are primarily used to mark special occasions among families, such as birthdays, weddings and holidays (Bourdieu 1990: 13–39). The photographs made are shown to others, stored in albums, and copies are distributed to other family members. In this role, photography records and reinforces social integration, reproducing the institution of the family.

In a fascinating section on 'barbarous taste' (the phrase is another link to Kantian theory), Bourdieu describes how people are 'ordinarily' photographed face-on, striking a respectful pose for the camera. A great deal of effort is invested in making the photograph appear 'natural' and everyday; yet neither the pose, clothes or the context are

everyday – they are, by virtue of when and where snapshots are usually made, out-of-the-ordinary 'cultural' constructs (Bourdieu 1990: 80–81). Through an examination of the snapshots and comments of subjects such as 'J. B.', whose photographs (including pictures from his honeymoon in Paris) join those from *The Family of Man* as the illustrative figures in the book, Bourdieu details the composition and poses widely found in family albums. In most group photographs, he notes, the people are shown pressed together in the centre of the photograph, often with their arms around each other, and with their eye lines converging in the direction of the camera. 'The convergence of looks and the arrangement of individuals', Bourdieu asserts, 'collectively testifies to the cohesion of the group' (Bourdieu 1990: 81). In this way, each individual snapshot performs in microcosm the role of snapshots *en masse*: the representation and reproduction of social integration.

For this function to work, it is necessary that the photographs are believed to be realistic and objective. Inevitably, Bourdieu's take on this vital area of photographic debate derives from a sociological perspective. In what could be considered a tautological section of the book, 'The Social Definition of Photography', Bourdieu argues that photography is not an objective medium, it is only considered to be an accurate record 'because (from its origin) it has been assigned *social uses* that are held to be "realistic" and "objective"' (Bourdieu 1990: 74). In other words, photography is seen to provide convincing evidence because it has always been used to do so. Again, the idea of continual, irrevocable reproduction underpins Bourdieu's approach. However, such ideas arising from research in 1960s France cannot always be applied globally. For instance, Christopher Pinney has shown that a very different approach to 'realism' has developed in many Indian photo studios, where theatrical poses, costumes, props and backdrops are used to create far more overtly staged identities (Pinney 2003).

The second part of *Photography: A Middle-Brow Art* is prefigured by the final section of the first part, where Bourdieu argues that photography lies between cultural forms such as painting and literature (which are legitimized as art by a long history of formal institutionalization through universities, academies and so on) and non-legitimate cultural forms, such as clothing or cookery (which, at least at the time of Bourdieu's writing, lacked such a history). The upper class and the petit bourgeoisie (those in the middle class who aspire to upper-class values) regard photography as a potential art form, although it is practised by them less frequently than the working class and lower middle class – whose snapping away is regarded by higher classes as vulgar (Bourdieu 1990: 46–72). But any attempt to legitimate photography

fully as an aesthetic art form will always be contradicted by its mass social function (Bourdieu 1990: 95–98). The rest of the book, researched and written by other sociologists working for Bourdieu, examines three groups that break with the mass social use of photography: camera clubs, photographic artists and professional photographers. The central focus of the second part of *Photography: A Middle-Brow Art* is an examination of how these groups make themselves distinct from other groups. For example, camera club members go to great lengths to distinguish their photographs, which are primarily aesthetic rather than functional, from snapshots (Bourdieu 1990: 103–127).

The links between culture and class and the opposing of different forms of culture are the basis of Bourdieu's book *Distinction: A Social Critique of the Judgement of Taste*, published in France in 1979 and translated into English five years later. Weighing in at over 500 pages, *Distinction* has a much broader scope than *Photography*. However, the first part of the book returns to that 1963 survey, now supplemented by a further 525 subjects who participated in 1967 and 1968 (Bourdieu 2010: 503), to examine how 'taste' (literally, the familiarity and liking of one thing and the distaste, or even disgust, towards something else) becomes habitual within particular classes. Extending ideas from the earlier book, Bourdieu's key point in relation to photography is that subjects from the lower classes are educated towards seeing photography in its purely functional role, while those of the petit bourgeoisie and upper class are more likely to embrace the aesthetic – and experimental – possibilities of photographs, no matter how 'banal'. In other words, a photograph of cabbages, a metal frame, the bark of a tree, perhaps even a car crash, has the potential to be beautiful (Bourdieu 2010: 3–55; see also Krauss 1990: 15–21). In semiotic terms – and Bourdieu occasionally employs such terminology – the uneducated see the photograph at the basic level of denotation, while the educated are aware of the potential connotations of the photograph. Importantly, Bourdieu does not argue that those subjects surveyed from working-class backgrounds cannot understand the connotations of a photograph, or that they are unaware that such meanings can be read into an image. Rather, he suggests that their taste has not been cultivated to enable them to do so habitually. Faced with a photograph that related more to aesthetics than social function, one subject is quoted as saying: 'Yes, it is beautiful, but you have to like it, it's not my cup of tea' (Bourdieu 2010: 33).

The writer and sociologist Tony Bennett has referred to Bourdieu's highly influential *Distinction* as 'a – if, indeed, not *the* – classic sociological text of the twentieth century' (Bourdieu 2010: xxxiii). Yet, he also acknowledges criticisms that Bourdieu tends to polarize class tastes

and that research from 1960s France cannot be universally or eternally applied (Bourdieu 2010: xxxii). Bourdieu himself notes that banal content became more widely accepted as subject matter for art by 'one avant-garde painter or another' between the 1963 survey and the publication of *Distinction* at the end of the 1970s, 'for example, the sunset over the sea by Richer [sic], who paints typically romantic landscapes from photographs, or Long and Fulton, English painters who make 'conceptual' landscape photographs … or the car crash by Andy Warhol' (Bourdieu 2010: 55). Pointedly, while Bourdieu's first survey was conducted, Warhol was mass reproducing his car crash screen prints based on photographs from police files. And even as Bourdieu's *Distinction* was published in France, Roland Barthes was writing *Camera Lucida*, where he repudiates the approach to photography 'by a team of sociologists', who see photography as 'nothing but the trace of a social protocol of integration, intended to reassert the Family' and instead identifies more with the base pleasures that Bourdieu attributes to the working class (Barthes 2010: 7).

As James Elkins observes at the end of a discussion transcribed in his book *Photography Theory*, the writings of Bourdieu (and Barthes) that are so often referred to are well over a quarter of a century old, yet they remain key texts in the analysis of photography (Elkins 2007: 201). Now, with the unprecedented public access to private snapshots that the internet has provided, it is not just J. B.'s albums that are shown to exhibit the recurring elements of snapshots Bourdieu identifies. Simultaneously, the legitimization of photography as an art form has increased in pace since the start of the new millennium, edging it closer to the 'sphere of legitimacy'. It is important to take into account the specific methods and approach that Pierre Bourdieu used, as well as the geographical and historical context of his research. Nevertheless, in the twenty-first century, Bourdieu's classic writings on the social function and cultural status of photographs are arguably of greater relevance than ever before to the critical study of photography.

Biography

Pierre Bourdieu (1930–2002) was a leading French sociologist whose influential research and writings embrace a wide range of subjects, including photography, art, literature and television. Central concepts in Bourdieu's work include *cultural capital*, the idea that culture has a status that conveys distinctions between people and classes in a similar way to financial capital, and *habitus*, the habitual taste of a person or class formed by their upbringing and education. The reproduction of the

status quo over social change is a key theme in much of Bourdieu's writings. Bourdieu initially studied philosophy, which continued to inspire his work, before turning to ethnography and sociology. While *Photography: A Middle-Brow Art* (first published in France in 1965) is Bourdieu's most significant contribution towards the analysis of photography, *Distinction: A Social Critique of the Judgement of Taste* (published in France in 1979) remains the most famous and important text by this key writer.

Primary texts

Bourdieu, P. (1990) *Photography: A Middle-Brow Art*, Cambridge, MA: Polity Press.
——(2010) *Distinction: A Social Critique of the Judgement of Taste*, Oxon, UK: Routledge.

Secondary texts

Barthes, R. (2010) *Camera Lucida*, London: Vintage.
Bate, D. (2009) *Photography: The Key Concepts*, London: Berg.
Elkins, J. (2007) *Photography Theory*, Oxon, UK: Routledge.
Frizot, M. (1998) *The New History of Photography*, Cologne: Könemann.
Kant, I. (2005) *Critique of Judgement* New York, NY: Dover.
Krauss, R. E. (1990) 'A Note on Photography and the Simulacral', in C. Squiers (ed) *The Critical Image: Essays on Contemporary Photography*, London: Lawrence and Wishart, pp15–27.
Pinney, C. (2003) 'Notes from the Surface of the Image: Photography, Postcolonialism, and Vernacular Modernism', in C. Pinney and N. Peterson (eds) *Photography's Other Histories*, Durham, NC, and London: Duke University Press, pp202–220.
Steichen, E. (1955) *The Family of Man*, New York, NY: Museum of Modern Art.
Wells, L. (2009) *Photography: A Critical Introduction*, Oxon, UK: Routledge.

Stephen Bull

BRASSAÏ (1899–1984)

Brassaï provided scores of images for the Surrealists, notably for the magazine *Minotaure*, without being a member of the group or indulging in the trick photography of Man Ray, arguing instead for what might be called 'straight Surrealism': 'Surreality lies within ourselves, in objects that have become banal because we no longer see them, in *the normality of the normal*' (Brassaï 1963: 230). When interviewed, he offered reformulations:

The 'Surrealism' of my images was just reality itself, but made Fantastic through vision. I only ever sought to express reality, because nothing is more 'Surreal'. If reality no longer astonishes us, it is because habit has made it banal. My ambition was always to show aspects of daily life as if we were seeing them for the first time.

(Brassaï 1980: 15)

These statements posit an apparently paradoxical combination of outstanding documentary objectivity/evidence and de-familiarization: we need photography to show us the equivalence of the normal and the Fantastic. This he brought out by his dark printing style, and by his recourse to close-ups, notably for graffiti or the rubbish dug out of his pockets; for these, the emphasis is on the gouging or rubbing done by now absent hands, the conscious or involuntary energy that has passed into the objects. Does Brassaï's important, startling and most quoted pronouncement only concern this aspect of his photography? It is disingenuous of Brassaï to insist on the 'banal' when his pictures also show the extremes of society, the upper-class haunts and the roughest of dives, behind-door scenes with occasional actor-friends secretly posing. The Surreality to which he refers is better found when looking at his whole corpus and recognizing how interested he was in primal drives and sensuality. These may be found in the banal and where least expected, if one's vision is so attuned. It is certainly to be encountered in the prints, for there is little sustained theorization in his books or interviews. He wrote on artists and writers such as Picasso and Henry Miller at the end of his life, but it is his study of Proust that contains his most thorough reflection on photography, in general, rather than on his own photography, in particular.

Marcel Proust sous l'emprise de la photographie was published posthumously in 1997. Brassaï had always had a passion for literature, no doubt encouraged by his father who taught French. Brassaï had published poems when he was 21, collected 'found poetry' to make his textual collage *Histoire de Marie*, and his half a dozen years as a journalist had allowed him a margin of creativity, to the point of publishing a fictitious interview with former Russian Prime Minister Count Kokotzoff. His friends included writers, notably Henry Miller, Léon-Paul Fargue, André Breton, Raymond Queneau, Jacques Prévert, Henri Michaux, Lajos Kassák, György Bölöni and Endre Ady. Though he would cite Goethe as the main literary influence on his life, it was with Proust that he developed an obsession. Both of them had frequented the high life and the low life of Paris; furthermore, being such an astute technician, it was easy for Brassaï to catch the many allusions to

his art and so lay claim to a feeling of kinship (Brassaï 1997: 137–138). He started writing his *Proust* in 1973 when he found himself in hospital, cloistered like Proust, and continued his research on and off for ten years. He had accumulated eight different drafts of his projected book by the time he died. These were piled on a shelf which one day collapsed, so Brassaï's widow, Gilberte Boyer, commissioned Roger Grenier, novelist and long-time friend of Brassaï, to put the jumbled papers into order (Sanchez 2010: 405).

Brassaï's title, literally 'Marcel Proust under the influence of photography', alerts the reader to the main thesis: here is a literary figure whose high art owes much to what in the early twentieth century was considered a lowly art. Brassaï will signal the types of artistic cross-over that can be found in *À la recherche du temps perdu*. We therefore have a case of photography theory that is literary theory.

The influence of photography he divides into three categories: autobiography, plot devices and photo-literary aesthetics. Drawing from correspondence and memoirs, Brassaï first shows the emotional and intellectual investment that the portrait represented for Proust: he regularly posed for his likeness, offered his latest picture to his friends or the press, and went to extraordinary lengths to obtain photos of friends and celebrities. These were exploited when he drew his characters, borrowing features from real people and combining them to make composite portraits. Rather than listing all the possible sources behind each character, Brassaï demonstrates that a collection of portraits encourages the search for resemblances, and that these visual links become novelistic structure.

Family resemblances become clearer with age, and the portrait of a parent might foretell the future of a child; indeed, comparing the portraits of two unrelated people, Proust discovers a family air, thus leading him to believe that they must share personality traits. Proust also thought that by combining the portraits of all the lovers of a single person, one could discover the ideal that was sought, believing that one is only ever in love with a single person, though the bodies are not the same (Brassaï 1997: 117–118), and Brassaï singles out occasions when the resemblance occurs between the sexes, since the 'type', for Proust, transcends sexual differentiation (Brassaï 1997: 115–122). Already it is clear that meaning is not to be found in a single photograph, but in comparisons, when story-telling takes over.

Brassaï then shows how Proust transformed his often emotional contacts with photography into dramatic scenes. Drawing from personal experience and society gossip, Proust has portraits inspire animism and

projection, fetishism and sadism: Morel flees, surprised by guilt and fear, when he sees the portrait of Charlus at his rendezvous (Brassaï 1997: 107–108); Gilberte dyes her hair and dresses to resemble the photo of her husband's mistress (Brassaï 1997: 70); Mademoiselle Vinteuil's friend spits on the portrait of the late Monsieur Vinteuil (Brassaï 1997: 94–106). In all three cases, the viewers are mistaken (Charlus was not testing Morel's fidelity, Gilberte's rival was not a woman, and the desecration was a form of love), just as the Narrator's progress is a long realization that his impressions were mistaken. Brassaï demonstrates how Proust's relativism is made up of individual impressions, like snapshots in time, which reveal their true meaning cumulatively and in retrospect. A photographic reproduction solves the triple mystery of the identity of Uncle Adolphe's 'lady in pink', the bisexual courtesan Miss Sacripant and Odette: they are the same woman, at different periods of her life (Brassaï 1997: 107–108). Likewise, the Narrator did not know that his grandmother was dying when he criticized her dressing up for a portrait, which she was only having made that he might have something to remember her by (Brassaï 1997: 90–92). As experiences are deficient in themselves, art must give them meaning by relating them; such is the conclusion of À la recherche (simplifying somewhat), and Brassaï's contribution is to reveal that Proust used photography as the symbol of that primary incompleteness. Proust's thinking being thus bound up with photography, its vocabulary and operations saturate the novel (Brassaï 1997: 17).

Brassaï's main claim is that photographic metaphors – pose, camera obscura, impression, sensitivity, instantané (snapshot), cliché, negative, latent image, development, fixing – though commonly employed by novelists, exercise a deep influence in Proust's philosophy of the novel. Nevertheless, it must be remembered that photography is the model that Proust evokes in order to create a meta-photography that can only exist in literature. Proust defines his philosophy in terms of the art that he rejects.

Brassaï coined the word 'a-humain' ('not human') to describe Proust's eye in certain scenes when the vision is deliberately 'reduced to a mere optical mechanism, with every human quality removed, thought, feeling, memory, conscience, etc.' (Brassaï 1997: 151). The most famous example is the long description of the Narrator failing to recognize his grandmother and seeing only an old lady (Brassaï 1997: 152–153) – an experience Proust describes as seeing photographically. The snapshots memory is made up of are likewise criticized for being immobile, unrelated (Albertine disparue, 217; À l'ombre des jeunes filles en fleurs, 539,

556), and yet Proust insists that it cannot be otherwise: photography is an accurate metaphor of our condition in the world, subjected as we are to the passing of time from one second to the next, which we record piecemeal. Hence the 'ten Albertines' seen by Marcel as he moves to kiss her on the cheek (Brassaï 1997: 159–160), and the chronophotography that Brassaï finds in Proust's descriptions of motion, as if the author were describing imaginary photos of human locomotion taken by Marey or Muybridge (Brassaï 1997: 145–149).

The work of the novelist is therefore to confer mobility to the immobility of snapshot-memories, to stagger them across time, to superimpose them, to revisit them and give them retrospective meaning, to allow the links between them to come of their own. And so it is logically with Proust's most famous literary invention, 'involuntary memory', that Brassaï ends, equating it with the latent image appearing in the developing solution (Brassaï 1997: 166). Proust employs this photographic metaphor (with unusually positive connotations) not just for involuntary memory, but for all the intellectual or emotional operations that revivify time past (*À l'ombre des jeunes filles en fleurs*, 535; *Sodome et Gomorrhe*, 226). Brassaï sees in Proust a theory of photographic meaning: photographs are holistic, their true meaning arising from their grouping (in the case of an album) or from the relationships between scenes of the present and those from the past. Whereas the eye records mechanically, the forces of the unconscious work in the night, like Brassaï in his darkroom, to transform the familiar image into one new-born.

Biography

Gyula Halász (1899–1984) was born in Brassó, Transylvania, trained as an artist at Budapest and Berlin, and adopted the name Brassaï ('from Brassó') when he settled in Paris in 1924. The pseudonym was meant to distinguish his real artistic self from the persona he adopted for hack journalism. After organizing the distribution of press photographs and working with photographers – notably his friend and compatriot André Kertész – Brassaï switched trades. 'I realised that photography was the most relevant means of expression for the times we were living in' (Brassaï 2000a: 24). He operated as a freelance photographer from 1930 to 1963, producing photojournalism, portraiture, Surrealism and eroticism, documenting Paris night-life, graffiti and Picasso's sculptures. His first book, *Paris de nuit* (1933), made him famous overnight.

Primary texts

Brassaï (1933) *Paris de nuit*, Paris: Arts et Métiers Graphiques; Flammarion: 2001; *Paris after Dark*, New York: Pantheon, 1987.

——(1949) *Histoire de Marie*, Paris: Point du Jour; Arles: Actes Sud, 1995 (drafted from the malapropisms of his cleaning lady).

——(1961) *Graffiti*, Paris: Éditions du Temps; Paris: Flammarion: 1993.

——(1963) Talk by Brassaï at UNESCO (1 March 1963), quoted by S. Sanchez, *Brassaï, le promeneur de nuit*, Paris: Grasset, 2010, p230.

——(1964) *Conversations avec Picasso*, Paris: Gallimard. *Picasso and Co.*, translated by F. Price, preface by H. Miller, introduction by R. Penrose, New York, NY: Doubleday, 1966; *Conversations with Picasso*, translated by J. M. Todd, Chicago, IL: University of Chicago Press, 1999.

——(1975) *Henry Miller grandeur nature*, Paris: Gallimard; *Henry Miller: The Paris Years*, translated by T. Bent, New York, NY: Arcade Publishing, 1995.

——(1976) *Le Paris secret des années 30*, Paris: Gallimard, reprinted 1988; *The Secret Paris of the 30s*, translated by R. Miller, London: Thames and Hudson, 1976.

——(1978) *Henry Miller, rocher heureux*, Paris: Gallimard; *Henry Miller: Happy Rock*, translated by J. M. Todd, Chicago, IL: University of Chicago Press, 2002.

——(1980) interviewed by F. Bequette, *Culture et communication*, no 27 (May 1980), p15, quoted in *Brassaï, notes et propos sur la photographie*, Paris: Centre Pompidou, 2000, p52.

——(1997) *Marcel Proust sous l'emprise de la photographie*, Paris: Gallimard, 1997. All references are to the French edition and all translations are my own; but see *Proust in the Power of Photography*, translated by R. Howard, Chicago, IL: University of Chicago Press, 2001.

——(2000a) *Lettres à mes parents (1920–1940)*, translated from the Hungarian by A. Járfás, Paris: Gallimard; *Letters to My Parents*, translated by P. Laki and B. Kantor, Chicago, IL: University of Chicago Press, 1997.

——(2000b) *Brassaï, notes et propos sur la photographie*, Paris: Centre Pompidou.

Secondary texts

Proust, M. (1913–1927 [1954]) *À la recherche du temps perdu*, Paris: Folio/ Gallimard.

Sanchez, S. (2010) *Brassaï, le promeneur de nuit*, Paris: Grasset.

Paul Edwards

VICTOR BURGIN (1941–)

In a career trajectory that spans from conceptual art during the 1960s through to the present day, Victor Burgin has been a consistently significant figure as an artist and theorist of the photographic image. His early artworks were conceptual pieces, often written texts

in installations, but he soon turned his attention to the use of photography.

Burgin's initial contributions to a *theory* of photography emerged across art journals during the 1970s. Some of these essays were collated in his widely read and cited anthology *Thinking Photography*, first published in 1982. His own contributions to that book mark a specific trajectory of theoretical work in thinking about photographs: how photographs achieve meaning, their rhetorical status, social value and ideological functions, and a consistent deconstruction of the myths that surrounded fine art photography.

The cover of *Thinking Photography* famously shows a Leica M4 camera sandwiched between books: on one side, Robert Frank's *The Americans* and, on the other, a *New Left Review* journal and a volume of Sigmund Freud's writings. The range of materials is 'symptomatic' of the important references at the time: photography, a theory of ideology and psychoanalysis. Underneath the Leica lay other key 'foundation' texts: the 1980 *Classic Essays on Photography* compilation by Alan Trachtenberg; essays by Walter Benjamin; *Communications* journal, which had published Barthes's early semiotic essays, and Ferdinand de Saussure's *General Course in Linguistics* (the bible of structuralist semiotics).

The essays in *Thinking Photography* mark a pivotal moment in the theory of photography. First, it can be seen that the deep impact of semiotics registered a recognition of the wider social ideological function of photography across different institutional practices: art, advertising, various amateur uses, documentary and news photo-journalism. As Burgin put it in the incisive introduction to *Thinking Photography*, the widening of the study of photography was to include 'photography considered as a practice of signification' because 'the primary feature of photography as an omnipresence in everyday social life, is its contribution to the production and dissemination of *meaning* (Burgin 1982: 2). Some of these early arguments were brilliantly summarized in his essay 'Art, Photography and Commonsense', first published in London's *Camerawork* magazine in 1976 (Evans 1997).

These sorts of argument developed the point once made by Walter Benjamin, whose 'The Author as Producer' is the first essay in *Thinking Photography*, that the photographer who cannot understand the meanings of their own photographs is a modern 'illiterate'. The idea that a photographer should be able to understand the meanings of their own photographs (let alone the media environment around them) was not universally accepted at that time. Many would say – and perhaps still do – that theory (and this theory, in particular) was 'against'

creativity, spontaneity and inhibits practice, that 'making pictures' is not concerned with theory. Yet, what had made this project distinct from, say, philosophy, asking abstract theoretical questions such as 'what is photography?', was that it was precisely aimed at *praxis* – a theory developed to impact upon the making of photographic images as much as their criticism or 'appreciation'.

A second stage of theoretical development can be seen emerging through the trajectory of *Thinking Photography* too. Beyond the general interrogation of the historical photographic image and its (rhetorical) 'structure' across different specific social uses, the texts recognize the active role that the spectator (and photographer) occupies in the production of meaning. The study of photographic meaning shifts to include the role of the spectator within the process. In the essay 'Looking at Photographs', for instance, the system of perspective that governs most photographs is seen as intersecting with the very desire to look. Seeing, fantasy and the imagination become (ideological) perspectives in their own right. A Lee Friedlander photograph is cited as an example of the contestation of the normal positioning offered by photographs. It should be noted that the theoretical impetus and context for such arguments was in film studies, where psychoanalytic theory was already leading a critique of the forms of visual pleasure at stake in Hollywood cinema (e.g. the famous critical essay of 1975 by Laura Mulvey, 'Visual Pleasure and Narrative Cinema': Mulvey 1989).

The impact of some of this theory appears in Burgin's next book, *The End of Art Theory*, which takes the above arguments to realism, modernism and, towards the end of the book, postmodernism too. Indeed, the subtitle of the book *Criticism and Postmodernity* heralds a specific critique in the book of the wish for art theory to be separated from the wider world of what Burgin called the 'integrated specular regime of our "mass-media" society' (Burgin 1986a: 204).

This point might well be read as a shot at the new art criticism emerging then, which was exploiting much of the new critical vocabulary of structuralist semiotics and psychoanalysis (the image as sign, the gaze, etc.) to champion the new photo-artists (mostly American: Cindy Sherman, Barbara Kruger, Richard Prince, Sherrie Levine, et al) then emerging on the international art scene. Theory was turned into a new vocabulary for art criticism. The same year that *The End of Art Theory* was published, a collection of Burgin's own photographic art works and interviews also appeared called *Between* (Burgin 1986b). The book shows the trajectory of Burgin's photo-works during that period and offers an alternative paradigm of practices to the often-vacuous 'postmodern' works that adorned the walls of galleries. True to his

theoretical word, his photo-works also engaged the wider 'specular regime of our "mass-media" society', with image-text pieces interrogating a critical discourse on desire and the social world.

Burgin's subsequent writings develop this route for theory too. His essays on Helmut Newton in the 1990s, for example, interrogate specific images, *but also* the subject position of the critic/spectator viewing them. Yet, the essays are far from naval-gazing or self-flagellating criticism; rather, they attempt to work through and demonstrate the specific psychical space that an optical-image may come to occupy. His next theory book, *In/Different Spaces* (Burgin 1996a), published while living in the US, broadens this thesis, so that the concurrent discourses of image and fantasy are framed by a wider cultural and geo-political sensitivity. Always grounded, the book quite literally explores cultural space as a question of social and psychical experience located in memory and place, thus interrogating the role of the image in the politics of everyday life.

After returning to live and work in the UK in 2001, Burgin's *The Remembered Film* (2004) became an extremely popular book, with a highly refined writing, dense yet accessible, poetic and critically sharp. The questions of memory–image–place haunt the essays in the book and coincide with the preoccupations of his digital video practice. Indeed, in many ways the book begins to dissolve the distinctions of his written theory and visual practice into one *praxis*. In different forms, the critical issues of memory, culture and representation overlap in competing spirals of interest. The kaleidoscope of images that inhabits modern media space (e.g. the internet, cinema, advertising, photographs) and, thus, our collective and individual minds act as an archive of social experience. Burgin shows how these media images and personal memories intertwine, often involuntarily; how they can form 'an increasingly uniform memory' (Burgin 2004: 109). The final section of the book, a Coda subtitled 'Possessive, Pensive and Possessed', summarizes the shifts in the theory of ideology and the image from the 1960s and 1970s to the contemporary media regime, where the spectator today can be possessive, pensive or (as Burgin adds) become *possessed* by images.

Burgin's own work offers a critical possession of images. The internet, digital 'capture' and the cinema inform his recent 'un-cinematic' practice as a writer and artist. The whole trajectory of his artworks from painter to photographer and video artist show a sustained engagement with the changing processes of our image culture, as do his writings: from conceptual art to photography theory and history, to the wider cultural and historical function of visual images. Yet, the sustained

component of his engagement has been, consistently, the politics of the image. Today, when ethics and responsibility are part of a new demand for a global politics of the image, Burgin's essays have found a new urgency in relating to these questions. While some recent 'political artists' have returned to 'pre-semiotic' naive arguments about the value of their interventions, Burgin's theoretical work offers a rich history of critical arguments developed about precisely the role and conditions of intervention for artists, photographers and political art. His latest artworks show a real engagement with these issues, too, about uses of social memory, history and modern technology. These issues are discussed in his recent *Parallel Texts* book (Burgin 2011). While in the last two decades his contemporary works have become predominantly digital (and virtual) video work, his ideas and critical writings still have massive relevance and continuity with his world-famous theoretical work on photography.

If today 'fine art photography' is not the object it was, the 'increasing mediatization of art' (Burgin 2011: 225), as Burgin puts it, means that art (and photography) is increasingly subject to the specific ideological conditions of production and dissemination of the wider popular image culture. It is within the interstices of this dynamic that Burgin's conceptual work intervenes. His work offers, as Raymond Bellour put it in an interview discussion on Burgin's visual work, a 'critical aim and the phantasmatic aim' (Burgin 2011: 206). These two aims remain a central problematic for contemporary photographic issues too (the fantasies we tell ourselves about what we do are not necessarily that received by others). Few practising artists have offered such rigour or clarity of intellectual insight into their own field.

Biography

Victor Burgin, born in 1941 in England and trained as a painter, studied at the Royal College of Art in London and received an MFA at Yale University in 1967. He became well known through his conceptual works during the 1960s and his theoretical writings. He taught photography in Nottingham Trent University and later at the Polytechnic of Central London (now the University of Westminster) from 1973 to 1988, where he constructed the famous photography theory programme within the photography degree course. During this time he published *Thinking Photography* in 1982 and was also nominated for the Turner Prize at the Tate in 1986. He moved to the US in 1988 as Professor of History of Consciousness at the University of California, Santa Cruz, and was subsequently Emeritus Professor.

He returned to the UK in 2001 and became Millard Professor of Fine Art at Goldsmiths College. Since 2006 he has been prolific in his visual works, commissioned across the world, and continued to write, publish and give public lectures.

Primary texts

Burgin, V. (ed) (1982) *Thinking Photography*, Basingstoke, UK: Macmillan.
——(1986a) *The End of Art Theory: Criticism and Postmodernity*, Basingstoke, UK: Macmillan.
——(1986b) *Between*, London: Blackwell/ICA.
——(1996a) *In/Different Spaces: Place and Memory in Visual Culture*, London: University of California Press.
——(2004) *The Remembered Film*, London: Reaktion.
——(2008) *Components of a Practice*, Milan: Skira.
——(2010) *Situational Aesthetics: Selected Writings by Victor Burgin*, edited by A. Streitberger, Leuven: Leuven University Press.
——(2011) *Parallel Texts: Interviews and Interventions about Art*, London: Reaktion.

Secondary texts

Burgin, V. (1973) *Work and Commentary*, London: Latimer.
——(1976) *Two Essays on Art, Photography and Semiotics*, London: Robert Self.
——(1986c) Donald, J. and Kaplan, C. (eds) *Formations of Fantasy*, London: Methuen.
——(1996b) *Some Cities*, London: Reaktion.
——(2006) 'Possessed, Pensive, Possessive', in J. Lowry and D. Green (eds) *Stillness and Time: Photography and the Moving Image*, Brighton, UK: Photoworks.
Evans, J. (ed) (1997) 'Art, Photography and Commonsense', in *The Camerawork Essays: Context and Meaning in Photography*, London: Rivers Oram.
Mulvey, L. (1989 [1975]) *Visual and Other Pleasures*, London: Macmillan.

David Bate

HENRI CARTIER-BRESSON (1908–2004)

The Decisive Moment (1952) was not the original title of Cartier-Bresson's landmark book, initially published in France as *Images à la sauvette*. The two key words were drawn from the epigraph: 'There is nothing in this world that has not its decisive moment' (Cardinal de Retz). Publisher Richard Simon thought it would make a better title than a translation. Cartier-Bresson himself could not find a fitting English equivalent for '*à la sauvette*', meant to establish a parallel between the

street photographer and the hawker ready to decamp at the first sign of trouble (Sire 2009: 56). Simon's choice was correct, as its critical fortune has proved: the 'decisive moment' has become a catchphrase for photography itself. A more positive-sounding synonym for 'snapshot' has yet to be found.

But photography cannot be reduced to snaps, and neither should Cartier-Bresson's writings be caricatured. There is a whole philosophy of life behind those famous words, and they are best understood in the context of his own photography. Cartier-Bresson was neither a writer nor a theoretician, and he penned his most famous essay in an oral rhetoric that fields questions in order to preserve his liberty, hence the recurrence of the same formulae in interviews over 50 years. The descriptions he provides of his activity perfectly encapsulate the visual logic of his approach, yet they cannot be easily applied to photo-journalism in general, since comparisons reveal how little fraught with narrative content, how little self-explanatory, how little *redundant* are Cartier-Bresson's signature images. Apart from the later, more routine magazine work, they are not 'illustrations'. Whereas it is standard photojournalistic practice to plan the pictures that will tell the story, to think of opening and closing shots, double-page spreads, scene-setting and close-ups and the right mix of lenses, Cartier-Bresson, for his part, refuses all this and trusts to chance: 'One cannot be thinking about the page layout while one is actually shooting a story' (Cartier-Bresson 1996: 30; the director of *Gamma* told me to do the exact opposite in 1990). The decisive moment of the professional is not his.

The 1952 preface explains and valorizes reportage at a particular conjunction in history: photojournalism was still booming, along with magazines, but the monograph was a relative novelty. The dangers of war had given photographers the status of heroes; formerly anonymous operators, they were now household names and were fast becoming international stars. Few, however, were exhibited in art galleries. Cartier-Bresson's work was shown at MoMA (New York) in 1947, and *Images à la sauvette* was published by Tériade, an art publisher, and featured a specially commissioned drawing by Matisse on the dust-jacket, as if to prove the fraternity of the arts. After the Pictorialist movement, which had proved before World War I that photography could be art if it looked like art, it was now photojournalism and street photography that was claiming to be the work of 'authors'. With William Klein's *New York* (1956) and Robert Frank's *Les Américains* (1958), the 1950s was the decade when the photo-book was to become considerably more visible. Ever faithful to this context and his own artistic background (two years at André Lhote's academy),

Cartier-Bresson puts the emphasis on the craft of the photographer. He speaks as a painter: 'The shots I take [*tir photographique*] are sketchbooks' (Cartier-Bresson 1996: 15). The eye and the camera produce a *sketch*.

Long thought to be a purely mechanical operation, the art of photography was handicapped by the negative associations of the camera as a machine, so Cartier-Bresson's first masterstroke is to assimilate the camera to his body: 'I discovered the Leica camera: it became the extension of my eye' (Cartier-Bresson 1996: 18) (the Leica A of 1925, the first to take 35mm film, bought in 1932 and now on display at the Fondation Cartier-Bresson). It had no rangefinder, so framing was guesswork. He continues: 'Photojournalism is the progressive operation of the head, the eye and the heart', and in 1976 the formulation runs better: 'To take a photograph is to put the mind, the eye and the heart along the same line of sight. It's a way of life' (Cartier-Bresson 1996: 35). Since he derived his inspiration from silent films (Cartier-Bresson 1996: 17), perhaps the phrase owes something to the final inter-title in Fritz Lang's *Metropolis* (1927): 'The intermediary between the brain and the hands must be the heart!' Whether the influence is there or not, the trio of humanitarian political sensibilities, art and the intellect are ever present in the photography that he promotes.

Cartier-Bresson puts the emphasis on the actual moment of taking the photo, not on the image as a print. He gives lyric descriptions of the energy that builds up to the decisive moment when the shutter is released: 'I'm a live wire waiting for the right moment, and the tension mounts and mounts, then it bursts – the joy is physical – dance, time and space all united. Yes! Yes! Yes! Yes! As at the end of Joyce's *Ulysses*. To see is a complete experience in itself' (Cartier-Bresson 1974: 30). Cartier-Bresson describes composition as bodily active, as movement. On footage taken of him in action (*L'Aventure moderne*, directed by Roger Kahane in 1962), he seems almost to dance, often on tiptoe. And then pounce. The film and shutter speed are always the same (400 ISO, 1/125th); all he needs to do is guess the aperture and focus, so all the work can go into framing and anticipating. In Robert Delpire's 1994 *Contacts* film about him, he says: 'The only thing that matters is the instant.' The excitement of shooting is the be-all and end-all of his photography theory.

As Cartier-Bresson's accent is on the picture-taking moment, little consideration is left for post-production work. He stigmatizes cropping as immoral: 'If a good photo is cropped, even ever so slightly, the relative proportions, the play of proportions, are sure to be destroyed, and besides, it is highly unlikely that a badly composed shot will be

saved by trying to frame it anew in the darkroom, cropping the negative under the enlarger: the integrity of the initial vision is lost' (Cartier-Bresson 1996: 27). As Jean-Pierre Montier points out, the *lapsus* is revealing: '*intégralité*', the 'whole' of what was seen, is replaced by the moral notion of '*intégrité*', 'integrity' (Montier 1995: 36). This application of a moral vocabulary to a formal exercise has no foundation. Bill Brandt jotted down Cartier-Bresson's edict and then wrote: 'No rules in photography [...] I'm interested in the end, not the means' (Brandt 1993: 15). If the absolute tone continues to irritate to this day, it can perhaps be tempered by the thought that Cartier-Bresson applies it mainly to himself, as an exercise in self-discipline. Did he disapprove of Brandt's cropped, high-contrast photographs? Not at all, he was drawn to them, as he was to the man (Cartier-Bresson 1990).

Cartier-Bresson's photography theory, if it may really be called that, is practical and describes his way of operating. For him, all the work is achieved when the shutter is pressed *because* printing did not interest him. He was finally able to delegate the work to Pierre Gassmann in 1949 (Cartier-Bresson, A. 2009: 147). One's admiration in front of the original prints is in large part due to Gassmann (1914–2004). Cartier-Bresson insisted upon a special all-grey printing style, known in France as 'Cartier-Bresson grey' (Cartier-Bresson, A. 2009: 147). By exploiting the full range of mid-tones, and by avoiding the use of high-contrast, he diminishes the viewer's attention on the print itself as an aesthetic object or surface, full of the tensions and theatricality of the black and white, and transforms the print into a window so that the viewer concentrates upon the scene, as if reliving the original vision. Cartier-Bresson likewise invented the signature black line around the edge of the print (printing slightly beyond the edge of the negative by filing down the negative holder in the enlarger), pre-framing it in defiance of magazine editors who crop. He naturally condemns retouching as another post-production lie (Cartier-Bresson 1996: 15), as well as the use of flash, or posing the subject, which add fiction to reality. Lastly, seizing the moment must be a collaboration with the human moment, not a blind, mechanical, motor-drive approach: 'Shooting off lengths of film mechanically is, however, to be avoided wherever possible' (Cartier-Bresson 1996: 20). In Delpire's film, you see his contact sheets and all the attempts required to get the perfect shot, such as the 20 almost identical photos of Balthus (Cartier-Bresson 1990). The discourse of the decisive moment seems to imply that he always shoots a bull's-eye, whereas in fact he works much like any other photojournalist. In the *Contacts* TV series, the contact sheets of Doisneau, Klein, Koudelka, Riboud and others reveal the same search

for geometric perfection in a single shot or by working round a subject. So, apart from post-production considerations, Cartier-Bresson's words strike a chord with many.

The real difficulty with Cartier-Bresson's theory and practice lies at its very heart. Seeking the 'decisive moment' means immobilizing what is transient and choosing the peak of the action. Ever since Lessing's *Laocoon* (1766), artists have been warned against precisely these two errors. Lessing insists that artists represent a moment *prior* to the acme so that the viewer's imagination is stimulated. Artists learned to suggest duration: Bill Brandt waits until his sitters come to a natural point of rest, as does Cartier-Bresson sometimes. But to stop time and motion – the countless photos of empty streets with one figure running – is to renounce Lessing. It is, rather, to embrace Breton's notion of 'convulsive beauty', as defined in *L'Amour fou* (a book he helped to illustrate in 1937): the stilling of motion.

The most recurring Cartier-Bresson shot is of an empty street with one person arriving to fill the gap: a falling into place that gives coherence to chaos; life itself as brevity, the future an eclipse (no Christian iconography at play in this corpus). Cartier-Bresson found the confirmation of his philosophy of photography in Eugen Herrigel's *Le Zen dans l'art du tir à l'arc* (Herrigel 1948, first English edition 1953; first French edition 1955). Hence, the metaphors mentioned earlier: the 'line of sight' and '*le tir photographique*', which is not simply the translation of 'shot'. His 1976 essay 'L'Imaginaire d'après nature' concludes with his personal synthesis of Buddhist wisdom, which simply restates his *modus operandi*: receptivity to the moment and a disciplined search for harmony: a paradoxical mix of self-discipline and hyper-sensitive intuition. So this 'agitated Buddhist', as he liked to call himself, had, in fact, remained true to his Surrealist beginnings. When in 1973 he said that he sought the '*hasard objectif*' (Cartier-Bresson 1996: 45), he was referring to Breton's idea in *L'Amour fou* that there is a continuous interplay between our unconscious and what we see, and that we see 'coincidences' when the unconscious is made to work. In 1995 he wrote that Surrealism taught him to 'let the lens rummage the gravel of chance and the unconscious' (Cartier-Bresson 1996: 68). Breton's paradigmatic texts have a special resonance if they are read thinking about Cartier-Bresson's photography: they are the ground of his aesthetics.

Biography

Born in 1908 into one of the 200 wealthiest families of France, the young bohemian painter fled the circles of the *haute bourgeoisie*, frequented the Surrealists, lived a year in Africa (1931), started travelling

with a camera, abandoned photography in 1935 to study film, directed war documentaries (1937–1945), founded Magnum (1947), was the first photojournalist allowed into Russia (1954), and officially 'gave up photography' in 1974 in favour of painting. His output is prodigious, his monographs have inspired many to take up photography, and his statements on the art remain challenging.

Primary texts

Cartier-Bresson, H. (1996) *L'imaginaire d'après nature*, Cognac: Fata Morgana. All page references are to the French edition and all translations are my own, but see Cartier-Bresson, H. (1999) *The Mind's Eye*, New York, NY: Aperture. This provides an anthology of his major texts, including: 'L'instant décisif', in *Images à la sauvette*, Paris: Verve, 1952; 'L'imaginaire d'après nature', in *Henri Cartier-Bresson*, Paris: Delpire/Le Nouvel Observateur, 1976; 'Les Européens', in *Les Européens*, Paris: Verve, 1955; 'Moscou', in *Moscou*, Paris: Delpire, 1955; 'D'une Chine à l'autre', in *D'une Chine à l'autre*, Paris: Delpire, 1954; 'An Island Gone Adrift [Cuba]', in *Cuba*, Life, 15 March 1963, p42; '[Letter to *Cahiers de la Photographie*]', *Le Monde*, 17 December 1982; 'André Breton, roi soleil', in *André Breton, roi soleil*, Saint-Clément-de-Rivière: Fata Morgana, 1995.

Secondary texts

Assouline, P. (2006) *Cartier-Bresson: L'œil du siècle*, 2nd edition, Paris: Folio/Gallimard.

Brandt, B. (1993) *Bill Brandt*, London: Thames & Hudson.

Cartier-Bresson, A. (2009) '*Provenance et authentification des épreuves photographiques d'Henri Cartier-Bresson*', in: A. Cartier-Bresson and J. P. Montier (eds) *Revoir Henri Cartier-Bresson*, Paris: Textuel.

Cartier-Bresson, A., and Montier, J.-P. (eds) (2009) *Revoir Henri Cartier-Bresson*, Paris: Textuel.

Cartier-Bresson, H. (1974 [1995]) Interview, quoted in J.-P. Montier, *L'Art sans art d'Henri Cartier-Bresson*, Paris: Flammarion.

——(1990) In conversation with the author.

——(2000) *Henri Cartier-Bresson*, Paris: MK2. DVD anthology, includes: *Henri Cartier-Bresson: L'Aventure moderne*, directed by R. Kahane, 1962; *Henri Cartier-Bresson: Biographie d'un regard*, directed by H. Butler, 2003; *Contacts: Henri Cartier-Bressson*, directed by R. Delpire, 1994.

Herrigel, E. (1953) *Zen in the Art of Archery*, trans. R. F. C. Hull, London: Routledge and Kegan Paul, New York: Pantheon Books.

Montier, J. P. (1995) *L'Art sans art d'Henri Cartier-Bresson*, Paris: Flammarion; *Henri Cartier-Bresson and the Artless Art*, London: Thames & Hudson, 1996.

Sire, A. (2009) '*De l'errance à l'œil*', in A. Cartier-Bresson and J.-P. Montier (eds) *Revoir Henri Cartier-Bresson*, Paris: Textuel.

Paul Edwards

JEAN-FRANÇOIS CHEVRIER (1954–)

From the beginning of the 1980s, the art critic, historian and curator Jean-François Chevrier played a key role in the process through which photography both emerged as a theoretical object of study and was accepted in the artistic field in France. Far from being limited to a period or a subject, Chevrier's prolific thought is best defined through its taste for a broad spectrum of interests, considering photography in relation to literature, urbanism, architecture and modern art.

Chevrier develops this approach in his first book, *Proust et la photographie*, in 1982, a project that articulates his initial literary education with his personal interest in the medium, and provides a response to Roland Barthes's *Camera Lucida*, first published in French in 1980. Instead of subscribing to Barthes's melancholic and funereal definition of photography as inseparable from its depicted and vanished subject, Chevrier proposes an analogy between Proust's concept of involuntary memory – that reconstructs the past from a fortuitous sensation, as when the taste of the madeleine cake triggers the Narrator's recollection of his childhood at the end of *Combray I* – and the mechanisms of photography. For Chevrier: 'To look, to record, to inscribe, to reproduce, to imitate, to reveal, to imagine are for me the seven keys of photographic imagination' (Chevrier 2009: 7).

He establishes the role of the medium of photography (the act, as well as the image and its reception) in the process of creative imagination and writing. By demonstrating that photography is both a theme in the narrator's story and one of the structural methods of *In Search of Lost Time*, Chevrier has renewed our understanding of Proust. He has also paved the way for studies on the manifest or more underground influence of photography on the act of writing in nineteenth-century literature, such as Phillipe Ortel's *La Littérature à l'ère de la photographie* (2001). Chevrier's 2009 addendum concerning the relations between photography and reminiscence in the augmented version of his book stresses Proust's active reception of a series of watercolours, prints and Daguerreotypes of Venice made by John Ruskin and shows how the act of seeing overflows in his writing.

In 1982 Chevrier also founded the journal *Photographies*, for which he was chief editor until 1985. Its goal was to promote the existing correspondences between photographic and artistic practices. Through this art journal, Chevrier affirms his support of the photographic mission of the Interministerial Delegation to Land Use Management and Regional Attractivity (Délégation interministérielle à l'Aménagement du Territoire et à l'Attractivité Régionale, DATAR). Conceived

along the same historic lines as the Heliographic Mission of 1851 and the 1930s Farm Security Administration, it was a commission given to about 30 photographers, including Sophie Ristelhueber, Gabriele Basilico, Pierre de Fenoyl and Christian Milovanoff, to document the French contemporary landscape and, more precisely, discredited urban zones and rural sites. Revealing his interest for the documentary form, Chevrier emphasized the fact that these images hinge on both producing an archive and developing personal creation. Associating informative and aesthetic qualities, these photographs disrupt the classical codes of photojournalism and propose hybrid formulae that occur 'between the fine arts and the media', to use a well-known expression by Chevrier (1989: 75).

This approach underlines the originality of his position in the context of the institutional recognition of photography by French art museums during the 1980s. Chevrier opposed so-called 'creative' photography, defended by the curator of the French National Library (Bibliothèque Nationale de France), Jean-Claude Lemagny, in his aim to present the medium as an autonomous art form by emphasizing such specificities as lighting and texture effects in Jean-Claude Bélégou's photographs, for example. Considering that this conception only leads to the development of a craft industry, and that photojournalism only produces information, Chevrier chooses to defend a third path and to present the medium as an artistic tool, nourished by interactions between the different arts. He thus distances himself from an approach built on the model of modernist medium-specificity, without necessarily subscribing to postmodernist theories that deconstruct the notion of an 'original'. He refuses to come out in favour of either the 'Neo-Pictorialism' that appears at the end of the 1960s with Duane Michals and Leslie Krims, or the 'Neo-Conceptualism' of such artists as Cindy Sherman or Richard Prince that would reduce the image to verbal analysis, playing on 'bricolage' and critical efficiency.

In the 1989 exhibitions *Another Objectivity* at the Centre National des Arts Plastiques in Paris and *Photo-Kunst: Du XXe au XIXe siècle, aller et retour* at the Staatsgalerie in Stuttgart, Chevrier takes a new step and conceptualizes the ennoblement of photography with the notion of the 'Forme tableau'/'Picture Form'. This corresponds to the model of painting as an autonomous form, on which the fine arts' hierarchy and the modernist projects since the middle of the nineteenth century have been edified. If conceptual art had detached photography from this pictorial model at the end of the 1960s, Chevrier shows how the pictorial experienced a revival during the 1980s in the works of John Coplans, Bill Henson, Craigie Horsfield, Suzanne Lafont, Jeff Wall and

Thomas Struth. Having assimilated body and space issues specific to the context of minimal art, conceptual art and land art at the end of the 1960s, these artists appear to have transformed and rejuvenated the nineteenth-century 'Picture Form' by producing object-images and working on the space of perception. These images, created to be hung on the wall, set up an experience of confrontation with the spectator that differs from the common apprehension of photography in the book or as small prints. Chevrier thus extols the use of a large scale, the value of depiction, the planarity and frontality of images, as well as the principle of the single photograph.

Chevrier's term has become all the more famous since Michael Fried redeployed it in *Why Photography Matters as Art as Never Before* (2008). Although it was initially conceived by Chevrier to distance himself from the American division between modernism and post-modernism, Fried reintroduces it in a modernist reading of photography. Indeed, Fried presents Jeff Wall's work that exemplifies the 'Picture Form' as the heir to the critical relation between the artwork and the spectator that was previously at stake in modernist painting and which contributed to the assertion of the artwork's autonomy. Unlike Fried, who presents the 'Picture Form' as a new milestone in an art history that would linearly develop, Chevrier uses it as a figure to reread the history of modern art in its entirety by restoring photography to its crucial role. In *Entre les beaux-arts et les médias: Photographie et art moderne* (Chevrier 2010b), different collected texts deal with painters who worked from photography, such as Henri Matisse or Gerhard Richter.

Far from organizing his argument around a major concept, Chevrier's approach to art criticism and theory is characterized by fragmentation. In *Walker Evans dans le temps et dans l'histoire* (Chevrier 2010c), he refuses to reduce Evans's images to the documentary form and to develop a linear narrative. He presents a series of articles that fragment the general argument into several pieces, and jumps from one subject to the next, without masking ruptures, reconsiderations and deadlocks. He creates unexpected bridges between periods, disciplines, concepts and methods. For example, he discusses the photographic face in a comparison between Evans and Andy Warhol and then comes back several times to the same images and analyses them from different points of view. By so doing he makes the reader aware of the images' substance in time and history. Chevrier has helped to get Evans's works widely acknowledged and connected his work with a history differing from the modernist story shaped by John Szarkowski: for instance, Chevrier institutionalized the dialogue between Evans's

and Dan Graham's photography in an exhibition in 1992. He has also made Evans appear as a tutelary figure for artists who work with a 'documentary style', especially Bernd and Hilla Becher and their Düsseldorf School of Photography, work that he also helped introduce to France.

Chevrier's references are different from the one evoked by Fried in his modernist narrative. While the latter reads pictures in the light of Old Masters' painting and Wittgenstein and Heidegger's philosophy, the former is interested in social and political implications that were already at stake in his interest for the DATAR mission. During the 1990s and 2000s, he developed a reflection on the notion of territory within the framework of the 'Des Territoires' seminar created in 1994 at the *École nationale supérieure des beaux-arts* (ENSBA) in Paris that helped to nourish his work as adviser for *Documenta X* (1997). He explains:

> The word territory is insistent, omnipresent in the language of contemporary art: it designates an individual and social dimension (collective or communitarian) of the living, geographical and ethological space.
>
> (Chevrier 2011: 181)

Through his reflection on the notion of territory, Chevrier takes a stand and positions artists such as Wall or Patrick Faigenbaum with regards to topics that had overrun the art world since the 1990s as the identity-based debates, the resurgence of nationalism and globalization. Keeping his distance from any totalizing theoretical system, Chevrier is essentially an essay writer on photography. Through his personal trajectory, he has succeeded in showing that photography is fully anchored within key issues about the production of contemporary art.

Biography

Born in 1954 in Lyon, France, Chevrier studied literature at the École normale supérieure in Paris. He holds an *Agrégation* in literature (competitive national exam for France's top teachers). He subsequently founded and edited the journal *Photographies* (1982–1985). He has been a general consultant for the *Documenta X* (1997), and curator of many international exhibitions. He lives and works in Paris, where he has been a Professor of History of Contemporary Art at the École nationale supérieure des Beaux-Arts since 1988. His key writings are gathered in the seven books published by L'Arachnéen.

Primary texts

Chevrier, J.-F. (1989) *Photo-Kunst: Arbeiten aus 150 Jahren. Du XXe siècle au XIXe siècle, aller et retour*, Stuttgart: Cantz/Staatsgalerie.

——(1992) *Walker Evans & Dan Graham*, Rotterdam, Marseille, New York: Witte de With, Musée Cantini, Whitney Museum of American Art.

——(1999–2001) *Des territoires en revue* (dir.), no 1–5, Paris: Ensba.

——(2001) *Le Parti pris du document: littérature, photographie, cinéma et architecture au XXe siècle*, Paris: Seuil/EHESS, Communications, no 71.

——(2003–2004) 'The Adventures of the Picture Form in the History of Photography', in D. Fogle (ed) *The Last Picture Show: Artists Using Photography 1960–1982*, Minneapolis, MN: Walker Art Center.

——(2006) *Jeff Wall*, Paris: Hazan.

——(2009 [1982]) *Proust et la photographie. La resurrection de Venise*, Paris: L'Arachnéen.

——(2010a) *La trame et le hasard*, Paris: L'arachnéen.

——(2010b) *Entre les beaux-arts et les médias: Photographie et art moderne*, Paris: L'Arachnéen.

——(2010c) *Walker Evans dans le temps et dans l'histoire*, Paris: L'Arachnéen.

——(2011) *Des territoires*, Paris: L'Arachnéen.

Chevrier, J.-F. and Lingwood, J. (1989) *Une autre objectivité/ Another Objectivity*, Milano: Idea Books.

Katia Schneller

JACQUES DERRIDA (1930–2004)

Jacques Derrida was a French post-structuralist philosopher who was interested in the ways in which what we think of as fixed and self-evident truths and meanings are actually radically unstable and precarious constructions. He is probably most famous for the idea of 'deconstruction', which is commonly understood as showing how what was thought of as ideal and primary is actually secondary and real. For example, in his early major work *Of Grammatology* (1976), he argued that speech, which is usually thought of as being an immediate and self-present form of communication, is a form of writing, which is usually thought of as an indirect and secondary form of communication.

It would be fair to say that Derrida's relation to photography is complex. He freely admits that only words interest him and that his investment in and enjoyment of language is stronger and provides more enjoyment than the visual arts (Brunette and Wills 1994: 19–20). He has also written at least five books that are concerned with the visual arts and argues that a certain conception of the photograph 'photographs every conceptual opposition' and 'captures a relationship

76

of haunting that is perhaps constitutive of every "logic'" (Derrida 2007: 272). The logic of photography, once we understand it, describes all logic, all human thought. Derrida may be found on YouTube (http://www.youtube.com/watch?v=4RjLOxrloJ0) saying that, although he has nothing against photography, he 'forbade' the publication of all photographs of himself until 1979. He says that the theoretical and political reasoning behind this was complex but that the de-fetishization of the author, the fact the images were not in his control and that he was not happy with his own physical appearance were all involved.

Derrida would also have been decidedly less than comfortable with the idea that he was or could have been a 'key' writer on photography. This is most emphatically not to say that what Derrida wrote about photography is not or will not prove to be hugely influential on future accounts of both the practice and the theory of photography: at the time of writing, Derrida's posthumous texts are appearing almost monthly and it is difficult to keep up, let alone maintain perspective. It is to say that the idea that someone might be or that they might possess the instrument which could unlock in a single gesture the nature, functions and effects of photography, or that a simple device could open and bring light into the darkened room of photography would surely have provoked the flurry of delaying, distancing and differentiating strategies with which we are all familiar. Indeed, one of the main arguments in his (1998) 'polylogue', *Right of Inspection*, concerns the impossibility of one point of view, one reading, providing the key, or meaning, to a series of photographs taken by Marie-Françoise Plissart. If this were not bad enough, the metaphor and its effects repeat themselves, here in this chapter, in which I have been invited, as a sort of minor key, to introduce or unlock Derrida's writing on photography. The likelihood of my opening up Derrida's thinking as he, in turn, provides the key to photography is, therefore, doubly if not infinitely doubtful.

However, there is one idea that may fairly be described as key or central to Derrida's thinking. This idea is time: if there is a point from which Derrida may be said to start then the idea of time is it. It is central to Derrida's philosophy and it is the beginning of his account of photography. An informal colloquial French word for 'photo' or 'snapshot' is '*instantané*', which translates as 'instantaneous' (Derrida 2010b: 10). It is this notion of the temporal instant that is central to a certain conception of photography and to Derrida's critique of that conception (Derrida 2010b: 2–3; 2007: 292). Derrida's account of photography may also be read as beginning from the work of Roland Barthes. In the essay 'The Deaths of Roland Barthes', written shortly

after his friend's death, he concentrates on Barthes's notions of '*l'avoir été là*', the 'having been there' (Barthes 1977: 45), and the '*punctum*' (Barthes 1984: 26–27). According to Barthes, the 'having been there' is the sense that the photograph offers irrefutable evidence of how things were because of the way in which cameras work with light, lenses and film/image sensor. The situation must have been as it is shown in the photograph because the camera must have been there for the image to have been captured. The word *punctum* is Latin for 'point' and it is Barthes's term for whatever in the photograph stings or pricks him; whatever is 'poignant' to him, as he says. It is the detail that rises out of the photograph like an arrow to wound or pierce him (Barthes 1984: 26). Derrida makes two moves here: he links these ideas together and then he profoundly complicates the relation between them.

First, Derrida argues that the *punctum* is not a point or an instant, but a duration. This characteristic move stems from the phenomenological background he shares with Barthes. Barthes follows the French phenomenologist Jean-Paul Sartre in his interest in how photographs are experienced and in how they appear to us (as he says on the dedication page, *Camera Lucida* is an homage to Sartre's *L'Imaginaire*). Derrida follows the German phenomenologist Edmund Husserl who is also concerned with how we experience the world but who thinks that time plays a central and constitutive role in that experience. Husserl's account of time (e.g. Husserl 1975: 197–198) entailed a radical complication of time: his account of the present 'instant' involved a reference to protention (imagining the future) and retention (remembering the past) as well as the present. Derrida also argues that the present 'instant' contains a relation to the past and the future. Consequently, he says that Barthes's *punctum* cannot be a point in time; the *punctum* must be a duration or a period of time.

Second, if the *punctum* is actually a duration, then time is now 'heterogenous' and there is time (room) for difference and differentiation (Derrida 2010b: 8); there is, therefore, a time and a place for culture. This is Derrida's critique of Barthes's notion of the *punctum*, which, as an uncoded instant, excluded culture and is 'opposed' to the coded *studium*, which is where culture is to be found (Barthes 1984: 51). The *studium* is Barthes's term for the vague, generalized and 'unconcerned' interest that is the product of one's cultural background and which generates the sort of interest that one almost can't help having (Barthes 1984: 27–28). Derrida wants to argue that the *punctum* and the *studium* are not opposed in the way that they sometimes appear and have been presented by Barthes. He says that Barthes

acknowledges as much when he describes the *punctum* as an 'addition', or 'supplement', to the photograph: 'It is what I add to the photograph and what is nonetheless already there' (Barthes 1984: 55). What Derrida calls the 'ghostly power' of this supplementary relation enables them to compose together in photography (Derrida 2007: 271). Moreover, the relation between them describes every conceptual opposition and represents the conditions for the possibility of all thought and logic. This is the sense, noted above, in which this conception of photography describes how all conceptual oppositions work. As Derrida says:

> Ghosts: the concept of the other in the same, the *punctum* in the *studium*, the completely other, dead, living in me. This concept of the photograph *photographs* every conceptual opposition; it captures a relationship of haunting that is perhaps constitutive of every 'logic'.
>
> (Derrida 2007: 272)

If it is the case that the *punctum* is a duration and that, as a result, the cultural is always already in relation to the natural', then the referential and documentary aspects of photography, which have been theorized as passive processes, are not the whole story. If the *punctum* is actually a duration and makes time/room for difference, then artifice and *techne* are now part of photography. Artifice and *techne* are how difference gets into photography and, as a consequence, there is now as much active creation and 'art' as there is passive documentary in photography. As Derrida says, this insight, although clearer when thinking about digital photography, can also 'teach us about what the structure of the old technology *already was*' (Derrida 2010b: 6). Analogue photography was already as much a productive and performative event as it was passive archivization and recording (Derrida 2010b).

It is at this point that all the other apparent oppositions with which we have hitherto tried to account for photography also start to break down. If there is no simple *punctum*, no instant without duration, then there is no natural 'perception' and no passive recording or documenting of events or people without the active input of culture and *techne*. The active/passive dichotomy begins to break down and Derrida starts casting around for more appropriate terms. He tries 'acti/passivity' (2010b: 12) and he tries 'passactivity' (2010a: 67) to describe another structure or temporality in which passivity is not simply opposed to activity or in which activity is itself a form of passivity (2010b: 14).

And, third, he critiques, or sharpens up, Barthes's account of '*l'avoir été là*' and argues that the experience of the 'having been there' is a function or product of reference but not of the referent. This is to argue that the referent (which we take to be the present or the real in photography) is necessarily absent. The referent does not, therefore, relate to a present or a real, but reference itself persists and cannot be denied. Reference persists or adheres in the 'having been there' that the photographic apparatus uniquely generates (Derrida 2007: 284–285). Derrida is not interested in some naïve or 'realist' referentialism, but the *punctum* is useful in that it enables us to think the relation to what was once, undeniably, present for an instant, even as that referent disappears and the instant instantly divides itself (Derrida 2007: 292). This necessary absence of the referent can take various forms and Derrida follows the hints in Barthes's work to explain that they are forms of death. The referent may be actually, potentially or metaphorically dead, for example, and in *Athens, Still Remains*, Derrida sketches what he calls three temporalities of death and mourning. The first mourns an Athens that is already gone, and which shows spectators what is left of itself in its ruins; the second mourns an Athens that the photographer knows will be gone, even as he records it; and the third anticipates what is present today but which must be absent soon, tomorrow, perhaps (Derrida 2010a: 27).

Athens, Still Remains is as much about the conditions for the possibility of photography as it is about the place of death, mourning and the ruin in photography and in Jean-François Bonhomme's photographs of Athens. Derrida's account begins to mirror that of Foucault (1970) in 'Las Meninas', as he analyses the conditions for the possibility of representation. Foucault describes how all the elements necessary for representation (light, gazes, models, an artist, canvas, paints and so on) are present in Velazquez's painting except one: the 'sovereign subject'. This latter is dimly glimpsed in a mirror that nobody is looking at: the perfect metaphor of the transition into the age of representation. In the central, or key, photograph of the sleeping/dead photographer and the corresponding 'Still XII' of his book, Derrida also enumerates the paraphernalia of photographic representation: the photographer, the light, the cameras, the photographs, the reflector and the model (Derrida 2010a: 13, 21–25). In Derrida's account, it is the delay mechanism (which the photographer must have used) that turns the instant, the 'taking' of the photograph, into a duration, along with the notion of the incalculable or un-decidable that provides the possibility of photography. As Derrida says, the delay mechanism, which is a version of the differing and deferring that he has found in the *punctum*,

allows the photographer to return to his seat, feign sleep/death and have the camera 'take' the photograph. Where the photograph 'photographs every conceptual opposition ... every logic', that logic, which is the logic of the delay in the instant, and of difference and art in the *punctum*, is also the condition for the possibility of photography. This haunting/mourning of one thing in and by another is also the condition and the effect of both photography and thought and as such is to be found 'everywhere' (Derrida 2007: 279).

Biography

Jacques Derrida was born in 1930 in French Algeria to Jewish parents. He was educated at the École Normale Supérieure in Paris and completed his *Agrégation* on Husserl in 1955. In the early 1960s Derrida taught philosophy at the Sorbonne and from 1964 to 1984 at the École Normale Supérieure. The year 1967 saw the publication of the three books that would establish his place in Western philosophy: *Of Grammatology*, *Writing and Difference* and *Speech and Phenomena*. During the 1980s and 1990s, he held various visiting and permanent professorships at many European and American universities, including Johns Hopkins, Yale, Cambridge, Leuven and New York. In 2003 Derrida was diagnosed with pancreatic cancer and he died in Paris on 8 October 2004.

Primary texts

Derrida, J. (1973) *Speech and Phenomena*, Evanston: Northwestern University Press.
——(1976) *Of Grammatology*, Baltimore, MD: Johns Hopkins University Press.
——(1978) *Writing and Difference*, Chicago, IL: University of Chicago Press.
——(1987) *The Truth in Painting*, Chicago, IL: University of Chicago Press.
——(1993) *Memoirs of the Blind*, Chicago, IL: University of Chicago Press.
——(1998) *Right of Inspection*, New York, NY: Monacelli Press.
——(2007) 'The Deaths of Roland Barthes', in *Psyche: Inventions of the Other Volume 1*, Stanford, CA: Stanford University Press.
——(2010a) *Athens, Still Remains*, New York, NY: Fordham University Press.
——(2010b) *Copy, Archive, Signature: A Conversation on Photography*, edited and introduced by G. Richter, Stanford, CA: Stanford University Press.
——(2010c) 'Aletheia', *Oxford Literary Review*, vol 32, no 2, pp169–188.
Derrida, J. and Malabou, C. (2004) 'Athens and Photography: A Mourned-for Survival', in *Counterpath: Travelling with Jacques Derrida*, Stanford, CA: Stanford University Press.

Secondary texts

Barthes, R. (1977) *Image-Music-Text*, Glasgow: Fontana/Collins.

——(1984) *Camera Lucida*, London: Fontana.

Brenner, F. (2003) *Diasporas: Homelands in Exile, Vol 2 Voices*, New York, NY: HarperCollins.

Brunette, P. and Wills, D. (1994) *Deconstruction and The Visual Arts: Art Media, Architecture*, Cambridge: Cambridge University Press.

Foucault, M. (1970) 'Las Meninas', in *The Order of Things*, London: Tavistock.

Husserl, E. (1975) *Ideas: General Introduction to Pure Phenomenology*, London: Collier Macmillan.

Krell, D. F. (2004) 'Shudder Speed: The Photograph as Ecstasy and Tragedy', *Mosaic: A Journal for the Interdisciplinary Study of Literature*, vol 37, no 4, pp21–38.

Richter, G. (2007) 'Unsettling Photography Kafka, Derrida, Moses', *CR: The New Centennial Review*, vol 7, no 2, pp155–173.

——(2010) 'Between Translation and Invention: The Photograph in Deconstruction', in J. Derrida, *Copy, Archive, Signature: A Conversation on Photography*, Stanford, CA: Stanford University Press.

Sartre, J.-P. (2004) *The Imaginary: A Phenomenological Psychology of the Imagination*, translated by J. Webber, London: Routledge.

Websites

http://www.youtube.com/watch?v=4RjLOxrloJ0 (accessed December 2010).

Malcolm Barnard

LADY EASTLAKE (1809–1893)

Published anonymously in 1857 in the *Quarterly Review*, Elizabeth Eastlake's article 'Photography' has been much anthologized. Its awareness of aesthetic and technical debates on art and photography made it an authoritative assessment of the cultural impact of a medium that only recently had become 'a household word and household want' (Eastlake 1980: 81). Eastlake had been exposed to 'the glamour of photography' (Eastlake 1980: 91) during the early 1840s through David Hill's and Robert Adamson's 'small, broadly-treated, Rembrandt-like studies' portraying ministers of the Scottish Free Church (Eastlake 1980: 91). Further involvement came when her husband became the first chairman of the Photographic Society of London during 1853 to 1855.

Ostensibly a review of six publications on photography during 1839 to 1857, ranging from *History and Practice of Photogenic Drawing,*

or the true principles of the Daguerreotype, by the Inventor, L.J.M. Daguerre (1839) to Joseph Ellis's lecture *Progress of Photography – Collodion – the Stereoscope* (1855), Eastlake's article established some of the recurring themes in subsequent writings on the medium: the superiority of early portraiture, before Collodion in the 1850s made photographs more commercially viable; the importance of amateurs and the value of photographs in the creation of memories, sparked by inconspicuous details; and the power of photography as a new form of communication, freeing painting from representational tasks. It includes a history of photography notable for its insistence on the pan-European provenance of the medium, as France, England and Germany had all contributed to its development.

Before tackling the central issue of 'the connection of photography with art' (Eastlake 1980: 84), Eastlake comments on the diffusion of photographic culture in a wide variety of contexts. She sees photography as a levelling force, connecting people of different class, gender and culture through a shared experience, whether as photographers or as consumers of photographs. Keen amateur photographers (Green-Lewis 1996: 43–49), the Eastlakes might have been the 'sanguine little couple' described in the article struggling with the vagaries of photographic chemistry, in the hope of summoning pictures from the 'silence and darkness' of the darkroom (Eastlake 1980: 89). Collodion plates needed to be prepared immediately before exposure and developed right after. Photographers had to be accomplished in every stage of the process, and it was impossible to test and standardize emulsions for exposure or developing times. Photography, she despaired, 'will serve you bravely' but 'will never be taught to implicitly obey' (Eastlake 1980: 89).

In Eastlake's account, this 'Ariel-like' (Eastlake 1980: 89) quality is not just a technical hitch that might be overcome through improvements, but a condition of photography. Artists working with their hands were able to exercise aesthetic judgement by selecting the elements to include in a composition, and to signify their importance by degrees of detailed rendition. This control was crucial to convey the artist's unique understanding of the subject before him. Photography's lack of such control over details had been emphasized by Collodion plates, as unlike the earlier Calotypes, they made visible 'Every button' and layer of 'stratified flounces', so that, in portraits, the face, which as 'the most important part of a picture should be best done' in greater detail, seemed 'unfinished in relation to the rest' (Eastlake 1980: 92). This is why 'correctness of drawing, truth of detail, and absence of conventions', for Eastlake the 'best artistic characteristics of photography', were not sufficient to take it into the realm of 'that mystery called Art' (Eastlake 1980: 94).

Eastlake preferred the portraits by Hill and Adamson, or the soft-focus photography advocated by the painter William Newton (Eastlake 1980: 91), where the overall lack of detail sidestepped the issue:

> Mere broad light and shade, with the correctness of general forms […] will, when nothing further is attempted, give artistic pleasure of a very high kind; it is only when greater precision and detail are superadded that the eye misses the further truths which should accompany the further finish.
>
> (Eastlake 1980: 91)

The article discusses at length the tension between technical and artistic control over the image. More of the former might be desirable, but would not result in the latter. Photography, instead, is 'the perfect medium' to fulfil the modern need to communicate 'cheap, prompt and correct facts' (Eastlake 1980: 93) to a large public. Photography's 'success and failure' should be evaluated not in relation to its 'artistic feeling', but for 'the capabilities of the machine' (Eastlake 1980: 93) to convey visual knowledge in the form of 'unerring records […] which are neither the province of art nor of description' but a 'new form of communication':

> What indeed are […] those facial maps called photographic portraits, but accurate landmarks and measurements for loving eyes and memories to deck with beauty and animate with expression, in perfect certainty, that the ground-plan is founded upon fact? […] Though the faces of our children may not be modelled and rounded with that truth and beauty which art attains, yet *minor* things – the very shoes of the one, the inseparable toy of the other – are given with a strength of identity which art does not even seek.
>
> (Eastlake 1980: 94)

A painted portrait would be endowed with truth and beauty by the skill of the artist, while a photographic portrait has to be animated by the imagination of the viewer, retracing the experience of the beloved through the landscape of memory.

As William Henry Fox Talbot (1844: text with plate XIII) and David Brewster (1843) before her, Eastlake notes photographs' privileged relationship to time and history. As 'unerring record' of a moment in time, every photograph is potentially of 'historic interest':

Though the view of a city be deficient in those niceties of reflected light and harmonious gradation which belong to the facts of which Art takes account, yet the facts of the age and of the hour are there, for we count the lines [...] of telegraphic wire, and read the characters on the playbill or manifesto, destined to be torn down tomorrow.

(Eastlake 1980: 94)

The photograph will not convey the artist's privileged vision of city life, but is a document, 'evidence of facts' (Eastlake 1980: 94) open to the different readings and interests of its viewers.

Unlike Charles Baudelaire, Eastlake thinks that photography is beneficial to art because it can take over the practical mimetic tasks for which art had been employed as a means to an end. As she concludes, if anything can bring about the desirable climax of art being sought 'as it ought to be, mainly for its own sake', it will be because of 'the introduction of Photography'. In 1857, photography could not fit comfortably into definitions of 'Art', not without forced strategies such as soft focus when sharpness was available. Eastlake sympathizes with Newton's argument that photography would be 'more artistically beautiful' (Newton quoted in Eastlake 1980: 91) when 'taken slightly out of focus', a view later shared by Julia Margaret Cameron and by the Pictorialists. Yet, she also seems reluctant to give up photography's strength as an image which 'is the impress of one moment, or one hour, or one age in the great passage of time' (Eastlake 1980: 94); and her 'delight' in 'records of simple truth and precision' (Eastlake 1980: 93) rich in humble details that would be impossible to reproduce by hand: the 'texture of stone', of 'a face of rugged rock', 'of the sea-worn shell, of the rusted armour, and the fustian jacket' (Eastlake 1980: 93). Eastlake's is thus one of the first formulations of the aesthetic 'schism' between 'detail and mass' later theorized by Newhall as a characteristic of photography (Newhall 1937, quoted in Nickel 2001: 551), and is perhaps an unresolved attempt to reconcile the two.

If she was right in prophesizing that photography would allow painting to abandon realism to focus on form, it could also be argued that the success of the idea of art for art's sake, stripping art of its mimetic, narrative and, eventually, expressive functions, precipitated the aesthetic changes that made it possible for art to embrace photography.

Biography

Elizabeth, Lady Eastlake (1809–1893), née Rigby, was born in Norwich in a liberal family. Fluent in French, Italian and German, her writing

career took off when she published an account of her travels through Russia, *A Residence on the Shores of the Baltic* (1841), and became the first woman to write regularly for the prestigious *Quarterly Review*, contributing articles on a variety of artistic, literary and social topics (Sherman and Holcombe 1981: 24). In Edinburgh during the 1840s she met and was photographed by Hill and Adamson, and in 1849 she married Charles Eastlake (1793–1865), royal academician and later director of the National Gallery in London. The couple took up photography during the 1850s, and her husband became the first chairman of the (later Royal) Photographic Society of London. She contributed to the revival of interest in early Italian painting, and was instrumental in popularizing German art-historical research among British readers by translating Johann Passavant's *Tour of a German Artist in England* (1836), Franz Kugler's *Handbook of the History of Painting* (1851), one of the first surveys of art history, which she re-edited and updated in 1870, and Gustav Waagen's *Treasures of Art in Britain* (1854). She was an early supporter of the idea of art for art's sake, insisting on its autonomy from story-telling or moral messages. In 1863 she finished the *History of Our Lord*, an iconographic study of Christ began by art historian Anna Jameson, who had died in 1860, honouring her feminist approach.

Primary texts

Eastlake, E. (1857) 'Photography', *Quarterly Review*, vol 101, no 202, pp442–468.

——(1980) 'Photography', in B. Newhall (ed) *Photography: Essays and Images*, New York, NY: Museum of Modern Art, and London: Secker & Warburg, pp81–95.

——(1998) 'Photography', in C. Harrison, P. Wood and J. Geiger (eds) *Art in Theory 1815–1900*, Oxford, UK: Blackwell, pp655–666.

Secondary texts

Brewster, D. (1843) 'Photogenic Drawing, or Drawing by the Agency of Light', *Edinburgh Review*, vol 76, no 154, pp309–344.

Green-Lewis, J. (1996) *Framing the Victorian: Photography and the Culture of Realism*, Ithaca, NY, and London: Cornell University Press.

Mitchell, R. (2008) 'Eastlake, Elizabeth, Lady Eastlake', *Oxford Dictionary of National Biography*, Oxford, UK: Oxford University Press, oxforddnb. com/view/article/8415 (accessed March 2011).

Nickel, D. R. (2001) 'History of Photography; the State of Research', *Art Bulletin*, vol 83, no 3, pp548–558.

Sherman, C. R. and Holcombe, A. (1981) *Women as Interpreters of the Visual Arts 1820–1979*, Westport and London: Greenwood Press.
Talbot, W. H. F. (1844) *The Pencil of Nature*, London: Longman, Brown, Green, & Longmans.

Websites

Dictionary of Art Historians, edited by L. Sorensen, Durham, NC: Duke University, http://www.dictionaryofarthistorians.org/ (accessed March 2010).

Patrizia Di Bello

ELIZABETH EDWARDS (1952–)

During recent years there have been important contributions to a broadening understanding of what alternative histories of photography might be. Much of this has been in response to forms of post-modernism that came to prominence during the 1980s – embodied in writings by John Tagg, Allan Sekula, Victor Burgin and Abigail Solomon-Godeau. Elizabeth Edwards's writing has been at the fore-front of this shift towards a different mapping of the social, historical and political body of photography, primarily in and through the field of anthropology. Questions concerning how historical consciousness is made through the photograph as both image and object have been at the centre of her work within photographic archives and collections.

Historiography, materiality and identity politics, as sites of cross-cultural encounters, have been recurring elements in Edwards's writing. Unpicking the threads of these often-entangled histories begins from the starting point that photographs, the moments of their taking and circulation, constitute a complex matrix of power, authority, agency and desire. In *Raw Histories* she writes 'the intention here is not to produce a grand theory of photography, ethnography and history as abstract practices, but to look at specific photographs and specific acts of photographic involvement, collecting, displaying and intervening' (Edwards 2001: 3–4).

Trained as an historian at the universities of Reading and later Leicester, where she was sensitized to debates associated with Raphael Samuel and Ruskin College's *History Workshop*, Edwards became increasingly fascinated in the photograph as an historical object and as a way of 'seeing' history following her appointment to the Pitt Rivers Museum, at the University of Oxford. Writing about photography then became something born out of a practice of administering and

working with archives. This galvanized her interest in the materiality of photography as one type of historical encounter, a fascinating connection between the print's tactile and sensory power with the rituals of taking, display and collection. This constituted a shift towards a phenomenology of photography that unpicked the complexities of an experiential relationship to photographs that was not addressed by semiology. Such an approach is explored in her edited anthology with Janice Hart *Photographs Objects Histories: On the Materiality of Images* (2004).

Edwards's writings revolve around the need to understand how photographs are constructed and reconstructed as they move through a range of spaces and interpretative scenarios. She attaches importance to thinking through pictures and reading them both against the grain as well as with it. Her essay 'Tracing Photography' (Edwards 2011) discusses how 'photography might be positioned, not only in visual anthropology but in the discipline more broadly and shift[s] disciplinary expectations of what photographs can offer' (Edwards 2011: 161). Such an approach has enabled her to consider photographs and how they perform at different points in their 'lives', as images and objects whose meanings are never complete but contingent and mutable.

A recurring emphasis in her work has been the need to expand the terms of reference for analysing what photographs do and what is done to them. An early essay entitled 'Photographic "types": The Pursuit of Method' (Edwards 1990) underscores what has been an evolving part of her written work – that is, the need to build a critical toolbox to deal with the indeterminacy of photographs, to reveal elements that shape the photographic act, to uncover the historical conditions of visualization from below. *Raw Histories* offers such an exercise and in doing so highlights the limitations, gaps and inconsistencies in the linear narrative or cultural politics that have tended to dominate discussions of anthropological photographs. It is an important book because it complicates ideas of the colonial gaze. The chapter on T. H. Huxley takes the most extreme forms of dehumanizing and objectifying photography in the shape of the anthropometric grid. In an unflinching analysis, Edwards looks for cultural points of fracture, spaces where one can restore the voice and humanity to the subject of the representation and finds it where the 'dehumanising nature of the photographs is accentuated through the intrusion of humanising, cultural detail and the subjectivities of the photographic act itself – elements of subjectivity that the project was attempting to remove. They provide a productive dissonance that interferes with the communication of the truth value of science' (Edwards 2001: 144).

The exploration of the taxonomy of collections and archives reveals some of the historical impulses behind categorization and narrative sequencing that Edwards finds so vital to expanding ideas of history. Locating Edwards within a 'school' of writing that is linked with photographic history and theory is not straightforward: the substance and resonances of her texts gather from diverse reference points. Her work comes from a wide set of interests driven by the curatorial, museological and historiographical, as well as the written, as a necessary mix in order to render the slippery and historically awkward medium of photography more intelligible. Here the writings of, for instance, Tim Ingold, Alfred Gell, Daniel Miller, Ann Laura Stoler and Greg Dening, and their concepts of agency, performance, materiality or archive, have been more active ingredients in Edwards's expanding analysis of the photographic image both within anthropology and beyond.

Edwards has looked to restore voice or, as she would prefer to call it, 'social being' to both the photograph and to those it seeks to represent, to offer alternatives to simple power relations, to empower not silence the subjects of anthropology. The first extensive exploration of this came with the edited book of essays entitled *Photography and Anthropology 1860–1920* (Edwards 1992). This book examined how photography provides evidence of the past and how this evidence is used in conjunction with more traditional forms of information to consider the reflexive and critical nature of photographic vision within anthropology. The book provides a rich, discursive encounter with photographs drawn extensively from the archives of the Royal Anthropological Institute. Anthropology here is not discredited as an ideologically flawed enterprise through which photography simply further consolidates a biased power relationship, but is seen as a more sensitive handling of both the scientific and visual principles used to explain human difference. In many ways it can be perceived as a response to readings of anthropological photography that grounded their analysis of archives in too deterministic and reductive views that saw them only as expressions of colonial power and sites of subjugation. Rather, they become sites through which troubled colonial relations were performed.

The influence of a certain vein of photographic theory and writing indebted to the work of French philosopher Michel Foucault (Green 1984; Tagg 1988; Sekula 1989) did sharpen the critique of colonial images and related nineteenth-century practices; but it also gave the impetus to rethink anthropology and colonial relations. As did the 'New Museology' that emerged during the late 1980s (Vergo 1989),

where institutions became subject to critique and led to anthropology museums needing to respond to a crisis of confidence in order to address the colonial basis of major UK collections. The rethinking of museums' collections and the post-colonial voice has parallels with Edwards's writing. It was in that growing space that she found room to build a different critique of photography's multiple roles in anthropology and, by extension, open up a new photographic history by treating anthropology not only as subject matter, but as a methodology through which to examine the complex practices of photography.

In pursuit of methods to unpack the archive and the photograph, Edwards became very interested in and attuned to the power of arts practice as an analytical as well as a heuristic tool. Here was a sympathetic approach to the kind of archaeology of historical photographs and its contexts that she was interested in. Artists and photographers such as Dave Lewis, Jorma Puranen, Mohini Chandra and Susan Meiselas all interrogated archival dynamics and history in ways beyond written accounts. Again, this wider attention to the visual and inclusion of contemporary arts' institutional, historical and disciplinary critique breathed life into a more expanded and discursive sense of photographic history. Here was a very different but apposite cross-cultural encounter that spoke directly to past social relations, particularly in the case of Edwards's writing on Puranen's *Imaginary Homecoming* (Edwards 2001), on Chandra (Edwards 2005) and on Meiselas's photography (Edwards 2008a).

More recently, Edwards has turned to exploring British photographic history through an ethnographic and anthropological method. Her work on the relationship between amateur photography and historical imagination used the photographic survey project beginning in the late nineteenth century as a prism through which to explore wider ideas of the cultural efficacy of photography. In her subsequent book *The Camera as Historian* (Edwards 2012), she challenges the reduction of the survey movement to simply a nostalgic bourgeois response to modernity, and attempts to understand it as a cultural moment defined through concepts of localism, networks of knowledge, sociability, public utility and the ever-present tensions between evidence and aesthetics. The threads of material practice of production and the archive, which have marked her work, are again worked out in this book that also connects theoretically with her essay 'Photography and the Material Performance of the Past' (Edwards 2009a) in which she argued that historical values that clustered around photography were material performed through the practices of making and of the archive. *The Camera as Historian* demonstrated the theoretical possibilities of an

anthropological method applied to photographic practice and to a close reading of archival dynamics.

Elizabeth Edwards has done much to show us the complexities of photographs as material and historical objects, and as the site of social relations. Her writing offers ways of thinking through photographs that shed light on their journeys, institutional currencies and the competing investments within them. As a result, through a consistent demonstration of anthropological method applied to photographic practices, Edwards has provided us with a more complicated but engaging relationship with photography and established a methodological framework from which new histories of photography may emerge.

Biography

Elizabeth Edwards, born in Cumbria in 1952, is an historian by training but has been fully absorbed by anthropology. She works on the relationship between photography, anthropology and history, especially in the Pacific, on cross-cultural visual histories, on photographs as material culture, and the history of collecting and institutional practices. Until 2005 she was curator of photographs at Pitt Rivers Museum and lecturer in visual anthropology at the University of Oxford, and then senior research fellow at the University of the Arts London (LCC) until 2011, when she was appointed research professor and director of the Photographic History Research Centre at De Montfort University, Leicester. She led a major European-funded project on the role of the photographic legacy of colonialism in a post-colonial and multi-cultural Europe (PhotoCLEC: http://photoclec.dmu.ac.uk). She is further developing her work on photography and historical imagination in late nineteenth- and early twentieth-century Europe, and on photography and colonial governance. She remains closely linked to anthropology and was vice-president of the Royal Anthropological Institute of Great Britain and Ireland from 2009 to 2012.

Primary texts

Edwards, E. (1990) 'Photographic "types": The pursuit of method', *Visual Anthropology (1545–5920)*, vol 3, no 2, pp235–258.
——(1992) *Photography and Anthropology 1860–1920*, New Haven and London: Yale University Press.
——(2001) *Raw Histories: Photographs, Anthropology and Museums*, Oxford, UK: Berg.
——(2005) 'Mohini Chandra: A Diasporic Practice', in A. Schneider and C. Wright (eds) *Border Crossings: Anthropology and Contemporary Art*, Oxford, UK: Berg.

——(2006) 'Photographs and the Sound of History', *Visual Anthropology Review*, vol 21, no 1, pp27–46.

——(2007) 'Samuel Butler's Photography: Observation and the Dynamic Past', in J. Paradis (ed) *Samuel Butler: Victorian Against the Grain*, Toronto: University of Toronto Press, pp251–286.

——(2008a) 'Entangled Documents: Visualised Histories', in K. Lubben (ed) *Susan Meiselas In History*, Gottingen and New York: Steidl/ICP, pp330–341.

——(2008b) 'Straightforward and Ordered: Amateur Photographic Surveys and Scientific Aspiration 1885–1914', *Photography and Culture*, vol 1, no 2, pp185–210.

——(2009a) 'Photography and the Material Performance of the Past', *History and Theory*, vol 48, no 4, pp130–150.

——(2009b) 'Evolving Images: Photography, Race and Popular Darwinism', in D. Donald and J. Munro (eds) *Endless Forms, Darwin, Natural Sciences and the Visual Arts*, New Haven/London: Yale University Press, pp166–193.

——(2009c) 'Thinking Photography beyond the Visual?', in J. Long, A. Noble and E. Welch (eds) *Photography: Theoretical Snapshots*. London: Routledge, 31–48.

——(2011) 'Tracing Photography', in M. Banks and J. Ruby (eds) *Made to be Seen: Perspectives on the History of Visual Anthropology*, Chicago, IL: University of Chicago Press.

——(2012) *The Camera as Historian: Amateur Photographer and Historical Imagination, 1885–1918*, Durham, NC: Duke University Press.

Edwards, E. and Bhaumik, K. (eds) (2008) *Visual Sense: The Cultural Reader*, Oxford, UK: Berg.

Edwards, E. and Hart, J. (eds) (2004) *Photographs Objects Histories: On the Materiality of Images*, London: Routledge.

Edwards, E. and Morton, C. (eds) (2009) *Photography, Anthropology and History* Aldershot, UK: Ashgate.

Edwards, E., Gosden, C. and Philips, R. (eds) (2006) *Sensible Objects: Colonialism, Material Culture and the Senses*, Oxford, UK: Berg.

Secondary texts

Banks, M. (2001) *Visual Methods in Social Research*, London: Sage.

Dening, G. (1996) *Performances*, Chicago, IL: University of Chicago Press.

Edwards. E. (1997) 'Ordering Others: Photography, Anthropologies and Taxonomies', in C. Illes and R. Roberts (eds) *In Visible Light*, Oxford, UK: MoMA.

Green, D. (1984) 'Veins of Resemblance: Photography and Eugenics', *Oxford Art Journal*, vol 7, no 2, pp3–16.

Ingold, T. (2007) *Lines: A Brief History*, London: Routledge.

Ingold, T. and Vergunst, J. L. (eds) (2008) *Ways of Walking: Ethnography and Practice on Foot*, Aldershot, UK: Ashgate.

Sekula, A. (1989) 'The Body and The Archive', in R. Bolton (ed) *The Contest of Meaning*, Cambridge, MA: MIT Press, pp342–389.

Stoler, A. L. (2009) *Along the Archival Grain: Epistemic Anxieties and Colonial Common Sense*, Princeton, NJ, and Oxford, UK: Princeton University Press.

Tagg, J. (1988) *The Burden of Representation*, London: Macmillan.
Vergo, P. (ed) (1989) *The New Musueology*, London: Reaktion.

Russell Roberts

PETER HENRY EMERSON (1856–1936)

During the late 1880s, Peter Henry Emerson was, by his own reckoning, an innovator in the practice and understanding of art photography. When he published his most thorough text on the subject, *Naturalistic Photography for Students of the Art*, in 1889, he was already known in British photography circles as a controversial figure, and the book was a polemic against an apparent consensus on photographic theory and aesthetics. Key texts remained those of mid-century, when William Lake Price (*A Manual of Photographic Manipulation*, 1858) and Henry Peach Robinson (*Pictorial Effect in Photography*, 1869) instructed aspiring photographers in the pictorial elements of academic painting. Emerson rejected this deference to past art, and in *Naturalistic Photography* his thorough, if high-speed, art history cut swathes through the great and the good, dismissing most for falsity to nature.

For Emerson, 'Nature' was the crux of art, thus identified in his first public lecture on photography (Emerson 1885a: 230). Emerson's next public foray aligned his ideas to a school of English painters – the 'rustic naturalist' contingent of the New English Art Club – as 'the only artists who go directly to Nature to paint, beginning and finishing with Nature, and painting Nature as she is' (Emerson 1885b: 462). These artists included George Clausen and Thomas Goodall, with whom Emerson was well acquainted.

From naturalism in art, Emerson aimed to develop an equivalent visual language in photography predicated on the physiology of human vision. He argued that whether painted or photographed, 'a picture should be a translation of a scene as seen by a normal human eye' (Emerson 1889: 97). His cited scientific sources included Hermann von Helmholtz, a German scientist whose most widely known lecture, 'The Recent Progress of the Theory of Vision' (1868), had been published in English in 1885. Helmholtz's theories of physiological optics were gaining attention for their pertinence to art, and discussion centred on three issues: focus with regard to field of view, focal acuity as related to depth of field, and tonal gamut.

From Helmholtz, Emerson identified limitations in the focal capabilities of the eye across the field of view. He accordingly proposed

that photographic focus should be limited to what is seen distinctly – the centre of the composition and middle plane of the scene. Although Helmholtz qualified his theory, noting that the scanning eye effectively gave greater focal breadth, Emerson's reading was selective; the photographer should 'focus for the principal object of the picture', leaving other areas diffused (Emerson 1889: 102). Using Helmholtz's investigations on optical defects such as refraction and astigmatism, Emerson went on to argue that even the central point of focus should be slightly softened to tally with those imperfections.

Helmholtz's research showed that pigment and paper had a lower 'gamut or tone' than ambient light, and Emerson recommended that photographic highlights be suppressed to maintain the correct 'ratios of luminous intensities' (Emerson 1887: 10), adding that atmosphere ('turbidity') naturally reduced the clarity of tone and colour (Emerson 1889: 111). To represent these characteristics in a photograph, Emerson recommended printing on platinum paper, whose subtle tonal range and low contrast gave the most accurate rendition of natural light. He flagged this choice as early as 1886 (Emerson 1886: 176), and platinotype plates illustrated his first portfolio, *Life and Landscape on the Norfolk Broads* (Emerson and Goodall 1887). In 1888, Emerson turned to photogravure as the photomechanical process most closely approximating the tonal range of platinum, while giving greater control over the hues and tones of the print. He hailed it 'the final end and method of expression in monochrome printing' (Emerson 1889: 207), and from 1888, photogravure plates illustrated all of Emerson's portfolios and most of his books.

Emerson's allegiance to naturalism was diametrically opposed to the synthetic idealist work of older photographers such as Henry Peach Robinson, who believed that nature should be disciplined through the selection and composition of elements – figures, foreground interest, peripheral framing and background closure – that would dignify a photograph as 'pictorial'. To this end, Robinson used a composite of multiple negatives to produce a single photographic picture. Emerson was particularly damning of such 'combination prints' as false to nature and to art, a 'patchwork' no better than children's games with scissors and paste (Emerson 1889: 199).

Emerson's perspectives were informed by his connections within the New English Art Club. Thomas Goodall was Emerson's collaborator on *Life and Landscape on the Norfolk Broads,* and Goodall's 1886 essay for that volume, 'Landscape', included relevant points on visual perception and artistic practice that subsequently appeared in Emerson's lectures and writings. Shared ideas and phrasing can also be traced in

'The Naturalistic School of Painting' (Bate 1886), a series of essays published by another member of the NEAC, Francis Bate.

It was Henry Peach Robinson who first considered Bate's ideas in a photographic context and he led critics of *Naturalistic Photography*. Emerson responded with vigour; he was famously combative, and their subsequent sallies enlivened the photographic press for years. Other reviewers were more respectful. The book was controversial more for its intemperate language than its theories, which usefully extended longstanding discussions on the moderation of sharpness and detail, restraint in tonal range, and management of compositional emphasis, couched in familiar terms of truthfulness to art, nature and human vision.

Naturalistic Photography did well; the first edition sold out within three months, and a second, 1890, edition was also published in the US, where it was widely reviewed. Emerson gained allies such as Alfred Stieglitz, with whom he became a life-long correspondent. Naturalism was relevant for American photographers; Emerson's distant cousin was Ralph Waldo Emerson, whose Transcendentalist philosophy espoused the human perception of all-encompassing Nature as the route to spiritual liberation.

British acolytes included photographer George Davison, who updated Emerson's alliance of art and science in a Royal Society of Arts lecture, 'Impressionism in Photography' (1890). Davison cited Bate's *Naturalistic School of Painting*, but did not credit Emerson, who promptly renounced the whole enterprise, attacking Davison and repudiating his own theories in 'The Death of Naturalistic Photography', a black-bordered tract published in late December 1890.

Emerson's renunciation was more than a fit of pique; he gave concrete reasons for jettisoning his doctrine of photography's legitimacy as an art form. James Whistler's collected writings had just been published as *The Gentle Art of Making Enemies* (1890), and Emerson explained his position thus: 'Art – as Whistler said – *is not* nature – is not necessarily the reproduction or translation of it – much … that is good art, some of the very best – is not nature at all, nor even based upon it' (Emerson 1890b: 62).

Emerson also cited research in psychology. He did not give specifics; but the influence of subjectivity on perception had been discussed at the Camera Club, where Emerson was a founding member. He may have concluded that such ideas undermined his argument that photography could truthfully represent both human perception and contingent nature.

Sensitometry was Emerson's final dose of damnation. In 1890, Ferdinand Hurter and Vero Charles Driffield calibrated the standardized

exposure and development of photographic materials, apparently obviating Emerson's belief in artistic control over photographic tonal range. In practical terms, Hurter and Driffield were not entirely correct, and Emerson's peers waded in to support his original thesis. But Emerson stuck to his renunciation, and in the 1899 edition of *Naturalistic Photography* he replaced the last chapter, 'Photography, a Pictorial Art', with 'Photography – Not Art'.

Emerson eventually relented and championed the 'limpid stream of pure photography' (Emerson 1900: 37) against the turn-of-the-century Pictorialists, anticipating the modernist rejection of Pictorialism as an impure use of the photographic medium. The idea of medium specificity would become a dominant twentieth-century perspective, and subsequent texts (Newhall 1975; Handy 1994) have situated Emerson among later 'straight' photographers, opposing the manipulated productions of Robinson and his antecedents.

Naturalistic Photography, its renunciation and subsequent revised editions stand as Emerson's key published works on photography. He also wrote numerous letters to photographic periodicals, and a series, 'Our English Letter', for the *American Amateur Photographer* from September 1889 to March 1890. But the majority of Emerson's prolific writings concerned other themes; he published adventure stories and detective novels, while natural history, ethnography and folklore characterize the texts of his photographically illustrated books, which are largely devoted to narratives of rural life, imparted with an exacting recreation of indigenous dialect and vocabulary. Yet, these books include beautifully expressed descriptions of nature that evoke the photographs. In *Wild Life on a Tidal Water*, Emerson explained that his writing was an artistic response to direct experience; 'all my descriptions are *written on the spot*, and with as much care and thought as a good landscape painter bestows on his work' (Emerson 1890a: ix). The prose and its ethos were appreciated; an *Amateur Photographer* review of *Wild Life* quoted Emerson's 'picture writing' at length (Review 1890: 417), including this passage:

> The tide was falling, and as the rain abated we could distinguish the sky, the deep water of the channel, and the shallow water on the partially-covered flats spangled with silvery drops of rain, which splashed into tiny fountains, falling like liquid silver into molten silver.
>
> (Emerson 1890a: 40)

During 1890 to 1891, many months on a sailing barge produced photographs for *On English Lagoons*, whose text of anecdotal set-pieces is

punctuated by mere vignettes of nature. Emerson did not explain the dichotomy between the down-to-earth texts and the lambent abstractions of the photographs, but he did suggest that nature is simply beyond representation (Durden 1994: 283, 284), describing its 'perfect beauty' as 'unpaintable' (Emerson 1893: 22).

Biography

Born Pedro Enrique on 13 May 1856 in La Palma, Cuba, Emerson was the son of an American plantation owner and an English mother. He lived in Cuba and Delaware until 1869, when his widowed mother took him home to England. From 1874 to 1885 he studied medicine and natural science at King's College, London, and Clare College, Cambridge, and practised medicine from 1883 until 1885. In 1881, he took up photography, joining the Photographic Society of Great Britain in 1883 and the Camera Club in 1885. Emerson made few photographs after 1891 and published little on photography after 1900. He died on 12 May 1936 in Falmouth, Cornwall.

Primary texts

Emerson, P. H. (1885a) 'The Ground Glass Picture', *Amateur Photographer*, vol 2, no 41, pp230–231.
——(1885b) 'An Ideal Photographic Exhibition', *Amateur Photographer*, vol 2, no 55, pp461–462.
——(1886) 'Photography' (lecture), *Amateur Photographer*, vol 3, no 78, pp163–164; vol 3, no 79, pp175–176.
——(1889) *Naturalistic Photography for Students of the Art*, London: Sampson Low, Marston, Searle and Rivington; first edition 1889; revised second edition 1890; revised and enlarged third edition, London: Dawbarn and Ward, 1899.
——(1890a) *Wild Life on a Tidal Water: The Adventures of a House-Boat and Her Crew*, London: Sampson Low, Marston, Searle and Rivington.
——(1890b) 'The Death of Naturalistic Photography', London, privately printed (December 1890); published as 'A Renunciation', *Photographic News*, vol 35, no 1690, pp62–63.
——(1893) *On English Lagoons: Being an Account of the Voyage of Two Amateur Wherrymen on the Norfolk and Suffolk Rivers and Broads*, London: David Nutt.
——(1900) 'Bubbles' (lecture), *Photograms of the Year 1900*, pp35–42.
Emerson, P. H. and Goodall, T. F. (1887) *Life and Landscape on the Norfolk Broads*, London: Sampson Low, Marston, Searle and Rivington.

Secondary texts

Bate, F. (1886) 'The Naturalistic School of Painting', *The Artist and Journal of Home Culture*, vol 7, no 75–77, p82; compiled as *The Naturalistic School of Painting*, London: The Artist, 1887.

Durden, M. (1994) 'Peter Henry Emerson: The Limits of Representation', *History of Photography*, vol 13, no 3, pp281–284.

Handy, E. (1994) *Pictorial Effect, Naturalistic Vision: The Photographs and Theories of Henry Peach Robinson and Peter Henry Emerson*, Norfolk, VA: The Chrysler Museum.

McWilliam, N. and Sekules, V. (eds) (1986) *Life and Landscape. P. H. Emerson: Art and Photography in East Anglia, 1885–1900*, Norwich: Sainsbury Centre for the Visual Arts, University of East Anglia.

Newhall, N. (1975) *P. H. Emerson: The Fight for Photography as a Fine Art*, New York, NY: Aperture.

Peterson, C. (2008) *Peter Henry Emerson and American Naturalistic Photography*, Minneapolis, MN: Minneapolis Institute of Arts.

Review (1890) 'Wild Life on a Tidal Water', *Amateur Photographer*, vol 12, no 323, pp417–418.

Taylor, J. (2006) *The Old Order and the New: P. H. Emerson and Photography 1885–1895*, London: Prestel.

<div align="right">Hope Kingsley</div>

WALKER EVANS (1903–1975)

Walker Evans was one of the most renowned photographers of the last century. His documentary style is often described as 'literary' and his reputation rests, in part, on books produced in collaboration with writers: *The Crime of Cuba* (Beals 1933); *Let us now Praise Famous Men: Three Tenant Families* (Agee and Evans 1941); and *The Mangrove Coast: The Story of the West Coast of Florida* (Bickel 1942). For each, Evans provided a discrete folio of 32 photographs. However, his significance as a *writer* concerns a small number of unusual texts produced across his career.

As a student, Evans avidly followed modernist writing as it appeared in progressive journals of the 1920s. Dropping out of college, he worked in a French language bookstore and at the New York Public Library, securing access to the latest European culture. In 1926 he went to Paris for a year. He enrolled on language and civilization courses and made tentative forays into writing short fiction while translating extracts of Charles Baudelaire, André Gide, Jean Cocteau and others.

Returning to New York he pursued writing and photography in parallel. The journal *Alhambra* published one of his photographs of skyscraper construction and his translation of part of Blaise Cendrars's novel *Moravagine* (Cendrars 1929). For the feature 'Mr Walker Evans Records a City's Scene', published in *Creative Art* (Evans 1930),

he combined words with images in various ways: within the picture frame, as dynamic typography, as titles and as captions. *Hound & Horn* published small groupings of his photographs and the remarkably perceptive 'The Reappearance of Photography', a review of several recent photographic books (Evans 1931). This text can also be read as a statement of intent at the outset of his photographic career. It opens with remarks on photography's relation to history, time and space, noting that its early promise was followed by a long and moribund development. Recent practice was dominated by 'swift chance, disarray, wonder and experiment' (snapshots, disorienting close-ups, the unorthodox angles of the New Vision and Constructivism). This, thought Evans, was already becoming a tiresome gimmick and less significant than the slower, measured procedures of August Sander, and most importantly, Eugène Atget:

> Certain men of the past century have been renoticed who stood away from this confusion. Atget worked right through a period of utter decadence in photography. He was simply isolated, and his story is a little difficult to understand. Apparently he was oblivious to everything but the necessity of photographing Paris and its environs; but just what vision he carried with him of the monument he was leaving is not clear. It is possible to read into his photographs so many things he may never have formulated to himself. In some of his works he even places himself in a position to be pounced upon by the most unorthodox of surréalistes. [Four Atget photographs had been reproduced in the journal *La Révolution Surréaliste*.]
>
> (Evans 1931: 126)

The slickly commercial book *Steichen the Photographer* (1929) was quite the opposite: 'photography off track in our own reiterated way of technical impressiveness and spiritual emptiness […] his general tone is money'. Evans also considered *Photo-Eye* (1929) the influential survey of New Vision photography assembled by the critic Franz Roh and graphic designer Jan Tschichold to coincide with *Film und Foto*, the huge touring exhibition that debuted in Stuttgart. It was a 'nervous and important' publication and he admired its preference for direct documents over art. It included press photos of corpses, 'because you like nice things', wrote Evans sardonically. He found Albert Renger-Patzsch's *Die Welt ist schön* (*The World is Beautiful*, 1928) 'exciting to run through in a shop but disappointing to take home', a 'round-about return to the middle period of photography'.

August Sander's *Antlitz Der Zeit* (*The Face of the Time*, 1929) comprising 60 portraits from his survey of the German people was an assembly of 'type studies' and 'one of the futures foretold by Atget': a 'photographic editing of society, a clinical process' (Evans 1931: 128).

'The Reappearance of Photography' has much in common with Walter Benjamin's celebrated essay 'A Small History of Photography', published concurrently in Germany (Benjamin 1931). It too was a review of recent photobooks, including the Atget, Sander and Renger-Patzsch titles, couched as a diagnosis of the medium's past and present. Both writers noted nineteenth-century photography was undergoing renewed interest. Both noted that early achievements were followed by descent into the populist mire of *cartes de visite*, narcissistic portraiture and kitsch. This was the complaint of Charles Baudelaire in his tirade against photography 'The Salon of 1859' and both were profoundly influenced by Baudelaire's ability to look elsewhere and find the spirit of modernity in its everyday details and vernacular forms. Both also noted an important recent turn towards books of intelligent documents assembled along archival lines that might reward a historically and politically alert audience.

From 1934 Evans worked occasionally for the business and industry magazine *Fortune*. In 1936 he was commissioned to travel with James Agee to document the lives of poor tenant farmers in the American south. Their overlong and unpublishable material was eventually reworked into the book *Let us now Praise Famous Men*.

With little paid photographic work during the war, Evans took a job at *Time* magazine reviewing films, books and art. Although not ideal, it satisfied the desire to write. Agee was part of the close-knit staff, as were Louis Kronenberger and Saul Bellow. *Time* writers were encouraged to be concise, urbane, witty and worldly. Wherever possible, Evans championed the aesthetic restraint he admired and took swipes at artiness, including a withering assessment of Georgia O'Keeffe's paintings, whose success was due in no small measure to her partner, the photographer 'Dealer Stieglitz' (Evans 1945). He also highlighted *The Bombed Buildings of Britain*, a photographic book of war damage, noting the 'the peculiar aesthetic' of the 'architecture of destruction', a theme central to his own photography. Honing his short-form prose he published around 70 uncredited reviews.

In 1945 Evans joined *Fortune*'s staff, remaining until 1965. 'Homes of Americans' (Evans 1946) presented an archival trawl of uncaptioned photos of US housing stock. An introductory text showed his interest in testing limits of photos as documents:

Photography, that great distorter of things as they are, here as elsewhere, played its particularly disreputable, charming trick. But like the deliberate inflections of men's voices, they are tricks now and then lifted to an art. Take your time with this array […] it may pay you to incline with Herman Melville to 'let the ambiguous procession of events reveal their own ambiguousness'.

(Evans 1946: 148)

In 1948 he became *Fortune*'s Special Photographic Editor, securing a level of autonomy unheard of in American magazines. He set his own assignments, shot the images, wrote the text and designed the layouts, answering not to the art director but to the editor. He never used the pages as an art gallery but produced subtle photo-essays that subverted magazine convention, addressed marginal subjects and encouraged audiences to think about how photographs function, always resisting the slick narrative style and hegemonic populism of Time Inc.'s flagship illustrated magazine, *Life* (Evans and Agee once planned to gain control over several pages of each issue of *Life* for more experimental forms of journalism, but nothing came of it).

'Main Street Looking North from Courthouse Square' (Evans 1948a) presented turn-of-the-century postcards with a text arguing that as an epoch passes, so does its specific mode of self–representation (an idea central to Walter Benjamin). 'Along the Right of Way' (Evans 1950) was a series of landscapes shot from train windows, where the nation appears 'semi-undressed', exposing the 'anatomy of its living'. His images for 'Imperial Washington' (Evans 1952) resemble a tourist's survey of the capital's stately architecture; but the captions undermine this. The place is a 'stage set' of power, indebted more to show business than history:

The last, large burst of classicism struck Washington as a direct result of the Chicago World's Fair of 1893. So successful was the midwestern creation in plaster that its chief architects and planners moved on to the capital almost to a man and forever froze the face of the city into its Romanesque Renaissance expression.

(Evans 1952: 198)

The colour photographs for 'The Pitch Direct' (Evans 1958b) relish the unsophisticated display outside small shops, while his text is ironic and affectionate:

The stay-at-home tourist, if his eye is properly and purely to be served, should approach the street fair without any reasonable

intention, such as that of actually buying something [...] Does this nation overproduce? If so one can get a lot of pleasure and rich sensual enjoyment out of contemplating great bins of slightly defective tap wrenches, coils upon coils of glinty wire and parabolas of hemp line honest and fragrant. A man of good sense may decide after due meditation that a well-placed eggplant (2 for 27 cents) is pigmented with the most voluptuous and assuredly wicked color in the world.

(Evans 1958b: 139)

Evans produced over 40 image-text essays for *Fortune* and seven for *Architectural Forum* (also part of Time Inc.). 'Color Accidents' was a suite of square compositions picked out from weathered walls of a New York street (Evans 1958a). The writing compares but distances them from abstract expressionist painting, then at its popular height:

The pocks and scrawls of abandoned walls recall the style of certain contemporary paintings, with, of course, the fathomless difference that the former are accidents untouched by the hand of consciousness [...] Paul Klee would have jumped out of his shoes had he come across the green door below [...] Lest the buildings of tomorrow engender no patina whatsoever, certain nicely encrusted objects may well be recorded now. Decorative design itself, such as that on this ponderously charming door – as modish as a celluloid collar – is surely being threatened by the forces of speed and utility.

(Evans 1958a: 110–115)

During the 1950s Evans also wrote reviews of books on film and photography for *The New York Times*.

In 1969 Evans was invited to write the section on photography for Louis Kronenberger's anthology *Quality: Its Image in the Arts* (Evans 1969). It was his last major statement on the medium. He chose images taken by Nadar, Cameron, Steichen, Steiglitz, Strand, Brandt, Brassaï, Cartier-Bresson, Levitt, Frank, Friedlander, Arbus and Lunar Orbiter 1, among others. Each double spread carried one image with a text opposite, a format developed by John Szarkowski for his influential book *Looking at Photographs* (Szarkowski 1973). Although there was great variety in Evans's selection, it conformed to his own photographic aesthetic established 40 years earlier:

(1) absolute fidelity to the medium itself; that is, full and frank and pure utilization of the camera as the great, the incredible

instrument of symbolic actuality that it is; (2) complete realization of natural, uncontrived lighting; (3) rightness of in-camera view-finding, or framing (the operator's correct, and crucial definition of his picture borders); (4) general but unobtrusive technical mastery.

(Evans 1969: 169–170)

Biography

Walker Evans was born in 1903 in St. Louis, Missouri. Early ambitions to write took him to Paris for a year. In New York he became part of a literary and artistic scene including Hart Crane and Lincoln Kirstein. His photographs appeared in various journals and he took commissions to document Victorian architecture and African sculpture. In 1933 he photographed Havana for Carleton Beals's exposé *The Crime of Cuba*. For the Farm Security Administration and *Fortune* magazine he photographed the effects of the Depression in the American South. In 1938 he was given a solo exhibition at the Museum of Modern Art (MoMA), New York. The accompanying publication *American Photographs* became highly influential. He wrote reviews for *Time* magazine (1943–1945) before producing photo-essays at *Fortune* for 20 years. In 1965 he took a teaching post at Yale. In 1966 he published two books: *Many Are Called* and *Message From the Interior*. Overlooking his publications and focusing largely on the Depression work, a retrospective at MoMA in 1971 sealed Evans's reputation as a maker of exemplary single photographs in what he called the 'documentary style'. He died in 1975.

Primary texts

Cendrars, B. (1929) 'Mad', translated by W. Evans, *Alhambra*, vol 1, no 3, August, pp34–35, 46.

Evans, W. (1930) 'Mr. Walker Evans Records a City's Scene', *Creative Art*, December, pp453–456.

——(1931) 'The Reappearance of Photography', *Hound & Horn*, October–December, pp125–128.

——(1943) 'Among the Ruins', *Time*, 27 December, p73.

——(1945) 'Money Is Not Enough', *Time*, 5 February, p86.

——(1946) 'Homes of Americans', *Fortune*, April, pp148–157.

——(1948a) 'Main Street Looking North from Courthouse Square', *Fortune*, May, pp102–106.

——(1948b) 'Faulkner's Mississippi', *Vogue*, October, pp144–149.

——(1950) 'Along the Right of Way', *Fortune*, September, pp106–113.

——(1952) 'Imperial Washington', *Fortune*, February, pp94–99.

——(1958a) 'Color Accidents', *Architectural Forum*, January, pp110–115.
——(1958b) 'The Pitch Direct', *Fortune*, October, pp139–143.
——(1969) 'Photography', in L. Kronenberger (ed) *Quality: Its Image in the Arts*, New York, NY: Atheneum, pp169–210.

Secondary texts

Agee, J. and Evans, W. (1941) *Let us now Praise Famous Men: Three Tenant Families*, Boston, MA: Houghton Mifflin.
Baier, L. K. (1978) *Walker Evans at Fortune*, Wellesley, MA: Wellesley College Museum (ex. cat.).
Beals, C. (1933) *The Crime of Cuba*, Philadelphia, PA: J. B. Lippincott Company.
Benjamin, W. (1931) 'Kleine Geschichte der Photographie' ['A Little History of Photography'], *Die Literarische Welt*, 18 and 25 September, 2 October.
Bickel, K. A. (1942) *The Mangrove Coast: The Story of the West Coast of Florida*, New York, NY: Coward-McCann Inc.
Campany, D. (2012) *Walker Evans: The Magazine Work*, Göttingen, Germany: Steidl.
Evans, W. (1947) 'Chicago: A Camera Exploration', *Fortune*, February 1947, pp112–121.
——(1960) 'James Agee in 1936', *Atlantic Monthly*, July, pp74–75.
——(1962) 'Walker Evans: The Unposed Portrait', *Harper's Bazaar*, March, pp120–125.
Katz, L. (1971) 'Interview with Walker Evans', *Art in America*, March–April, pp82–89.
Kingston, R. (1995) *Walker Evans in Print: An Illustrated Bibliography*, R. P. Kingston Photographs.
Mellow, J. R. (2001) *Walker Evans*, New York, NY: Perseus.
Rosenheim, J. L. and Schwarzenbach, A. (eds) (2000) *Unclassified: A Walker Evans Anthology*, New York, NY: Scalo.
Szarkowski, J. (1973) *Looking at Photographs: 100 Pictures from the Collection the of Museum of Modern Art*, New York, NY: Museum of Modern Art.

David Campany

VILÉM FLUSSER (1920–1991)

Vilém Flusser died before the full impact of either the World Wide Web or digital photography, but his writings and lectures on photography presage the changes they have brought and provide a unique confluence of systems theory and phenomenology in trying to make sense of the industrialization of the image. Flusser was in many ways the modern peripatetic philosopher: a Czech Jew who fled the Nazis during the 1930s and, after a brief sojourn in England, lived in Brazil

until 1972, when he returned to Europe, his work covers politics, culture, design, literature, media history and what is today called post-colonialism. His short book *Towards a Philosophy of Photography*, originally published in 1983, has had an influence far greater than its small number of pages.

For Flusser, photographs are the prime example of the 'technical image', which he distinguishes from the 'traditional image', which was a first-level abstraction from the concrete world of appearances. A traditional image took such features as outlines and translated them onto flat surfaces. By doing so, it reduced the richness of concrete experience with a single selected moment of perception. A drawing is never as rich or as changing as concrete reality. In a second historical stage, textual abstractions verbalized what the traditional image had abstracted from reality – for example, through explanatory captions. The technical image arrives in a third historical period, where the relationship is reversed: images become visualizations of texts. Where traditional images point towards phenomena – the sensory experience of the world celebrated by phenomenological philosophers – the technical image points towards concepts. Thus, he can argue that technical images – especially photographs – only appear to be automatic effects of light from the real world: they are, he insists, symbols, not symptoms. Like all images, they are magical; but where traditional magic sought to change the world by telling stories, technical images seek to change our concepts about the world through the automatic programme, the 'black box', of photography.

According to Flusser, the rise of mass publishing and mass literacy during the nineteenth-century split society into an elite of gallery-going connoisseurs focused on traditional images; a second elite of readers focused on science, philosophy and other difficult texts; and a proletariat devoted to the 'subliminal magic' of cheap texts. Photography's destiny was supposed to bring these classes together again; but instead it succeeded only in flattening every event photographed, every event staged in order to be photographed, from laboratory experiments to street demonstrations. Stripping them of their historical depth, photographed events became ahistorical rituals endlessly repeated on the surface of images. Here Flusser foreshadowed the dystopian thesis that the data economy, by reducing everything to the exchange of bits, has converted meaning into units of information, each one equivalent to every other (e.g. Fuchs 2009).

Step by step, Flusser develops a profoundly troubling definition of photography: 'It is an image created and distributed automatically by programmed apparatuses in the course of a game necessarily based on

chance, an image of a magic state of things whose symbols inform its receivers how to act in an improbable fashion' (Flusser 2000: 76). What he means by 'magic' is ritual acts designed to effect change. The term 'programmed apparatus' is trickier. According to Shannon and Weaver's (1949) mathematical theory of communication, the information content of a message is a function of how unlikely it is: repetition of old news is not information. Flusser uses this definition to argue that photography – including all elements, from Kodak factories to photo albums – is a machine which creates information by generating improbable situations. But where the traditional image relied on intuition, the technical image depends upon the automatic programme of the camera. The playful point-and-click photography of snapshots effectively uses the programmed actions of photographers: an album of images from a trip to Italy, for example, 'shows the places in Italy where the camera was, and how it seduced its owner there to press the button. The album is in fact a camera memory' (Flusser 1984c: 2).

But what of the mission to 'inform its receivers how to act in an improbable fashion'? As information – as a substitute for text – photography depends, ironically, upon how little we prize photographs. Because we believe they are automatic, we don't bother to criticize, and therefore they are all the more able to persuade: to buy toothbrushes or to see a complex political situation in black-and-white terms. The endless replacement of one image by another, in the press, on TV, in our own happy snapping, is the opposite of information: it is an endless repetition of the same form, even though the colours and appearance change. The tendency of the camera to churn out image after image in a kind of arithmetic frenzy is matched by the circulation of endlessly similar photographs – of weddings, of celebrities, of wars – where the repetition replaces any kind of historical process, such as 'progress', with a programmed replacement of image by image. The task of the critic is to reveal this programmed nature of the image, and the work of the 'true' photographer is to struggle against the automation of the apparatus, and to struggle towards making photographs that are not the simple result of a camera seducing a photographer into taking a snap.

But it is problematic, Flusser argues, to call what a photographer does 'work' – and for that reason to think of the photographer as an 'author'. In pre-history, according to Flusser, the human task was to interpret the world, to fill it with meaning through myth, ritual and magic. The 'historic' period that followed was dominated by work: the physical, and especially manual, job of changing the world. From

an information-theoretic standpoint, work gives raw materials – for example, cow hides – highly improbable forms – such as shoes. In our visually dominated 'post-historical' era, our task is to give the world new meanings. But where imparting information to raw materials ('in-forming') was in the old world of work the source of value, today's images have no value because they can be automatically produced and reproduced without the intervention of a worker, something it shares with all printed matter. The negative is 'true' to the world, and the copy is 'true' to the negative, with no recourse to a human author.

The 'true' photographer faces a further challenge in the distribution networks which effectively decide what pictures will be circulated in the press, political parties, scientific journals, art galleries and so on. He or she will have to make images that fit the requirements of these parts of the total photographic apparatus, while at the same time trying to keep some aspect of the unforeseen. Part of the problem lies in the split, during the historical period, of ethics, truth and beauty: the good, the true and the beautiful. The apparatus is likewise split between political-educational (good), scientific (true) and artistic (beautiful), where, following Flusser, information in the sense of work is all three, as a shoe is well made, true to its materials and pleasant to look at and wear. What passes for creativity – and therefore value – may only be introducing inappropriate elements in the wrong institutional context, as in the use of political and scientific imaging in much contemporary photographic art. The 'true' photographer struggles against the automation of the camera. He or she also has to struggle with the programmes and the automated systems of publishing (and nowadays Flickr) which control distribution. This, Flusser is very explicit, is the dialectical position of mass photography: an automated process struggling to free itself from the technological system that makes it possible.

Flusser's historical periodization can be compared to Marshall McLuhan's four-stage history of oral, written, print and electronic eras, except that there is no sense of progress in Flusser. In 1986, Flusser published an essay suggesting that 'electromagnetized photos' would be 'practically eternal' and be altered by receivers, unlike the older physical photos, so that 'one can see how information abandons its material basis'. This very different utopian conception he linked to a prefiguration of network cultures and the emergence of an inter-subjective and immaterial civilization devoted to 'the useless dialogical elaboration of pure information. This of course is called "play"' (Flusser 1986: 331). After the contradictions of dialectic comes the

dialogue of equals, playful and 'useless' in the sense that it does not serve wealth or power. Thus, after a deeply dialectical account of photography as struggle, Flusser offers a vision of a fulfilled and fulfilling peace, where the art moves from depicting objects to designing programmes, and the contradictions between old and new are resolved. It is easy enough (though many critics have yet to realize this) to spot errors in Flusser's prognostications which make his utopia unlikely. The most important is perhaps the persistence of institutional government of the circulation of images – for example, Google's Picassa; and next to it the sad truth that digital images are, if anything, more subject to decay than printed ones through a combination of rapid technical obsolescence of equipment and the phenomenon of '*bitrot*', the effect of multiple passages through the compression-decompression transmission software ('codecs') ubiquitous in image processing and distribution. The data caught on a camera's CCD (charge-coupled device) chip is the largest quantity of data the image will ever carry: from the moment it is ported to the camera's memory, it begins to lose resolution and colour data. Flusser saw culture as a massive machine for developing and storing improbabilities: for amassing information against the universal entropy of the physical universe. Sadly, our image culture is far more vulnerable to entropy – the loss of information – than any other before it. Flusser believed that the new digital photography would help to bring about a utopia of free exchange and radical playfulness. While that is partly true, we are still flooded with trivial, exploitative images and a mercenary image culture. The dialectic is not over yet.

Biography

Vilém Flusser was born in 1920 in Prague. In 1938, he began to study philosophy at the Juridical Faculty of the Charles University in Prague, but in 1939, shortly after the Nazi occupation, emigrated to London to continue his studies for one term at the London School of Economics and Political Science. Flusser lost all of his family in the German concentration camps. In 1940 he emigrated to Brazil. In 1963 he was appointed professor of philosophy of communication at São Paulo University. He returned to Europe in 1972 and settled in France. During this time he published books and articles in several languages, including *The Shape of Things: A Philosophy of Design* and *Toward a Philosophy of Photography*. He died in 1991 in a car accident, while visiting his native Prague to give a lecture.

Primary texts

Flusser, V. (1984a) 'Photo production', first lecture on 23 February 1984, École Nationale de la Photographie, Arles, *Flusser Studies*, vol 10, http://www.flusserstudies.net/pag/10/flusser-photo-production.pdf, accessed 8 April 2011.

——(1984b) 'Photo distribution', second lecture on 15 March 1984, École Nationale de la Photographie, Arles, *Flusser Studies*, vol 10, http://www.flusserstudies.net/pag/10/flusser-photo-distribution.pdf, accessed 8 April 2011.

——(1984c) 'Photo reception', third lecture on 2 April 1984, École Nationale de la Photographie, Arles, *Flusser Studies*, vol 10, http://www.flusserstudies.net/pag/10/flusser-photo-reception.pdf, accessed 8 April 2011.

——(1986) 'The Photograph as Post-Industrial Object: An Essay on the Ontological Standing of Photographs', *Leonardo*, vol 19, no 4, pp329–332.

——(2000) *Towards a Philosophy of Photography*, translated by A. Matthews, introduction by H. Von Amelunxen, London: Reaktion Books.

——(2011) *Into the Universe of Technical Images*, translated by N. A. Roth, introduced by M. Poster, Minneapolis, MN: University of Minnesota Press.

Secondary texts

Finger, A. (2010) 'On Creativity: Blue Dogs with Red Spots', *Flusser Studies*, vol 10, http://www.flusserstudies.net/pag/10/finger-on-creativity.pdf, accessed 8 April 2011.

Finger, A., Guldin, R. and Bernardo, G. (2011) *Vilém Flusser: An Introduction*, Minneapolis, MN: University of Minnesota Press.

Fuchs, C. (2009) 'A Contribution to the Critique of the Political Economy of Transnational Informational Capitalism', *Rethinking Marxism*, vol 21, no 3, July, pp387–402.

McLuhan, M. (1964) *Understanding Media: The Extensions of Man*, London: Sphere.

Shannon, C. E. and Weaver, W. (1949) *The Mathematical Theory of Communication*, Urbana, IN: University of Indiana Press.

Sean Cubitt

GISÈLE FREUND (1908–2000)

A famous photographer, Gisèle Freund has written eloquently in compilations of her work about the power of photography to manipulate its subject, and the role of context in creating meaning (see, for example, Freund 1985). Her most influential contribution, however, is *La Photographie en France au dix-neuvième siècle*. Published in 1936, it was one of the first histories to tackle photography's aesthetic and ideological relationship with portrait painting, and its uses by the

bourgeoisie to visualize their rising status. Its arguments on the social impact and low aesthetic values of the output of commercial portrait studios, and on the importance of the photographers who strived to develop a new aesthetic for the medium, independent from painterly precedents, has had a lasting effect on subsequent histories. Walter Benjamin reviewed the book when it came out, praising its 'materialist dialectic', its understanding of the effects of photography on 'the entire character of art' and its focus on the relationship of 'the artistic scope of a work to the social structure at the time of its production' (Benjamin 2008: 313); he also cited her writings extensively in the *Arcades Project* (Benjamin 1999: 671–692). Freund's analysis of 'the social aesthetic forces that shaped photography' was also 'of great importance' to Beaumont Newhall, who came to Europe in 1936 in order to research for his exhibition *Photography 1839–1937* at the Museum of Modern Art in New York (Bertrand 1997: 142).

In 1974 Freund published *Photographie et société*, bringing her earlier history up to date. Translated into German, Danish and Japanese, it was published in English as *Photography and Society* in 1980 and is still considered an important critical history of the medium. Like its antecedent, it discusses the rise of photography in the context of industrialization and the expansion of capitalism, arguing that portraiture was an example of how the middle classes during the eighteenth century started to push into the cultural domains of the aristocracy. The miniature portrait was particularly appealing because it combined an aristocratic format with a 'new cult of individualism' (Freund 1980: 10) and was cheaper than oil paintings; as the middle classes expanded, increasing demand led to the industrialization of portraiture, first with the physionotrace and then the Daguerreotype.

Freund highlights the tension between opposite uses of mechanization. A positive force when associated with the modernization of cultural forms and democratic ideals, mechanization became negative when, driven by the economic power of the *petit bourgeoisie* and uncultured *nouveau riches*, it was used to service the indiscriminate consumption of cultural forms that were previously exclusive: 'men […] with just enough education to keep their account books' (Freund 1980: 20) used photography to ape the aristocracy, vulgarizing and cheapening old cultural forms instead of evolving new ones. A new breed of intellectuals, on the other hand, could develop a more modern aesthetic, materially and conceptually suited to the new means of production, because their knowledge and culture allowed them to 'understand their relative historical position' and have a more open vision of the world (Freund 1980: 21).

The narrative unfolding in Freund's book is of the struggle for survival of the photographers who produced images that were artistic expressions of their time, visualizing the 'potential of human intellectual and moral progress' (Freund 1980: 42). Nadar, for example, was able to develop a photographic aesthetic transcending the cultural outlook of his own class through portraits that concentrated on facial expression and intellectual affinity, rather than on the outward trappings of social status. As a freelance artist no longer working under a patron, he was free to do so. Yet, as Freund demonstrates, this came at the cost of constantly having to negotiate market forces. Nadar could afford to portray 'the inner spirit' of his sitters (Freund 1980: 42) because his contacts in the art world made enlightened customers; when they were not enough to sustain business, his standards had to drop.

Freund has no sympathy for the self-consciously 'Art' photography of combination prints or Pictorialism, which she considered as an 'artistic decline' (Freund 1980: 89). Instead, she celebrates the work of Eugène Atget (1857–1927) in Paris and Heinrich Zille (1858–1929) in Berlin as the fathers of documentary photography. As she makes it clear in her chapter on 'Photography as Art', during the twentieth century the distinction between 'concerned photographers', who use the medium as part of their commitment to social issues, and those who use photography for 'personal artistic expression' is relative, as they are all 'creators or craftsmen' (Freund 1980: 193) whose cultural and aesthetic roots can be traced to the historical *avant-gardes* after World War I, especially in Germany (Freund 1980: 193). She argues that Moholy-Nagy was the first to conceptualize explicitly the need for photography to develop its own independent aesthetic (Freund 1980: 196–198).

In Freund's account, photojournalism emerges as the socially and aesthetically most important twentieth-century photographic practice. She analyses how the political, economic and artistic situation of the Weimar Republic gave rise to a new conception of photographically illustrated news and a new role for the photojournalist. As the economic crash after World War I had left many well-educated upper-middle-class people without fortune or job, some turned to photography to make a living. Photographers such as Erich Salomon were from the same class and educational background as the political dignitaries whom they photographed. Armed with the right clothes and manners, as well as the latest cameras and films, they were able to mix as equals with their subjects and take unprecedented candid photographs. Freund highlights how their political understanding, as well as their visual flair, meant that they could work without

directions from a writer. Editors such as Stefan Lorant developed the 'photostory' (Freund 1980: 124), defined, like classical theatre, by unity of time, place and action. Even as she celebrates photojournalism Freund is alive to its dangers:

> [...] in the theatre the stage keeps the audience aware of the fictional nature of the action. The reader poring over a magazine, on the other hand, identifies what he sees in the photographs as real.
> (Freund 1980: 124)

By aligning photojournalism with narrative and fiction rather than art or document, Freund highlights how photographs acquire evidential power by being *staged* as facts, creating a suspension of disbelief that is all the more powerful because the viewer is not aware of it.

Freund's analysis of illustrated magazines contextualizes them in the development of advertising. The large markets reached in America by publications such as *Life* meant that advertisers were willing to pay a lot for space. This revenue allowed it to fund its reportage lavishly, but it also brought a new pressure to address audiences as consumers rather than readers, and to concentrate on content with the widest mass appeal. Freund's approach is rare in considering the magazine as a whole in which photographs and text, layout and adverts, circulation, cover price and even inflation have an impact upon its meaning.

Freund can be idealistic about the photographers she endows with the power to transcend their ideological and economic conditions, but she never lets the reader forget that, however inspired, artistic production needs technological means to be realized and markets to circulate. New aesthetic languages might be developed, but need ideological and semiotic currency within a culture to acquire meaning. One of the strengths of her book is the clarity with which she makes the connections between photography, politics and economics. This central argument gives coherence to the wide variety of photographic practices that she considers, from photojournalism to soft pornography; from the role of trade associations and agencies to that of photographic reproductions of works of art; from 'Photography and the Law' to how 'Amateur Photography' gives the illusion of creativity to people trapped in boring jobs (Freund 1980: 208). She does not ignore the contribution of women photographers, or the impact of photography upon the ecosystem. However brief, she is never superficial. Intellectually stimulating and emotionally involving, this key text in the historiography of photography is still one of the most informative and accessible general histories of the medium. Freund's

influence on many of the now classic formalist histories of photography can be traced via Newhall; and yet, through her impact upon Benjamin's writings, she has also informed late twentieth-century social histories of the medium that have been critical of formalist approaches.

Biography

Gisèle (Gisela) Freund (1908–2000), was born in Berlin and studied sociology in Frankfurt, where her teachers included Karl Mannheim, Theodor Adorno and Norbert Elias. Having taken up photography, she decided to write her thesis on its evolution in nineteenth-century France, 'Entwicklung der Photographie in Frankreich' (Benjamin 1999: 673). As a Jew and an anti-fascist, she had to leave Germany in 1933 when a plot against Hitler, in which she had been involved, was discovered (Hopkinson 2000: 26). She fled to Paris and graduated from the Sorbonne with a thesis on 'La Photographie au point de vue sociologique'. While researching at the Bibliothèque Nationale she became friends with Benjamin and photographed him several times. A pioneer of the use of colour in portraiture on location, her images of writers, artists and philosophers are now famous. Her photo-journalism was published internationally, including in *Life*, and she joined Magnum in 1947, covering Latin America for them until 1954. Her photographic work might not have received the attention it deserves in histories of the medium, yet she won many accolades, including a Doctorate *honoris causa* from Bradford University (recommended by the National Museum of Photography) in 1989.

Primary texts

Freund, G. (1936) *La Photographie en France au dix-neuvième siècle: Essai de sociologie et d'esthétique*, Paris: La Maison des Amis du Livre.
——(1974) *Photographie et société*, Paris: Editions du Seuil.
——(1980) *Photography and society*, translated by D. Godine, London: Gordon Fraser; Boston, MA: David Godine.
——(1985) *Gisèle Freund Photographer*, translated by J. Shepley, New York, NY: Harry Abrams.

Secondary literature

Benjamin, W. (1999) 'Photography', in R. Tiedman (ed) *The Arcades Project*, translated by H. Eiland and K. McLaughlin, Cambridge, MA, and London: Belknap Press.
——(2008) 'Review of Freund's *Photographie en France au dix-neuvième siècle* (1936)', in M. Jennings, B. Doherty and T. Levin (eds) *The Work of Art*

in the Age of Its Mechanical Reproducibility and Other Writings on Media, translated by E. Jephcott, R. Livingstone, H. Eiland et al, Cambridge, MA, and London: Belknap Press of Harvard University.

Bertrand, A. (1997) 'Beaumont Newhall's *Photography 1839–1937'*, *History of Photography*, vol 21, no 2, pp137–146.

Hopkinson, A. (2000) 'Gisele Freund', *The Guardian*, 1 April, p26.

Patrizia Di Bello

MICHAEL FRIED (1939–)

What does it take to be able to consider photography as art? This is a question first posed when the early Victorian photographers framed their photographs like paintings and hung them in tiers on the walls of the salon. At the end of the twentieth century, these aspirations were rewarded by the ascendance of photography to a central position in museums of fine art. Technical developments and a voracious art market provided the context for the production of vast, spectacular colour photographic prints of a kind impossible to produce before. Jean-François Chevrier argued that prints like these, made by artists such as Jeff Wall, Andreas Gursky and Thomas Struth, among others, occupied the visual and discursive space previously occupied by painting and that they seemed to demand, in the context of the gallery, a form of attention and evaluation that was very different from the cultural analyses that had dominated discussion of photography up until then (Chevrier 1989). However, one of the key problems for photography when considered as an art object is its apparent transparency to the world: a transparency that makes us forget that it is a medium in its own right and that it runs the danger of engaging us too directly. The problem, then, for the art critic is how to hold this unruly photography in place so that it can become the object of a critical aesthetic attention. This is the main problem that the American critic Michael Fried, responding to Chevrier's analysis, is attempting to explore. This new type of photographic work seems to him to embody an answer to a problem in the crisis of modernist aesthetics that he has been dealing with for over 30 years. It is in the context of this history that his book *Why Photography Matters as Art as Never Before* needs to be seen (Fried 2008).

As a student in the US during the 1960s, Fried was influenced by the modernist art critic Clement Greenberg. He became part of a group of influential critics (Philip Leider, Max Kozloff, Annette Michelson, Rosalind E. Krauss) on the magazine *Artforum* at a time when

influence on many of the now classic formalist histories of photography can be traced via Newhall; and yet, through her impact upon Benjamin's writings, she has also informed late twentieth-century social histories of the medium that have been critical of formalist approaches.

Biography

Gisèle (Gisela) Freund (1908–2000), was born in Berlin and studied sociology in Frankfurt, where her teachers included Karl Mannheim, Theodor Adorno and Norbert Elias. Having taken up photography, she decided to write her thesis on its evolution in nineteenth-century France, 'Entwicklung der Photographie in Frankreich' (Benjamin 1999: 673). As a Jew and an anti-fascist, she had to leave Germany in 1933 when a plot against Hitler, in which she had been involved, was discovered (Hopkinson 2000: 26). She fled to Paris and graduated from the Sorbonne with a thesis on 'La Photographie au point de vue sociologique'. While researching at the Bibliothèque Nationale she became friends with Benjamin and photographed him several times. A pioneer of the use of colour in portraiture on location, her images of writers, artists and philosophers are now famous. Her photo-journalism was published internationally, including in *Life*, and she joined Magnum in 1947, covering Latin America for them until 1954. Her photographic work might not have received the attention it deserves in histories of the medium, yet she won many accolades, including a Doctorate *honoris causa* from Bradford University (recommended by the National Museum of Photography) in 1989.

Primary texts

Freund, G. (1936) *La Photographie en France au dix-neuvième siècle: Essai de sociologie et d'esthétique*, Paris: La Maison des Amis du Livre.

——(1974) *Photographie et société*, Paris: Editions du Seuil.

——(1980) *Photography and society*, translated by D. Godine, London: Gordon Fraser; Boston, MA: David Godine.

——(1985) *Gisèle Freund Photographer*, translated by J. Shepley, New York, NY: Harry Abrams.

Secondary literature

Benjamin, W. (1999) 'Photography', in R. Tiedman (ed) *The Arcades Project*, translated by H. Eiland and K. McLaughlin, Cambridge, MA, and London: Belknap Press.

——(2008) 'Review of Freund's *Photographie en France au dix-neuvième siècle* (1936)', in M. Jennings, B. Doherty and T. Levin (eds) *The Work of Art*

in the Age of Its Mechanical Reproducibility and Other Writings on Media, translated by E. Jephcott, R. Livingstone, H. Eiland et al, Cambridge, MA, and London: Belknap Press of Harvard University.

Bertrand, A. (1997) 'Beaumont Newhall's *Photography 1839–1937*', *History of Photography*, vol 21, no 2, pp137–146.

Hopkinson, A. (2000) 'Gisele Freund', *The Guardian*, 1 April, p26.

Patrizia Di Bello

MICHAEL FRIED (1939–)

What does it take to be able to consider photography as art? This is a question first posed when the early Victorian photographers framed their photographs like paintings and hung them in tiers on the walls of the salon. At the end of the twentieth century, these aspirations were rewarded by the ascendance of photography to a central position in museums of fine art. Technical developments and a voracious art market provided the context for the production of vast, spectacular colour photographic prints of a kind impossible to produce before. Jean-François Chevrier argued that prints like these, made by artists such as Jeff Wall, Andreas Gursky and Thomas Struth, among others, occupied the visual and discursive space previously occupied by painting and that they seemed to demand, in the context of the gallery, a form of attention and evaluation that was very different from the cultural analyses that had dominated discussion of photography up until then (Chevrier 1989). However, one of the key problems for photography when considered as an art object is its apparent transparency to the world: a transparency that makes us forget that it is a medium in its own right and that it runs the danger of engaging us too directly. The problem, then, for the art critic is how to hold this unruly photography in place so that it can become the object of a critical aesthetic attention. This is the main problem that the American critic Michael Fried, responding to Chevrier's analysis, is attempting to explore. This new type of photographic work seems to him to embody an answer to a problem in the crisis of modernist aesthetics that he has been dealing with for over 30 years. It is in the context of this history that his book *Why Photography Matters as Art as Never Before* needs to be seen (Fried 2008).

As a student in the US during the 1960s, Fried was influenced by the modernist art critic Clement Greenberg. He became part of a group of influential critics (Philip Leider, Max Kozloff, Annette Michelson, Rosalind E. Krauss) on the magazine *Artforum* at a time when

there were radical changes taking place in the art world: new move-
ments such as conceptualism, performance art and minimalism were
challenging ideas about what art was, where it was to be seen, and
how it was to be encountered. Fried came to prominence through an
essay called 'Art and Objecthood' (1967) in which he defended a
form of modernist art and spectatorship against these types of practice.
The art work, he said, needs to be governed by a kind of autonomous
integrity, 'a continuous and entire presentness, amounting as it were
to the perpetual creation of itself, that one experiences as a kind of
instantaneousness', art that existed in a 'continuous and perpetual pre-
sent' (Fried 1998: 167). The modernist art object that Fried referred
to was not to be encountered by us in time: the experience we had of
it was outside time. It was separate from the beholder, complete in
itself. This contrasted with minimalist sculptures such as those made
by Robert Morris and Donald Judd, which were always located in a
state of 'literalness', dependent upon a relationship with the beholder,
who experienced them in durational time and whose presence was
necessary in order to complete them.

His second important work, *Absorption and Theatricality: Painting and
Beholder in the Age of Diderot* (1980), took some of these ideas further.
The French philosopher Denis Diderot had distinguished between two
types of painting. Some paintings were 'theatrical' in that they involved
a dramatic awareness of the beholder with the characters often turning to
address him or looking him in the eye. Other paintings, which had a
higher value for Diderot, were 'non-theatrical' and had their own
autonomy. In these paintings, which often represented a withdrawn,
absorbed figure, the beholder was not directly addressed and could
therefore, in a paradoxical way, become fully absorbed by the painting
in a pure aesthetic sense. Fried's analysis of the paintings of this period
focused on this distinction. It is easy to see the connection between this
work and the ideas in 'Art and Objecthood'. He is preoccupied in both
studies by a sense of what type of attention the art object should com-
mand. However, in this later book an ambiguity emerges in the way
the representational trope of absorption within figurative painting
sometimes gets blurred with the issue of the absorption of the spec-
tator in the painting itself. From a theoretical point of view, this ambi-
guity seems problematic; but it does also raise interesting issues when he
goes on to analyse photography. It forces the issue of content in a way
that is particularly significant, for there is a sense in which in the
photograph the 'content' of the image is always to the fore.

In *Why Photography Matters as Art as Never Before*, it was this polarity
between the theatrical and the non-theatrical, a concern with the way in

which the artwork engages with the beholder – either severing itself from him or her and establishing a self-contained presentness in the world, or alternatively engaging with him or her directly in time – that Fried brought to the problem of contemporary photographic art. His chief inspiration was the work of Jeff Wall. This was unsurprising because Wall himself had been influenced by Fried's earlier writings, and had used these to develop his own theories around the aesthetics of photographic picture-making. Wall is in some ways a perfect Friedian modernist – preoccupied with establishing the boundaries of the medium and its relationship to the spectator. His work plays continually with the dialogue between absorption and theatricality, depicting figures who are either absorbed and withdrawn or self-consciously confrontational. However, the sense of the integrity of the picture frame in this work is always complete: the composition contains an entire world, one that we can look at but one which is not dependent upon our own participation. Fried is at his best when describing the photography of Jeff Wall – the photographs relate to his interests both formally and thematically and his description of certain key pictures (*A View From an Apartment*: 2004–2005; *Morning Cleaning*: 1999; *After 'Spring Snow' by Yukio Mishima*: 2000–2005) are examples of thoughtful close readings that open up a full sense of the work that a picture can do. They are important, too, in the opportunity that they give Fried to introduce the ideas of Ludwig Wittgenstein and Martin Heidegger to the discussion of the photograph.

These two philosophers provide a framework for dealing with the 'content' of the pictures. Wall's pictures played an important role throughout the 1980s in a general shift of interest within the art world towards an engagement with 'everydayness'. But if the vast majority of photographs actually exist in the 'everyday' and partake of it, what makes Wall's different? And how do they link to Fried's modernist ideals? Fried focuses on a short essay by Wittgenstein in which he talks about the peculiar idea of observing someone going about their every-day activities while unaware that they were being observed. Even though, he says, we see such activities on a daily basis, in reality we are nevertheless entranced by them when they are presented to us as art – 'the work of art compels us to see it in the right perspective' (Fried 2008: 76).

This sense, grasped by Fried, that photography offers that 'right perspective' is the crucial one. And the promise it offers is precisely that of the distancing of the beholder, a sense that reality might be offered to us without acknowledging our presence. This also allows him to talk about the peculiar quality of 'to-be-looked-atness' and 'facingness' that emerges in work made by photographers responding

to the anti-theatrical quality of the image. This is particularly impor-
tant in relationship to portraiture, and his analyses of the work of
Thomas Struth, Rineke Dijkstra and Thomas Ruff attempt to open
up a discussion about the dynamics of the relationship between self
and other produced within the photographic encounter. Fried also
introduces Heidegger's writings on Dasein and on technology. These
help him to deal with the reality that is actually being represented in
Wall's photographs, a context in which people are fully engaged with
'the worldhood of the world' and with an engaged connectedness
between things, objects, tools and spaces. This ontological relatedness
of things is used to try to make sense of the ways in which things are
revealed to be connected by the photograph. It is, indeed, the fragile
sense of what it is 'to be in the world' that is the elusive grail that
Fried's version of art photography is searching for.

In the promotion of his vision of a modernist photographic prac-
tice, Fried deals with a number of other photographers, among them
Beat Streuli, Jean-Marc Bustamante, Thomas Demand, Thomas Ruff,
Luc Delahaye, Patrick Faigenbaum and Bernd and Hilla Becher; but his
theoretical model is sometimes strained by the nature of the work itself.
The writing becomes difficult and sometimes confused as he tries to
maintain the important sense of distance that is vital to his theory of
the beholder. This may be seen as evidence of an inherent weakness
in his theoretical model: these photographers are, after all, producing
work that is often informed by the minimalist and post-conceptualist
practices that he has arraigned himself against (Maimon 2010). He has
also been criticized for promoting a particularly narrow and elitist
view of photographic art practice. However, there is a more generous
point to be made. Fried has stood up consistently for the importance
of a particular kind of attentiveness to the art object, and to a belief in
its status as an aesthetic object existing outside history and outside
time. *Why Photography Matters as Art as Never Before* may in time come
to be seen as an apologia for a particular moment in photography's
flirtation with the high end of the art market, but it does stand up for
the potential seriousness of the photograph as an art form. Wresting
photography out of its embedded social contexts, Fried creates a space
in which it can speak of the world rather than through it.

Biography

Born in 1939, Michael Fried studied English at Princeton, US, where
he first became interested in art criticism, making contact with
Clement Greenberg in 1958. He studied briefly at Oxford and at

University College London before returning to the US in 1962 to complete his doctorate at Harvard. In 1965 he began writing for *Artforum* and was contributing editor between 1966 and 1973. Fried lectured at Harvard University before taking up a professorship at Johns Hopkins University in 1975. He is currently J. R. Herbert Boone Professor of Humanities. Fried has been on the editorial board of *Critical Inquiry* and several other journals. His other art historical writings include *Realism, Writing, Disfiguration: On Thomas Eakins and Stephen Crane*; *Courbet's Realism*; *Manet's Modernism or the Face of Painting in the 1860s*; and *Menzel's Realism: Art and Embodiment in Nineteenth-Century Berlin*.

Primary texts

Fried, M. (1980) *Absorption and Theatricality: Painting and Beholder in the Age of Diderot*, Berkeley, CA: University of California Press.

——(1998) *Art and Objecthood: Essays and Reviews*, Chicago, IL, and London: University of Chicago Press.

——(2005) 'Barthes' Punctum', *Critical Inquiry*, vol 31, no 3, Spring, pp539–574.

——(2008) *Why Photography Matters as Art as Never Before*, London and New Haven, CT: Yale University Press.

Secondary texts

Brückle, W. (2010) 'Absorption Revisited', *Art History*, vol 33, no 4, pp731–734.

Chevrier, J.-F. (1989) *Photo-Kunst: Arbeiten aus 150 Jahren. Du XXe siècle au XIXe siècle, aller et retour*, Stuttgart: Cantz/Staatsgalerie.

——(2003–2004) 'The Adventures of the Picture Form in the History of Photography', in D. Fogle (ed) *The Last Picture Show: Artists Using Photography 1960–1982*, Minneapolis, MN: Walker Art Center.

Costello, D. (2007) 'After Medium Specificity Chez Fried: Jeff Wall as a Painter; Gerhard Richter as a Photographer', in J. Elkins (ed) *Photography Theory*, New York, NY, and Abingdon, UK: Routledge, pp75–90.

——(2008) 'On the Very Idea of a Specific Medium: Michael Fried and Stanley Cavell on Painting and Photography as Arts', *Critical Inquiry*, vol 34, Winter, pp274–312.

Costello, D. and Iversen, M. (ed) (2009) *Art History* (Special Issue: Photography after Conceptual Art), vol 32, no 5, December, pp825–1024.

Elkins, J. (2005) 'Critical Response: What do we Want Photography to Be?', *Critical Inquiry*, vol 31, no 4, pp938–956.

Kelsey, R. (2009) 'The Eye of the Beholder: Why Art Matters', *Artforum*, vol 47, no 5, January, pp53–58.

Maimon, V. (2010) 'Michael Fried's Modernist Theory of Photography', *History of Photography*, vol 34, no 4, November, pp387–395.

Joanna Lowry

CLEMENT GREENBERG (1909–1994)

Hans Namuth's photographic portrait of an appraising Clement Greenberg with cigarette, squinting directly at the lens, has become the iconic image of the combative modernist art critic and tastemaker. Although principally known for his advocacy of a particular kind of painting, throughout his career Greenberg authored some important and concise reviews and commentaries concerning the perceived role and limitations of photography. A chance meeting dated to around 1932 with an elderly Alfred Stieglitz at gallery 291 when, recently graduated, Greenberg was beginning to familiarize himself with the then comparatively small New York modern art world, did nothing, however, to lessen a life-long reservation concerning the status of photography relative to painting (Marquis 2006: 18). Paradoxically, it might be conjectured that it was precisely just such a close and polemical association with a particular account and valuation of painting that has made what Greenberg had to say concerning photography both so cogent and valuable.

Relative to the abstract painters he came to valorize, Greenberg qualified the endorsement of photography because of its perceived indexicality – an apparently transparent relationship to the world and an orientation towards the anecdotal and the literary. At best, photographic referentiality and its grounding in the literary supported the descriptive reportage of a practitioner such as Walker Evans. At worst, any pretension towards 'artiness' in the work of Edward Weston was pilloried. In his first major essay, 'Avant-Garde and Kitsch' (*Partisan Review*, Fall 1939), the implication of commercial photography and film within a broader continuum of advertising and mass culture justified dismissal and the appellation of 'kitsch'.

In much of Greenberg's art journalism and criticism, the subject of photography typically appears as an aside or in parenthesis to other considerations. Where it is the principal focus of review, Greenberg hedges his assessments with caveats and qualifications. In an excoriating 1942 review of a general survey book on American art, Greenberg notes Stieglitz's 'inestimable' service to 'American art' but concludes:

> ... for all that there is about him and some of his disciples too much art with a capital A, and too many of the swans in his park are only geese.
>
> (Greenberg 1986c: 108)

For Greenberg, photography remained authentic only while it conceded the literary limitations of the medium. In a review for *The Nation*

(1944), he does acknowledge photography's technical and historic influence on the work of Degas, Manet, Monet and Pissarro and their approach to 'describing variations of light' and (in the case of Degas) his 'innovations in design' (Greenberg 1986e: 233–234). In the same year, reviewing the Museum of Modern Art's (MoMA's) survey exhibition *Art in Progress*, he praises Walker Evans as 'our greatest living photographer since Stieglitz', although the criteria for both judgements are not elaborated upon (Greenberg 1986d: 213).

In another review for *The Nation* (1947) of a MoMA exhibition of work by Henri Cartier-Bresson (respected as having undergone earlier training as a painter), Greenberg conceded the possibility that photography could 'assimilate' some of the 'discoveries of modern painting' while retaining 'its own essential virtues' (Greenberg 1986h: 139). Both Cartier-Bresson and Evans – judged by Greenberg to be exemplars of the photographic genre – are credited with a compositional awareness, that among their best work, every millimetre of an image should play, as he puts it, 'a positive role'. But even here, such 'design and technical finish' should be subordinated to the primary purpose of conveying 'anecdotal content' with the photographic medium only recognized insofar as it became 'transparent' (Greenberg 1986h: 139).

The hinterland to Greenberg's concern with narrative and the literary in art had been outlined in his second major essay, 'Towards a Newer Laocoon' (1940), in which he had advanced the premise that since the European Enlightenment each of the various arts – painting, music, sculpture and literature – had sought self-definition through a process of progressive differentiation from the other arts. According to Greenberg, it was in academic and naturalistic painting that the legacy of the literary and the anecdotal had been the most pervasive and detrimental. This historical logic (and the medium's intrinsic referentiality) bequeathed photography a legacy geared to reportage and the documentary, the premise which underpins another passing observation penned in a review for *The Nation* (1946):

> [Edward] Hopper's painting is essentially photography, and it is literary in the way that the best photography is. Like Walker Evans's and [Arthur Fellig] Weegee's art, it triumphs over the inadequacies of the physical medium.
>
> (Greenberg 1986g: 118)

Reviewing an exhibition of work by Edward Weston at MoMA (1946), Greenberg makes some of his most expansive statements of the medium. Photography's 'heroic age' is judged to have been the

experimental half century from its invention when its physical technique was 'imperfect in result and clumsy in procedure' – conditions which he applauds as emulating the underlying condition of good art: 'conception and intuition'. By contrast, the 'estranging coldness' of recent practice is 'contrived and without spontaneity' (Greenberg 1986f: 60). Greenberg perceives this as one of the deficiencies in Weston's aesthetic, which in attempting to emulate the effects of modern painting and 'a failure to select' creates under-modulated compositions lacking in 'decorative unity' in which there is no differentiation between details and motif (Greenberg 1986f: 62). He concludes with the emphatic exhortation: 'let photography be "literary"' (Greenberg 1986f: 63).

In this and the other published reviews, Greenberg returned to what he perceived as the intrinsic and determining character of the photograph: that while a painted surface was generally looked 'at', a photograph was looked 'through'. Where 'ambitious' photographic practitioners did emphasize the genre's 'artiness' (a retrograde step), they did so in contradistinction to its inferior status relative to the secure institutional standing of modernist painting.

Greenberg reprised these ideas in his most substantive account and response to photography outlined in a review of 'Four Photographers', published in the *New York Review of Books* in January 1964. Although commissioned as a review of recently published catalogues and accounts of work by Eugène Atget, Edward Steichen, Andreas Feininger and Cartier-Bresson, Greenberg's principal concern was the perceived commonality which connected the work under review. The review starts with the declaration:

> The art in photography is literary art before it is anything else: its triumphs and monuments are historical, anecdotal, reportorial, observational before they are purely pictorial. Because of the transparency of the medium, the difference between the extra-artistic, real-life meaning of things and their artistic meaning is even narrower in photography than it is in prose.
>
> (Greenberg 1993: 183)

He then opines that 'the purely formal or abstract is a threat to the art in photography', noting that although it contributed to 'knowledge' it was 'abortive as art' (Greenberg 1993: 186).

Greenberg's reservations with photography – and much of the *avant-garde* practice of the 1950s and 1960s – reflected his absolute conviction that the best modernist painting (and some noted sculpture by David Smith and Anthony Caro) had an identifiable ontology which

rested with a progressive awareness of, and surrender to, medium specificity and the elimination of the inessential. In the 1981 interview with T. J. Clark, Greenberg describes this remorseless process of purification as akin to that of a physicist 'paring down' an object to its essentials (Greenberg 1981). Against such *a priori* beliefs, photography as a category of cultural production deeply implicated in context, reproducibility and mass culture never lost its secondary and contingent status as a principally descriptive form.

Although his written work fell off markedly after 1969, Greenberg cannot have failed to notice the apparent mainstreaming and institutionalization of photographic practice during the 1960s and 1970s. Photography became one of the ascendant cultural forms associated with the increasingly pluralistic terrain of late modernism and the critical theory that he so eschewed. As Steve Edwards has noted, although conceptual art privileged language as its 'primary material', photography very much became its 'secondary form', being used both as a means of documentation and as a conceptual end in itself (Edwards 2004: 137).

Where they were articulated, Greenberg's views on photography were made with the same peremptory certitude which characterized all of his critical valuations. In attempting to rationalize such polarized convictions, Alice Goldfarb Marquis has looked to the psycho-biographical, noting that while Greenberg 'pursued a militantly secular life, he could not escape the moral penumbra of the traditional Jewish world built around a faith that strictly sequestered the sanctioned from the forbidden' (Marquis 2006: 260). In his emphasis on opticality and the privileging of painting, others have perceived a connection with a broader continuum of post-war positivism and a rationalized approach to isolating and segmenting the senses (Jones 2006).

Regardless of the refusals of Greenberg's own art criticism, and the 'proliferation of the photographic' – from photo-chemical to video and digital – a close regard to medium specificity and a noticeably modernist vocabulary has informed aspects of subsequent photographic analysis and criticism. Greenberg's ultimately parenthetical interest in photography ironically helped to generate a rich and discursive framework, exploring the photographic in all its permutations – epistemological, ontological and phenomenological – discourses which gathered pace from the 1970s onwards. His baleful influence underpinned John Szarkowski's book *The Photographer's Eye* (1966), in which, with an echo of Greenberg's central concern with medium specificity, 'photography was to be understood only in terms of qualities unique to photography' (Durden 2012: 126).

Biography

Clement Greenberg (1909–1994), essayist, tastemaker and modernist art critic *par excellence*, was the son of Jewish migrants who came from Russia to start a new life in America. Raised partly in the Bronx, New York City, he graduated from Syracuse University with a BA in Literature in 1930. Greenberg's key essays comprise 'Avant-Garde and Kitsch', published for the left-wing journal, *Partisan Review* (1939), 'Towards a Newer Laocoon' (1940), 'The Decline of Cubism' (1948) and 'Modernist Painting' (1965), which first appeared as a radio broadcast ('Forum Lecture', *Voice of America*, Washington, DC). The latter was republished in a selection of his essays in the anthology *Art and Literature* (1965). Never reconciled to the 'expanded field' of postmodern art, Greenberg's central intellectual contribution and legacy was to establish, defend and variously refine over more than four decades an influential tradition of modernist art criticism. His distinctive approach to a selective canon of work, principally by abstract painters, situated its development through the apparent logic of 'medium specificity' which eschewed figuration and narrative in the pursuit of painting's apparent 'independence as an art'. Greenberg's assorted reviews, essays and art journalism have been published in John O'Brian's authoritative four-volume edited anthology *Clement Greenberg. The Collected Essays and Criticism* (1988–1995).

Primary texts

Greenberg, C. (1981) Interviewed by T. J. Clark for the Open University Art and Culture Course A315 (video presentation).

——(1986–1993) *Clement Greenberg: The Collected Essays and Criticism*, Vols 1–4, John O'Brian (ed), Chicago, IL: The University of Chicago Press.

——(1986a) 'Avant-Garde and Kitsch' (*Partisan Review*, Fall 1939), in J. O'Brian (ed) *The Collected Essays and Criticism: Perceptions and Judgements, 1939–1944*, Vol 1, Chicago, IL: University of Chicago Press, pp5–22.

——(1986b) 'Towards a Newer Laocoon' (*Partisan Review*, July–August 1940), in J. O'Brian (ed) *The Collected Essays and Criticism: Perceptions and Judgements, 1939–1944*, Vol 1, Chicago, IL: University of Chicago Press, pp23–38.

——(1986c) 'Study in Stieglitz: Review of *The Emergence of an American Art* by Jerome Mellquist' (*The New Republic*, 15 June 1942), in J. O'Brian (ed) *The Collected Essays and Criticism: Perceptions and Judgements, 1939–1944*, Vol 1, Chicago, IL: University of Chicago Press, pp106–108.

——(1986d) 'A New Installation at the Metropolitan Museum of Art, and a Review of the Exhibition *Art in Progress*' (*The Nation*, 10 June 1944), in J. O'Brian (ed) *The Collected Essays and Criticism: Perceptions and Judgements, 1939–1944*, Vol 1, Chicago, IL: University of Chicago Press, pp212–213.

——(1986e) 'Context of Impressionism: Review of *French Impressionists and Their Contemporaries*, Prefaced by Edward Alden Jewell' (*The Nation*, 21 October 1944), in J. O'Brian (ed) *The Collected Essays and Criticism: Perceptions and Judgements, 1939–1944*, Vol 1, Chicago, IL: University of Chicago Press, pp233–234.

——(1986f) 'The Camera's Glass Eye: Review of an Exhibition of Edward Weston' (*The Nation*, 9 March 1946), in J. O'Brian (ed) *The Collected Essays and Criticism: Arrogant Purpose, 1945–1949*, Vol 2, Chicago, IL: University of Chicago Press, pp60–63.

——(1986g) 'Review of the Whitney Annual' (*The Nation*, 28 December 1946), in J. O'Brian (ed) *The Collected Essays and Criticism: Arrogant Purpose, 1945–1949*, Vol 2, Chicago, IL: University of Chicago Press, pp117–118.

——(1986h) 'Review of the Whitney Annual and Exhibition of Picasso and Henri Cartier-Bresson' (*The Nation*, 5 April 1947), in J. O'Brian (ed) *The Collected Essays and Criticism: Arrogant Purpose, 1945–1949*, Vol 2, Chicago, IL: University of Chicago Press, pp137–140.

——(1993) 'Four Photographers: Review of *A Vision of Paris* by Eugène-Auguste Atget; *A Life in Photography* by Edward Steichen; *The World Through My Eyes* by Andreas Feininger; and *Photographs* by Cartier-Bresson, Introduced by Lincoln Kirstein' (*New York Review of Books*, 23 January 1964), in J. O'Brian (ed) *The Collected Essays and Criticism: Modernism with a Vengeance 1957–1969*, Vol 4, Chicago, IL: University of Chicago Press, pp183–187.

Secondary texts

Durden, M. (2012) 'John Szarkowski, *The Photographer's Eye* (1966)', in D. Newall and G. Pooke (eds) *Fifty Key Texts in Art History*, London: Routledge, pp126–131.

Edwards, S. (2004) 'Photography out of Conceptual Art', in G. Perry and P. Wood (eds) *Themes in Contemporary Art*, New Haven and London: Yale University Press, pp137–180.

Elkins, J. (ed) (2007) *Photography Theory*, London: Routledge.

Fried, M. (2008) *Why Photography Matters as Art as Never Before*, Hew Haven and London: Yale University Press.

Jones, C. A. (2006) *Eyesight Alone: Clement Greenberg's Modernism and the Bureaucratization of the Senses*, Chicago, IL: The University of Chicago Press.

Kriebel, S. (2007) 'Theories of Photography: A Short History', in J. Elkins (ed) *Photography Theory*, Cork: University College Cork.

Kuspit, D. (1979) *Clement Greenberg: Art Critic*, Wisconsin, IL: University of Wisconsin Press.

Marquis, A. G. (2006) *Art Czar: The Rise And Fall of Clement Greenberg*, London: Lund Humphries.

Grant Pooke

OLIVER WENDELL HOLMES (1809–1894)

Oliver Wendell Holmes published three substantial essays on photo-graphy. 'The Stereoscope and the Stereograph', the most substantive of the three, appeared in 1859, the same year that Holmes himself invented a light and easy-to-use version of the stereoscope; the other two essays – 'Sun-Painting and Sun-Sculpture' (1861) and 'Doings of the Sunbeam' (1863) – are, in effect, supplements to the first since they largely take up topics and ideas introduced in the earliest piece. Holmes's stereoscope was to prove extremely popular and a commercial success (though Holmes himself did not patent the device) and a fascination with stereographic photography runs through all the essays. But this is not a reflection of a merely private passion. Many people who encountered photography during the nineteenth century did so in large part through the parlour pastime of viewing stereo cards; to reflect on what these cards showed and how they showed it was, then, to reflect centrally on the very nature and culture of photography.

All three essays, along with many other essays by Holmes, first appeared in *The Atlantic Monthly*. The journal, named by Holmes, was founded in 1857 and quickly established itself as an index of New England middle-class cultural preoccupations. The fact that the essays on photography were published in *The Atlantic Monthly* suggests the extent to which the relatively new medium had already become a subject worthy of sustained attention by the culturally literate. Almost all of Holmes's readers would have been familiar with a variety of pho-tographic forms, even if most of them were not themselves practising photographers. Indeed, 'The Stereoscope', written only 20 years after the photographic process was unveiled in France and Britain, begins by asking its readers to look again and in detail at the unique properties and achievements of photography because Holmes worries that the new medium has been too readily domesticated and that, as a result, photography's true nature and potential have been inadequately understood.

The remainder of 'The Stereoscope' essay is divided into three parts. The first provides a clear and useful outline of the technological and chemical aspects of nineteenth-century photography. Holmes starts with the Daguerreotype, already by then in decline; but he focuses most of all on stereographic photography. The second part of 'The Stereoscope' is a sustained reflection on the nature of the photographic image. Holmes here offers not only one of the earliest and richest explorations of the effects of the fugitive detail in a photographic image, but he also proposes a connection between the mimetic democracy of

the photograph and a form of social and cultural democracy. This is the discussion which constitutes Holmes's most substantial contribution to photographic criticism. The final and briefest part of the essay speculates on the future of photography and its cultural role.

Holmes's thinking on photography is anchored in his sense that the exactitude of the photograph exceeds the capabilities of the eye; photography's potential to transform our relationship to the past and memory and also to the physical and social realities around us resides in this difference, this transformation of human vision. In the second part of 'The Stereoscope', Holmes notes the 'frightful amount of detail' which makes every 'perfect photograph' theoretically 'absolutely inexhaustible' and gives the viewer the impression of an 'infinite complexity' commensurate with Nature itself. (Holmes 1864: 156) Holmes rightly argues that often it is the 'incidental truths' that 'interest us more than the central object of the picture' (Holmes 1864: 156). As he imagines the viewing of stereographs from around the world (a photographic version of the Grand Tour greatly extended in the 'Sun Painting' essay), Holmes perceptively registers a counter-note struck by such details in the midst of the exotic mental travel across geographies and through time encouraged by the photograph: 'in the rawest Western settlement and the oldest Eastern city, in the midst of all the shanties at Pike's Peak and stretching across the courtyards as you look into them from above the clay-plastered roofs of Damascus, wherever man lives with any of the decencies of civilization, you will find the *clothes-line*' (Holmes 1864: 156).

Holmes's most telling example of an 'incidental truth' that has the power to become central is his account of his viewing of an image of Alloway Kirk in Scotland, supposedly the setting for Burns's poem 'Tom O'Shanter':

> Here is Alloway Kirk, in the churchyard of which you may read a real story by the side of the ruin that tells of more romantic fiction. There stands the stone 'Erected by James Russell, seedsman, Ayr, in memory of his children', – three little boys, James and Thomas and John, all snatched away from him in the space of three successive summer-days, and lying under the matted grass in the shadow of the old witch-haunted walls. It was Burns's Alloway Kirk we paid for, and we find we have bought a share in the griefs of James Russell, seedsman; for is not the stone that tells this blinding sorrow of life the true centre of the picture, and not the roofless pile which reminds us of an idle legend?
>
> (Holmes 1864: 151–152)

The desire that brings Holmes to the image in the first place is the same desire that underwrites the Romantic love of ruins. But Holmes is stopped short by the grave and pulled into a consciousness of human sympathy and commonality with James Russell and his family, just as the spell of the exotic view of difference in the Grand Tour stereographs is broken by the common sameness of the clothesline. It may be that we cannot fully understand the historical and social dimension of this view of photography unless we understand it, to some extent at least, as also an American view.

But Holmes's essay juxtaposes this sense of elective affinity and the revelation of a common world produced by the photograph with a potentially less comforting prevision of the role of photography in a modern mass society. Towards the end of 'The Stereoscope' Holmes seems to be almost postmodern in his apparent celebration of the triumph of the copy over the original. The Colosseum or the Pantheon have been replaced by the 'millions of potential negatives' and the 'billions of pictures' made of them. '*Form*,' writes Homes in a state of seeming euphoria, '*is henceforth divorced from matter* Give us a few negatives of a thing worth seeing ... and that is all we want of it. Pull it down or burn it up, if you please' (Holmes 1864: 161). However, such statements should not be taken simply at face value. Holmes's writing is allusive, indirect, suggestive and demands a literary sensibility from the reader. Holmes shifts both the mood and the direction of critical attention dramatically at the close of his essay:

> We are looking into stereoscopes as pretty toys, and wondering over the photograph as a charming novelty; but before another generation has passed away, it will be recognized that a new epoch in the history of human progress dates from the time when He who
> 'never but in uncreated light
> Dwelt from eternity'
> took a pencil of fire from the 'angel standing in the sun', and placed it in the hands of a mortal.
>
> (Holmes 1864: 165)

The first quotation is a misquotation from *Paradise Lost* (Book 3, ll.4–5): Milton writes 'unapproached light', not 'uncreated light'. The second quotation refers us to the Book of Revelation and God's vengeance (19: 17–20). Holmes, then, brings together the divine light (or Tabor light) which is also the light of Christ's and potentially our own transfiguration with the light that announces God's avenging angel who bids 'all the fouls that fly in the midst of heaven' to come and feed upon 'the flesh

of kings and captains' and to help defeat not only 'the beast' but also 'them that worshipped his image'. Holmes offers no explanation for this note of brooding ambivalence; he simply leaves his readers to reflect on the fact that the 'pencil of fire' (surely an allusion to Henry Fox Talbot's *The Pencil of Nature* (1844–1846), the first book of photography ever published) has now been placed in all its ambiguous potentiality in the hands of every human being. Whatever else it is, photography is not for Holmes merely a parlour game.

Biography

Oliver Wendell Holmes was born in Cambridge, Massachusetts, in 1809. He was a member of nineteenth-century New England's social and cultural elite; his family numbered among a group of families which Holmes himself referred to as 'Boston Brahmins' and which helped to found and shape the cultural and social life of the North American East Coast. Having abandoned studies in law, he pursued a career in medicine and became a successful practitioner, and a teacher and researcher at the Dartmouth and Harvard medical schools. But Holmes was far better known during his own lifetime as a poet, novelist and essayist. Though little read today, he was among the most highly regarded American writers of his generation. A number of his poems achieved both critical acclaim and a wide readership. Holmes's place in American literary history rests, however, on his essays in which he developed a distinctive conversational and digressive style of reflection. The essays were fictionalized versions of breakfast table-talk and were gathered in three volumes, *The Autocrat of the Breakfast-Table* (1858) being the first and best known.

Primary texts

Holmes, O. W. (1859) 'The Stereoscope and the Stereograph', *The Atlantic Monthly*, vol 3, no 20 (June), pp738–748.

——(1861) 'Sun-Painting and Sun-Sculpture', *The Atlantic Monthly*, vol 8, no 45 (July), pp13–29.

——(1863) 'Doings of the Sunbeam', *The Atlantic Monthly*, vol 12, no 69 (July), pp1–15.

——(1864) *Soundings from the Atlantic*, Boston, MA: Ticknor and Fields.

The Atlantic Monthly articles are available through Cornell University at http://digital.library.cornell.edu/a/atla/index.html or through Project Gutenberg at http://onlinebooks.library.upenn.edu/webbin/gutbook/serial?name=The%20Atlantic%20Monthly.

Secondary texts

Ellenbogen, J. (2010) 'The Eye of the Sun and the Eye of God,' *Visual Resources*, vol 26, no 2, pp113–130.

Gibian, P. (2004) *Oliver Wendell Holmes and the Culture of Conversation*, Cambridge: Cambridge University Press.

Marien, M. W. (1997) *Photography and Its Critics: A Cultural History, 1839–1900*, Cambridge: Cambridge University Press.

Sekula, A. (1981) 'The Traffic in Photographs', *Art Journal*, vol 41, no 1, pp15–25.

Small, M. R. (1962) *Oliver Wendell Holmes*, New York, NY: Twayne.

Taft, R. (1938) *Photography and the American Scene: A Social History, 1839–1889*, New York, NY: Macmillan.

Trachtenberg, A. (1989) *Reading American Photographs. Images as History: Matthew Brady to Walker Evans*, New York, NY: Hill and Wang.

——(1991) 'Photography: The Emergence of a Key Word', in M. A. Sandwiss (ed) *Photography in Nineteenth-Century America*, Fort Worth/New York: Amon Carter Museum/Harry N. Abrams, pp16–47.

West, N. (1996) 'Fantasy, Photography and the Marketplace: Oliver Wendell Holmes and the Stereoscope', *Nineteenth-Century Contexts*, vol 19, no 3, pp231–258.

Shamoon Zamir

BELL HOOKS (1952–)

Fundamental to understanding bell hooks's writing on photography is to see it as part of a larger project that seeks to understand, from the point of view of critical theory, the politics of representation. 'Representation', she asserts, 'is a crucial location of struggle for any exploited and oppressed people asserting subjectivity and decolonization of the mind' (hooks 1995: 3). Having been academically trained during the late 1970s and early 1980s, hooks has been strongly influenced not only by the Civil Rights Movement, but also by feminism, post-colonialism, post-structuralism and deconstruction. Hers was an important voice in cultural debates of the 1990s that were grappling with what was at the time ubiquitously referred to as multiculturalism, a phenomenon of seeming racial, gender and cultural inclusionism that art critic Lucy Lippard described as a mixed blessing for people of colour (Lippard 1990). Broadly speaking, hooks's work is dedicated to the examination and polemical critique of hegemonic discourses as they manifest themselves in representation, understood in both its cultural sense as a 'depiction of' and in its political sense as something that 'gives voice to'. Thus, her writing has focused on depictions of

race, class, gender, sexuality and ethnicity as they are found in literature and literary criticism, film, art, music and politics.

Although she writes about visual art (including painting, sculpture, film and photography) and aesthetics in several of her books, including *Outlaw Culture*, *Black Looks*, *Yearning* and *Reel to Real*, it is in her book *Art on My Mind: Visual Politics* that she offers her most sustained discussion of photography. In this book, hooks examines, through both essays and interviews, the work of photographers such as Robert Mapplethorpe, Lyle Ashton Harris, Carrie Mae Weems, Lorna Simpson and Andres Serrano, as well as artists who sometimes employ photographic methods and imagery: Glenn Ligon, Félix González-Torres, Emma Amos, Arthur Jaffa and Marlon Riggs. Hooks does not study photography in terms of its formal qualities, its technological features or its historical development as manifested through the work of canonical practitioners. Rather, she employs diverse techniques and literary genres such as memoir, editorial essay and interview to understand photography in both its ideological and counter-ideological forms.

Among the essays and interviews collected in that volume, hooks's 'In Our Glory: Photography and Black Life' offers a sustained theory of photography in relation to African-American experience in the US. In what reads as a canny nod to Roland Barthes's famous search for and discussion of the childhood photograph of his mother in his book *Camera Lucida*, hooks's essay begins with her discussion of a photograph of her father, Veodis Watkins, taken when he was a young man. Of this snapshot, she writes in Barthesian fashion: 'I want to rescue and preserve this image of our father, not let it be forgotten. It allows me to understand him, provides a way for me to know him that makes it possible to love him again, despite all the other images, the ones that stand in the way of love' (hooks 1995: 56). Hooks's photographic search is tinged not with maternal longing as it is for Barthes, but with the fraught politics of black paternity and masculinity. The photograph, showing a smiling and seemingly carefree young man posed next to a pool table, comes to stand for the ways in which photography has functioned as a means of identity formation, self-fashioning and self-representation in black communities. As she writes: 'Cameras gave black folks, irrespective of class, a means by which we could participate fully in the production of images. Hence it is essential that any theoretical discussion of the relationship of black life to the visual, to art making, make photography central' (hooks 1995: 57).

For hooks, the photograph is an agile technology that crosses class divisions and that enables African-Americans to define reality (Wilkins

1992: 44–45) and produce counter-hegemonic imagery. In short, the camera is a tool for transgressive self-imagining and radical world-making among people who are routinely reduced to grotesque stereotypes in the representations most often produced by dominant white culture. Moreover, to the degree that photography is commonly used to document family, it functions as a portable means towards the preservation of genealogical lineages and family histories, a particularly crucial role in a racist society that has sought – during the period of slavery, the great migration and, more recently, through the disproportionate incarceration of black men – to separate black families. 'When we concentrate on photography,' she writes, 'we make it possible to see the walls of photographs in black homes as a critical intervention, a disruption of white control over black images' (hooks 1995: 59). In addition to their critical function – their role in questioning racist ideologies – such photographs also have a part in the glorification of black life, the production of a positive visual vocabulary that is, in her words, unashamed, living, open and free.

The photographers of colour about whom hooks writes and whom she interviews are engaged in the same form of critical intervention and the production of race-positive imagery on a larger scale. She regards their work as subversive, as transgressing aesthetic boundaries as well as racial and class divisions, and as interrogating privilege. Moreover, she regards them as offering an alternative aesthetics in which beauty is a consequence of political freedom. For example, she says of Félix González-Torres's work that it 'declares that to be political is to be alive – that beauty resides in moments of revolution and transformation' (hooks 1995: 53). In her lively interview with Carrie Mae Weems, hooks describes the photographer's work as a moving representation of 'the exilic nature of black people'. It constitutes more than a mere document of black life; it is a trenchant critique of the politics of representation and a keen analysis of race and gender (hooks 1995: 74–76).

In addition to her celebration of photographers such as Weems and Lyle Ashton Harris, hooks was a persuasive and influential voice in the condemnation of white photographer Robert Mapplethorpe's famous *Black Book*, published in 1986, which contains a series of nearly 100 black-and-white photographs of nude black men in erotically charged poses. Her essay 'Representing the Black Male Body' was included in the influential exhibition 'Black Male: Representations of Masculinity in Contemporary Art' at the Whitney Museum of American Art in 1994. The text engages the work of cultural critics including Kobena Mercer, Michael Dyson and Melody Davis, and

analyses depictions of black male bodies from media images of Michael Jordan to Mapplethorpe's male nudes. She views Mapplethorpe's images as complicit in the complexly racist history of depictions of black men, depictions that routinely portray them as overly sexualized and aggressively masculine in their physicality, on the one hand, and passively objectified, one might say feminized, on the other. These tropes are not only blameworthy for their racist characterizations of black men, hooks suggests, but because they foment homophobia and sexism. More objectionable than Mapplethorpe's photographs, however, is the critical apparatus that surrounds them, which, even when it negatively assesses the sexism and racism in which he and other white male artists partake, still valorizes and gives market exposure to white photographers at the expense of photographers of colour. For hooks, this tendency can only 'be countered by the production and curatorial dissemination of a substantive body of oppositional representations from diverse locations' (hooks 1995: 210).

Not without her detractors, critics sometimes complain that hooks's writing is polemical, that it lacks proper citations, and that it relies too heavily on jargon (Barnet 1995: 25; Farris 1996: 93). English and film studies scholar Michelle Wallace is perhaps the most outspoken. In her review of *Art on My Mind*, she accuses hooks of sloppy scholarship, self-indulgent writing, unyielding and dogmatic political positions and venal motives. With regard to her prolific output, comprising more than 35 books and hundreds of articles and essays, Wallace describes hooks as a 'one woman black feminist cottage industry'. 'I have grown accustomed to making excuses for the doctrinaire, self-righteous attacks on various members of her ever-expanding hit list', she continues, 'as well as her repetitive sloppiness in the use of such catch-all condemnatory phrases as "white supremacist patriarchal domination"' (Wallace 1995: 8). The severity of Wallace's critique is an index of the enormity of what is at stake in their shared political cause. If hooks does not acknowledge her sources, does not contextualize her work within a broader history of black scholarship, and does not bring greater nuance to her arguments (including being willing to acknowledge the positive contributions of white scholars), Wallace fears that she will undermine efforts to critique racism and sexism and to bring about greater equality.

Although hooks's writing on photography constitutes only a small portion of her oeuvre, one can see her views on that medium reflected more broadly in her strategic approaches to writing itself. Just as she prizes the snapshot over the fine art photograph, the personal photographic archive – animated by private narratives – over

institutional collections and discourses, so she values non-professional, non-academic writing techniques and autobiographical accounts over traditional academic conventions. Thus, while Wallace's concerns may have merit with regard to hooks's role as a scholar and public intellectual, understanding her work as a radical snapshot, as a personal archive of images and stories, with their capacity for 'critical intervention', helps to contextualize her approach to writing and expand in interesting ways the implications of her views on photography. Her approach might be understood as a form of 'working-class scholarship' in which, to quote another critic, 'art is not an adornment for life, but essential to it' (Winchester 1996: 390, 391).

Biography

Born Gloria Jean Watkins in 1952, hooks grew up in segregated Kentucky, US, and in 1978 took on the pseudonym bell hooks in honour of her great-grandmother, Bell Blair Hooks. She received a BA in English Literature from Stanford University in 1971, an MA from the University of Wisconsin in 1976, and a PhD from the University of California at Santa Cruz in 1983, where she wrote her doctoral dissertation on the work of Toni Morrison. She has taught English, ethnic studies, Afro-American studies, women's studies and English at the University of Southern California, Yale University, Oberlin College, the City College of New York and Berea College in Kentucky. A prolific essayist, she has written extensively on the relations between race, class, ethnicity, gender and culture. In addition to numerous books, she has published essays in a variety of anthologies and in academic journals such as *Callaloo*, *Signs* and *American Literary History*, as well as articles in political, literary and art periodicals such as *Z Magazine*, *Utne Reader*, *Art in America* and *Artforum*. Her work has examined contemporary art, film, photography, music, literature, the media, feminism, pedagogy and politics. She has also published poetry, children's books and memoirs.

Primary texts

hooks, b. (1990) *Yearning: Race, Class and Cultural Politics*, Cambridge, MA: South End Press.
——(1992) *Black Looks: Race and Representation*, Cambridge, MA: South End Press.
——(1994) *Outlaw Culture: Resisting Representation*, New York, NY: Routledge.
——(1995) *Art on My Mind: Visual Politics*, New York, NY: New Press.
——(1996) *Reel to Real: Race, Sex, and Class at the Movies*, New York, NY: Routledge.

Secondary texts

Barnet, A. (1995) 'Books in Brief: Nonfiction', *New York Times Book Review*, 17 September, p25.

Farris, P. (1996) 'Review of *Art on My Mind: Visual Politics*, by bell hooks', *Art Journal*, vol 55 (Fall), pp91–93.

Lippard, L. (1990) *Mixed Blessings: New Art in a Multicultural America*, New York, NY: Pantheon Books.

Wallace, M. (1995) 'Art for Whose Sake?', *The Women's Review of Books*, vol XIII, no 1 (October), p8.

Wilkins, R. (1992) 'White Out', *Mother Jones*, November/December, pp44–45.

Winchester, J. (1996) 'Review of *Art on My Mind: Visual Politics*, by bell hooks', *The Journal of Aesthetics and Art Criticism*, vol 54, no 4 (Autumn), pp389–391.

Jane Blocker

IAN JEFFREY (1942–)

As well as an inspired essayist, Ian Jeffrey is primarily known as the author of a number of books that offer varying perspectives on photographic history, including *Photography: A Concise History* (1981), *Revisions* (1999) and *How To Read a Photograph* (2008). All of these books have been aimed at a wide readership and have embraced the challenges of a market where the interests of the specialist, the student and the intrigued newcomer are likely to intersect. In these books, on the one hand, Jeffrey has consistently appeared as a writer operating to a brief, while, on the other, the books have provided the discipline through which he has honed a unique form of critical writing, one that is intent on clarity and that enlivens its evident scholarship with speculation, wit, a fondness for vernacular language and a tendency towards anarchy. Having played a leading role in establishing photography as a new art historical discipline in the UK during the 1970s, Jeffrey has, especially over the last 20 years, largely distanced himself from academic discourse, preferring to adopt a determinedly independent voice that is fired first and foremost by his strong responses to photographs themselves.

During the late 1960s and 1970s photography had little institutional or academic status in the UK. There were no specialist photography departments in British museums and no courses devoted to photographic history at British universities. But for Jeffrey this marginal status was liberating: 'photography came as a fantastic relief from what I had known'; there were 'few set texts' and in research terms the field was wide open. And, for a young art historian, it was an attractively radical option, subverting art historical hierarchies and embracing what

Jeffrey's colleague David Mellor has called a 'dirty history', one of 'commercial pressures, state agencies and anonymous archives where photography had its awkward but distinctive places' (Evans 1997: 132). Looking beyond that period's narrow pantheon of recognized photographic artists, was not, as Jeffrey put it, to gaze 'into an arid infinity but into some complex place where the ordinary is mixed inextricably with the dissonant and the enigmatic' (Jeffrey and Mellor 1975: 5). The research also had a stirring immediacy. Photography's sacred texts were magazines such as *Life*, *Picture Post* and *Lilliput*, which were at the time readily and cheaply available in local bookshops. Many of the photographers, particularly those in the UK who were seen as seminal figures of this newly opening history, were also still there to provide first-hand accounts, and during the 1970s many important interviews were conducted by Jeffrey, Mellor and others that underpinned later book and exhibition projects.

The first of these projects, whose catalogue included Jeffrey's first concerted piece of writing on photography, was the exhibition *The Real Thing*, organized for the Hayward Gallery, London, in 1975. Subtitled 'An Anthology of British Photographs 1840–1950', an important aim of the exhibition was to challenge and rewrite the conventional and largely American account of British photography of the time, one 'largely de-coupled from cultural or social histories' (Mellor quoted in Evans 1997: 132). *The Real Thing* introduced a more nuanced and pluralist view of British photography and its artistic, social and industrial/commercial contexts, in the process rediscovering long-overlooked practitioners such as James Jarché, while reinstating the importance of others such as E. O. Hoppé and Cecil Beaton. However, in 1975, the exhibition was already set in counterpoint to developing theoretical criticism that argued strongly against both the 'real' history and the 'realism' of photography that its title had implied (see Burgin 1982).

Although he openly attacked the new photographic theory (see Brittain 1999: 88–97), it was its dogmatic tendencies rather than its broad spectrum of ideas that Jeffrey fundamentally objected to. In the introduction to *Photography: A Concise History* he wrote: 'It would be possible, and perhaps justifiable, to write a (photographic) history in which individuals scarcely appear, one in which credit is given to impersonal ideological determinants. Such a history would be centrally concerned with news, advertising and fashion, and would be both fascinating and intricate; it would be concerned with non-visual matters, opinion forming and social control' (Jeffrey 1981: 8–9). But for Jeffrey the biographical details and imaginative capacities of individual photographers,

and the evidential nature of photographic transcription, remained central to the understanding and interpretation of photographs. The achievement of his 'Concise History' was to set those details, for the first time, within a social and cultural fabric rich in illuminating detail, whether regionalist reporting in nineteenth-century Norfolk (when discussing P. H. Emerson) or small farm production in 1930s America (Farm Security Administration photographs). The book is a brilliant series of interwoven vignettes and introduced what would be an enduring quality of Jeffrey's writing that is the balancing of empiricism, his tracing of iconographic and aesthetic origins, with an eagerness to entertain possibilities in response to particular pictures and the circumstances of their making.

During the 1980s in the UK, with a new social order emerging and with new theories of photography to consider, there were widespread readjustments in photographic practice. Jeffrey became one of the most astute commentators on this transitional practice, although again his writing often cut against the grain. As photographers defined and marketed their ideas and strategies more rigorously, proffering issues as much as images, Jeffrey remained resolutely anti-didactic, refusing to be distracted from his primary interest in the content of their photographs. For him, contemporary photography presented ever more enticing invitations to inhabit pictures both as a narrator and a guide. In response to an image of a seaside café by the British photographer Jem Southam, for example, Jeffrey begins: 'Imagine an unambitious restaurant at a beach resort. The owners want to give the place an identity, and this means colour schemes, compatible furniture and a house style in tableware. The work, however, is hard, and no fortunes are made. Life becomes a question of managing or getting by. An ashtray is broken or stolen, and is replaced with whatever comes to hand ... a plastic seat cover splits, to be quickly tacked together until there is more time' (Jeffrey 1987: 5). Characteristically, Jeffrey grounds his response in the quotidian, in everyday human activity: work, striving, disappointment, pragmatism. Photography communicates partly, he suggests, by offering us the opportunity to recognize and consider the continuities and contingencies of human endeavour over time (as well as, elsewhere, its uncertainties, disjunctions and aberrations). By empathizing with Southam's view, 'so achingly full' (Jeffrey 1987: 5) of the details above, and perhaps in some way by becoming the photographer in the act of writing, Jeffrey's aim is not to pin down and seal the photograph's meaning, but to open it up and engage the viewer in his or her own imaginative process. Jeffrey not only places significant value on what we see in the photograph, in its

trace of the real, but also on the integrity and authenticity of the human activity that it represents, two things implicitly challenged by photographic theory.

Increasingly during the later 1980s and 1990s, Jeffrey became pre-occupied with this form of responsive writing as a practice. His language, with its use of vernacular phrasing and art historical terminology, its blending of the conversational and the arcane, was both readably direct and intellectually bracing. It seemed a hybrid language, rid of clichés, often abrupt and then deftly poetic, a form ideally suited to the collapsed distinctions between 'high' and 'low' culture alive in postmodernism, and to the enigmatic power of common photo-graphs. Jeffrey's writing was well tuned to the ironies and ambiguities of photography during the 1980s and 1990s; but when applied to more scholarly projects, such as his retrospective view of Bill Brandt's work *Bill Brandt: Photographs 1928–1983*, it found a subject to expand into, and the results were at once critically incisive and entertainingly brisk. Characterizing Brandt's bleak landscapes for his series *Literary Britain*, for example, Jeffrey says: 'Brandt's contemporaries, most of them subject to *horror vacui*, cluttered their literary sites with friendly paraphernalia, with summer clouds and wicket gates. Brandt and his tenants put the shutters up – literally in some cases – and the result is a landscape of exclusion and negation, a landscape of absence' (Jeffrey 1993: 35).

Although he has remained unconvinced about the viability of a coherent photographic history, in his book *Revisions*, written to accompany an exhibition of that name at the National Museum of Photography, Film and Television, Bradford, Jeffrey took the oppor-tunity to redress the imbalance of his earlier 'Concise History', rein-stating layers of photographic production that he had recognized as significant but deliberately excluded from that narrative. Drawn mainly from the museum's collection, and therefore embodying to some degree that institution's history of collecting, Jeffrey's book nevertheless uses the opportunity to unveil fragments of a commercial, industrial and technological history that, as he suggested, might constitute 'photography proper, with better claims to that position than anything produced by the medium's major artists', a photography 'deeply implicated in what could be provisionally termed the cultural unconscious' (Jeffrey 1999: 8).

Although it includes two intriguing sections of 'amateur' photo-graphs from the two world wars that could have been part of *Revisions*, Jeffrey's *How To Read a Photograph* (2008) returns to the surveying of major artists. But for this book he devised what was for him a more workable solution to the historical overview: what he

has called 'an atomised history in near vernacular English' that considers the work of over 100 photographers organized into chronologies, specific picture analyses and more general contextual comments. In many ways the book is both a vehicle for and demonstration of Jeffrey's evolved approach to writing about photography: a collection of social, historical and biographical accounts that, from micro-readings of pictures, opens out to form what Max Kozloff calls in his preface a 'panorama of observers, idiosyncratically engaged with their world, as chance, enterprise and purpose would allow' (Jeffrey 2008: 7). As the book's title suggests, the approach is instructive, but also companionable to its imagined audience: though photographs 'invite naming and reading', these are essentially 'tautological and redundant exercises … Documentary returns us to early childhood in the first instance, before raising supplementary questions' (Jeffrey 2008: 363). It is these questions, this consistent uncertainty, which sustains Jeffrey's interest in photography.

In *How To Read a Photograph*, with reference to a photograph by Roger Fenton, Jeffrey says: 'It was photography's destiny to be scanned and seen through … leaving the nuances as a reserve – too elusive for public speech' (Jeffrey 2008: 19). It has been Jeffrey's abiding task to give voice to those nuances as signs, not of social control but of a mosaic of cultural influences and formations, and as inflections of biography and psychology that benefit from his natural impulse towards speculation. Reviewers of *How To Read a Photograph* tended to approach the book as something of a guilty pleasure (see, for example, Hargreaves 2009: 85), suggesting not only the scent of the illicit in Jeffrey's writing but also the attraction of his role as a rule-breaker, part consummate scholar, part unrepentant renegade resistant to all forms of authority, including the 'old school' art establishment, academic institutions, received wisdom and photo-theory. As he has said: 'In "real life", I like certainties, delimited fixities which can be weighed up, held in the hand (empirical), and I like pictures which are apparently fixed (discrete) but which have a convulsive side – one of those tropes where things large, noble and distinctive dissolve into a shower of wayward words.'

Biography

Born in Edinburgh in 1942, Ian Jeffrey read history at Manchester University during the early 1960s and went on to undertake postgraduate studies in Italian Renaissance art at the Courtauld Institute, London. He taught art history at Goldsmith's College from 1970,

where he became an influential figure for the generation of young British artists, including Damien Hirst, who studied there during the 1980s. Jeffrey contributed an essay to the catalogue of the Young British Artists' (YBA's) ground-breaking exhibition *Freeze* (1988). A book of his own photographs, *Universal Pictures*, was published in 2003. He lives and works in Suffolk.

Note

Unless otherwise attributed, all quoted remarks by Ian Jeffrey are either from notes to the author or from an interview with the author conducted on 9 March 2011.

Primary texts

Jeffrey, I. (1981) *Photography: A Concise History*, London: Thames & Hudson.
——(1987) 'Stories of Detection and Home-Made Majesty', in *Inscriptions and Inventions*, London: British Council.
——(ed) (1993) *Bill Brandt: Photographs 1928–1983*, London: Thames & Hudson.
——(1999) *Revisions: An Alternative History of Photography*, Bradford: National Museum of Photography, Film and Television.
——(2008) *How To Read a Photograph*, London: Thames & Hudson.
Jeffrey, I. and Mellor, D. (1975) *The Real Thing: An Anthology of British Photographs 1840–1950*, London: Arts Council of Great Britain.

Secondary texts

Brittain, D. (ed) (1999) *Creative Camera: Thirty Years of Writing*, Manchester and New York: Manchester University Press.
Burgin, V. (ed) (1982) *Thinking Photography*, London: Macmillan Press.
Evans, J. (ed) (1997) *The Camerawork Essays: Context and Meaning in Photography*, London: Rivers Oram Press.
Hargreaves, R. (2009) 'Review of *How To Read a Photograph*', *Photoworks Magazine*, Brighton, issue 12, May–October.

David Chandler

MAX KOZLOFF (1933–)

Max Kozloff's approach to photography has always been circumspect. In 1967, a showing of three young photographers, Diane Arbus, Lee Friedlander and Garry Winogrand, at New York's Museum of

Modern Art caught his eye. Although classed by the gallery as artists, Kozloff admired their diagnostic take on the US in a time of crisis. American fact, in the 1960s, was, he thought, stranger than fiction, and this odd state of affairs was the new photographers' subject matter. In his foreword to *Photography and Fascination*, a collection of 13 essays published in 1979, he noted an 'ongoing obsession with photography' that had started ten years back 'as a pleasant interest' (Kozloff 1979: 4).

This obsession was prompted by misgivings about the new art (minimalism and conceptualism) which was coming into being during the late 1960s and early 1970s. Around 1970, Marcel Duchamp was a prime instigator of aesthetic introversion. Duchamp's disinterested puzzles evoked little in the way of 'individual experience' and more or less disregarded history and tradition. Kozloff may have disapproved but, at the same time, enjoyed Duchamp's epistemological challenges. He was even harsher on Ludwig Wittgenstein's 'self-liquidating discourse'. His objections to Wittgenstein, and to Viennese and modernist thought, in general, are developed in an uncollected review of *Wittgenstein's Vienna* by Allan Janik and Stephen Toulmin, published in *Artforum* in December 1973.

Wittgenstein's ethics, Kozloff remarks, 'has nothing to say about the way people might best behave toward each other in a particular society – that is, a bounded and limited situation' (Kozloff 1973: 77). To accept these ethics, 'you must do away with yourself as an embodied, localized receiver, you must render yourself "transparent"' (Kozloff 1973: 77). Kozloff's sympathies, as declared in these texts on Duchamp and Wittgenstein, were for embodied individuals acting in quite material circumstances, subject to custom and histories large and small. They relied on common sense and would have made very little of Duchamp's finessing and of Wittgenstein's restricted reasoning. Worst of all, such modernist theorizing obscured the workings of history, from which a lot might have been learned.

Seen from Kozloff's well-founded point of view during 1970, there was very little to be expected from vanguard art in the foreseeable future. Photography, most of which was locally practised and thoroughly empirical, must have looked attractive when approached from this viewpoint. Nor, at that time, was photography discussed with any great acumen. *The Photographer's Eye*, assembled by John Szarkwoski for the Museum of Modern Art in 1964, was grouped under a set of headings: 'The Thing Itself', 'The Detail', 'The Frame', 'Time', 'Vantage Point'. These were useful categories, applicable to most photographers at any time, but explained next to nothing. Szarkowski, a

curator in an influential organization, also wrote *ex cathedra*, with a bias towards formalism. He remarked on pictorial geometry and on the achievement of 'balance and clarity and order'. Under formalist terms of reference, assessors could intuit a picture's virtues at a glance. Formalism omitted history and consideration of context, and in Kozloff's scheme of things that was quite irresponsible. In 1973, in *Looking at Photographs*, Szarkowski tried to put things right by mixing formalist appreciations with empirical data and subjective asides.

Despite his obsession and the provocations offered by John Szarkowski, and by Walter Benjamin and Susan Sontag (all three mentioned in the foreword to *Photography and Fascination*), Kozloff was slow to find his stride. His first accomplished essay on a photographer was on Ralph Eugene Meatyard (*Artforum*, November 1974). It is a review of a monograph published by *Aperture*, the most noteworthy photographic publisher of that era; but more strictly it is an account of the writer's encounter with Meatyard's mysterious oeuvre. He has to find his way through a life's work, and the narrative involves his efforts to understand. He makes distinctions and comparisons, placing Meatyard in the history of the medium. Looking for a way forward, he might offer a careful description of a scene, or pause on a particular word to test its possibilities. He hazards a guess because he suspects that there is really no knowing what Meatyard saw in the pictures. In Meatyard's case, he ends with a sequence of major proposals, one to a sentence, each one challenging enough to constitute an essay in itself. His tendency has always been to maintain a stream of consciousness, closely argued and informed, often suddenly and surprisingly enlarged.

Wanting to understand the medium as fully as possible, he undertook a long essay, 'Photography and Fascination', written in 1978 and used as an introduction to the collected essays published under that title. He wanted to clarify certain terms and to find out just what could be known about photography. What sort of impacts had it made upon behaviour and upon expectations since its invention. Always wary of what he calls 'shorthand', meaning the brisk certainties used by dogmatists, he scouted photography's position in detail. We understand it, for instance, as a naturalistic medium, although at the same time its frozen moments are not what we are used to in real life. It contributed to asymmetries in social life, introducing us to much of which we had no first-hand knowledge. Its meaning depended on usage and on caption writing, and it was intrusive and even aggressive. Kozloff thinks of what it is like to take a picture of another creature, of the uneasiness involved, and goes on to discuss Paul Strand's famous portrait of a blind street vendor taken in 1916. Photography originated at a time

of social upheaval and of mass migration and mediated between the uprooted dwellers in the expanding cities and the varied world at large. Although it catered for the new masses, it did so one at a time, most obviously via the stereopticon. This text, like many of his texts, is marked by a liking for paradox: photography as a medium which promises insights but which is weighted towards surface details – a mass medium which can only be scanned in solitude.

That 'fascination', mentioned in the essay title of 1978, results from photography's 'high intensity stimulus', sometimes delightful and sometimes repellent. The 'protean swirl' of photographic images, of the kind represented in *The Photographer's Eye*, is regulated by 'photographic culture', hinted at but certainly not itemized in 'Photography and Fascination', which deals mainly with the social psychology of the medium. Kozloff's ethical stance, as outlined in the Wittgenstein piece, is clear – embodiment at all times combined with a respect for singularity; but photographic culture with all its protean elements was much harder to place. His writing, often cast in the narrative mode in which he features as an explorer and investigator of his own responses, might, of course, be picked apart and systematized, although that would be a betrayal of the spirit of the venture.

The photography writings, important though they are, can be thought of as entertainments. They are, as suggested, narratives recounting his engagement with a topic in photography. In the course of the story he almost always comes across obstructions in the shape of liberal art history – for example, incapacitated by complacency. Single issue theorists appear and are disposed of, as are formalists. Oddly, given his attachment to history, empirical research is also treated brusquely. Most of it is, as readers know, beside the point and is part of a museum inculcated blight which has affected all major figures in the medium. Detailed research into itineraries, income and employment also results in low-intensity prose easily disregarded. Kozloff's assumption is that an unattractive text won't be read. With this in mind, he ranges far and wide in language: archaic slang – for example, the 'flivver automobiles' of J. H. Lartigue – before touching on Kantian 'apperception', a difficult term which occurs in his essays whenever the relationships between perceptions and concepts is at issue. He looks always, too, for the *mot juste*, liking its sometimes strange outcomes (for example, 'frothing modernism'). Mainly, though, he writes with a horror of cliché and of disposable phraseology.

The essay of 1978, 'Photography and Fascination', has a retrospective feeling. The setting is urban and the tone rumbustious. Photography, especially in the US, had been through some violent

times (for example, in Vietnam) and they had left their mark. History, constituted of wars, mass migrations and shifts in the moods of nations and generations, is still presupposed in the 1978 essay. What came after looks like disintegration or a kind of bathos as new American photographers eschewed heroism. In 1980 Kozloff wrote a text for an exhibition of *American Photographs* of the 1970s: 'Where Have All the People Gone? Contemporary American Photography'. The text seems to have been commissioned by the organizers of the exhibition who must have been taken aback by Kozloff's misgivings. These misgivings were even more pronounced in 1989 in a review 'Hapless Figures in an Artificial Storm', written for *Artforum*. In 1980 he complained that the public and private spheres of contemporary life shared 'a common, spiritless identity' (Kozloff 1987: 197). In 1989 he remarked on 'a bleak public atmosphere of unremitting entertainment' (Kozloff 1994: 293).

Photography, as evaluated by Kozloff in 1978, was a potent medium, affecting the self-standing of everyone involved. It was implicated in the formation of manners and in the shaping of society, and should, ideally, be used with precaution. The rights of the subject ought to be taken into account, and Kozloff was interested in such transgressors as Weegee who took advantage of the distracted and distraught. Kozloff's picture of society, like that proposed by Szarkowski in *The Photographer's Eye*, was energetic and dignified. It was not a static society, of course, but it was marked by continuities. Artists working in such an environment could opt in or out. If in, they had time to develop an interpretation of the world around them (August Sander, for instance, or Eugène Atget). If out, they would be left alone to develop an art of their own devising (Meatyard).

Suddenly, it seems, all of the assumptions of 1978 were called into question. The collective memory, which had been such a feature of Kozloff's early years – the era of American studies – gave out, and a new generation of photographers, epitomized by Lee Friedlander, began to picture their homeland as a wasted archaeological site. Society became untrustworthy, indifferent to its inheritance – to the landscape, in particular. In 1980 photography still maintained itself; but by 1990 the medium was in the process of being subsumed into the culture of simulacra. Photographers, confronted by this newly plethoric image culture, acquiesced, studiedly bemused, or chose the scholastic path. Society, to which Kozloff owed his allegiance, survived; but from the 1980s it was culture which had the upper hand ('unremitting entertainment'), allowing neither time nor space for the kind of career development that had once characterized a Sander, an Atget or a Meatyard. Photographers, from the 1980s onwards, flourished for a

season or two before the scene moved on. Without the extended careers which characterized modernism, there was no longer a tale to be told. With culture in the ascendant, there was no longer an ethical or a moral case to make, and this had always been at the basis of Kozloff's writing.

Biography

Max Kozloff was born in Chicago in 1933 and studied at its university. He took an MA in Art History and in 1959 continued his postgraduate studies at the Institute of Fine Arts at New York University. He taught briefly at the University of Chicago and in New York, but made his name as a reviewer and critic writing for *The Nation* during 1961 to 1968. In *Renderings*, 1969, his first book of critical essays, he paid tribute to the teaching skills of Joshua Taylor at the University of Chicago and to the editorial acumen of Robert Hatch, his editor at *The Nation*. During 1962 to 1963 he was a Pulitzer Fellow and then a Fulbright Fellow in Paris. Between 1961 and 1964 he was New York correspondent of the influential *Art International* magazine. His rise as a commentator was meteoric. In 1963 he became an associate and contributing editor at the newly established *Artforum* monthly in New York. For a while he parted company with *Artforum*, returning as associate editor (books) and then, during 1974 to 1976, as executive editor. *Jasper Johns*, published by Abrams in 1969, was his first monograph. On 15 June 1964, *The Nation* published his review of John Szarkowski's subsequently celebrated survey *The Photographer's Eye*, staged at New York's Museum of Modern Art.

Primary texts

Kozloff, M. (1969) *Renderings: Critical Essays on a Century of Modern Art*, New York, NY: Simon and Schuster.
——(1973) 'Review of *Wittgenstein's Vienna* by Allan Janik and Stephen Toulmin', *Artforum*, December, pp75–77.
——(1979) *Photography and Fascination*, Danbury, NH: Addison House.
——(1987) *The Privileged Eye*, Albuquerque, NY: University of New Mexico Press.
——(1994) *Lone Visions, Crowded Frames*, Albuquerque, NY: University of New Mexico Press.

Secondary texts

Lichtenberg, D. C. (1990) *Aphorisms*, translated by R. J. Hollingdale, Harmondsworth, UK: Penguin Books.

Rosenberg, H. (1964) *The Anxious Object*, New York, NY: Horizon Press.
Szarkowski, J. (1966) *The Photographer's Eye*, New York, NY: Museum of
Modern Art.

Ian Jeffrey

SIEGFRIED KRACAUER (1889–1966)

In his trail-blazing essay of 1927, 'Die Photographie', Siegfried Kracauer
set the tone and purview for a political-sociological approach to photo-
theory. Foreshadowing such diverse thinkers as Jacques Lacan, Roland
Barthes and Jean Baudrillard, Kracauer recognized the extent to which,
already by the late 1920s, the world has 'taken on a "photographic face"'
(Kracauer 1995a: 59) whereby every concept, experience and nuance
must 'yield' to the camera as it is 'absorbed into the spatial continuum of
the snapshot' (Kracauer 1995a: 59). Above all, this 'flood' or 'assault' of
photographs tends to 'sweep away the dams of memory' and threatens
to 'destroy the potentially existing awareness of crucial traits' (Kracauer
1995a: 58). In other words, the photo-image as mass media motif tends
to banalize and render experience generic, 'devouring' whatever it
encounters and leaving only an *ornament* – a 'residuum that history has
discharged' (Kracauer 1995a: 55).

Assessing the impact of mass media photo reproduction, Kracauer
argued that through photography, the object is continuously stripped of
its contextualizing apparatus and history as it is endlessly appropriated
and recycled as *image*: 'Never before has an age [1920s] been so informed
about itself, if being informed means having an image of objects that
resembles them in a photographic sense. Most of the images in the
illustrated magazines are topical photographs, which refer to existing
objects. The reproductions are thus basically signs which may remind us
of the original object that was supposed to be understood' (Kracauer
1995a: 57). In this *mêlée* (violent free-for-all), any adequate historio-
graphy begins to 'crumble' – 'the *contiguity* of these images systematically
excludes their contextual framework available to consciousness. The
"image-idea" drives away the idea. The blizzard of photographs
betrays an indifference toward what the things mean' (Kracauer
1995a: 58).

In this context, we may ask: what is the fate of the photographer?
In Kracauer's conception, the activity of the photojournalist, for
example, is reduced to that of a puppet: independent of subjective
criteria, their photos are merely 'triggered'. In one example, offered

in the 1927 text, athletes at a track event cross the finishing-line and a photo-finish photo (or slit-scan image, as these are known technically) records the placement of the runners, too fleeting to be discerned by the human eye alone. A photo determines the winner of the race and, as is well noted by Kracauer, this first photo also now 'triggers' a second: the activity of the waiting press photographers who seek their photos of the winner – which will appear in newspapers the world over, the following morning. The photojournalist is integral to a process of circulation that is entirely self-sustaining and self-propagating. The press photographer operates automaton-like devoid of will – and so, too, in this way, mass media dissemination appears to circumvent morality simply by rendering it redundant.

The process whereby an athlete (or performer, musician, actress, etc.) becomes a celebrity is hermetic – the result of a chain reaction that is inevitable, utterly predictable, but not inexplicable, for as Kracauer argues, this pervasive urge to endlessly replenish the 'spatial continuum of the snapshot' (we might think, in particular, of the burgeoning photo-hobbyist here) can be interpreted psychologically: the urge is an attempt to circumvent or insulate against the viscera of death, for 'photographs by their sheer accumulation attempt to banish the recollection of death (Kracauer 1995a: 59).' Here, too, Kracauer is pessimistic, for 'in the illustrated magazines the world has become a photographable present, and the photographed present has been entirely eternalized. Seemingly ripped from the clutch of death, in reality it has succumbed to it' (Kracauer 1995a: 59). That is, in the format that Baudrillard would later term 'hyper-reality', the photo-image functions relentlessly as a lure. The apparent comfort of instant *always already* mediation is paradoxical; as Barthes would also later reflect, in our attempts to insulate – or inoculate – ourselves, we unwittingly produce an unexpected trauma; we are immobilized by the 'blizzard' or 'flood' of images that introduce an unexpected paradox. However closer we get, some unreachable distance remains – reality has been mediated; the photo-image *always already* includes distance.

Kracauer also appraises an image printed on the cover of one of the popular pictorial weekly magazines – which began production during the 1920s. The photo depicts a young female film actress promoting a new movie in front of a luxury hotel; her lithe youthfulness is combined with a backdrop that functions to communicate and encode a concoction of sex-and-success. The gathered photographers and the alluring actress collude in the production of a richly connotative 'image' – a cynical but seductive fabrication. Kracauer opens his 1927 essay with this scene because it is the epicentre of a key social

function of photography: here is a photo of a famous person who is instantly recognizable to one and all but only because we recognize her *from other photos and films*.

In perhaps the most well-known section from *Die Photographie* – and one of the most poignant and poetical passages in all photo-theory – Kracauer considers an old photograph of 'a grandmother', very likely an old photo of his own relative. In commenting on the relationship between this person in-person and the photo at which he stares, he introduces a philosophical discourse which prefigures Sartre's commentary on Pierre in his *The Imaginary* in which Sartre argues that in order to capture a 'true likeness' we must resort to distortion – for Sartre a caricature is more effective than a photo:

> When grandmother stood in front of the lens, she was present for one second in the spatial continuum that presented itself to the lens. But it was this aspect and not the grandmother that was eternalized. A shudder runs through the viewer of old photographs. For they make visible not the knowledge of the original but the spatial configuration of a moment; what appears in the photograph is not the person but the sum of what can be subtracted from him or her. The photograph annihilates the person by portraying him or her, and were person and portrayal to converge, the person would cease to exist.
>
> (Kracauer 1995a: 56–57)

Kracauer proposes the photo-portrait as a residue of human presence that has a potent occult-like supernatural quality. But, above all, once again he underlines the disunity between a human and their photo-image – for, of course, they do merge but precisely, only at the moment of death, a theme that was developed later by, for example, Chris Marker in his 1962 film *La jetée*.

Writing a review of Kracauer's sociological study, *Die Angestellten*, in 1930 for the journal *Die Gesellschaft*, the critic and philosopher Walter Benjamin described his contemporary as 'a malcontent, not a leader. Not a founder – a kill-joy. Industrious and solitary: like a stubborn rag-picker collecting scraps from the street – grumbling as he goes and perhaps a little drunk – he scrutinizes each speech-fragment as it flutters in the breeze "humanity", "introspection", "depth" – before tossing it into his cart. Yes, this is Kracauer: a rag-picker at dawn, on the day of the revolution' (Benjamin 1972: 225; author's translation). There are many ways to interpret this evocative description of Kracauer by his friend and contemporary. Perhaps the most cogent

is that the rag-picker here remains utterly indifferent to impending social change, his activity of assessing fragments will continue unaltered before and after any such momentous events; hence, the process, as carried on apparently doggedly by Kracauer, is, Benjamin offers, a kind of basic critical outlook, an activity which is rendered poignant precisely because it is essential in all social conditions – and often carried on by those on the fringes of society. As Foucault, Barthes and Lacan would echo 40 years later in 1960s Paris, the intellectual's critical outlook is absolutely political.

Biography

Born in Frankfurt, Germany, in 1889, Siegfried Kracauer became a journalist and editor; during the 1920s his critical articles and reviews often appeared in the *Frankfurter Zeitung*. In 1933, soon after the Nazi dictatorship began, Kracauer moved to Paris where he spent several years writing a biography of Jacques Offenbach; in 1941, he then moved to New York where, affiliated first to the Museum of Modern Art and then Columbia University, he continued his writing and research work, now with a focus on the history of German cinema. He died in 1966.

Primary texts

Kracauer, S. (1994) *From Caligari to Hitler: A Psychological History of the German Film*, Princeton, NJ: Princeton University Press.
——(1995a [1927]) 'Photography', in T. Levin (ed) *Siegfried Kracauer: The Mass Ornament*, Cambridge, MA: Harvard University Press, pp47–63; originally published as 'Die photographie', *Frankfurter Zeitung*, 28 October 1927.
——(1995b) *The Mass Ornament*, Cambridge, MA: Harvard University Press.
——(1997) *Theory of Film*, Princeton, NJ: Princeton University Press.

Secondary texts

Barnouw, D. (1994) *Critical Realism: History, Photography, and the Work of Siegfried Kracauer*, Baltimore, NJ: Johns Hopkins University Press.
Benjamin, W (1972 [1930]) 'Ein Aussenseiter macht sich bemerkbar. Zu S. Kracauer "Die Angestellten"', in H. Tiedmann-Bartels (ed) *Walter Benjamin: Gesammelte Schriften III*, Frankfurt am Main; English translation: 'Appendix', in Q. Hoare (ed) *Siegfried Kracauer: The Salaried Masses*, pp109–114.
Cadava, E. (1997) *Words of Light*, Princeton, NJ: Princeton University Press.
Lacan, J. (1978 [1973]) 'The Seminar of Jacques Lacan, Book XI', *The Four Fundamental Concepts of Psychoanalysis*, translated by A. Sheridan, New York, NY: Norton and Co.

Reeh, H. (2006) *Ornaments of the Metropolis: Siegfried Kracauer and Modern Urban Culture*, Cambridge, MA: MIT Press.
Sartre, J.-P. (2004 [1940]) *The Imaginary*, Abingdon, UK: Routledge, pp17–19.

Henry Bond

ROSALIND E. KRAUSS (1941–)

Rosalind E. Krauss began as a critic at *Artforum*, but today is mostly associated in people's minds with *October*, an influential American quarterly journal of art criticism which she co-founded with Annette Michelson. Since publishing its first issue in 1976, *October* has played a crucial role in introducing theories drawn from structuralism, post-structuralism and deconstruction into art criticism and art history. Alongside her *October* colleagues Douglas Crimp and Craig Owens, she developed theories that sought to theorize photography within the context of art (see Krauss 1985; Crimp 1993; Owens 1992). Krauss's interest (as well as *October*'s) in photography was aligned, in part, with the growth of postmodern theories and practices, and an emergent younger generation of American photographers – such as Louise Lawler, Cindy Sherman, Sherrie Levine and Richard Prince (often referred to as 'The Pictures Generation' after *Pictures*, an exhibition curated by Crimp in 1977; see Eklund 2009).

These practices were contrasted to the practices and theories of modernism, often associated with the figure of Clement Greenberg but sometimes with Michael Fried; Krauss had personal formative links with both critics. Greenberg, for example, defined modernism as a cultural-historical period within which it was the duty of each art medium (painting, sculpture, music, etc.) to discover and focus upon elements specific to itself and not shared with any other medium. Famously, Greenberg argued that the medium-specific quality of painting was the flatness of the canvas, and so claimed that abstract painters emphasized the flatness of the canvas, thereby sacrificing painting's convention of presenting illusionistic spaces or of being like a 'window upon the world'. Through this process each medium would become 'pure' and 'self-critical' (Greenberg 1993).

To a very large degree, challenging modernism as exemplified by Greenberg's criticism was especially important for Krauss. Her early writings were marked by her intellectual kinship with Fried and indicated the influence of Greenberg (see Krauss 1971). Her break from Greenberg led her to not only positing postmodernism as

the cultural logic that displaces modernism, but also to rethink modernism as a whole through uncovering moments of modernist art largely suppressed or marginalized by conventional modernist theory.

Surrealist photography is one of those areas that has been overlooked by 'traditional' conceptions of modernism. Looking at how Krauss approaches Surrealist photography of the 1920s and 1930s, what theories she draws towards and from it, will help give us a sense of how she engages with photography as such. 'The Photographic Conditions of Surrealism', an essay written in 1981, reveals the importance of Surrealist photography for Krauss. Responding to the problem of Surrealism's stylistic heterogeneity, a problem that has thwarted art-historical efforts to discover a core principle unifying Surrealistic practices, Krauss suggests that its underanalysed photographic works might provide the missing key. She closely reads photographs by Hans Bellmer, Boiffard, Brassaï, Dora Maar, Man Ray, Maurice Tabard and Raoul Ubac and interprets them through André Breton's writings and the deconstructive philosophy of Jacques Derrida (which emerged some 30 years after the photographs she discusses). Although she doesn't proceed explicitly with this, preferring instead to focus upon the photography, the wider ramification of the essay, as suggested by its title, is that apparently non-photographic practices such as Surrealist writing, painting and performance in order to be properly described as 'Surrealist' must contain a condition that is inherently associated with photography. Krauss thus takes a medium considered by some to be 'realist' and renders it markedly 'Surrealist'.

Her important 1985 essay 'Corpus Delicti' redirects art-historical attention away from the centrality of André Breton and towards the dissident Surrealist Georges Bataille (Krauss and Livingston 1985). Especially important is his 'anti-concept' of the *informe* or formless intended to liquefy and refuse the apparently rational boundaries that enclose concepts within particular compartments (see Bataille 1985: 31; see also Bois and Krauss 1997). Krauss detects a correlation between the *informe* and the peculiar strategies of surrealist photography. Indeed, her contention is that the *informe* can assist us in comprehending photographers such as Bellmer (and others) and their recurring use of disarticulated, fragmented, doubled, elongated, distorted and rotated deformations. The representation of form through photography becomes, in Surrealism, the generating of formlessness and the negation of categorical distinctions. From this juncture, Krauss surveys and brings into relation with this brand of photography texts from writers as diverse as Roger Caillois, Sigmund Freud and Roland Barthes. Bellmer's disturbing photographs of dolls, for instance, are studied

through the lens of Freud's essay 'The Uncanny' and its discussion of objects dissolving the border between art and life (see Freud 1955).

Rudolf Kuenzli bemoaned Krauss's apparent blindness to the fact that the disarticulated *informe* representations were mostly of women and thus charged her with ignoring what seemed like a latent misogyny in these images (see Kuenzli 1991). Her relative lack of interest in feminism is further apparent and concretized in essays on photographers Cindy Sherman and Francesca Woodman in *Bachelors*, where she foregrounds the idea of gender as something unfixed, open to the operations of the *informe*, and hence not fully or even at all determined by biology. That is to say, the fact that these artists are women 'needs no special pleading' (Krauss 1999: 50). Given her broad range of influences, Krauss might also be accused of implementing a very *ad hoc* methodology that ignores or downplays the historical specificities of the texts she uses and/or effectively divorces them from the philosophical systems in which they are embedded. Arguably, however, the validity of her references is not to be judged according to how accurately she appropriates from a given philosophical or theoretical (con)text, but rather in connection with how productively she engages with and interprets the artwork under discussion or to what degree they invite us to see familiar artworks anew.

If these examples offer the most direct indication of Krauss's contribution to photography theory, it is worth finishing this entry by considering a significantly less direct contribution which suggests an alternative and intellectually rich way of thinking about what constitutes a photograph. Published across two issues of *October*, Krauss's bipartite 1977 essay 'Notes on the Index' offers a rethinking of Charles Sanders Peirce's semiotic category of the 'Index' and its relevance for artistic practice and for revealing latent unities amid the formally diverse practices of the 1970s art world. The index, for Peirce, is a type of 'sign' that is physically caused by something else – namely, its 'referent' (see Peirce 1940). For instance, a footprint in the snow is a sign caused by someone who has walked through the snow; photographs, too, are taken to be indexes insofar as the photographic image is caused by light particles emanating from the object photographed and exposed on light-sensitive film. Peirce's index is combined with another semiotic concept, that of the 'shifter'; shifters are those signs such as 'here', 'you', 'now' and pointing fingers, all of which are empty or indeterminate with regards to meaning until they are set or spoken within a particular context. However, before examining 1970s art practices, Krauss is intrigued by Marcel Duchamp's famous *The Bride Stripped Bare by her Bachelors, Even* (1915–1923; often referred to as

The Large Glass) and his painting *Tu 'M* (1918), both of which reproduce pre-existing paintings and ready-mades from elsewhere in the artist's oeuvre, and function as antecedents for artists engaging with the index during the 1970s. Especially striking, for Krauss, is Duchamp's peculiar description of *The Large Glass* as a 'photograph'. Another version of this description is proffered in connection with Duchamp's ready-mades, spoken of by the artist as 'snapshots', a contention backed by Krauss insofar as ready-made and photograph alike involve 'the physical transposition of an object from the continuum of reality into the fixed condition of the art-image by a moment of isolation, or selection' (Krauss 1985: 206). According to Krauss, 1970s American art intensifies the indexical logic emblematized by Duchamp. Her opening example is Dennis Oppenheim's *Identity Stretch* (1975), where the artist took his thumbprint (which is an indexical sign) and then reproduced that thumbprint in hugely enlarged fashion in a field in Buffalo by using tar to copy the unique identificatory lines of the thumbprint. This earthwork was then documented through photographs (another index) and a copy of the original thumbprint at its true size that were mounted on board. As an example, she cites in the second part of 'Notes on the Index' Lucio Pozzi's abstract paintings exhibited within a 1975 group show at P.S.1 (a former school that became a gallery). Pozzi's site-specific paintings are positioned upon former school walls bisected into two colours, with the colours varying for different regions of the ex-school; his paintings are likewise divided into two colours and are hung in such a way that each painting's chromatic division is continuous with the chromatic division of the wall. If taken out of their precise architectural context, these paintings would no longer function in the same way insofar as they are 'indexically' related to that context. In a sense, Pozzi's paintings could be viewed as 'photographs' of their site (similar, in that respect, to Victor Burgin's *Photopath*, 1969).

Krauss, we might argue, enacts a reversal between the category of the index and photographs: instead of presenting photography as a specific example of the index or showing how indexical properties define photographs as photographs, Krauss hints that photography could serve as the conceptual bedrock for the index. The photograph, then, is not defined or constrained by its material constituents, such as exposed light-sensitive film, but exceeds that materiality. Indeed, the outcome of Krauss's art criticism and her writings on photography is to make palpable a distinction between material and medium, with the latter akin to a logic or group of possibilities that must find embodiment or take form somehow. Photography is thus shown to exist in an

expanded field within which, for example, site-specific paintings could, however unexpectedly, be comprehended as 'photographs'. Likewise, the giant thumbprint that constituted Oppenheim's earthwork *Identity Stretch* might be considered as a 'photograph' of the original thumbprint.

For much of her career, she has defined her position *contra* notions of medium specificity insofar as such notions were closely identified with Greenberg. But in recent writings on James Coleman, William Kentridge (for both, see Krauss 2010) and Marcel Broodthaers (Krauss 2000), she has reinvested in the medium as a category, seeing within it potentialities for critiquing the spread of installation art. Although this reinvestment and reinvention of the medium seems like a new phase in her criticism, it is better to view it as rendering explicit issues that have for a long time been largely implicit and even under-acknowledged by Krauss. It is also noteworthy that her renewed interest of the medium is largely counterposed to the mediums typically considered by artists and critics. Instead of discussing painting and sculpture, her essays focus on slide projectors, animated drawing and film as mediums – in other words, technologies interconnected with photography in some measure. We might say, in conclusion, that Krauss not only expands the definition and our comprehension of photography, but discovers within photography the resources to rethink what constitutes an art medium.

Biography

Rosalind E. Krauss was born in 1941 and grew up in the Washington, DC, area. She co-founded *October* in 1976 and has been an editor and contributor for the journal since that time. Prior to *October*, she was one of the leading art critics for *Artforum*, first writing for the journal in 1966 and serving as contributing editor from 1971 to 1975. She received her doctorate from Harvard in 1969 and has taught at Wellesley, MIT, Princeton University, the Graduate Centre of the City University of New York and Columbia University.

Primary texts

Bois, Y.-A. and Krauss, R. (1997) *Formless: A User's Guide*, New York, NY: Zone Books.

Krauss, R. (1971) *Terminal Iron Works: The Sculpture of David Smith*, Cambridge, MA: MIT Press.

——(1985) *The Originality of the Avant-Garde and Other Modernist Myths*, Cambridge, MA: MIT Press.

——(1993) *The Optical Unconscious*, Cambridge, MA: MIT Press.

——(1999) *Bachelors*, Cambridge, MA: MIT Press.

——(2000) 'A Voyage on the North Sea': Art in Age of the Post-Medium Condition, London: Thames & Hudson.
——(2010) Perpetual Inventory, Cambridge, MA: MIT Press.
Krauss, R. and Livingston, J. (1985) L'Amour Fou: Photography and Surrealism, Washington, DC: Corcoran Gallery of Art.

Secondary texts

Bataille, G. (1985) Visions of Excess: Selected Writings, 1927–1939, edited and translated by A. Stoekl, Minneapolis, MN: University of Minnesota Press.
Carrier, D. (2002) Rosalind Krauss and American Philosophical Art Criticism: From Formalism to Beyond Postmodernism, Westport, CT: Praeger Press.
Crimp, D. (1993) On the Museum's Ruins, Cambridge, MA: MIT Press.
Eklund, D. (2009) The Pictures Generation, 1974–1984, New York, NY: Metropolitan Museum of Art; New Haven, CT: Yale University Press.
Freud, S. (1955) 'The Uncanny', in J. Strachey (ed and trans) The Standard Edition of the Complete Works of Sigmund Freud: Volume XVIII, London: Hogarth Press and Institute of Psychoanalysis.
Greenberg, C. (1993) 'Modernist Painting', in J. O'Brian (ed) Collected Essays and Criticism, Volume 4: Modernism with a Vengeance, 1957–1969, Chicago, IL: University of Chicago Press.
Kuenzli, R. (1991) 'Surrealism and Misogyny', in M. A. Caws, R. Kuenzli, and G. Raaberg (eds) Surrealism and Women, Cambridge, MA: MIT Press.
Newman, A. (2000) Challenging Art: Artforum 1962–1974, New York, NY: Soho Press.
Owens, C. (1992) Beyond Recognition, edited by S. Tilman et al, Berkeley, CA: University of California Press.
Peirce, C. S. (1940) 'Logic as Semiotic: The Theory of Signs', in J. Buchler (ed) The Philosophy of Peirce, New York, NY: Dover Press.

Matthew Bowman

CAROL MAVOR (1957–)

Carol Mavor's seductive readings of photographic imagery are informed not only by rigorous archival research and the application of complex ideas and theories, but also from the perspective of an artist and maker; she studied painting and film at undergraduate level, and received an MFA in Studio Practice. Her writing – always erudite, often surprising – is a pleasure to read. Characterized by extended metaphors and sophisticated wordplay, where theoretical allusions often depend upon textual puns, her texts palpably *perform* on the page. Her evident curiosity in the way in which photographs signify emotionally as well as intellectually ensures that her histories are not

reduced to analyses dictated by a purely scopic regime but, instead, encourage the engagement of all our senses; they invite us to take delight in the photographic object and the way in which it affects the sensate body and memory. Describing how she works, Mavor writes: 'I better understand what I see through the sense of touch, even if I'm not actually touching them [the photographs]' (Mavor 1995: 68). But Mavor's sensitivity to the potential subjectivity of photographic meaning – how they make us *feel* – is always matched by her scholarly knowledge. While discussing the photographs of Julia Margaret Cameron (1815–1879), for instance, she explains that Cameron's husband, Charles Hay Cameron, wrote a treatise that considered the relationship between touch and sight and concluded that an understanding of what we see is always underpinned by the haptic (Mavor 1995: 68–69).

Mavor has published extensively: books, essays, articles and interviews. She contributes regularly to anthologies and exhibition catalogues. *Pleasures Taken: Performances of Sexuality and Loss in Victorian Photographs* put Mavor on the photo-history map. Originally published by Duke University Press in 1995, it was reissued in Britain by I.B. Tauris a year later. The book analyses three bodies of work from the nineteenth century: by Cameron, Lewis Carroll (aka the Reverend Charles Dodgson) and the Victorian gentleman and amateur photographer Arthur Munby. All three 'portfolios' of photographs involve an element of performance, whether Mary Hillier (Cameron's maid) dressed as the Virgin Mary or Hannah Cullwick (Munby's collaborator of sorts) acting out her servant-hood as a form of slavery, naked and 'blacked' up with a chain around her neck. The young girls that Carroll/ Dodgson photographs also perform before him: whether it's the game of playing out myths and fairy tales for the camera, or a parody of adult sexuality (as evident in *Portrait of Evelyn Hatch*, circa 1878).

Mavor's quest for authenticity in her understanding of how photographs *really* signify is stated explicitly in *Pleasures Taken*: 'the photograph's analogical relationship with its referent doesn't stop there [as simulacrum]; it extends into our fantasies or our identities and histories. The "reality of an object" in a photograph, like the smell and taste of Proust's Madeleine cakes, triggers our own memories, our own stories' (Mavor 1995: 4). Her *homage* to Roland Barthes's *Camera Lucida* is evident in all her writings. What distinguishes the two writers here, perhaps, is this: Barthes *looks* for the essence of his mother in *Camera Lucida*. Mavor *feels* her way around the multifarious possible meanings of the photographs she engages with. An emphasis on tactility and sensuality – the intimacy of touch – resounds throughout her writings on photography. Likewise, Mavor insists that we acknowledge what we would rather

conceal or deny. Quoting Nina Auerbach, she writes: 'Some embarrassed viewers have tried to see no sexuality in these photographs, but it seems to me needlessly apologetic to deny the eroticism' (Mavor 1995: 12).

Becoming: The Photographs of Clementina, Viscountess Hawarden (1999) sits in stark opposition to a contemporaneous account of the photographer's life which complies more readily with a traditional, so-called objective, photographic history; Mavor's is neither a monograph nor a biography. Drawing on nineteenth-century literature and painting, as well as contemporary women's photography, Mavor's text focuses on the eroticism that she reads into the photographs of Hawarden (1822–1865). Although dying young, Hawarden proved prolific and innovative in terms of photographic production. Most of her oeuvre comprises portraits of her two eldest daughters, Clementina and Florence. Made within the domestic sphere of her London home, Hawarden deployed fancy dress, dressers, mirrors and other props to describe the particular luxurious kind of nineteenth-century 'women's experience' expressed so well by the Victorian novelist Mary Elizabeth Braddon in *Lady Audley's Secret*. Like Braddon, Mavor is prepared to shock her readers; she unleashes an unexpected account of Hawarden's images. Esoteric and deliberately 'Sapphic', the text is full of multi-layered and deep-seated desires.

In this way, Mavor manages to disrupt the critically cool and distanced established discipline of photography history and theory. After all, if we are to react viscerally and instinctively to photographic imagery, then interpretation will always also be subjective. To acknowledge and embrace this fact is brave, and it has radical consequences on how we (continue to) engage intellectually with photography. Such practice, however, does not preclude addressing the social and cultural, and in Mavor's hands the meanings of photographs remain potentially political, too. Best described as phenomenological, Mavor's approach to reading photography 'addresses the meaning things have in our experiences, notably, the significance of objects, events, tools, the flow of time, the self, and others, as these things arise and are experienced in our "life-world"' (http://plato.stanford.edu/entries/phenomenology/). As with current ethnographic methods that are increasingly being deployed to interpret photographic images meaningfully, Mavor thus provides a pertinent and relevant strategy to enable us to relate personally, intimately and emotionally to the photographic object. As Elizabeth Edwards writes in *Raw Histories: Photographs, Anthropology and Museums*: 'Photography … cannot be reduced to a totalising abstract practice but instead comprises photographs, real visual objects engaged within social space and real time' (Edwards 2001: 2).

Reading Boyishly: Roland Barthes, J. M. Barrie, Jacques Henri Lartigue, Marcel Proust, and D. W. Winnicott is, to date, Mavor's *pièce de résistance*. As an object, it is extraordinary. Lucy Rollin admits in *Children's Literature Association Quarterly*: 'I love even the way it looks and feels: a thick white block of fine paper, the text enhanced by different fonts, touches of sky-blue ink, and more than two hundred photographs' (Rollin 2008: 323). As a literary work of art, it gives voice to the relationship between mothers and sons and the centrality of the mother figure in the lives of five eminent men: 'For Barrie, Proust, Winnicott, Lartigue, and Barthes, the maternal is a cord (unsevered) to the night-light of boyish reading' (Mavor 2007: 31). But you don't have to be a parent or a son to appreciate the quality of Mavor's close reading and stylish writing. *Reading Boyishly* is first and foremost a call for, and celebration of, hedonism in art and literature and life. It offers a sumptuous feast of ideas and tropes – endlessly nourishing – while simultaneously making manifest the artistic and literary antecedents in which Mavor's own approach to photography and writing should be understood and appreciated.

In 2010, Mavor was included in Geoffrey Batchen's *Photography Degree Zero: Reflections on Roland Barthes's 'Camera Lucida'*. An anthology of essays that extends beyond the usual rehearsals of Barthes's hugely insightful and highly influential meditation on photography, it provides less orthodox re-readings and critical perspectives on his text. The focus of Mavor's 'Black and Blue: The Shadows of *Camera Lucida*' is race. Expressed through the works of Proust, Joseph Cornell and Toni Morrison, it 'regards Barthes's "obvious, erroneous readings of race" and explores, in a deeply personal text, the figuring of blackness throughout *Camera Lucida*' (Batchen 2010: 20).

It is precisely this fearless engagement with the 'deeply personal' that renders Mavor's meticulously researched writings on photography so fascinating and mesmerizing. Her expansive and interdisciplinary approach to the medium combined with her insistence on the subjective and autobiographical deliberately disrupts and 'destabilizes the boundaries of psychoanalysis, literary criticism, art history and philosophy' (Topping 2010: 248). The result: subtle, sophisticated, evocative (as well as sometimes blushingly intimate) texts that continue to reveal the profound ways in which photographs affect and motivate us.

Biography

Carol Mavor was born in 1957. She studied painting and film at undergraduate level, and received an MFA in Studio Practice from

the University of California, San Diego, in 1984. Her PhD in the History of Consciousness was supervised by Hayden White and Helene Moglen at the University of California in Santa Cruz, and awarded in 1989. She is currently Professor of Art History and Visual Studies at the University of Manchester. Mavor was named the Northrop Frye Chair in Literary Theory at the University of Toronto for 2010 to 2011. Her latest publications include *Black and Blue: The Bruising Passion of Camera Lucida, La Jetée, Sans Soleil and Hiroshima mon amour* (Duke University Press, 2012) and *Blue Mythologies: Reflection on a Colour* (forthcoming from Reaktion, 2013).

Primary texts

Mavor, C. (1995) *Pleasures Taken: Performances of Sexuality and Loss in Victorian Photographs*, Durham, NC: Duke University Press.

——(1999) *Becoming: The Photographs of Clementina, Viscountess Hawarden*, Durham, NC: Duke University Press.

——(2007) *Reading Boyishly: Roland Barthes, J. M. Barrie, Jacques Henri Lartigue, Marcel Proust, and D. W. Winnicott*, Durham, NC: Duke University Press.

——(2010) 'Black and Blue: The Shadows of *Camera Lucida*', in G. Batchen (ed) *Photography Degree Zero: Reflections on Roland Barthes's 'Camera Lucida'*, Cambridge, MA: MIT Press.

Secondary texts

Barthes, R. (1980) *Camera Lucida: Reflections on Photography*, London: Jonathan Cape.

Batchen, G. (ed) (2010) *Photography Degree Zero: Reflections on Roland Barthes's 'Camera Lucida'*, Cambridge, MA: MIT Press.

Edwards, E. (2001) *Raw Histories: Photographs, Anthropology and Museums*, Oxford, UK: Berg.

Rollin, L. (2008) 'Review', *Children's Literature Association Quarterly*, vol 33, no 3 (Fall), pp323–325.

Topping, M. (2010) 'Review', *Photography & Culture*, vol 3, issue 2, July, pp247–250.

Websites

http://www.manchester.ac.uk/research/Carol.Mavor/
http://plato.stanford.edu/entries/phenomenology/
http://www.artinfo.com/news/story/33606/photography-degree-zero-reflections-on-roland-barthess-camera-lucida/

Jane Fletcher

KOBENA MERCER (1960–)

Kobena Mercer is a British academic currently based in the US but from a Ghanian-British family. He has written extensively about photography by African diaspora artists in the UK and the US. Mercer's identity as 'mixed race' (his father was from Ghana and his mother was English) and gay is crucial to his approach to photography and the choice of photographers whom he has written about. Many of his early essays from the mid 1980s to the early 1990s have been reprinted as a single volume, *Welcome to the Jungle: New Positions in Black Cultural Studies*, published in 1994. A central preoccupation, which determines the choice of artists and photographers he writes about, is the representation of the black male body in fine art and popular culture.

Mercer's writings can be divided into three stages that reflect the changing nature of debates within and beyond African diaspora cultures. In the first stage, during the mid 1980s, he is concerned with the struggle for visibility, representation and acknowledgement of artists, photographers and film-makers of the African diaspora. Photography by artists is examined within a wider context of advertising images and posters, sports, fashion and music magazines, gay pornography magazines or popular film; the intention is to see fine art photography as part of a wider struggle for visibility within mainstream representation. These ideas can be found in his early essays, such as 'True Confessions' (Mercer and Julien 1986a) and 'Black Hair/Style Politics' (Mercer 1987). From 1989 onwards, he is concerned with the problems that come with the entry of African diaspora artists into the establishment, examined in 'Black Art and the Burden of Representation' (Mercer 1990). In this second stage, as institutional support for black artists emerges, Mercer authors a number of monographic essays on individual artists such as Keith Piper (Mercer 1996a) or critical overviews of art practices and debates in key exhibitions: *Black Male, Representations of Masculinity in Contemporary American Art* at the Whitney Museum of American Art in New York (Mercer 1994–1995), *Mirage, Enigmas of Race, Difference and Desire* at the ICA in London (Mercer 1995a) or *Imagined Communities* at the South Bank in London (Mercer 1996b). The third and current stage of Mercer's writings is concerned with the repositioning of African diaspora artists within mainstream canons of European and North American art history in the light of globalization: 'Adrian Piper 1970–75: Exiled on Main Street' (Mercer 2008a).

Certain themes recur throughout his writings: language as a model for a black aesthetic drawn from Creolization, the mix of different languages that emerged in the Caribbean and became a form of literary

invention, and the multiple meanings that photographic imagery can hold, which frequently centre on the post-colonial concept of hybridity, developed by the literary theorist Homi K. Bhabha. For Mercer, a black aesthetic is inseparable from the subjectivity of the African diaspora artist who is caught between two or more cultures, and whose sexuality, whether homosexual or heterosexual, has already become visible within colonial fantasies as a source of fear and desire. It is not surprising that psychoanalysis features in Mercer's approach to photographic practices, as it draws out the unconscious meanings given to images.

Mercer's concern with interpretation is never separate from an awareness of how African diaspora artists are perceived by mainstream institutions, critics or even African diaspora spectators. A consistent criticism, since the 1950s, is that their creativity is based on the mimicry of European and North American artists' practices. Although postmodernism has been described as a discourse of others (Owens 1983), the interventions made by marginalized artists 'coming to voice', or making themselves visible, against a canon of great photographers can be misinterpreted. Postmodern photographs by European and North American artists such as Cindy Sherman, Jeff Wall or Richard Prince subvert authorship by appropriating the work of existing canonical artists and photographers. Appropriation is more complex in the case of African diaspora photographers. The first collection of photographs, *Black Male/White Male*, in 1988 by British-Nigerian gay photographer Rotimi Fani-Kayode was consistently interpreted through the work of the white gay photographer Robert Mapplethorpe. Such comparisons raise problems for the post-colonial critic, as the dominant canon that Mapplethorpe references in his photographs has been formed by historians, critics and curators who have frequently neglected the presence of African diaspora photographers in surveys. Furthermore, for Mercer, Robert Mapplethorpe's photographs in collections such as *The Black Book* (1986) are marked by what Homi K. Bhabha describes as 'racial fetishism', conflicting attitudes within a white and colonial imagination of fear and seduction towards the black male, based on stereotypes within the past but recurring in the present of the 1980s (Mercer and Julien 1986a, 1989).

For Mercer, the Russian linguist Mikhail Bakhtin's concept of language as multi-accentual and steeped in power relations (Bakhtin 1935) allows him to demonstrate that, just as language is taken from a master narrative and adapted within Creole, so artists such as Rotimi Fani-Kayode adapt the form of the photographic tableau in order to create conflicting associations that forge a hybrid imagination. The

term hybridity itself acquires power through appropriation; originally a negative term for mixed-race children coined by eugenicists during the late nineteenth and early twentieth centuries, it is used by Mercer and Bhabha to actively celebrate difference that does not fit into nationalist ideals of racial purity (Bhabha 1993; Mercer 1994). To this end, photographic images are interpreted as codes that can be used, transformed and made to reverse or subvert their original meanings. The rest of this essay examines these aspects of Mercer's writings as they enter his interpretation of photographs by the British-Nigerian gay photographer Rotimi Fani-Kayode and the British artist Keith Piper.

Like other diaspora artists, Fani-Kayode struggled during the 1980s to find institutional support for his photographic practice, leading to the establishment in the UK of Autograph: The Association of Black Photographers, a collective formed under Fani-Kayode's directorship (Fani-Kayode 1988). His erotic colour photographs of naked black men in a series of large-scale tableaux, holding props such as African fetish masks, wearing Nigerian robes and posing in scenes drawn from a mixture of Catholic and Yoruban rituals, suggest a complex set of cultural and historical associations that draw on his movement between Lagos, New York and London. Mercer first wrote about Fani-Kayode's images (Mercer 1991) in an analysis of black gay image-making that included Isaac Julien's *Looking for Langston* (1989) produced by the black film collective Sankofa; he went on to revise it as a monograph in three different versions (Mercer 1997b, 1999, 2008b). Examining the photograph 'Bronze Head' (1987), Mercer argued that the appearance of a Benin mask beneath the naked splayed buttocks of a black man produces a 'shocking recontextualisation' that places the picture in 'two imaginary spaces at once: it is simultaneously inscribed as an instance of contemporary African art, specifically referring to Yoruba traditions in Nigerian culture, *and* as an instance of Western metropolitan homoerotica, alluding to codes of pornography and art photography (such as Mapplethorpe's sculptural "portrait" of Derrick Cross)' (Mercer 1994: 227). Fani-Kayode deploys 'dominant codes of exoticism, primitivism and ethnicized otherness' to problematize a politically correct approach to 'racial fetishism' (Mercer 1994: 227).

Mercer's essays on Keith Piper during the mid-1990s are indicative of the new challenges facing the post-colonial critic: to evaluate a body of work shown in fragments within group exhibitions during the 1980s but rarely seen in its entirety. The Institute of International Visual Art was established in the UK in 1994 to facilitate these solo shows, such as Piper's exhibition *Relocating the Remains* for which Mercer wrote a catalogue essay (Mercer 1997a). Piper was born into a

working-class immigrant family, based in Birmingham in the West Midlands, once the centre of post-war migration because of the region's industrial manufacturing. His artistic practice emerged as a result of his politicization by a local activist and against what he saw as the 'self-indulgent and apolitical brand of creativity being encouraged within art schools' (Mercer 1997a: 21). Piper's use of photography was just one medium among many which Mercer first examined in an early essay (Mercer 1992), where he assessed its relative invisibility, alongside the work of Danny Tisdale, for the prestigious mainstream New York-based art magazine *Artforum*. The second essay (Mercer 1995a) was published in *Portfolio*, a newly established magazine devoted to showcasing the work of British photographers. The concept of 'maroonage' was central to Mercer's analysis and was taken from the Caribbean poet Édouard Glissant to evoke a history of resistance by the maroons, escaped slaves who sought refuge in the hills of Cuba, Jamaica and Haiti and away from the plantation fields of the islands, that in art suggests the 'cross-cultural dynamics of a Creole aesthetic' (Mercer 1995a). In a third monographic essay in a group exhibition, Mercer contrasts the recent establishment of a Truth and Reconciliation Committee to address injustices carried out under apartheid by President Mandela in South Africa, with the lack of any confrontation on the part of the state in the UK and the US. He argues that such trauma finds its way into art and examines Piper's work from 1984 onwards as a means of releasing ghosts of the body of colonialism that has never been buried (Mercer 1996c). In the later catalogue essay of 1997, Mercer examines Piper's socially and politically marginalized position as one of strength, from which he questions visual and textual power structures at the centre of British culture and history. In contrast to Jeff Wall's approach to photography as history painting, Mercer's view of Piper as history painter lies in the connections between memory and photography to position the artist as one who witnesses the resistance of the African diaspora, and others, to neo-conservative aspects of post-Thatcherite Britain.

Mercer's attention to photographic history beyond the UK and the US is evident in reviews of a number of exhibitions on African photography (Mercer 1998), but first emerges in his essay for the group exhibition *Self-Evident* (Mercer 1995b), which was significant for its inclusion of Seydou Keïta's studio photographs from 1948 to 1964, revealing the changing character of modern life in Mali. Except for representation in a few group exhibitions in France and the US, since the early 1990s, Keïta's work was largely unknown in the UK, but has subsequently become celebrated and well-known through touring

exhibitions such as *You Look Beautiful Like That*, which showcased Keïta and fellow Malian photographer Malick Sidibé at the Fogg Art Museum, University of Harvard and National Portrait Gallery, London (2002–2003). Mercer's essay for *Self-Evident* placed Keïta and the work of Mama Casset from Senegal in a historical and geographical trajectory of the emergent modernities of West African societies during the 1940s and 1950s 'as part of an extended family album' that included post-colonial photographers in the UK: Ingrid Pollard, Maxine Walker and Oladele Bamgboye, with diasporic connections to Guyana, Nigeria and Jamaica. Mercer suggested that as these older historic images were formerly part of the private exchange of the family album but had begun to be shown in museums and galleries as aesthetic objects, they formed a spectatorship among an African diaspora and beyond that encouraged recognition of migrant identities as 'imagined selves' (Mercer 1995b) with the potential to alter the public perception of African subjects. This signals a shift in Mercer's writings beyond the post-colonial critique of European history and colonial stereotypes of African subjects in photography to consider debates on art and globalization, which continues in a recent essay where he argues that focusing attention on the photographic archive in Africa solicits a more complex history, away from received narratives: 'photography now reveals the planetary conditions of cross-cultural modernity by showing us how colonial subjects appropriated its picture-making technology to depict their own experiences of modern life in different regions of the globe' (Mercer: 2011).

Biography

Kobena Mercer, born in 1960, is Professor of the History of Art and African American Studies at Yale University. Born in London, he was educated in Ghana and England and studied fine art at St. Martin's School of Art, graduating in 1981, before completing a PhD at Goldsmiths College, University of London, in 1990. Writing on art, film and photography in a range of publications, from *Creative Camera*, *Ten.8* and *Third Text* to *Artforum International* and *Screen*, he contributed to the black British arts scene by organizing a conference on *Black Film/ British Cinema* at the Institute of Contemporary Art in London, and by his subsequent collaborations with Autograph: The Association of Black Photographers and the Institute for International Visual Arts. His scholarship on issues of race, sexuality and identity in visual culture and art history has informed courses that he has taught at the University of California, Santa Cruz, New York University and Middlesex University,

London, as well as his research into black diaspora art during fellowships received from Princeton University, Cornell University and the New School University in New York. In 2006 Mercer was an inaugural recipient of the Clark Prize for Excellence in Arts Writing, awarded by the Sterling and Francine Clark Art Institute in Massachusetts.

Primary texts

Mercer, K. and Julien, I. (1986a) 'True Confessions', *Ten-8 22 Black Experiences*, Summer.

——(1986b) 'Imaging the Black Man's Sex', in J. Spence, P. Holland and S. Watney (eds) *Photography/Politics Two*, London: Comedia, pp61–69.

——(1987) 'Black Hair/Style Politics', *New Formations*, vol 3 (Winter).

——(1989) 'Skin Head Sex Thing: Racial Differences and the Homoerotic Imaginary' in B. Objects (ed) *How Do I Look? Queer Film and Video*, Seattle, WA: Seattle Bay Press, pp169–210.

——(1990) 'Black Art and the Burden of Representation', *Third Text*, vol 10 (Spring).

——(1991) 'Dark and Lovely: Black Gay Image-Making', *Ten.8*, vol 2, no 1 (Spring).

——(1992) 'Engendered Species', *Artforum International*, vol XXX, no 10 (Summer), pp74–77.

——(1994) *Welcome to the Jungle, New Positions in Black Cultural Studies*, London: Routledge.

——(1994–1995) 'Skin Head Sex Thing: Racial Differences and the Homo-erotic Imaginary', *Black Male, Representations of Masculinity in Contemporary American Art*, New York, NY: Whitney Museum of American Art.

——(1995a) 'Busy in the Ruins of Wretched Phantasia', in *Mirage, Enigmas of Race, Difference and Desire*, London: ICA, pp15–55.

——(1995b) 'Home from Home: Portraits from Places In-Between', in *Self-Evident*, Birmingham, UK: Ikon Gallery.

——(1996a) 'Maroonage of the Wandering Eye', *Portfolio Magazine*, no 23, June, pp54–55.

——(1996b) 'Prologue', in *Imagined Communities*, London: South Bank, 7 September–27 October.

——(1996c) 'To Unbury the Disremembered Body', in *New Histories*, Boston, MA: ICA, pp161–166.

——(1997a) 'Witness at the Cross-roads: An Artist's Journey in Post-colonial Space'. in *Relocating the Remains*, London: Iniva, pp12–85.

——(1997b) *Rotimi Fani-Kayode and Alex Hirst*, edited by M. Sealy and P. Martine, St. Leon, Paris: Editions Revue Noire.

——(1998) 'Africa by Herself: African Photography from 1840 to the Present', Maison Europeanne de la Photographie, Paris, *Frieze*, issue 43, November–December, pp84–85.

——(1999) 'Mortal Coil: Eros and Diaspora in the Photographs of Rotimi Fani-Kayode', in C. Squires (ed) *Overexposed: Essays on Contemporary Photography*, New York, NY: New Press, pp183–210.

——(2008a) 'Adrian Piper 1970–75: Exiled on Main Street', in K. Mercer (ed) *Exiles, Diasporas and Strangers Annotating Art's Histories*, Cambridge, MA: MIT; London: Inivia, pp146–165.
——(2008b) 'Eros and Diaspora', *Artafrica*, http://www.artafrica.info/html/artigotrimestre/artigo_i.php?id=15.
——(2011) 'Photography and the Global Condition of Cross-cultural Modernity' in S. Blokland and A. Pelupessy (eds) *Unfixed: Photography and Postcolonial Perspectives in Contemporary Art*, The Netherlands: Unfixed Projects and Japsam Books.

Secondary texts

Bakhtin, M. (1935 [1981]) 'Discourse in the Novel', in *The Dialogic Imagination*, Austin, TX: University of Texas Press, pp259–422.
Bhabha, H. K. (1993) *The Location of Culture*, London: Routledge.
Fani-Kayode, R. (1988) 'Traces of Ecstasy', *Ten.8*, vol 28, Summer, pp36–43, reprinted in O. Oguibe and O. Enwezor (eds) *Reading the Contemporary: African Art from Theory to the Marketplace*, London: Iniva, pp276–281.
Owens, C. (1983) 'The Discourse of Others: Feminists and Postmodernism', in H. Foster (ed) (1985) *Postmodern Culture*, London: Pluto Press, pp57–82.

Amna Malik

LÁSZLÓ MOHOLY-NAGY (1895–1946)

László Moholy-Nagy was a polymath artist whose practical engagement with photography was most intense during the 1920s, beginning with photogram experiments with his wife Lucia Moholy in 1922 and climaxing with *Film und Foto* (Stuttgart, 1929), the now legendary international exhibition that he helped to organize and to which he was the largest individual contributor. A decade of intense experimentation is distilled in *60 Fotos* (1930), a monograph that includes his photographs (positive and negative), photograms and photomontages, along with an introduction by art historian and photographer Franz Roh.

Moholy-Nagy's campaign to overhaul the photographic medium in order to make it relevant to the twentieth century also embraced polemical writing, usually in small circulation publications that were an important forum for *avant-garde* debate and discussion in 1920s Europe. The Dutch journal *De Stijl* was the platform for his inaugural essay in photographic theory, entitled 'Production-Reproduction' (1922). To date, he argues, photographers have tended to restrict themselves to 'reproduction', using the camera merely as a machine for recording appearances. Such

timidity must be overcome, he insists, and instead photographers should be committed to 'production', relentlessly exploring all forms of 'light drawing', with and without cameras. Comparisons are made with the gramophone and film where mere 'reproduction' is pervasive in the form of records based on existing acoustic phenomena or films that are no more than recorded theatre. In both cases, he urges 'production' such as sound recordings made by direct incisions onto wax plates, or films that deal with movement in space. If 'production' can gain the upper hand in all of these media, then a major outcome could be nothing less than a transformation of human senses, he predicts.

The basic distinction between photographic 'production' and 'reproduction' underpins contrasting programmatic statements by Moholy-Nagy and Albert Renger-Patzsch in the first issue of the German annual *Das Deutsche Lichtbild* (1927). Both have little time for a photography that merely mimics painting; but Renger-Patzsch advocates a sophisticated form of 'reproduction' when he argues that the camera's distinctive domain is the faithful recording of 'material things' such as wood, stone and metal (Renger-Patzsch 1927: 105). By 1927, Moholy-Nagy can also acknowledge the importance of photographs that reveal 'the texture and structure ... of various materials', but only as one element in a multi-faceted development of 'the new culture of light'. The core of this new culture will be experimental cinema, he assumes; but still photography will not be made redundant. Rather, he envisages a 'reciprocal laboratory' with 'photography as an investigatory field for film, and film as a stimulus for photography' (Moholy-Nagy 1927a: 85).

In 1927, Moholy-Nagy also contributed to an important debate in the Dutch *avant-garde* journal *i10* around painting and photography. The gauntlet is thrown down by art historian Ernö Kállai who sees a decisive difference between the flat surface of a photographic print and the nuanced surface of an original painting that varies according to the artist's handling of 'facture' – that is, tactile values and different materials. The absence of 'facture' in a photograph, obvious in a photographic reproduction of a painting, inherently limits its creative potential, Kállai claims, though he does concede that photography can produce 'marvelously clear and distinct reproductions of reality' (Kállai 1927: 96). In his response, Moholy-Nagy agrees that still and moving photography are unrivalled 'reproductive' media and he also sees a continuing role for painting, at least abstract painting. But he vehemently opposes Kállai's attempts to belittle 'productive' photography, and claims that advances in this realm will continue to explore a distinctive 'facture of light' (Moholy-Nagy 1927c: 102).

Moholy-Nagy's most sustained reflections on photography and neighbouring media are contained in the book *Malerei Photographie Film* (1925; second expanded edition, 1927; English translation *Painting Photography Film*, 1969). It was originally published in Munich as the eighth volume of an experimental book series that the Bauhaus launched as an extension of its activities as an art school, and has recently been described as 'the most influential treatise on photography of its day', offering 'the stunning thesis that camera vision could revolutionize, modernize, all of human perception' (Witkovsky 2007: 15). It is worth dwelling for a moment on a seemingly straightforward title. On one level, it identifies three related media that are Moholy-Nagy's themes. On another level, it presents photography as the central medium of the modern era. And on a further level, the title can be understood temporally, with painting as the medium of the past from which contemporary photography needs to distance itself in favour of creative exchanges with the medium of the future: film.

His arguments are wide-ranging and speculative, conveyed through a short text, in part based on earlier articles and a complementary series of carefully edited plates that give equal status to *avant-garde* and vernacular photography. One important concern is an attempt to provide a contemporary reformulation of the debate about the relations between painting and photography that had been inherited from the nineteenth century. Moholy-Nagy regrets the ways in which the possibilities of photography had been hampered since the 1830s by servile attempts to imitate changing styles of painting. Its most recent manifestation was Pictorialism, he believes, represented in the plates section with a photograph from 1911 of a Parisian street by Alfred Stieglitz, accompanied by a disparaging caption: 'The triumph of Impressionism or photography misunderstood' (Moholy-Nagy 1969: 49).

Instead, he proposes a frontier between painting and photography that would permit practitioners to clearly identify their chosen medium and to concentrate on its specific problems. Henceforth, the distinctive domain of painting is to be colour composition, he boldly asserts. Photography is to have different ends, concentrating on accurate visual representation of the world, thus usurping the traditional representational functions of painting, as well as exploring the significance of light that is the basis for its unique form of creation. In short, painters are to devote themselves to pigment, photographers to the manipulation of light.

He is proposing a strict division of labour between painters and photographers, based on the uniqueness of their respective working materials. He seeks to further ratify his proposals by referring to

supposed laws of human perception. Abstract painting involves arrangements of colour, and a spectator's response is dependent upon psycho-physical factors that are independent of time and place. In contrast, photography is a representational art, and a response is influenced by many variables, ranging from cultural assumptions to the personality and experience of an individual spectator. In other words, Moholy-Nagy envisages the new abstract or non-objective painting as a universal art that transcends history, whereas photography is considered an art of contingency.

The arguments are audacious and Moholy-Nagy anticipates a number of objections. Foremost is the need to account for the continued interest in figurative painting by sophisticated contemporaries such as the Neo-Classicists in France or the painters in Germany associated with *Neue Sachlichkeit*. One curt response is simply to dismiss their work as reactionary. A second, more subtle, line of thought involves comparing their work to earlier Futurist attempts to render movement with pigment when cinema had already been invented. Similarly, Moholy-Nagy suggests, certain artists in the 1920s are using old forms to deal with a new, as yet unfocused, problem. Yet, when this problem does come into focus, the efforts of these artists will be as obsolescent as Futurist painting.

He is also aware of the problems posed by his key idea that human responses to colour are dependent upon biological laws, uninfluenced by historical factors. He acknowledges that the great painters of the past may have been unaware of these laws, yet he insists that they inform their handling of colour and provide constant criteria for evaluating any painting. Themes may vary, but the problems of colour composition are unchanging and transcend time and place. Yet, on occasions, Moholy-Nagy seems to acknowledge that response to colour may be subject to historical modification, such as a speculative aside where he fears that the greyness of modern life could result in the atrophying of the optical organs, providing a further reason for the urgent implementation of his proposals for colour composition.

Writing during the mid-1920s, Moholy-Nagy is already anticipating the development of colour film. He welcomes this development, claiming that it will encourage, rather than compromise, the divisions he advocates. Colour film will be closer to nature, enhancing photography's reputation as the richest medium for representing the world. Additionally, it will permit more elaborate fantasy. Both advances will further confirm that the distinctive end of contemporary painting is abstract or non-objective colour composition.

Moholy-Nagy notes that his paintings often incorporate lessons learned from his photography, and vice versa. Comparable exchanges take place

between still and moving photography. Indeed, Moholy-Nagy some-times blurs distinctions, using the terms 'film' and 'photographic art' interchangeably. Nevertheless, he makes it abundantly clear that he regards cinema as the summation of a new 'culture of light': 'Since as a rule light phenomena offer greater possibilities of differentiation in motion than in the static condition, all photographic processes reach their highest level in the film (relationships between the motions of the light projection)' (Moholy-Nagy 1969: 33). Yet, this level can only be attained if the film camera is not merely treated as a 'repro-ductive' tool, but is used 'productively' to convey, for example, 'formal tensions, penetration, chiaroscuro relationships, movement, tempo' (Moholy-Nagy 1969: 34).

Moholy is advocating a rigorous investigation of the specific fea-tures of each medium of visual communication. These formal resear-ches are considered an essential precondition for a successful combination of media in a *Gesamtkunstwerk* (total work of art), understood as an aesthetic prefiguration of a *Gesamtwerk* (life), a rich everyday life that would render art and artists redundant. The *Gesamt-werk* is in the distant future, Moholy-Nagy assumes. Nevertheless, hints of what it might entail are embodied in his exhibition designs of 1929 to 1930, such as the introductory room of *Film und Foto* (1929) that inventively brings together art and vernacular photography (Botar 2010: 159–168).

Biography

László Weisz, better known as László Moholy-Nagy, was born in 1895 in southern Hungary. During World War I he served in the Austro-Hungarian army on the Russian Front. In 1920 he moved to Berlin and by 1923 he was teaching at the Bauhaus. He was a poly-math, but photography became an important dimension of his work as artist and writer. He resigned from the Bauhaus in 1928 and worked in Berlin as a freelance artist-designer. He was a key organizer of *Foto-Auge* (Stuttgart, 1929), a major international survey of recent innovations in still and moving photography. When Hitler took power in 1933, Moholy-Nagy emigrated to London where he engaged in commercial design work. In 1937 he accepted an invitation to direct the New Bauhaus in Chicago. It closed after one year; but in the same city Moholy-Nagy subsequently became the director of the School of Design, later the Institute of Design. He was diagnosed with leukaemia in 1945 and died the following year, aged 51.

Primary texts

Moholy-Nagy, L. (1922) 'Production-Reproduction', in C. Phillips (ed) (1989) *Photography in the Modern Era: European Documents and Critical Writings, 1913–1940*, New York, NY: Metropolitan Museum of Art/Aperture, pp79–82.

——(1925) *Malerei Photographie Film*, Munich: Albert Langen Verlag.

——(1927a) 'Unprecedented Photography', in in C. Phillips (ed) (1989) *Photography in the Modern Era: European Documents and Critical Writings, 1913–1940*, New York, NY: Metropolitan Museum of Art/Aperture, pp83–85.

——(1927b) *Malerei Fotografie Film*, Munich: Albert Langen Verlag, second expanded edition.

——(1927c) 'Response to Ernö Kállai', in C. Phillips (ed) (1989) *Photography in the Modern Era: European Documents and Critical Writings, 1913–1940*, New York, NY: Metropolitan Museum of Art/Aperture, pp101–103.

——(1930a) *60 Fotos*, edited and introduced by F. Roh, Berlin: Klinkhardt & Biermann.

——(1930b) *Von Material zu Architektur*, Munich: Langen.

——(1938) *The New Vision*, New York, NY: WW Norton, English language version of *Von Material zu Architektur* (1930).

——(1969) *Painting Photography Film*, London: Lund Humphries, English language version of *Malerei Fotografie Film* (1927).

——(1993) *László Moholy-Nagy: Peinture Photographie Film et autres écrits sur la photographie*, edited and introduced by D. Baqué, Paris: Éditions Jacqueline Chambon.

——(2011) *60 Fotos*, edited and introduced by F. Roh, New York, NY: Errata Editions, with an Afterword by D. Evans and J. Ladd.

Secondary texts

Botar, O. A. I. (2010) 'Taking the *Kunst* out of *Gesamtkunstwerk*: Moholy-Nagy's conception of the *Gesamtwerk*', in O. M. Rubio et al (eds), *László Moholy-Nagy: The Art of Light*, Madrid: La Fabrica, pp159–168.

Haus, A. (1980) *Moholy-Nagy: Photographs and Photograms*, London: Thames & Hudson.

Heyne, R. and Neusüss, F. M. (eds) (2009) *Moholy-Nagy the Photograms: Catalogue Raisonné*, Ostfildern: Hatje Cantz Verlag.

Hight, E. (1995) *Picturing Modernism: Moholy-Nagy and Photography in Weimar Germany*, Cambridge, MA, and London: MIT Press.

Kállai, E. (1927) 'Painting and Photography', in C. Phillips (ed) (1989) *Photography in the Modern Era: European Documents and Critical Writings, 1913–1940*, New York, NY: Metropolitan Museum of Art/Aperture, pp94–99.

Phillips, C. (ed) (1989) *Photography in the Modern Era: European Documents and Critical Writings, 1913–1940*, New York, NY: Metropolitan Museum of Art/Aperture.

Renger-Patzsch, A. (1927) 'Aims', in C. Phillips (ed) (1989) *Photography in the Modern Era: European Documents and Critical Writings, 1913–1940*, New York, NY: Metropolitan Museum of Art/Aperture, pp104–105.

Rubio, O. M. et al (eds) (2010) *László Moholy-Nagy: The Art of Light*, Madrid: La Fabrica.
Witkovsky, M. S. (2007) *Foto: Modernity in Central Europe, 1918–1945*, London and New York: Thames and Hudson.

David Evans

DAIDO MORIYAMA (1938–)

A Japanese photographer known for his high-contrast black-and-white photographs that are at once rough, violent and yet strangely lyrical, Daido Moriyama has also written a considerable number of essays. Many of these have been subsequently edited and republished in anthologies of his writings (e.g. Moriyama 2006) and some have been published in English and other languages (Phillips and Munroe 1998: 41–48; Moriyama 2004; Vartanian et al 2006: 34–36, 95–104, 115–124). Yet Moriyama has never identified himself as a writer and his photography books – a form of photographic expression that he has prioritized over original prints or museum exhibitions – usually contain just a few lines of text. Most of his published texts were not meant to be read as independent essays but were instead produced as short commentaries to be encountered in conjunction with his photographs. These conjunctions of text and image have usually appeared in monthly photography magazines, a primary medium of the development of post-war Japanese photography.

During the early 1980s, however, texts came to assume a more important position in Moriyama's work. In 1982 to 1983, for example, he contributed a 15-instalment serial entitled *Inu no kioku* (*Memories of a Dog*) to the photography magazine *Asahi Camera*, in which he juxtaposed his photographs with essays he wrote for each instalment. The serial was then edited by Moriyama, along with a newly added memoir entitled 'Boku no shashin ki' ('My Photographic Diary'), and published as an independent volume in 1984. *Memories of a Dog* was later translated into English, but without the memoir (Moriyama 2004). When Moriyama started writing about his daily events, he might have been inspired by his acquaintance with Nobuyoshi Araki. Perhaps the only photographer who rivals Moriyama in popularity, Araki claimed that his photographic output could not be separated from his private life, which he frequently emphasized in his interviews and essays (Vartanian et al 2006: 143–153, 165–187).

As the title suggests, memory serves as a leitmotif in *Memories of a Dog*. Moriyama's concern, however, is not with narrating his own

past from a coherent perspective. Rather, his writing expresses a longing for what he calls 'original scenes (*genkei*)' sunk deep in his memory. He also addresses his bewilderment and frustration at the gap between the image in his memory and the actual scene he saw during his shooting trip. In the first instalment of the serial, Moriyama writes about his recent visit to his birthplace, the town of Ikeda in Osaka Prefecture. Since his family left the town shortly after he was born and moved frequently throughout his childhood because of his father's job, it was impossible for him to remember the scenery of his birthplace. Yet, he was determined to make a trip to Ikeda, 'anticipat[ing] the awakening of memories that might come to be perceived suddenly through the tip of my finger [clicking the shutter]' (Moriyama 2004: 18). Travelling to the town with a camera, his anticipation was met with both fulfilment and disillusionment. He writes: 'the actual scene before my eyes gradually began to overlap with the illusory scene until, wherever I looked, I was seized by the strange hallucination that this must be the place where I was born'. But then he began to feel, he tells us, that 'As long as I was carried along by emotion, the verification of my memory was dubious.' He ends up returning to Tokyo with 'a vague sense of dissatisfaction' (Moriyama 2004: 19).

In this episode the purpose of Moriyama's trip was to encounter an 'illusory scene' he had never seen before. But Moriyama also visited places where he had once been and kept the images of the sites in his memory, experiencing similar ambivalent feelings mixed with hallucination and disappointment. Visiting Kyoto where he had lived 30 years ago, Moriyama realized that the landscape he remembered had drastically changed over the course of time. He then began to wonder:

> The scenes I am certain I saw some thirty years ago could just be something that I am convinced that I saw in my memory, and it is possible they were imaginary scenes to start with. With a completely transformed landscape before me, I am suddenly aware of how helpless my life is, and how it is not possible to verify to anyone else the scene that I saw once.
>
> (Moriyama 2004: 122; translation slightly modified)

Despite such uncertainty about his own memory, Moriyama also aims his camera at unfamiliar landscapes, hoping that 'standing again before that landscape without traces [he] may be able to call forth new traces' (Moriyama 2004: 125; translation slightly modified). It is in this respect that photography becomes for him a medium of memory. However, in the same way that his 'illusory scene' has nothing to do

with specific landscapes he actually saw, the memories conjured up by photographs hardly belong to any specific event or place in time. This is clear from his remark on an encounter with a nineteenth-century photograph displayed in an ethnographic museum in Hokkaidô. After seeing an anonymous photograph depicting a village populated by the indigenous peoples of the island, he writes:

> Without exaggeration, I have never received as much of a shock as when I encountered this single, evidently copied and recopied scenic photograph. The image was for the most part unclear, but such as it was, the light of that distant day in Hokkaidô came flooding brilliantly into my eyes, as if I was in its very midst.
>
> (Moriyama 2004: 134)

For him, this photograph was distant, yet familiar at the same time, revealing the paradoxical nature of memory. Even though he claims that 'it rejects all words and feelings and sometimes even imagination' (Moriyama 2004: 137), the photograph strikes him with the same vividness of light that once exposed the film. His heightened sensibility towards photographic images also enabled him to have a similar empathetic encounter with a picture whose subject is distant, not just in terms of time, but also of place. Upon his encounter with a reproduction of the well-known earliest surviving photograph, made by Nicéphore Niépce in 1826, Moriyama writes: 'That arabesque of light and shadow, that scene filtered by light soaked into the depths of my memory, just as if I had seen it myself suddenly one summer day' (Moriyama 2004: 177).

Not that his longing for 'original scenes' and fascination with anonymous photographs was something new to Moriyama. As early as 1971, Moriyama's interest in anonymous photographs was evident in his conversations with Nakahira (Moriyama 2000: 22). He even suggested in 1976 that the purpose of his recent visit to the village of Tôno in Iwate Prefecture, a place to which he had no biographical connection, was to witness 'original scenes' (Moriyama 2000: 196). However, it was *Memories of a Dog* that developed these themes sub- stantially, joining them together under the banner of memory. After reading Moriyama's words, one might find in them an affinity with Roland Barthes's *Camera Lucida* (Barthes 1981), the Japanese translation of which did not appear until 1985 and, therefore, is unlikely to have been a direct inspiration for *Memories of a Dog*. Nevertheless, Moriyama and Barthes share a number of commonalities, from their sceptical views towards photography's ability to restore memory, to their ecstatic

responses towards certain old photographs (interestingly, they both quote Marcel Proust). However, their differences are also important. Whereas Barthes approaches photography from the position of 'the Spectator' (Barthes 1981: 16–18), Moriyama's search for memories culminates in his act of making photographs, from releasing the shutter at the site to the developing and printing process in the darkroom.

Interestingly, the photographs with which Moriyama experienced such hallucinatory visions are not those we usually consider vivid or illusionistic; they are weathered, dim and even abstract. Moriyama calls these photographs 'fossils': photographs are not just 'fossilizations of things'; they can also turn into 'fossil[s] of time' or 'fossils of light and memory' in his imagination (Moriyama 2004: 146, 147). During the early 1980s, when Moriyama wrote these essays, he attempted, so it seems, to imbue his own photographs with a similar fossil-like quality to that he found in old photographs. In August 1982 he published one of the most significant photo-books of his entire career, *Hikari to kage* (*Light and Shadow*) (Moriyama 1982). The book itself, filled with pictures of mundane everyday objects such as boots or buckets lit by sunlight, offers no indication that the images are connected to the memories of the photographer. However, a viewer of the book familiar with the photographer's writings cannot help but think about the haunting presence of memory in Moriyama's photographs.

The format of the book *Memories of a Dog* is carefully conceived so that the viewer can intuitively perceive both the connections and discontinuities between photography and memory. Already in the first version published in *Asahi Camera*, the relationships between images and texts are far from obvious; throughout the serial, the photographs never illustrate texts in the usual meaning of the word. In fact, every time a new version of *Memories of a Dog* appeared, Moriyama replaced many of the photographs used in the earlier version, thereby emphasizing the arbitrary relationships between the texts and photographs. This arbitrariness – his deliberate effort to prevent a specific photograph from being fixed to a specific text – reveals a number of gaps that Moriyama expresses in his text: namely, the gap between the image in his memory and the scene before his eyes; the gap between the emotionlessness of an old photograph and the vivid presence of its light; and the gap between his feeling towards the photograph and that of someone else viewing the same image. And, as Moriyama also implies, the medium of photography carries the potential to both point to and miraculously bridge those gaps.

Biography

Daido Moriyama was born in 1938 in Osaka, Japan. After making a living practising commercial design for a few years, he started working in the studio of the Osaka-based photographer Takeji Iwamiya in 1959. In 1967 he received the Newcomer's Award by the Japan Photo Critics Association for his magazine work, including *Nippon gekijô* (*Japanese Theater*). The following year, Moriyama participated in the now-legendary magazine *Provoke*, to which he and his fellow photographer Takuma Nakahira contributed what have been dubbed *buré boké* (blurred and out-of-focus) photographs. Although his long professional career has been interspersed with relatively inactive periods, he remains one of the most popular and admired photographers in Japan. During 1999 to 2000 his retrospective exhibition was held in the US and Europe, bringing him international recognition.

Primary texts

Moriyama, D. (1982) *Hikari to kage* [*Light and Shadow*], Tokyo: Tojusha.
——(2000) *Kako wa itsumo atarashiku mirai wa tsuneni natsukashii* [*The Past Is Always New, The Future Is Always Nostalgic*], Tokyo: Seikyusha.
——(2004) *Memories of a Dog*, translated by J. Junkerman, Tucson, AZ: Nazraeli Press.
——(2006) *Shashin to no taiwa soshite shashin kara shashin e* [*A Dialogue with Photography and From Photography/To Photography*], Tokyo: Seikyusha.

Secondary texts

Barthes, R. (1981) *Camera Lucida*, New York, NY: Hill and Wang.
Phillips, S. and Munroe, A. (1998) *Daidô Moriyama: Stray Dog*, San Francisco, CA: San Francisco Museum of Art.
Vartanian, I., Hatanaka, A. and Kambayashi, Y. (eds) (2006) *Setting Sun: Writings by Japanese Photographers*, New York, NY: Aperture.

Yoshiaki Kai

WRIGHT MORRIS (1910–1998)

Wright Morris was a remarkably prolific novelist, essayist and photographer. He championed the concept of the photo-text in his own work as well as in his many essays on the intersections between words and photography. By centralizing the role of documentary photography, in particular, as part of a longer cultural heritage, Morris's

essays – collected in *Time Pieces: Photographs, Writing, and Memory* (1989) – share an undeniable appreciation of the recognizable surrounding world as a key to creativity. For Morris, a valuable image 'both reveals and enhances our shared awareness of the visible world around us and the invisible world within us' (Morris 1989: 65). Morris claimed that he was merely 'a writer who very early saw the visible as a complement to the verbal' and yet his essays on photography, as well as in his own fiction, show an astute awareness of how a mix of regional settings, vernacular speech and anecdotal material might provide a picture – written as well as photographic – of something quintessentially American (Morris 1975: 120).

In a series of books, *The Inhabitants* (1946), *The Home Place* (1948), *God's Country and My People* (1968), *Photographs & Words* (1982), and throughout the essays in *Time Pieces*, Morris's own black-and-white photographs of his native Nebraska are united with a variety of textual formats – prose poems, quotes, first-person narrative and essays – into an expansive image of a region ripe with local and national implications. Searching for the exterior and interior psychology of a rapidly vanishing America, Morris shares the same territory and motifs of small town lives and rural existences as many of the documentary photographers that he writes about, from Walker Evans to Dorothea Lange. Yet his own projects stand out as distinctly literary efforts designed to foreground the potential of the documentary photograph.

In several of his essays on the importance of photography as an entry into an understanding of the American psyche, Morris deliberately mixes his knowledge of small town America with a sense of a larger literary past. Extracts from Thoreau's *Walden*, for instance, appear first as a postscript to *The Inhabitants*, and then reappear in his writing on Walker Evans and in interviews as a way of stressing his belief in the photographer/writer as a transcendent poet/seer. For Morris, Thoreau's vision of the American landscape sought to (as later photography would) synthesize the internal vision of the artist with his or her external surroundings. Morris quotes and identifies with Thoreau's adage that 'What of architectural beauty I now see, I know has gradually grown from within outward, out of the necessities and character of the indweller, who is the only builder.' In these terms, exterior models, the houses and objects with which we surround ourselves, are the only true indicators of who we are and proof of the fact that: 'What photographs usually do, more than anything else, is authenticate … existence. Authentication, not enlargement or interpretation is what we want' (Morris 1989: 64).

To a large extent, the key to Morris's writing on photography, and indeed his overall photo-textual oeuvre, lies in a particularly

nineteenth-century form of American idealism: an idealism based on the firm belief that an 'aesthetic rooted in American experience testifies to our hunger for what is real, a word that vibrates in our consciousness more persistently than the word truth' (Morris 1989: 62). For Morris, realism in photographic terms was thus entirely co-existent with an idealistic belief in the ability of the artist to genuinely render the world around them, to take actual experience as the starting point for their art.

In similar terms, most of Morris's commentary on photography's temporal quality rests on this belief in the importance of realism, in the belief that photography is at its most meaningful when it represents a communal past in recognizable terms. In striving, for instance, to be both the ideal narrator and illustrator of an American life, the life of his youth and boyhood in 1920s Nebraska, Morris articulates one of the chief purposes of documentary photography as he sees it: 'confirmation' as a way 'to hold on to what was passing' (Morris 1989: 44). Just as photography always comments in some way on the future extinction of its subject, it is also – in this respect – simultaneously 'in and out of time, timely and timeless' (Morris 1989: 39). Morris's desire can, in this respect, be read in either nostalgic or progressive terms as an antiquated form of idealism in which what is inevitably disappearing within American society is idealized, or as an acknowledgement that the documentary capabilities of the photograph inevitably tend to make objects and places iconic and timeless.

In Morris's own documentary photos, most of which were made between 1934 and 1954, structures, buildings and artefacts associated with the Depression are commemorated as a wistful commentary on the state of America and on the intimate relationship between an artist and his subject. In his first photo-text, *The Inhabitants* (1946), photographs of farms and outhouses are accompanied by captions ranging from vernacular speech to local anecdotes and lyrical asides. Morris's *The Home Place* (1948) consolidated his efforts at combining photography and text into a genuinely synthetic project in which the encounter with the past sets off a series of ruminations on what it means to return, both in a visual and metaphysical sense, to one's birth place.

The importance of the photographer's regional affiliation is therefore a crucial element in Morris's thinking and it informs both his own attempts at combining text and images and the ways in which he writes about photography, in general. Writing about Eugène Atget's images of Paris, Morris notes how 'the camera was used to confirm what was visible' even while caught up in 'the photographic dilemma … of what should come first, the photograph or the photographer' (Morris 1989: 55). In these terms, the photographer will always inevitably

have to negotiate whether he is governed by the environment in which he photographs or whether he is, in a sense, creating that environment through his photographs. Regardless, documentary photography's 'extravagant respect for what we describe as the facts of life' (Morris 1989: 109) remains, for Morris, the most important thing.

For Morris, this respect 'for what we describe as the facts of life' is paramount and it is partially what leads him to be less concerned with the fissures of American life and more interested in documentary photography as an act of remembrance, a repository for an on-going belief in the ability of the image to speak for collective as well as individual histories. Rather than a critical apparatus in political terms, photography was a way to illuminate how the minutia of daily life could be as valid a subject as larger societal concerns.

Morris's insistence on those seemingly innocuous things we surround ourselves with, from objects to the anonymous family snapshots, is also a way to reconsider what actually constitutes culture in the first place. By gravitating towards photographs of artefacts, for example, whose value hinges on the fact that they predate a more commodified society, Morris attempts to rearticulate what constitutes value in photographic terms as well. For Morris, those images that bear a direct link to past histories and past lives are those richest in meaning. It is not necessarily that contemporary life is less charged with meaning, simply that: 'There is a diminishment of value in the artefact itself, and there is a limited way in which a photographer can deal with the diminished values of the contemporary artefact. There is a statement to be made about them, but it will be relatively shallow' (Knoll 1977: 150).

This fidelity to the past partially explains Morris's reuse of his own photographs across several books and it also explains, to some extent, his anxieties about the camera's tendency to render 'all subjects' new and old 'as symbolic facts' (Morris 1989: 112). In his own work, the visible signs of lives lived and gone reflect a desire for permanence that can be viewed in symbolic terms: 'I couldn't go out and make a new world for myself to photograph and it wasn't advisable. This is a revisitation. In fact, a repossession' (Knoll 1977: 149). The definition of photography as a form of repossession, with the act of photography understood as a way to reaffirm not only the existence of the world around us but the importance of it, is a crucial point for Morris. What it does, among other things, is validate documentary photography as an act of retrieval as crucial as memory itself.

If the persistence of the past is the terrain of documentary photography, for Morris in any case, it is also a way to access a collective as well as a personal sense of identity. It illuminates his central purpose,

to clarify the process by which we imbue the things we photograph, regardless of what they are, with meaning. Morris was acutely aware that much American documentary photography of the early to mid-twentieth century could be seen as a form of salvage operation, a potentially nostalgic way to idealize the past as a purer, 'truer' version of American life. If he himself gravitated towards a particular aesthetic of the 'homestead' and of his childhood, it was in search of personal ballast and also because, on a wider level, he was astute about American photography and its inevitable links to regional sympathies and allegiances. In an attempt to genuinely synthesize form and con-tent, Morris's writing thus constitutes a very active encounter with documentary photography as a way of both seeing and understanding the world. As Morris put it, we 'make images to see clearly: then we see clearly what we have made' (Morris 1989: 76).

Biography

Wright Morris was born 5 January 1910 in Central City, Nebraska. In 1924 he moved to Chicago, where he stayed until he left for a year in Europe in 1934. He was awarded two Guggenheim fellowships in 1942 and 1946 for photo-textual studies. He received the National Book Award in 1957 for *The Field of Vision* and in 1981 for *Plains Song*. He has published over 30 books and numerous short stories; his photo-texts include *The Inhabitants* (1946), *God's Country and My People* (1968), *Love Affair: Venetian Journal* (1972), *Structures and Artifacts: Photographs 1933–1954* (1975) and *Photographs and Words* (1982). His collected essays on photography, *Time Pieces: Photographs, Writing, and Memory*, were published in 1989. Morris died on 25 April 1998, aged 88.

Primary texts

Morris, W. (1946) *The Inhabitants*, New York, NY: Scribners.
——(1948) *The Home Place*, New York, NY: Scribners.
——(1975) *Structures and Artifacts*, Lincoln, NE: University of Nebraska Press, Sheldon Art Gallery.
——(1982) *Photographs and Words*, Carmel, IN: Friends of Photography.
——(1989) *Time Pieces: Photographs, Writing, and Memory*, New York, NY: Aperture.

Secondary texts

Blinder, C. (2010) 'The Bachelor's Drawer: Art and Artefact in the Work of Wright Morris', in M. Gidley (ed) *Writing with Light*, London: Peter Lang.

Knoll, R. E. (1977) *Conversations with Wright Morris: Critical Views and Responses*, Lincoln, NE: University of Nebraska Press.

Trachtenberg, A. (2002) *Distinctly American: The Photography of Wright Morris*, London: Merrell.

Caroline Blinder

BEAUMONT NEWHALL (1908–1993)

Few figures are as closely linked with writing on photography as Beaumont Newhall, the pioneering historian, curator and educator whose ground-breaking text *The History of Photography* influenced the public's perception of photography and ultimately charted a new field of scholarship.

Newhall published his first writing on photography as part of a series of reviews begun in 1932 for *The American Magazine of Art*. In his review of *Aus der Frühzeit der Photographie, 1840–70*, an illustrated account of the medium by German art historian Helmuth Th. Bossert and journalist Heinrich Guttmann published in 1930, Newhall suggests that photographs by Nadar, Talbot and D. O. Hill would be a 'revelation' to many readers because of their 'astounding modernity of feeling'. Newhall immediately associates this sense of modernity with '"Pure" photography' (Newhall 1932: 130), championing the inherent capabilities of the medium over painterly imitation and asserting that 'the ability of the camera to capture the utmost possible detail of the natural world is its chief characteristic, and should be fully realized' (Newhall 1932: 131). Newhall details this philosophy in his first lecture on the history of photography, 'Photography and the Artist', delivered to the College Art Association in New York in March 1934 and printed in the journal *Parnassus* later that year. Newhall's lecture constitutes his first published statement on the relationship of painting and photography, and ties the genesis of photography in the nineteenth century with the artistic ambitions of its inventors. From these beginnings, photography, as Newhall presents it, emerged as an independent art determined by its own technological capabilities. He reiterates his belief that the camera's true function is 'to record limitless detail' (Newhall 1934: 29), and later, in a 1935 review of Ansel Adams's *Making a Photograph: An Introduction to Photography*, Newhall links this principle to contemporary practice as exemplified by photographers of the 'straight school'.

This outlook would inform Newhall's enormously influential exhibition *Photography 1839–1937*, presented at the Museum of Modern Art

(MoMA) in New York in 1937 and accompanied by a catalogue of the same name. Newhall joined the staff of MoMA as its librarian in 1935, and one year later the museum's director, Alfred H. Barr, proposed that Newhall prepare a major survey of photography. Newhall enthusiastically accepted the challenge, assembling a broad historical overview that included 841 objects, including prints, negatives, cameras and apparatus. Newhall's catalogue essay proceeds chronologically through the medium's technical advances, organized into sections such as 'Daguerreotypes', 'Calotypes' and 'The Collodion (Wet Plate) Process' and illustrated with representative masterworks by Nadar, Mathew Brady, and Hill and Adamson. Based on these nineteenth-century precedents, Newhall ultimately establishes a lineage for the photographers whom he includes in his section 'Contemporary Photography', such as Ansel Adams, Paul Strand and Edward Weston. In doing so, Newhall positions straight photography as the inevitable outcome of a historical tradition, the fulfilment of the medium's unique technical and artistic potential. This ground-breaking text provided an art historical framework for the history of photography, determining the scope of the medium and identifying its canon of masterpieces. The initial run of 3000 copies sold out in the first year, leading the museum to issue a slightly revised version with the new title *Photography: A Short Critical History* in 1938. Newhall, then recognized as a leading authority in the field, was instrumental in founding the department of photography at MoMA in 1940 and was named its first curator.

Newhall's advancing career was interrupted in 1942 by service in the air force during World War II. His wife, Nancy Newhall, herself an accomplished writer on photography and a close collaborator, assumed leadership of the department at MoMA in his absence. He resumed his post in 1945 only to resign in 1946, after Edward Steichen was abruptly appointed director of the department of photography. It would be two years before Newhall would secure employment at another museum; he spent the interim writing an almost entirely new edition of his history with the support of a Guggenheim fellowship, awarded in 1947, as well as working as a freelance contributor to a variety of periodicals. Newhall's writing in the late 1940s reflects a distinct concern with the communicative potential of photography, with its ability to move people and ulti-mately bring about change. Writing about Henri Cartier-Bresson for *Popular Photography* in 1947, Newhall warned: 'To retire within an ivory tower, or to allow an esthetic approach to dominate over appreciation of human values, is to deny photography as a means of

communication. One must have something to say, something concrete, definite, and constructive to share with others' (Newhall 1947: 136). The following year he served as contributing editor of *Photo Notes*, the mimeographed bulletin of the Photo League, an organization of photographers committed to social causes. Reviewing an exhibition of student work at the Photo League in 1948 he advised: 'messages are needful, and we have learned that many of the most needful can be imparted more effectively with the camera than by any other medium' (Newhall 1948: 25). Newhall emphasized his conception of photography as a persuasive medium when he allocated a discrete chapter to documentary photography in the third edition of his history, issued in 1949 under the title *The History of Photography from 1839 to the Present Day*.

In 1948, just as he completed the manuscript for his revised history, Newhall became founding curator (and later director) of George Eastman House in Rochester, New York. At Eastman House, he served as editor of *Image*, a publication started in 1952 as a vehicle through which Newhall, Eastman House staff and a host of guest writers could deliver their historical findings, largely based on the museum's extensive and uncharted collections. As one of the few historians of photography during the 1950s and 1960s, Newhall was invited to contribute to an array of publications, writing for journals, magazines, annuals, newspapers and encyclopaedias. He was a key contributor to *Aperture*, a magazine that he helped to found in 1952 with Nancy Newhall, Ansel Adams, Minor White, Dorothea Lange and others who aspired to present contemporary photography with the dignity epitomized by Alfred Stieglitz's *Camera Work*. While also writing for *Modern Photography*, *Popular Photography* and *The Photographic Journal*, Newhall was photography editor for *Art in America* from 1957 to 1965. All the while, he was food editor of the suburban newspaper *The Brighton-Pittsford Post*, writing over 200 articles for his column 'Epicure Corner' between 1956 and 1969.

In this exceptionally productive period, Newhall completed nearly a dozen books, catalogues and monographs, including *On Photography: A Source Book of Photo History in Facsimile* (1956), *The Daguerreotype in America* (1961) and *Frederick H. Evans* (1964), in addition to *Masters of Photography* (1958) and *T. H. O'Sullivan* (1966), both collaborations with Nancy Newhall. Newhall considered his 'best book' to be *Latent Image* (1967), a story of photography's invention written for teenage science students (Ginsberg and Hagen 1975: 10). In order to sustain the attention of his intended audience, he may have applied some of the techniques he learned from his friend Ferdinand Reyher, a novelist and

Hollywood scriptwriter, who helped Newhall to rewrite a significantly modified draft of his history in 1964, teaching him how 'to make a story, instead of an academic treatise. To use some of the tricks of the novelist' (Clune 1964). This edition served as a standard textbook for the growing number of photography courses at universities across the US during the 1960s and 1970s, influencing a new generation of photographers, curators and historians, and essentially defining the history of photography as it developed as a unique field of study.

Newhall left Eastman House in 1971 and began teaching at the University of New Mexico. Relieved of the daily responsibilities of managing a museum, Newhall was able to devote his attention to on-going projects, completing *Photography: Essays and Images* (1980), *Photography and the Book* (1983) and *Supreme Instants: The Photography of Edward Weston* (1986). Newhall spent much of the 1970s revising the fifth and final edition of *The History of Photography*, published in 1982. During the years that followed, his pioneering history would be a prime target for an emerging group of scholars critical of the aestheticization and canonization of photography, in general, and of Newhall's narrow view of the medium, in particular. In several published interviews, and in his memoir, appearing shortly after his death in 1993, Newhall responded to this criticism in his characteristically gracious and generous manner. He expressed both pride in his efforts on behalf of the field and uneasiness with his monumental role in constructing the history of photography; indeed, Newhall called for more histories throughout his career, even composing the editorial 'Wanted: Historians of Photography' for *Image* in 1957. He repeatedly claimed that his history was never intended to be absolute or encyclopaedic, strongly objecting to being called the 'Father of the History of Photography' (Newhall 1986: 7; Hill and Cooper 1979: 409). Nevertheless, Newhall's history set the standard by which all histories of the medium would be measured, and his total contribution to the literature of the field remains unequalled.

Biography

Beaumont Newhall (1908–1993) was born in Lynn, Massachusetts. He studied art history and museum studies under Paul J. Sachs at Harvard University, completing an MA in 1931. In 1935, after working briefly at the Philadelphia Art Museum and the Metropolitan Museum of Art, and completing fellowships in Paris and London, Newhall became librarian at the Museum of Modern Art in New York. A year later, museum director Alfred H. Barr invited Newhall to organize a

major exhibition of photography. The exhibition *Photography 1839–1937*, along with its ground-breaking catalogue, effectively launched Newhall's unprecedented career as the pre-eminent historian in the field. At MoMA, he was named curator of the newly founded department of photography in 1940, a position from which he resigned in 1946. He was the founding curator of George Eastman House in Rochester, New York, in 1948, and became director of that museum ten years later. While in Rochester he taught courses in the history of photography at the University of Rochester, Rochester Institute of Technology and Visual Studies Workshop. He retired from George Eastman House in 1971, relocating to Albuquerque, New Mexico, where he was professor of art history at the University of New Mexico until 1984. Steadfastly committed to advancing photography's status as an independent art, Newhall wrote nearly two dozen books and more than 650 articles on photography over the course of his extraordinary career.

Primary texts

Clune, H. W. (1964) 'Writing Team', *Rochester Democrat and Chronicle*, 20 September.

Ginsberg, P. and Hagen, C. (1975) 'Beaumont Newhall: An Interview', *Afterimage*, vol 2, no 8, pp9–11.

Hill, P. and Cooper, T. (1979) 'Beaumont Newhall', in *Dialogue with Photography*, New York, NY: Farrar, Straus, Giroux, pp377–412.

Newhall, B. (1932) 'Review of *Aus der Frühzeit der Photographie, 1840–70,* by H. T. Bossert and H. Guttmann', *The American Magazine of Art*, vol 25, no 2, pp130–131.

——(1934) 'Photography and the Artist', *Parnassus*, vol 6, no 5, pp24–25, 28–29.

——(1935) 'Review of *Making a Photograph: An Introduction to Photography*, by Ansel Adams', *The American Magazine of Art*, vol 28, no 8, pp508–512.

——(1937) *Photography 1839–1937*, New York, NY: Museum of Modern Art.

——(1947) 'Vision Plus the Camera', *Popular Photography*, vol 20, no 1, pp56–57, 134, 136, 138.

——(1948) 'Two Schools', *Photo Notes* (Fall), pp23–25.

——(1957) 'Wanted: Historians of Photography', *Image*, vol 6, no 1, p3.

——(1986) 'The Challenge of Photography to This Art Historian', in P. Walch and T. Barrow (eds) *Perspectives on Photography: Essays in Honor of Beaumont Newhall*, Albuquerque, NM: University of New Mexico Press, pp1–7.

Secondary texts

Bertrand, A. (1997) 'Beaumont Newhall's "Photography 1839–1937": Making History', *History of Photography*, vol 21, no 2, pp137–146.

Chickey, D. (ed) (2009) *Beaumont's Kitchen: Lessons on Food, Life, and Photography with Beaumont Newhall*, Santa Fe, NM: Radius Books.

Gasser, M. (1992) 'Histories of Photography 1839–1939', *History of Photography*, vol 16, no 1, pp50–60.

Marien, M. W. (1986) 'What Shall We Tell the Children? Photography and Its Text (Books)', *Afterimage*, vol 13, no 9, pp4–7.

Newhall, B. (1956) 'Photography as Art in America', *Perspectives USA*, vol 15 (Spring), pp122–133.

——(1963) 'The Photographic Revolution in the Visual Arts', *The Photographic Journal*, vol 103, no 9, pp245–260.

——(1983a) *In Plain Sight: The Photographs of Beaumont Newhall*, Salt Lake City, UT: Peregrine Smith.

——(1983b) 'Toward the New Histories of Photography', *Exposure*, vol 21, no 4, pp4–8.

——(1993) *Focus: Memoirs of a Life in Photography*, Boston, MA: Bulfinch Press.

Nickel, D. (2001) 'History of Photography: The State of Research', *History of Photography*, vol 83, no 3, pp548–558.

Jessica S. McDonald

MARCEL PROUST (1871–1922)

Marcel Proust's long modernist novel, *À la recherche du temps perdu* (*In Search of Lost Time*), is *photographic*. He *appears* to leave out no detail in his Nile-long sentences that seek to represent the truth. Nevertheless, *À la recherche* does not deliver the conventional 'real' associated with the photograph. Proust's novel, which is neither memoir, nor fiction, neither history nor philosophy (yet is also all of these things), is an echo of the photograph's essentially paradoxical nature: the real and the fictional at once. *À la recherche* and the photograph sit uneasily, if productively, between science and art.

Other photographic paradoxes (including black and white, positive and negative, time held and time lost, authored and authorless) figure dramatically in Proust's novel. It is as if the photograph, which continually flaunts its contradictions, was invented for Proust's literary investigation of memory. As Mieke Bal writes, Proust seeks to recover lost time, not through photographs, but rather through the medium's 'art of paradox, of the positive-negative' (Bal 1997: 193). *Writing photography* is the form of *À la recherche*, although its content can also be photography.

Photographs themselves are not Proustian. When Roland Barthes (a devotee of Proust) writes: 'nothing Proustian in the photograph', he is underscoring the fact that *À la recherche* draws out the medium's inseparable (if seemingly secret) battling paramours of reality and fantasy (Barthes 1981: 82). Similarly, a photograph is not an 'involuntary memory' (though it could prompt one in the fashion of Barthes's

punctum). Yet, an involuntary memory is like a photograph in that it ushers the past into the present in a single 'flash'.

The fact that Proust made use of photographs, especially of those by Paul Nadar, to build *À la recherche*'s 'fictional' characters, often composites of several figures, is well-known and is documented in the book edited by Anne-Marie Bernard: *The World of Proust as Seen by Paul Nadar*.

Proust wrote about the current photographic productions of his time, including (but not limited to) the stereoscope, art reproductions (especially Giotto), magic lantern slides and X-rays. For example, he writes about the strangeness of seeing his bedroom modified by the magic lantern: 'this mere change of lighting was enough to destroy the familiar impression I had of my room … I no longer recognised it, and felt uneasy in it, as in a room in some hotel' (Proust 1992: I, 10). Likewise, the Narrator's mother is described as 'worse than the X-rays' for 'she can see what is in your heart'; and the writer/Narrator of the novel claims himself as a 'surgeon', going beyond what he sees on the surface of his subjects in order 'to examine them with X-rays' (Proust 1992: I, 73; VI, 40).

Plagued with asthma for most of his life, the disease restricted Proust, but afforded him time to sit, watch, observe, record and *develop* his ideas. Proust's beloved maid Céleste Albaret claimed the novelist's observations as that of a camera, but even better. 'In thirty seconds everything was recorded, and better than a camera could do it, because behind the image itself there was often a whole character analysis based on a single detail – the way someone picked up a salt cellar, an inclination of the head, a reaction he had caught on the wing' (Proust 1992: I, 251–252). Pointing to his brow and famed dark eyes, he told Albaret: 'It's all recorded here, Céleste … . But it is never finished' (Proust 1992: I, 252).

As a boy, the Narrator of *À la recherche* tries to 'recapture' the world by 'closing his eyes', like a camera's shutter (Proust 1992: I, 252). Even 'pleasure' in *À la recherche* develops like a photograph:

> Pleasure in this respect is like photography, What we take, in the presence of the beloved object, is merely a negative, which we will develop later, when we are back at home, and we have once again found at our disposal that inner darkroom the entrance to which is barred to us so long as we are with other people.
>
> (Proust 1992: II, 616–617)

Metaphors of the darkroom play a role, not only in Proust's texts, but also in the way in which he lived a good part of his life, shut away

from the light in his cork-lined room, writing in bed at night and sleeping during the day. Likewise, À la recherche, a book about trying to write a novel, is narrated by Proust's fictional (non-fictional) double. The Narrator also has asthma, writes in bed, sleeps during the day, etc.

Proust's biographical and literary inversion of night into day and day into night is yet another repetition of the many reversals of the photographic process. In Proust's time, a photograph began under the darkness of the photographer's black cloth. Under the tent, the image would appear upside down and backwards, on the ground glass of the 'view camera'. It was in darkness that the process of 'light-writing' (photography's much commented on etymology) began. Likewise the large glass negatives that the photographer printed from were an inversion of the final photograph's positive image, in which light areas appear dark and vice versa. 'Inversion – as *form*', according to Barthes, 'invades the entire structure of *La Recherche* ... there is a pandemia of inversion, of reversal Reversal is a law' (Barthes 1986: 273–275). In *Camera Lucida*, Barthes makes a sport of it too. With a Proustian influx he writes: 'My stories are a way of shutting my eyes' (Barthes 1981: 53). 'In order to see a photograph well, it is best to ... close your eyes' (Barthes 1981: 53).

Proust pushes the *development* of photography through stories of psychological observation, including, among a much longer list, photography as scopophilia (the love of watching) and photography as abjection (a loss of distinction between subject and object).

Scopophilia is the name of the game when the young Mlle Vinteuil places a photograph of her father in the middle of her lesbian lovemaking, so as to metaphorically force him to watch. 'This photograph was evidently in regular use for ritual profanations' (Proust 1992: I, 229). The scopophilia is more than doubled by the fact that the Narrator is watching the young women and the reader is watching the Narrator watch the young women who are watched by the father: scopophilia *en abyme*, not unlike what Craig Owens has referred to as 'Photography *en abyme*'.

Abjection permeates when the Narrator watches his grandmother waiting to be photographed. Unaware of his presence, she is not acting or posing; her imagined distinction is lost. She is near death. Stunned by the sight, the Narrator explains that 'the process that automatically occurred in my eyes ... was indeed a photograph' (Proust 1992: III, 184). He watches a woman whom he did not know: 'red-faced, heavy and vulgar, sick, day-dreaming, letting her slightly crazed eyes wander over a book' (Proust 1992: III, 185).

'Instead of ... eyes' the scene was taken with 'a photographic plate' (Proust 1992: III, 183–184).

Abjection permeates again when the Narrator moves in to kiss the cheek of his lover, Albertine. As if he was using 'the most recent application of photography' (Proust 1992: III, 498), he sees her close up, and monstrously so. 'The neck, observed at closer range and *as though through a magnifying glass*, showed its coarser grain a robustness which modified the character of the face ... this one girl being like a many-headed goddess, the head I had seen last ... gave way to another' (Proust 1992: III, 498–499). The Narrator is *like* a camera using 'a zoom lens', which at the time of the novel is coming into its own development (Bal 1997: 202).

'By the end of the nineteenth century the gestures of the Western bourgeoisie were irretrievably lost,' claims Georgio Agamben (1993: 149). This 'loss' is a result of the overproduction of recording the gesture. Agamben notes Gilles de la Tourette's 1886 publication of *Clinical Studies in Psychologies of Walking* as one last step towards the loss of gesture. Like Muybridge's split-second pictures, Tourette's study (which used coloured powder to achieve indexical traces of the subject's steps on a long roll of white paper) is, at its heart, photo-graphic. The following year, Tourette would publish a book on the syndrome that took his name. Perhaps overzealously, Agamben sees early film, like that by the Lumières and Marey, as creating the loss of gesture through its 'scientific' representation, which simultaneously filled that loss with a 'catastrophe' (Agamben 1993: 150). Suddenly, in early film, gestures appear in jumps, as unhinged, fitful and spasmodic: as if Tourettism has become the norm. *À la recherche*, Agamben suggests, is one of the last gestures towards 'gesture lost'. Proust traced the 'magic circle in which humanity sought, for the last time, to evoke what was slipping through its fingers for ever' (Agamben 1993: 138).

À la recherche with its famed careful attention to gesture ('the way someone picked up a salt cellar, an inclination of the head') is *writing photography*. The writing comes through the gestures of Proust's own hand informed by the paradoxes of photography. It is a gesture not stopped: 'Celeste ... it is never finished.' Proust's long gestures, often written on pieces of paper, folded accordion-style, up to four feet long and then glued into his notebooks (the famed '*paperoles*'), are the material of his always-developing *search for lost time*.

In 1980, Barthes died on the way to deliver what would have been his last lecture at the Collège de France, 'Proust and Photography': an unfinished gesture.

Biography

Marcel Proust was born in 1871 to a Jewish mother and Catholic doctor. Proust seems to have begun his multi-volume masterpiece in 1908. The first volume, *Swann's Way*, was published in 1913; the second volume, *Within a Budding Grove*, was published in 1919; *The Guermantes Way* in 1920–1921 and *Sodom and Gomorrah* in 1921. Proust died on 18 November 1922. The American surrealist Man Ray photographed him on his deathbed. The remaining volumes of *À la recherche* were published after his death: *The Captive* in 1923, *The Fugitive* in 1925 and *Time Regained* in 1927.

Primary texts

Albaret, C. (2003) *Monsieur Proust, as told to Georges Belmont*, translated by B. Bray, New York, NY: New York Review of Books.

Barthes, R. (1986) 'An Idea of Research', in *The Rustle of Language*, translated by R. Howard, New York, NY: Hill and Wang.

Proust, M. (1992) *In Search of Lost Time*, Vols I–VI, translated by C. K. Montcrieff and T. Kilmartin, revised by D. J. Enright, New York, NY: Random House.

Secondary texts

Agamben, G. (1993) *Infancy and History: On the Destruction of Experience*, translated by L. Heron, London and New York: Verso.

Bal, M. (1997) *The Mottled Screen: Reading Proust Visually*, translated by A.-L. Milne, Stanford, CA: Stanford University Press.

Barthes, R. (1981) *Camera Lucida: Reflection on Photography*, translated by R. Howard, New York, NY: Hill and Wang.

Mavor, C. (2007) *Reading Boyishly: Roland Barthes, J. M. Barrie, Jacques Henri Lartigue, Marcel Proust and D. W. Winnicott*, Durham, NC, and London: Duke University Press.

Nadar, P. (2004) *The World of Proust as Seen by Paul Nadar*, edited by A.-M. Bernard, photographs by P. Nadar, translated by S. Wise, London and Cambridge, MA: MIT Press.

Owens, C. (1978) 'Photography *"en abyme"'*, *October*, vol 5 (Summer), pp73–88.

Carol Mavor

JACQUES RANCIÈRE (1940–)

When an author begins to have books written about them then you know their texts are becoming important and influential (see Deranty

2010; Bowman and Stamp 2011). Jacques Rancière is one such author, who since he retired from teaching has turned his attention to writing on art, culture and its politics. As a result, Rancière's work has become the latest in a line of French thinkers to have an important impact upon a wider critical discussion of contemporary culture, art and photography. In a string of books translated from French to English over the last decade, his thinking has been seen to challenge the stagnant debates and presumptions of the existing aesthetic theories of art, film, literature and photography. Indeed, in terms of his engagement with aesthetics, Rancière's work is very different from those who have gone before.

As a political philosopher, Rancière's work deals with the dimensions of aesthetics and politics and their critical (ethical) intersection. As the title of one of his books insists, *The Politics of Aesthetics* (2004) is a crucial area of work for contemporary theory. Aesthetic acts of perception, he argues, can configure 'novel forms of political subjectivity' (Rancière 2004: 9). Rancière lays out in broad terms (as is custom among philosophers) his critique of the dominant consensual categories under which art is discussed. In *The Politics of Aesthetics* he writes: 'I do not think that the notions of modernity and the avant-garde have been very enlightening when it comes to thinking about the new forms of art that have emerged since the last century or the relations between aesthetics and politics' (Rancière 2004: 20). For Rancière, the urgency of dealing with the present 'regime of images' in intellectual thought is crucial. It is this sort of bold critical challenge to twentieth-century categories of thought that attracts a readership, along with the sense that somewhere in his thought must be some answers to the gap that we often experience between contemporary images and the theories that exist to explain them in culture today. The insistence on a return to aesthetics aims to enlighten, enliven and disrupt the critical debates around the role of the image in culture. Rancière's book *The Future of the Image* (2007), for example, sets out to deal with this question directly. What the reader finds, however, is a sophisticated interrogation of what an image actually is, with multiple examples from the past and present, rather than any putative 'future'.

Rancière's concept of the 'image' is a multifunctioning term whose concept refers to things beyond the 'visual', beyond *pictures*: the cinematic image, television, drawing and the photographic image. For Rancière, the blank screen in a film is nevertheless an *image*, whose meaning is to be situated somewhere.

Rancière is able to draw together (through aesthetics) what is an otherwise fragmented field of study (the usual sociological distinctions

of cinema, photography, television, art and theatre, etc.). By inter-
rogating any one type of image, he is able to draw our attention to
the more general and underlying principles governing thinking about
the image in modern culture. Photography is one key central focus in his
elaboration of this problematic:

> Photography became an art by placing its particular techniques in
> the service of the dual poetics, by making the face of anonymous
> people speak twice over – as silent witnesses of a condition
> inscribed directly on their features, their clothes, their life setting
> and as possessors of a secret we shall never know, a secret veiled
> by the very image that delivers them us.
>
> <div align="right">(Rancière 2007: 15)</div>

Rancière's point is that photography ushers in a relation to the image
that is both laden with language, the cultural 'message' (of Roland
Barthes's *studium*) and its silence (as Barthes's *punctum*) (Barthes 1981).
In this way, the regime of photography, and its visual representations
that we are now almost all born into, is merely a development of
what was already articulated by the invention of the novel. Words
on a page make images, they show things; yet like the photograph they
also hide things or, rather, leave them as invisible. This dual visible
and invisible economy of images is what Rancière calls the 'aesthetic
regime', which begins somewhere in the nineteenth century (Rancière
2007: 13) (like many philosophers writing on cultural history and art,
he is remarkably vague on specific dates).

Rancière rids himself of the usual polite disciplinary nuances drawn
between paintings, novels and photographs by sweeping them all into
one discursive framework: the aesthetic regime. All images are gov-
erned by the paradoxical principles of revelation and hidden presence.
From this position Rancière can then interrogate this or that form of
image, a type of photograph, painting, novel, film or cinema, and
consider its relation to the double poetics of visible/invisible as 'encoded
history'/'presence'. The particular power attributed to '*aesthetic* images'
is through this paradox, the twofold combination of 'the inscription of
the signs of history and the affective power of sheer presence that is no
longer exchanged for anything' (Rancière 2007: 17).

Rancière mobilizes this distinction elsewhere in his writing
on pictures, for example, in his essay 'The Pensive Image' (Rancière
2009c), where the relation of photography to art is at the centre of
his text. The 'pensive' image, he argues, is 'something in the image
which resists thought – the thought of the person who has produced
it and of the person who seeks to identify it' (Rancière 2009c: 131).

Rancière describes pensiveness as a sort of contamination of different arts, of different aesthetic regimes. In an example, Rancière cites the pictorial silence of a Walker Evans photograph contaminated by the projection of a literary description, as in Flaubert (it is well-known that Evans cites Flaubert as a key reference). As Rancière puts it: 'The pensiveness of the image is then the latent presence of one regime of expression in another' (Rancière 2009c: 124). The cross-contamination of the aesthetic puts any closure on hold, and any conclusion is inhibited or suspended.

Thus, Rancière resists the notion that these aesthetic ideas are restricted to certain technologies. As he puts it: 'The art of the aesthetic age has never stopped playing on the possibility that each medium could offer to blend its effects with those of others, to assume their role and thereby create new figures, reawakening sensible possibilities which they had exhausted' (Rancière 2009c: 131–132).

Yet, if images are haunted by a silent discourse, so are Rancière's writings. Irritating for some, Rancière's writings are often allusive and speculative. He cheerfully displaces a discussion from one domain to another, making reference to texts that are implicit, not explicit, and not necessarily easy to follow. Any such 'difficulty', of course, is usually associated with a lack of familiarity and his writings do demand an awareness of shifting references. This system of fleeting references can be seen at work even in his very book titles. Behind Rancière's book title *The Future of the Image* (2007) is the famous 1927 essay title 'The Future of an Illusion' by Sigmund Freud on the problematic of human culture (Freud 1984). Jacques Rancière's title substitutes Freud's future of an 'illusion' with the future of the 'image', in this way equating illusion with image – without ever stating this literally. Another book title finds Rancière substituting 'aesthetics' for 'civilization' to become *Aesthetics and Its Discontents* (2009b). This is another reference to a famous essay by Freud, 'Civilization and its Discontents' (Freud 1984), which discusses the contradictions inherent in forms of human civilization and culture. In these playful book titles Rancière substitutes the word 'aesthetics' into the titles of well-known works by others; another example is *The Aesthetic Unconscious* (2009), a direct reference to Fredric Jameson's book on radical literary aesthetics *The Political Unconscious* (Jameson 1989). I refer to these 'inter-textual' references because it is precisely the sort of slippage in meanings, reference and dialogue with other theorists that Rancière is attentive to in his theorization of images – including photographs. It is this slippage of meanings and reference that organizes his theory of the aesthetic image and often his texts. Nonetheless, the debt paid to Freud in his

titles is not repaid in the text, at least not directly in relation to Freud's theory of the unconscious (so relevant to the 'other of the image' in Rancière's work) or to questions of sexuality in art.

In a more direct political engagement with images, Rancière uses his distinction between consensual and the 'dissensual' to generate critical discussions of specific contemporary artworks. Here his writings begin to function more like that of a theoretically informed art critic. Rancière adopts a position towards certain images, assessing the role that silence and speaking play in the artwork (film, photograph, video, etc.) and locates it in terms of the dissensual or a dominant consensual political dimension of the aesthetic domain, and for what it contributes as 'critical art' to a 'new landscape of the sensible' (Rancière 2010: 149). Such positions invite interest from the art world and it is no surprise that Rancière has become an important figure in international art criticism and contemporary cultural theory. Yet, in this way his work might be accused of generating consensual aesthetics, championing artworks and offering closure where it does not exist. Victor Burgin, for example, although sympathetic to Rancière's thinking, has pointed to, in his words, 'a general limitation of philosophy when it becomes art criticism' (Burgin 2011: 176).

However, Rancière's categories of consensual and dissensual make for a clear dichotomy that seems likely to become popular in use. The aesthetic image is a complex formulation, one negotiating language and its other in the image. No doubt these attributions are as complex as Barthes had intended his distinction between *studium* and *punctum* to be, although, perhaps similarly, their destiny will also be to betray the critical purposes to which they were intended in the text.

Biography

Jacques Rancière was born in 1940 in French Algeria, like Jacques Derrida before him (ten years later than Derrida). He became professor and taught at the University of Paris VIII from 1969 and was chair of aesthetics and politics from 1990 until his retirement in 2000. Since then his writings have appeared constantly and insistently on the realm of art. His teaching and research career was based at Vincennes in the outer suburb of Paris, University of Paris VIII, set up after the 1968 general strike and protests in Paris. Other leftist intellectual figures such as Michel Foucault, Gilles Deleuze and Jean-François Lyotard also worked and taught there. Rancière ran philosophy seminars, but in the earlier years was also deeply preoccupied in historical work (on the lives of workers). His first book to be translated into English was *The Nights of Labour: The*

Workers Dream in Nineteenth-Century France (1989), followed by *The Ignorant Schoolmaster: Five Lessons in Intellectual Emancipation* (1991).

Primary texts

Rancière, J. (1974) *La leçon d'Althusser*, Paris: Gallimard.

——(1989 [1981]) *The Nights of Labour: The Workers Dream in Nineteenth-Century France*, first published as *La Nuit des prolétaires: Archives du rêve ouvrier*, Paris: Fayard.

——(1991 [1987]) *The Ignorant Schoolmaster: Five Lessons in Intellectual Emancipation*, translated by K. Ross, Stanford, CA: Stanford University Press; originally published in French as *Maitre ignorant: Cinq leçons sure l'emancipation intellectuelle*, Paris: Fayard.

——(2004 [2000]) *The Politics of Aesthetics*, translated by G. Rockhill, London: Continuum; originally published in French as *Esthétique et politique*, Paris: Éditions La fabrique.

——(2006) *Hatred of Democracy*, London: Verso.

——(2007 [2003]) *The Future of the Image*, translated by G. Elliott, London: Verso; originally published in French as *Le Destin des images*, Paris: Éditions La fabrique.

——(2008) *Conditions*, London: Continuum.

——(2009a [2008]) *The Emancipated Spectator*, translated by G. Elliott, London: Verso; originally published in French as *Le spectateur émancipé*, Paris: Éditions La fabrique.

——(2009b [2004]) *Aesthetics and Its Discontents*, translated by S. Corcoran, London: Polity; originally published in French as *Malaise dans l'esthetique*, Paris: Éditions Galilée.

——(2009c) 'The Pensive Image', in *The Emancipated Spectator*, translated by G. Elliott, New York and London: Verso, pp107–132.

——(2010) *Dissensus: On Politics and Aesthetics*, edited and translated by S. Corcoran, London: Continuum.

——(2011) *Chronicles of Consensual Times*, translated by S. Corcoran, London: Continuum.

Secondary texts

Barthes, R. (1981) *Camera Lucida, Reflections on Photography*, London: Fontana.

Bowman, P. and Stamp, R. (2011) *Reading Rancière: Critical Dissensus*, London: Continuum.

Burgin, V. (2011) *Parallel Texts: Interviews and Interventions about Art*, London: Reaktion.

Deranty, J.-P. (ed) (2010) *Jacques Rancière: Key Concepts*, Durham, NC: Acuen.

Freud, S. (1984) *Civilization, Society and Religion*, Vol 12, Pelican Freud Library, Harmondsworth, UK: Penguin.

Jameson, F. (1989) *The Political Unconscious: Narrative as a Socially Symbolic Act*, London: Routledge.

David Bate

MARTHA ROSLER (1943–)

Central to Martha Rosler's writing on photography is the question of how cultural and artistic practice can be politically engaged. The initial development of Rosler's writing and her own photographic practice were connected to her involvement with anti-war and feminist activism in California during the early 1970s. Throughout her highly successful exhibition and publication career, she has remained a vocal advocate for criticality and political consciousness within and beyond the art world. Rosler's writing on photography is broadly concerned with how relationships between representations and realities are produced and ideologically manipulated for certain audiences. She is critical of how the knowledges created in those processes interact with existing power dynamics of class, race and gender.

Rosler's understanding of photography goes against the idea that the medium can be understood according to a technological essence. Photography is a material practice that throughout history has always been in flux and cannot be considered separately from its history. Moreover, the production of photographs and the ways in which they are interpreted are connected to wider historical trends and events (Rosler 1999: 41). This means that for Rosler, photography is part of a wider matrix of cultural practices that can be used in a critical way, but that have also historically been subject to appropriation.

Most open to political appropriation and manipulation is the way in which photography is identified with truth and objectivity, an idea that Rosler seeks to historicize. The claim to objectivity of photojournalism she locates as stemming from the early twentieth century, particularly from the Spanish–American War. This was a period characterized by anxiety within the newspaper industry about political jingoism in jour- nalism (Rosler 2006d: 269). In the essay 'Image Simulations, Computer Manipulations: Some Considerations' (originally published in 1989), she explores the way in which photographic truth is always an ideological production, fabricated in a given context. In each context, certain practices of image production and manipulation are available, such as staging, cropping, textual contextualization of an image or lack thereof and computer editing. These techniques affect the specific photographic truth statements that can be produced. Equally impor- tantly, these tactics and technologies determine if photographs are received as true or untrue in journalistic or legal contexts.

Rosler develops a dialectical theory of culture in which cultural practices never have a stable, self-contained meaning but are part of a shifting field that is both shaped by and shapes power. This position is

strongly influenced by the Marxist philosophy of Frankfurt School thinkers Herbert Marcuse and Theodor Adorno. However, unlike Marcuse and Adorno, Rosler wants to imagine possibilities for agency on the part of the artwork that go beyond negation. Also, in contrast to them, she is equally interested in the resistant potential of popular and 'low' cultural production as in high art (Schube et al 2005: 10). Rosler is concerned with how, during the twentieth century, photography crossed over from being considered a craft dominated by amateur practitioners to a high art practice, on the one hand, and a profession of photojournalism, on the other. This shift has clearly had consequences for questions of audience. She writes that photography, and subsequently video, were 'removed from wide public address by [their] incarceration in museum mausoleums and collectors' cabinets' (Rosler 2004: 219).

In her nuanced readings of the work of other photographers, Rosler pays close attention both to the qualities of others' images and to the ways in which those images are circulated and received. For example, in her essay 'Lee Friedlander, an Exemplary Modern Photographer' (originally published in *Artforum* in 1975), she argues that Friedlander's discourse imposes a formalist, modernist frame for reading photographs that transforms a formerly public practice into an individualizing aestheticized one (Rosler 2006b: 117). Simultaneously, Friedlander's body of work productively dislodges the idea that the photograph shows a singular moment of truth. It does so by repeatedly foregrounding Friedlander's own interests and concerns across images that when seen in isolation look accidental and spontaneous (Rosler 2006b: 115). In general, Rosler stresses the non-neutrality of photographs and the discourses that surround them. In her view, every image, and every statement about an image, is shaped by multiple strata of agency and power.

The essay for which Rosler is best known is the 1981 'In, Around, and Afterthoughts (On Documentary Photography)'. It was originally published in a catalogue for her series of photo-text artworks, *The Bowery in Two Inadequate Descriptive Systems* (1974–1975). In this essay, Rosler brings a number of the themes of power, objectivity and context discussed above to bear on a critique of the American tradition of documentary photography. Rosler argues that documentary, as it has been practised in the work of photographers including Jacob Riis, Lewis Hine, Walker Evans, Diane Arbus, David Burnett and Dorothea Lange, consistently frames and objectifies an underprivileged subject for a privileged middle-class viewer. 'Documentary, as we know it,' she writes, 'carries (old) information about a group of powerless people to

another group addressed as socially powerful' (Rosler 1990: 306) The privileged viewer is interpellated as morally superior through viewing the image, and reassured about his or her own status and social power. The way in which documentary images are consumed thus mirrors the wider Western consumption of products, food and aestheticized imagery seen as linked to an exoticized Other (Rosler 1990: 311). The process of assuaging the viewer's conscience is strongly supported by the viewer's identification with the position of the photographer. The photographer's individual, usually male, authorship and personal bravery become a major focus of discourses surrounding documentary photography (Rosler 1990: 308).

Rosler focuses, in particular, on photographs of homeless alcoholic men in New York's Bowery district (which since the essay's writing has been radically gentrified, like many formerly down-and-out neighbourhoods in New York). In typical images of the Bowery, the figure of the drunken homeless man becomes a focus of the viewer's simultaneous pity and disgust. This mode of viewing blocks any systematic class analysis of the social and economic factors that lead to homelessness. The photographed 'drunken bum' is stripped both of personal identity and of wider social context. Rosler writes:

> Drunken bums retain a look of threat to the person. ... They are a drastic instance of a male society, the lumberjacks or prospectors of the cities, the men who (seem to) choose not to stay within the polite bourgeois world *of* (does 'of' mean 'made up of' or 'run by' or 'shaped by' or 'fit for'?) *women and children.* They are each and every one an unmistakably identifiable instance of a physically coded social reality.[...] Bums are an 'end game' in a 'personal tragedy' sort of chance.
>
> (Rosler 1990: 321–322)

Rosler's own artwork, *The Bowery in Two Inadequate Descriptive Systems*, is 'a work of refusal' (Rosler 1990: 322) of this moralizing economy of representation. The artwork consists of black-and-white photos of the Bowery taken by Rosler, but with no human figures present. These are paired with poem-like collections of words that colloquially describe drunkenness – for example, 'stewed/boiled/potted/corned/pickled/preserved/canned/fried to the hat'. In juxtaposing the two 'descriptive systems' of photography and text, Rosler demonstrates how they are both inadequate in capturing unequal social reality and the people who inhabit it.

Though 'In, Around, and Afterthoughts' has often been received as a wholesale rejection of the possibility of documentary photography,

it is important that Rosler specifies that she is discussing documentary 'as we know it' (Rosler 1990: 306). She thereby leaves open the possibility for other future forms of documentary that do not fall within the patterns of representation she discusses. In other articles, Rosler has explored both the possibilities and limitations of specific documentary practices, such as in 'Wars and Metaphors', a 1981 article on Susan Meiselas's book of photographs of the war in Nicaragua. In 'Post-Documentary, Post-Photography?' (1999), Rosler considers continuing changes in the author and truth functions of photography as a result of discursive and technological transformations. In a 1989 interview, she is clear about the fact that the problematic nature of documentary photography cannot lead to an abandonment of efforts to represent the world. Rosler states: 'I've written about documentaries as a dead form. But without some reference to the real, there's no place of departure' (Harper 1998: 10).

Ultimately, the strongest stake in Rosler's writing and art is the desire to enable a different kind of seeing: 'If people can be halted, even momentarily, in the act of performing the unthought actions and responses of everyday life, perhaps there can be a *détournement* and an advance in understanding' (Aliage et al 2009: 192) That project is an on-going one, which must be persistently reworked and repeated with a variety of ideas, strategies and approaches. Rosler's writing both embodies such a commitment, and works hard to recognize it in the projects of others.

Biography

Martha Rosler was born in Brooklyn, New York, in 1943. She obtained a BA from Brooklyn College of the City University of New York in 1965, and an MFA from the University of California, San Diego, in 1974. Her artworks in various media have received extensive international exhibition at venues including Sculpture Projects Muenster, the Institute of Contemporary Art in London, Documenta in Kassel, and the Dia Art Foundation in New York. Rosler has received several awards including the Spectrum Prize in photography (2005) and the Oscar Kokoschka Prize (2006). Rosler is Professor of Photography and Critical Studies at Rutgers University. She lives and works in Brooklyn.

Primary texts

Aliage, J. V., Gómez, Y. R and Gilbert, A. (2009) *Martha Rosler: La Casa, la Calle, la Cocina = The House, the Street, the Kitchen*, Granada: Centro José Guerrero de Granada.

de Zegher, M. C. (1998) *Martha Rosler: Positions in the Life World*, Ikon Gallery, Birmingham, Vienna and Cambridge, MA: Generali Foundation and MIT Press.

Rosler, M. (1984 [1979]) 'Lookers, Buyers, Dealers, and Makers: Thoughts on Audience', in B. Wallis (ed) *Art After Modernism: Rethinking Representation*, New York and Boston: New Museum and David R. Godine.

——(1990 [1981]) 'In, Around and Afterthoughts (On Documentary Photography)', in R. Bolton (ed) *The Contest of Meaning: Critical Histories of Photography*, Cambridge, MA: MIT Press.

——(1999) 'Post-Documentary, Post-Photography?' in M. Engelhardt (ed) *Samuel P. Harn Eminent Scholar Lecture Series in the Visual Arts: 1996–1997*, Gainsville, FL: College of Fine Arts and Harn Museum, University of Florida.

——(2004) 'Out of the Vox: Martha Rosler on Art's Activist Potential', *Artforum*, September, pp218–219.

——(2006a) *Decoys and Disruptions: Selected Writings, 1975–2001*, Cambridge, MA: MIT Press.

——(2006b [1975]) 'Lee Friedlander, an Exemplary Modern Photographer', in *Decoys and Disruptions: Selected Writings, 1975–2003*, Cambridge, MA: MIT Press.

——(2006c [1981]) 'Notes on Quotes', in *Decoys and Disruptions: Selected Writings, 1975–2003*, Cambridge, MA: MIT Press.

——(2006d [1989]) 'Image Simulations, Computer Manipulations: Some Considerations', *Women Artists' Slide Library Journal*, no 29, June/July.

Schube, I., Nesbit, M. and Obrist, H.-U. (2005) *Martha Rosler: Passionate Signals*, Ostfildern-Ruit and Portchester: Hatje Cantz with Art Books International.

Wallis, B. (ed) (1991) *If You Lived Here: The City in Art, Theory, and Social Activism/A Project by Martha Rosler*, New York and Seattle: Dia Art Foundation with Bay Press.

Secondary texts

de Zegher, M. C. (2005) *Persistent Vestiges: Drawing from the American-Vietnam War*, New York, NY: The Drawing Center.

Harper, G. (1998) 'Martha Rosler interviewed by Robert Fichter and Paul Rutkovsky', in *Interventions and Provocations: Conversations on Art, Culture, and Resistance*, Albany, NY: State University of New York Press.

Levi-Strauss, D. (2003) 'The Documentary Debate: Aesthetic or Anaesthetic', in *Between the Eyes: Essays on Photography and Politics*, New York, NY: Aperture.

Möntmann, N. (2009) '(Under)Privileged Spaces: On Martha Rosler's "If You Lived Here … "', *e-flux journal*, vol 10.

Stimson, B. (2000) 'Review: Martha Rosler: Positions in the Life World', *caa.reviews*, 29 September, http://www.caareviews.org/reviews/370, accessed March 2011.

Websites

Electronic Arts Intermix: Martha Rosler, http://www.eai.org/artistTitles. htm?id=476, accessed March 2011.

Martha Rosler's website: http://www.martharosler.net, accessed March 2011.

Adair Rounthwaite

ALLAN SEKULA (1951–)

In 2010, Allan Sekula and Noël Burch completed *The Forgotten Space*. This essay film builds on Sekula's book and travelling exhibition project *Fish Story* (1989–1995), in which he represents the sea as the 'forgotten space' of third millennial global capitalism (Sekula 1995: 50). *The Forgotten Space* is the provisional final piece, bringing full circle almost four decades of prolific discursive activity on photography. Sekula focuses on 'economic and social themes' from 'work and unemployment, to schooling and the military–industrial complex' (Sekula 2011). This he combines with sharp analyses of (mainly) Western conventions of family life, including his own autobiography. It is his intention to talk 'with words and images about both the system and our lives within the system' (Sekula 1999: 147). He points strongly at post-war imperialist enterprises, particularly that of the US, his home country, in relation to the former Eastern Bloc and China.

Since the early 1970s, it has been Sekula's ambition to 'brush photography against the grain' (Sekula 1984: ix). John O'Brian states that his writings have shown a systematic interest in those photographic images, historical and contemporary, that display a narrative 'pieced together from the ready-made world of signs surrounding a particular situation' (O'Brian 1997: 81). This narrative, says O'Brian, allows for a reading 'against the tensions and abstractions of the conditions of advanced capitalism that helped to promote it' (O'Brian 1997: 81).

Photography is a child of the same mechanical age that saw the land industrialized and the sea transformed towards its current state as a space of ignorance and, at times, even rejection. Throughout his writings and work Sekula holds that it is exactly for this reason that photography is a privileged tool for pointing out the disastrous consequences of this dramatic transformation of the world. In his view, a photographic image is never a neutral reproduction of reality. The photograph is always immediately a public enunciation in a well-defined, ideologically charged political and social context. He

considers it therefore photography's task to function as a 'social practice, answerable to the world and its problems' (Sekula 2011).

Sekula constructs his overall praxis on the ruins of a photo-historical documentary legacy challenged by conceptual art practices, as he lucidly explains in a key essay (Sekula 1999: 138). A red thread is his firm conviction that photography today still has the capacity to develop an aesthetics of active resistance to the status quo. All of Sekula's work is therefore to be understood as an ingenious assemblage of photographs and accompanying texts aiming to achieve that intervening effect. He makes photographs and texts operate through a 'relay function', as he calls it – following the distinction made by Roland Barthes between anchorage and relay (Barthes 1986: 28). All of his photographically illustrated writings or discursively contextualized photographs are marked by this deliberate method of 'parallel alignment of autonomous image and autonomous text' meant to 'lead to other levels of meaning' in the head of the reader/spectator (Sekula 2010: 242). Sekula takes for granted that there is a price to be paid for this. Aligning his opinion with Walker Evans, he states that photographs are not necessarily meant to please those who only 'like nice things' (Sekula 1992: 196).

Sekula's thorough strategy of hybridization of meanings through deliberate alignment of photographs and texts can take on a wide variety of forms. He often takes a thematic approach in his now classic essays on the history and theory of photography. He addresses pressing issues such as the history of the photographic archive and its subservience to dominant forces of power in society during the nineteenth and twentieth centuries, to the point where photography became the dangerous ally of racial stereotyping and the emblematic tool of criminal jurisprudence. As a remedy, Sekula proposes a reading of the archive 'from below' in full solidarity with 'those displaced, deformed, silenced or made invisible by the machineries of profit and progress' (Sekula 2003a: 451). Following the example of Walker Evans, Sekula also makes a strong plea for artists to make 'combative and antiarchival' sequences of photographic work (Sekula 1986: 376).

Sekula reads the history of photography as a coin with two sides. There is the modernist teleological logic of the freestanding photographic image that seeks pictorial pleasure. But, at the same time, this success story has a shadow side in the history of accusatory police photography. His own photographs turn the underlying denunciative logic of police photography against itself by not pointing at the all too easily criminalized lower class outlaw, but instead at those who have interest in maintaining relationships of force. Sekula (1984, 2003a)

also finds inspiration in photographic methods that go against predominant models of photojournalism, often too easily allowing recuperation of images within a discourse that neutralizes their potential to point at situations of injustice. He has dedicated several essays to sharp analyses of photographic oeuvres that address these issues, such as those of Michael Asher (Sekula 2000), Carole Condé and Karl Beveridge (Sekula 2008), and Lewis Hine and Alfred Stieglitz (Sekula 1984).

Besides the reflective photo-historical or theoretical essays, Sekula experiments with vernacular styles of writing, often bringing his point home with a pun or a joke, such as: 'Black-and-white photos tell the truth. That's why insurance companies use them' (Sekula 1995: 62). Just as important in understanding his viewpoints on photography are his deliberately improper uses of writing genres, such as poetry. In an ode to Greek demigod Hercules – whose head, decapitated from an outdoor eighteenth-century sculpture in Kassel, Germany, he has photographed many times – Sekula writes: 'The Americans give him a thirteenth, unlucky task: Dig the Panama Canal. Use a nuke if you must. Spread democracy' (Sekula 2007: 209).

He has equally written a libretto for an opera, which accompanies his photographic sequence (*Black Tide/Marea Negra*, 2002/2003) of the cleansing activities on the Galician shore after the shipwreck of the *Prestige* and the subsequent coastal oil spill. In it, he asks for the reader's co-operation to further compose it, while making various comments on photography, among others: 'Publicity photographs are deceptive. These pictures, the product of photography's witless passion for uniforms and uniformity, give us the optimistic illusion of an artful array of disciplined, industrialized bodies in coordinated action, seen from the highest seats in the balcony' (Sekula 2003b: 324).

He clarifies that his photographic sequence of 2001 – *Titanic's Wake* – is a 'novelistic fantasy' (Sekula 2003a: 107), without an imposed order of reading. Never neutral either are Sekula's image captions – for example: 'CIA black site seen from across the lake just before the wrong film was confiscated. Kiejkuły, Poland, July 2009' (Sekula 2009: 72). Nor are his larger statements accompanying his photographic installations or films (Sekula 2006a, 2006b). All of his work, including the film essays, can be understood as one visuo-textual writing practice on photography. To Sekula, 'Photography [is] always positioned within a triangulated field marked out by painting, literature and cinema. Three spaces: the picture gallery, the reading room, and the projection room' (Sekula 2003a: 110). From that uneasy point of departure, he argues, photography can contribute to the conception of other ways of world-making.

Biography

Allan Sekula is an American photographer, writer, critic and film-maker. Born in Erie, Pennsylvania, in 1951, he lives and works in Los Angeles. He is a faculty member of the Photography and Media Program at the California Institute for the Arts (CalArts) in Valencia, California. Sekula is the recipient of numerous fellowships, awards and prizes, most notably the Orizzonti Jury Prize at the Venice Film Festival for *The Forgotten Space* (2010). His early collected writings on the history and theory of photography have been published as *Photography against the Grain* (1984). A more recent selection of essays has appeared in Polish translation as *Społeczne użycia fotografii* (*The Social Uses of Photography*) (Zachęta National Gallery of Art, Warsaw, 2010); similar English and French editions are in preparation.

Primary texts

Sekula, A. (1983) 'Reading an Archive: Photography between Labour and Capital', in L. Wells (ed) (2003) *The Photography Reader*, London and New York: Routledge, pp443–452.

——(1984) *Photography against the Grain*, Halifax, Nova Scotia: The Press of the Nova Scotia College of Art and Design.

——(1986) 'The Body and the Archive', in R. Bolton (ed) (1989) *The Contest of Meaning: Critical Histories of Photography*, Cambridge, MA: MIT Press, pp342–389.

——(1992) 'Walker Evans and the Police', in J.-F. Chevrier, B. H. D. Buchloh, and A. Sekula (eds) *Walker Evans and Dan Graham*, Rotterdam: Witte de With, pp193–196.

——(1995) *Fish Story*, Düsseldorf: Richter Verlag.

——(1999) *Dismal Science: Photo Works 1972–1996*, Normal, IL: Illinois State University Galleries.

——(2000) 'Michael Asher: Down to Earth', *Afterall*, vol 1, pp9–14.

——(2002) 'Between the Net and the Deep Blue Sea (Rethinking the Traffic in Photographs)', *October*, vol 102, pp3–34.

——(2003a) *Titanic's Wake*, Cherbourg-Octeville: Le Point du Jour.

——(2003b) *Performance under Working Conditions*, Vienna: Generali Foundation, pp322–333.

——(2006a) 'Shipwreck and Workers', in J. Baetens and H. Van Gelder (eds) *Critical Realism in Contemporary Art: Around Allan Sekula's Photography*, Leuven: University Press Leuven, pp184–187.

——(2006b) *A Short Film for Laos*, Unpublished text.

——(2007) 'Bring me the Head', *A Prior*, vol 15, p209.

——(2008) 'The Red Guards Come and Go, Talking of Michelangelo', in B. Barber (ed) *Condé and Beveridge: Class Works*, Halifax, Nova Scotia: The Press of the Nova Scotia College of Art and Design, pp45–50.

——(2009) *Polonia and Other Fables*, Chicago, IL, and Warsaw: The Renaissance Society and Zachęta National Gallery of Art.
——(2010) 'A Walk With Allan Sekula through His Exhibition *Polonia and Other Fables*, Zachęta National Gallery of Art, 12.12.2009', in D. Linck, M. Lüthy, B. Obermayr and M. Vöhler (eds) *Realismus in den Künsten der Gegenwart*, Zürich: Diaphanes, pp241–263.
——(2011) 'MPAS Critical Conversations: Allan Sekula', http://cgrimes-news.blogspot.com/2011/02/allan-sekula-to-speak-in-usc-critical.html, accessed 15 June 2012.

Secondary texts

Barthes, R. (1986 [1964]) 'Rhetoric of the Image', in R. Barthes, *The Responsibility of Forms*, Oxford: Basil Blackwell, pp21–40.
O'Brian, J. (1997) 'Memory Flash Points', in A. Sekula, *Geography Lesson: Canadian Notes*, Vancouver, BC, and Cambridge, MA: Vancouver Art Gallery and MIT Press, pp74–91.

Hilde Van Gelder

REBECCA SOLNIT (1961–)

Rebecca Solnit's contribution to photography history is evident in numerous journals, museum catalogues and publications. What makes her criticism vital to current photographic discourse is the wealth and breadth of her literary and visual references, combined with a courageous honesty and integrity. She turns theory into lived reality, with the acumen of an academic and the lyricism of a novelist. Solnit is, first and foremost, a cultural historian. Photography history is the history of ideas; the medium's applications infiltrate every aspect of our lives. What Solnit succeeds in doing is making photography relevant to everyday experience, regardless of whether she is interpreting historical archives or chronicling contemporary projects.

As a freelance writer, Solnit remains active in both ecological and human rights issues. She currently contributes to tomdispatch.com, a website that offers 'a regular antidote to the mainstream media'. She is also recognized for her involvement in fighting for Native American land rights, as well as anti-nuclear and anti-war campaigns. Her social activism is clearly articulated in her inspirational book *Hope in the Dark*, published in 2005. It is an impassioned call to vision and action. Quoting Mexican politician and essayist Carlos Quijano, Solnit writes: 'sins against hope are the only sins beyond forgiveness and redemption' (Solnit 2005b: 10).

Solnit's dedication to activism, along with her interest in revolution, informs her writing on photography. In *Motion Studies: Time, Space and Eadweard Muybridge* she details the life of the photographer who invented high-speed photography and, through the process, revealed reality to artists and laymen alike in ways that had never before been seen. Famously, Muybridge recorded how a horse runs. When he set his images in motion, allowing the animal to 'move' across a screen, he wowed the world. 'His zoopraxiscope, as he called it, projected versions of his motion studies on a screen: moving pictures, pictures of motion. It was the first time that photographs had dissected and reanimated actual motion, and it was the foundation of cinema, which emerged tentatively in 1889' (Solnit 2004: 4).

Muybridge launched his photographic career in 1867 with extraordinary scenes of Yosemite and San Francisco. He was 42 when he began the experiments with 'instantaneous' photography that would lead to his famous motion studies. Notoriously, in 1874 Muybridge shot the lover of his wife Flora. But while Solnit tells his story beautifully, she also makes reference to the larger context in which the pioneering photographer operated; her focus is wide and her analysis is sharp. She extends her vision beyond the topic's frame to describe the race for efficiency and speed that defined the Industrial Revolution. Indeed, the nineteenth century forced another revolution: one of perception, not least brought about by the introduction of railroads that engendered a rethinking of time and space. *Motion Studies* reveals the cultural historian at work, recording – like the camera – a minutiae of detail that enriches our understanding of the subject concerned, and demonstrates how Muybridge's experiments were both possible and legible to the public in a time of constant flux. Significantly, the publication contributes to a growing academic interest in the hybrid spaces between film and photography, brought about, to a large extent, by new digital technology.

In addition to her solo publications, Solnit is renowned for working with a number of highly acclaimed photographers. Mark Klett's *After the Ruins: 1906 and 2006; Rephotographing the San Francisco Earthquake and Fire* reveals how San Francisco's urban landscape has changed in the 100 years since the devastating circumstances that destroyed most of the city in 1906. Solnit's entry is characteristic of her multidisciplinary style. Combining various academic disciplines with personal experience and anecdote, she muses on topics under such subject headings as 'Dream Series' and 'The Ruins of Memory', while drawing on authors as diverse as Victor Hugo and Lucy Lippard. Historical and theoretical, her essay is also melancholic:

... everything is the ruin of what came before. A table is the ruin of a tree, as is the paper you hold in your hands; a carved figure is the ruin of the block from which it emerged, a block whose removal scarred the mountainside from which it was hacked; and anything made of metal requires earth upheaval and ore extraction on the scale of extraordinary disproportion to the resultant product.
(Klett and Solnit 2006: 18)

Solnit collaborated with Mark Klett and Byron Wolfe to produce *Yosemite in Time: Ice Ages, Tree Clocks, Ghost Trees*. Yosemite was a place that attracted Muybridge as well as Ansel Adams. Together, Klett, Solnit and Wolfe made numerous visits to the national park, mapping and re-photographing iconic images by seminal photographers. Solnit's literary contribution to the project eloquently weaves the past with the present to provide an understanding of Yosemite as a 'singular place onto which are mapped myriad expectations and desires' (Klett et al 2005: ix).

In *Hope in the Dark*, Solnit explains: 'I was one of thousands of activists at the Nevada Test Site in the late 1980s' (Solnit 2005b: 94). Her engagement with that political movement gave her the necessary experience and credentials to contribute to *Crimes and Splendors: The Desert Cantos of Richard Misrach*. The book provided the first comprehensive survey of Misrach's work in progress, as well as serving as an exhibition catalogue for a mid-career retrospective organized by the Museum of Fine Arts in Houston, Texas. The photographs depict a range of subjects from a variety of US states. While all the images visually describe desert landscapes, their meanings are often allegorical. Solnit writes: 'Misrach's photographs are so lavishly, engagingly visual that it doesn't occur to most viewers that their principal subject is more often what remains unseen' (Misrach et al 1996: 53). In the sub-section of the essay entitled 'Blue of Distance', Solnit explores the subject of navigating unexplored spaces; it is a topic she revisits in *A Field Guide to Getting Lost*. She speaks of the 'Wandering – unsettledness, rootlessness, estrangement' which is 'a classical American characteristic' (Solnit 2005a: 55). And she frames the 'forward motion of EuroAmericans ... from the Pilgrim patriarchs to the moon launch and Gulf war' in terms of the 'migrations of the Hebrews of the Old Testament' (Solnit 2005a: 56). The biblical analogy persists throughout her essay, as Solnit recounts the myth of the West in terms of exodus and exile. Its pretext is the expulsion from Eden: 'Exile and journey become metaphors for the human condition in the Judeo-Christian cultures' (Solnit 2005a: 57). Her description of the desert

skies anticipates Misrach's *The Sky Book*, published in 2000: 'The sky is volatile here … . This dry world is bathed in light, redemptive and interrogatory, illuminating crimes and splendors alike' (Solnit 2005a: 37). Her analysis of Beauty positions her perfectly as author of the essay for a more recent publication, *Michael Lundgren: Transfigurations*, in which are published his black-and-white photographs of the Sonoran desert. Thus, Solnit's writing has parallels with the photographic practice of Lee Friedlander. Both share a concern with revisiting similar interests and recurring motifs, and developing them, honing them, rather than considering them finished with and 'done'. Interests and agendas recur and reverberate through Solnit's writings, but the ideas – each time – become more complex and finely tuned.

Solnit's relationship with the landscape runs through her texts. For her, walking is a profoundly philosophical state of being: 'Like eating or breathing [walking] can be invested with wildly different cultural meanings, from the erotic to the spiritual, from the revolutionary to the artistic' (Solnit 2002: 3). Too often, photographic analysis is restricted and contained, limited by a reliance on scopic regimes; but Solnit privileges an understanding of landscape photography that is derived from the sensation of being fully embodied, fully sensate; as much alive to the sounds and feel of a place as the way it looks.

Solnit's writings on photography seamlessly integrate disparate discourses, to blend the personal with the political, sensitivity for nature with an insightful critique of culture. Importantly, her understanding of how memory and emotions determine our readings of photographs pays *homage* to Roland Barthes's *Camera Lucida*: 'So I make myself the measure of photographic "knowledge"' (Barthes 1982: 9). Thus, she asks us to view photography as a cultural phenomenon that has practical as well as allegorical applications, and implications for all of us. Embedded within a context of wide-ranging discourses, from feminism to environmentalism, her approach to writing about photography breathes life into the still image and sets our own responses in motion. Importantly, as an author, she takes ownership of, and responsibility for, her interpretations of images, refusing to resort to stylistic conventions in order to disguise inevitable subjectivity with the all-too-easy pretence of an authoritarian objectivity.

Biography

Rebecca Solnit, was born in California in 1961 and currently lives in San Francisco. Since 1988, Solnit has freelanced as a writer. The recipient of many literary prizes and awards, she was nominated for

the National Book Critics Circle Award in Criticism for her collection of essays *As Eve Said to the Serpent: On Landscape, Gender and Art*, and won the same prize for *River of Shadows: Eadweard Muybridge and the Technological Wild West*. She has gained a Guggenheim fellowship and been nominated for the Los Angeles Times Book Prize. Solnit has also been funded by the National Endowment for the Arts and, in 2003, was awarded the Lannan Literary Award.

Primary texts

Klett, M. and Solnit, R. (2006) *After the Ruins: 1906 and 2006; Rephotographing the San Francisco Earthquake and Fire*, Los Angeles, CA: University of California Press.

Klett, M., Solnit, R. and Wolfe, B. (2005) *Yosemite in Time: Ice Ages, Tree Clocks, Ghost Trees*, Texas: Trinity University Press.

Misrach, R., Solnit, R. and Wilkes Tucker, A. (1996) *Crimes and Splendors: The Desert Canto of Richard Misrach*, New York, NY: Bulfinch Press.

Solnit, R. (ed) (2002 [2001]) *Wanderlust: A History of Walking*, London: Verso.

——(2003) *As Eve Said to the Serpent: On Landscape, Gender and Art*, Athens, GA: University of Georgia Press.

——(ed) (2004 [2003]) *Motion Studies: Time, Space and Eadweard Muybridge*, London: Bloomsbury.

——(2005a) *A Field Guide to Getting Lost*, Edingburgh: Canongate.

——(2005b) *Hope in the Dark*, Edinburgh: Canongate.

——(2008) *M Lundgren: Transfigurations*, Santa Fe, CA: Radius Books.

Solnit, R. and Blessing, J. (2008) *True North*, New York, NY: Guggenheim Museum.

Secondary texts

Barthes, R. (1982) *Camera Lucida*, London: Jonathan Cape.

Misrach, R. (2000) *The Sky Book*, Suffolk, UK: Arena.

Nead, L. (2007) *The Haunted Gallery: Painting, Photography, Film c. 1900*, New Haven: Duke University Press.

Jane Fletcher

ABIGAIL SOLOMON-GODEAU (1947-)

Abigail Solomon-Godeau interrogates the ideological implications of photography's multiple uses, whether as scientific proof, legal or historical evidence, amateur snapshot or aesthetic object. Her art criticism intervened in art world discourses during the early 1980s, when

a major shift was taking place in photography's aesthetic status. Critics such as John Szarkowski legitimized photography in terms of formalist modernism; such a reading sanctions the marginalization of meaning and context in favour of visual aesthetics. Having spent ten years as a freelance picture editor, Solomon-Godeau understood photographic meaning as a social construction, and that photographs in relation to different texts can bear radically divergent meanings (Solomon-Godeau 1991: xxiv). She saw that when photographs are embraced as, or transformed into, primarily aesthetic objects, meaning, however mutable, is disavowed.

Insisting that such misrepresentation obscures political or ideological content in favour of connoisseurship, Solomon-Godeau's first book, *Photography at the Dock: Essays on Photographic History, Institutions, and Practices* (1991), called for the discourses of photography to stand trial. She challenges the modernist canon by calling attention to the problematics of exclusion and inclusion in terms of gender, 'race' and privilege. In 'Canon Fodder: Authoring Eugène Atget' (1986), Solomon-Godeau argues that art criticism is deeply embedded in art's institutional structure and supporting ideologies. She asks: 'Here is where I am most deeply implicated – what is the nature, the terms, even the possibility, of a critical practice in art criticism? Is such a practice not inevitable and inescapably a part of the cultural apparatus it seeks to challenge and contest?' (Solomon-Godeau 1984b: 91).

Solomon-Godeau has written numerous ground-breaking essays that transformed the discourse on photography. In a 1981 *October* interview, 'Photofilia' (Lifson and Solomon-Godeau 1981), she lamented how the new connoisseurship of photography subsumed context and function under the aegis of formalist aestheticism, the target of her critique 'the academicized mausoleum of late-modernist art photography' (Solomon-Godeau 1993: 56). In such essays as 'A Photographer in Jerusalem: Auguste Salzmann and His Times' (1981) and 'Calotypomania: The Gourmet Guide to Nineteenth-Century Photography' (1983a), Solomon-Godeau elucidates how photography's aesthetic marketability led to the resurrection of documentary or anthropological nineteenth-century photography as aesthetic objects, when they were not produced for those purposes (i.e. the work of Francis Frith or Désiré Charnay).

Among Solomon-Godeau's most influential essays is 'Just Like a Woman' (1986), on Francesca Woodman, who was little known at the time she wrote about her. She explores the contradictions that make Woodman's work so powerful: her understanding of and disruption of the 'woman's body as both a sight (a spectacle) and a site (of meaning,

desire, projection)', arguing that 'Woodman exposes the over-determination of the body as signifier, thereby significantly altering the spectator's relationship to it' (Solomon-Godeau 1991: 240). Moreover, Solomon-Godeau argues for understanding the camera as 'a technology that is itself inseparable from those operations of fetishism and objectification that Woodman consistently worked to dissect' (Solomon-Godeau 1991: 240). She continued her exploration of the constructedness of femininity and identity in articles such as 'Legs of the Countess' (1986), which considers photographs of the nineteenth-century beauty the Countess of Castiglione, who created a singular, obsessive series of self-portraits in unprecedented collaboration with studio photographers; and 'The Equivocal "I": Claude Cahun as Lesbian Subject' (1999) on Surrealist Cahun's self-portraiture and her exploration of masquerade and disguise related to gender.

During the late 1970s, photographic practices rebelled against modernist formalism. Postmodern artists began to rethink the function of photography away from aesthetics, originality and authenticity towards critiquing mass media through appropriation, pastiche and irony, recognizing that a photograph, rather than being a record of or window onto some objective reality, always creates meaning and ideology. For example, for Solomon-Godeau, the strength of Cindy Sherman's work is that for her 'photography – her use of it – is pre-dicated … on the uses and functions of photography in the mass media, be they in advertising, fashion, movies, pin-ups, or magazines' (Solomon-Godeau and Farwell 1994: 114). Instead of working within the realm of fine art photography, Sherman explores 'the global production of imagery so profoundly instrumental in the production of meaning, ideology, and desire' (Solomon-Godeau and Farwell 1994: 114). Solomon-Godeau finds the significance of postmodern photography in its 'concern with the politics of representation', instead of the modernist fetish of the quality of image or print quality and its correspondence with reality (Solomon-Godeau 1993: 26). Such art explores the way in which photographs represent and/or challenge assumptions about culture.

Embracing the photographic work of artists that few appreciated or understood at the time – including Sherrie Levine, Barbara Kruger and Richard Prince – Solomon-Godeau extolled their postmodernist critiques of aesthetics. Such artists found subject matter in the art world and in popular culture, appropriating and re-contextualizing images to reveal and challenge the ideologies at play within them. Post-modern art provided a meta-critique of the system of academy, history, sales, reputations, museums, posterity and originality. Solomon-Godeau

emphasizes that beyond its ironic appropriation, postmodern photography insists that any representation is political.

At times, as Emily Apter has observed, Solomon-Godeau may seem to withhold from her commentary the pleasures of looking. Apter refers to this as 'visual abstemiousness' (Apter 1992: 693). Solomon-Godeau has also been criticized for too strongly focusing on sexual difference (Baker et al 2003). She might counter such criticism by noting how pleasurable looking in Western culture is gendered male; even apparently innocent looking at photographs has ideological implications. Solomon-Godeau never loses sight of such issues. Her scholarship insists that no opportunity to analyse and expose ideology should be overlooked.

Solomon-Godeau's work embodies what she extols in art, 'art production defined *as* a critical practice', by finding questions to ask of art, and by interrogating her own subject position (Solomon-Godeau 2006: 396). Her later work goes beyond feminist critique, while continuing its dissenting tradition, to explore the marginalization of 'the art world's "others"' (Solomon-Godeau 1993: 3).

Solomon-Godeau argues that multiculturalism 'has altered the artistic terrain as decisively as has feminism' (Solomon-Godeau 2006: 396). She has addressed photography's capacity to raise issues of ethical responsibility, and its paradoxically limited capacity to transmit knowledge. For example, her essay 'Lament of the Images: Alfredo Jaar and the Ethics of Representation' (2005) explores Jaar's artistic responses to global political catastrophes and his critique of photography's capacity to be an effective witness, one that can inspire empathy and action. For Solomon-Godeau, the imperative of art and its criticism is to contest the institution from within, while subverting the market's tendency to rapidly domesticate and profit from such work and consumerism's tendency to efface difference. Her astonishing ability to witness and comment upon cultural changes as they are happening, and to recognize mythologizing, canonizing and repressive mechanisms, is matched by her dedication to art that challenges those very same issues.

Biography

Born in 1947, Abigail Solomon-Godeau received a BA from the University of Massachusetts, Boston, graduating *Magna Cum Laude*, and a PhD from the Graduate Center, City University of New York. She is currently Professor of Art History at the University of California

at Santa Barbara. Her research interests include photography, contemporary art, critical theory, gender studies and nineteenth-century French painting. She is the author of *Photography at the Dock: Essays on Photographic History, Institutions and Practices* (1991), *Male Trouble: A Crisis in Representation* (1999) and the forthcoming *The Face of Difference: Gender, Race and the Politics of Self-Representation* (Duke University Press). She also has numerous exhibition and book reviews, catalogue essays and articles published in journals such as *Afterimage*, *Art in America*, *Camera Obscura*, *October*, *The Print Collector's Newsletter* and *Screen*. She has curated several exhibitions, including *The Way We Live Now*, 1982; *Sexual Difference: Both Sides of the Camera*, 1992; *Mistaken Identities* (with Constance Lewallen), 1994; and *The Image of Desire: Femininity, Modernity, and the Birth of Mass Culture in Nineteenth-Century France* (with Beatrice Farwell), 1998. Currently, Solomon-Godeau is working on a book entitled *Genre, Gender, and the Nude in French Art*. She has received many awards, including a John Simon Guggenheim Memorial Fellowship (2001–2002).

Primary texts

Solomon-Godeau, A. (1981) 'A Photographer in Jerusalem: Auguste Salzmann and His Times', *October*, vol 18, pp90–107.

——(1983a) 'Calotypomania: The Gourmet Guide to Nineteenth-Century Photography', *Afterimage*, vol 11, no 1/2, pp7–12.

——(1984a) 'Photography after Art Photography', in B. Wallis (ed) *Art after Modernism: Rethinking Representation*, New York, NY: New Museum of Contemporary Art, pp74–85.

——(1984b) 'Living with Contradictions: Critical Practice in the Age of Supply-Side Aesthetics', *Screen*, vol 25, no 6, pp88–102.

——(1986a) 'Just Like a Woman', in A. Gabhart (ed) *Francesca Woodman: Photographic Work*, Wellesley, MA: Wellesley College Museum, pp11–35.

——(1986b) 'Canon Fodder: Authoring Eugène Atget', *The Print Collector's Newsletter*, vol 12, no 6, pp221–227.

——(1986c) 'Legs of the Countess', *October*, vol 39, pp64–108.

——(1991) *Photography at the Dock: Essays on Photographic History, Institutions, and Practices*. Minneapolis, MN: University of Minnesota Press.

——(1993) *Mistaken Identities*, essay by A. Solomon-Godeau, curated by A. Solomon-Godeau and C. Lewallen, Santa Barbara, CA: University Art Museum, University of California, pp19–65.

——(1999a) 'The Equivocal "I": Claude Cahun as Lesbian Subject', in S. Rice (ed) *Inverted Odysseys: Claude Cahun, Maya Deren, Cindy Sherman*, Cambridge, MA: MIT Press.

——(1999b) *Male Trouble: A Crisis in Representation*, London: Thames & Hudson.

——(2005) 'Lament of the Images: Alfredo Jaar and the Ethics of Representation', *Aperture*, vol 181, pp36–47.

——(2006) 'Taunting and Haunting: Critical Tactics in a "Minor" Mode', in C. Armstrong and C. de Zegher (eds) *Women Artists at the Millennium*, Cambridge, MA and London: MIT Press, pp372–401.

Solomon-Godeau, A. and Farwell, B. (1994) *The Image of Desire: Femininity, Modernity, and the Birth of Mass Culture in 19th-Century France*, Santa Barbara, CA: University Art Museum, University of California.

Secondary texts

Apter, E. (1992) 'Book Review: *Photography at the Dock: Essays on Photographic History, Institutions, and Practices*', *The Art Bulletin*, vol 74, no 4, pp692–694.

Baker, G., Daly, A., Davenport, N., Larson, L. and Sundell, M. (2003) 'Francesca Woodman Reconsidered', *Art Journal*, vol 62, no 2, pp53–67.

Lifson, B. and Solomon-Godeau, A. (1981) 'Photofilia: A Conversation about the Photography Scene', *October*, vol 16, pp102–118.

Nochlin, L. (1991) 'Forward', in A. Solomon-Godeau, *Photography at the Dock: Essays on Photographic History, Institutions, and Practices*, Minneapolis, MN: University of Minnesota Press, ppxii–xvi.

Solomon-Godeau, A. (1982a) 'Formalism and Its Discontents: Photography – a Sense of Order', *The Print Collector's Newsletter*, vol 32.

——(1982b) 'Playing in the Fields of the Image', *Afterimage*, vol 10, no 1/2.

——(1983b) 'The Armed Vision Disarmed: Radical Formalism from Weapon to Style', *Afterimage*, vol 10, no 6, pp9–14.

——(1987a) 'Who is Speaking Thus? Problems of Documentary Practice', in L. Falk and B. Fischer (eds) *The Event Horizon: Essays on Hope, Spirituality, Social Space, and Media(tion)*, Toronto: Coach House Press.

——(1987b) 'Sexual Differences: Both Sides of the Camera', *CEPA Quarterly*, vol 2, no 3 and 4, pp.17–24.

——(1988) 'Beyond the Simulation Principle', in A. Solomon-Godeau, A. Jardine, and E. Michaux (eds) *Utopia Post Utopia: Configurations of Nature and Culture in Recent Sculpture and Photography*, Boston, MA: Institute of Contemporary Art, pp83–89.

——(1990) 'Mandarin Modernism: Photography Until Now', *Art in America*, vol 78, pp140–149.

——(1995) 'Inside/Out', in G. Garrels (ed) *Public Information: Desire, Disaster, Document*, San Francisco, CA: San Francisco Museum of Art, pp49–61.

——(1996) 'The Other Side of Venus: The Visual Economy of Feminine Display', in V. de Grazia with E. Furlough (eds) *The Sex of Things: Gender and Consumption in Historical Perspective*, Berkeley, CA: University of California Press, pp113–150.

——(2010) 'Birgit Jürgenssen: Between the Lines, Beyond the Boundaries', in G. Schor and A. Solomon-Godeau (eds) *Birgit Jürgenssen: Art to Hear*, Munich: Hatje Cantz, pp107–145.

Elizabeth Howie

SUSAN SONTAG (1933–2004)

Susan Sontag's 1977 book *On Photography* began life as a series of essays written for *The New York Review of Books*, 'about some of the problems, aesthetic and moral, posed by the omnipresence of photographic images' (Sontag 1977). Joel Eisinger has claimed that her book 'may be seen as the first full-blown American version of post-modernist photographic theory' (Eisinger 1995: 258). The book is concerned with postmodern issues in its focus on the effects of pho-tography as a mass art form: how photography upsets distinctions between reality and image, original and copy, high culture and low culture. For Sontag, photography feeds the idea of art's obsolescence as it is turned into media by reproduction.

In understanding Sontag's response to photography, one needs to know something about her own position. She is considering photography as a novelist, film-maker and essayist steeped in a faith in a modernist *avant-garde* art tradition. Her problem with photography is that it 'reassures viewers that art isn't hard' (Sontag 1977: 131). Photography is, as she puts it, 'the most successful vehicle of modernist taste in its pop version, with its zeal for debunking the high culture of the past (focusing on shards, junk, old stuff, excluding nothing); its conscientious courting of vulgarity; its affection for kitsch; its skill in reconciling avant-garde ambitions with the rewards of commercialism' (Sontag 1977: 131). Small wonder, so many photographers hated and still hate her book.

The lead essay in her book *Against Interpretation* concluded with an account of 1960s American culture as one of 'excess, overproduction', which was felt to lead to a 'steady loss of sharpness in our sensory experience' (Sontag 1967: 13). The conditions of modern life 'dull our sensory faculties' (Sontag 1967: 13). The problem with photography, as *On Photography* makes clear, is that its very effect is also an integral part of this sensorial loss. Sontag's essays on photography respond to the emotional numbing and detachment effected by the excess, the overproduction of images, the way 'Industrial societies turn their citizens into image junkies' (Sontag 1977: 24).

One of her main arguments is that photography is a Surreal medium *per se*. This is to do with its fragmentation and dislocation of reality, and its tendency to aestheticize everything. As a result of this, photography enlarges what we find aesthetically pleasing. But there is still great uncertainty about photography's intrinsic aesthetic value: 'an unassuming functional snapshot may be as visually interesting, as elo-quent, as beautiful as the most acclaimed fine-art photographs' (Sontag 1977: 103). Photography also upsets traditional assumptions

about authorship. How, for example, asks Sontag, are we to speak of authorship in relation to a photographer such as Edward Steichen, 'whose work includes abstractions, portraits, ads for consumer goods, fashion photographs, and aerial reconnaissance photos?' (Sontag 1977: 137).

Diane Arbus's work introduces the key problematic of photography in the book and the most sustained critique of an art photographer's work. The point of her scathing attack rests upon the assumption that this is victim photography but 'without the compassionate purpose such a project is expected to serve' (Sontag 1977: 33). It fails the liberal documentary tradition. Much of her condemnation rests upon a distinction between photography and literature. Arbus 'was not a poet delving into her own entrails to relate her own pain but a photographer venturing out into the world to collect images that are painful' (Sontag 1977: 40). In an earlier essay, 'On Style', in 1965, Sontag's defence of form over content in relation to literature introduced the issues of morality and art. It was legitimate for great art to have a morally reprehensible subject, precisely because it was the expressive and creative work of the artist's imagination: 'Genet, in his writings, may seem to be asking us to approve of cruelty, treacherousness, licentiousness, and murder. But so far as he is making a work of art, Genet is not advocating anything at all. He is recording, devouring, transfiguring his experience' (Sontag 1967: 26). Photographers unlike writers deal with reality and therefore have a moral responsibility towards their subject matter.

In 'On Style', Sontag made one of the most radical claims for the supremacy of formal issues in relation to Leni Riefenstahl's films *Triumph of the Will* and *The Olympiad*. She said that 'Because they project the complex movements of intelligence and grace and sensuousness, these two films of Riefenstahl (unique among works of Nazi artists) transcend the categories of propaganda or even reportage' (Sontag 1967: 26). But she went on to recant this view in a review of Riefenstahl's photo book *The Last of the Nuba*, first published in *The New York Review of Books* in 1975 – that is, roughly in the middle of the period she was writing the essays that were to make up *On Photography*. Now beauty and form is seen as integral to a fascist aesthetic and Riefenstahl's book continues the themes of Nazi ideology in her films (Sontag 1981). Sontag argues that although the Nuba are black, her portrait of them can still be seen to accord with a fascist aesthetic in the way they celebrate and highlight their masculine physical power and strength.

For Sontag, 'photography's most important and original critic' was Walter Benjamin (Sontag 1977: 76). In many senses, *On Photography*

takes its cue from the Marxist line on photography put forward in his essay 'The Author as Producer', where he attacks the photography of Albert Renger-Patzsch for its indiscriminate aesthetic representation of things in the world (Benjamin 1983). But if for Benjamin the caption could rescue photography from what he called the 'ravages of modishness and confer upon it a revolutionary use value', Sontag felt that the caption could not 'prevent an argument or moral plea which a photograph (or set of photographs) is intended to support from being undermined by the plurality of meanings that every photograph carries, or from being qualified by the acquisitive mentality implicit in all picture-taking – and picture-collecting – and by the aesthetic relation to their subjects which all photographs inevitably propose' (Sontag 1977: 109).

Sontag revised part of her argument in *On Photography* in her only other book on photography, *Regarding the Pain of Others* (2003). *On Photography* claimed that after repeated exposure to photographs of suffering we become numb to them, 'photographs shrivel sympathy' (Sontag 2003: 105). By the time of *Regarding the Pain of Others*, she is not so sure this is true. In *On Photography* she proposed that 'our capacity to respond to our experiences with emotional freshness and ethical pertinence is being sapped by the relentless diffusion of vulgar and appalling images' (Sontag 2003: 109). But unlike Guy Debord and Jean Baudrillard, Sontag's stance was still a 'defense of reality and the imperilled standards for responding more fully to it' (Sontag 2003: 109). In what she refers to as Debord and Baudrillard's 'cynical' spin on her critique of images, there is nothing to defend: it is as if 'the vast maw of modernity has chewed up reality and spat the whole mess out as images' (Sontag 2003: 109). Debord and Baudrillard's writings represent for Sontag 'a breathtaking provincialism'; reality only becomes a spectacle for 'a small, educated population living in the rich part of the world, where news had been converted into entertainment' (Sontag 2003: 110).

Sontag's book closes with an interesting reading of Jeff Wall's 'imagining of war's horror' in his 1992 Cibachrome tableau, *Dead Troops Talk (A Vision After an Ambush of a Red Army Patrol near Moqor, Afghanistan, Winter 1986)* (Sontag 2003: 123). She suggests that because in this macabre spectacle of the living dead none of the 13 Russian conscripts slaughtered in the Soviet Union's colonial war look out of the picture, because they don't 'seek our gaze', the work is making a point about how 'we' – that is, 'everyone who has never experienced anything like what they went through – don't understand We truly can't imagine what it was like' (Sontag 2003: 125).

She goes on to claim that this incomprehension, this inability to understand and imagine, is 'what every soldier, and every journalist and aid worker and independent observer who has put in time under fire, and had the luck to elude the death that struck down others nearby, stubbornly feels' (Sontag 2003: 126). This is, of course, a defence of reality, but an odd one. Wall can only acknowledge his and our inability to comprehend war in his art photograph. But, as Susie Linfield has recently highlighted, the victims of atrocity are far from being as uninterested in us as Wall portrays them in his allegorical picture: 'those who have suffered through violent upheavals have much to tell us, and they have gone to extraordinary lengths to do so' (Linfield 2010: 99).

On Photography got photographers' backs up because Sontag said that photography was not an art form like painting and poetry. Sontag's book is best seen as a modernist's anxiety about photography's postmodern effects. There is a persistent frustration with the medium in her writings. Nearly all of *On Photography* is taken up with photography's problems, and dominated by critical and negative views about it. While she changes her view about the effect of images of atrocity in *Regarding the Pain of Others*, in celebrating Wall's tableau she still ends up gravitating to a work that is a staged fiction and far from the more troubling identity of the photographic document.

Biography

Susan Sontag was born in New York City on 16 January 1933, grew up in Tucson, Arizona, and attended high school in Los Angeles. She received her BA from the College of the University of Chicago and did graduate work in philosophy, literature and theology at Harvard University and Saint Anne's College, Oxford. Her many books include four novels, short stories and plays. She has also made four films. Her non-fiction books include *Against Interpretation*, *On Photography*, *Illness as Metaphor* and *Regarding the Pain of Others*. In 2001 she was awarded the Jerusalem Prize for the body of her work. Sontag died in New York City on 28 December 2004.

Primary texts

Sontag, S. (1967) *Against Interpretation*, London: Eyre and Spottiswoode.
——(1977) *On Photography*, Harmondsworth, UK: Penguin.
——(1981) *Under the Sign of Saturn*, New York, NY: Vintage Books.
——(2003) *Regarding the Pain of Others*, New York, NY: Farrar, Strauss and Giroux.

Secondary texts

Benjamin, W. (1983 [1934]) 'The Author as Producer', in *Understanding Brecht*, London: Verso.

Ching, B. and Wagner-Lawlor, J. A. (eds) (2009) *The Scandal of Susan Sontag*, New York, NY: Columbia University Press.

Eisinger, J. (1995) *Trace and Transformation*, Albuquerque: University of New Mexico Press.

Linfield, S. (2010) *The Cruel Radiance: Photography and Political Violence*, Chicago and London: University of Chicago Press.

Poague, L. (ed) (1995) *Conversations with Susan Sontag*, Jackson: University Press of Mississippi.

Sayres, S. (1990) *Susan Sontag: The Elegiac Modernist*, New York, NY: Routledge.

Mark Durden

JO SPENCE (1934–1992)

Jo Spence's writing presents photography as a powerful tool with which to address questions of cultural and political struggle. It has contributed to the development of 'visual literacy' in educational contexts, changing attitudes with regard to ethical photographic documentary, the establishment of the personal, the political and the autobiographical as valid subject matter, the development of staged or fictional photography, and, above all, the use of photographs for the purpose of debate. Her writing, appearing mostly in magazines concerned with politics or media studies, such as *Spare Rib*, *Feminist Art News*, *Media Education*, *Camerawork*, *Block*, *Screen* and *Ten.8*, always reflected her political and feminist perspective and her concern to use photography to address issues of class and power. Many of these essays are gathered together in the book *Cultural Sniping* (1995).

Spence's critique of representation contributed to the extensive 1970s debate concerning documentary photography, promoted by writers/ photographers such as Victor Burgin and Allan Sekula (Burgin 1982). In her concern to reconfigure what photography can do, Spence drew attention to social contexts, to the political content of personal photography and to the fictional aspects of documentary determined by the photographer's agency. Early essays expose the myth that photographers can be neutral or *un*political and argue that photographs always carry ideological messages that help to shape attitudes, values and what we consider to be 'real and normal' (Spence 1995: 31). 'The Politics of Photography' (1976) discusses the contradictions inherent in photojournalism that aim to be 'socially realistic' but give insufficient

reference to the detail of specific context. 'What Did You Do in the War Mummy?' (1979) analyses the visual representation of women and the stereotyping of gender roles during World War II, and demonstrates how photography, which has the capacity to generalize, does not present 'real things' but 'socially and culturally constructed concepts' (Spence and Dennett 1979: 30). This essay emphasizes the ideological processes by which a class identity is constructed, or even rendered invisible by its absence, and is significant for incorporating both a psychoanalytic perspective and a Marxist consideration of women's labour power under capitalism. Her assertion of the need to understand the context and power relations involved in photographing people responds, for example, to the ideas of Walter Benjamin (*A Short History of Photography*, 1931), the cultural structures discussed by Michel Foucault (*Discipline and Punish*, 1975), and their application to photography in the writings of John Tagg (*Currency of the Photograph*, 1978) and Stuart Hall (*The Social Eye of 'Picture Post'*, 1979).

The introduction to *Photography/Politics One* (Spence and Dennett 1979: II) had stated a commitment to exploit the potential of photography for political use and the need therefore to re-examine the histories of left-wing photography, an insistence that prompted their eventual exclusion from the *Half Moon Workshop* and *Camerawork*. Spence's essay 'The Sign as a Site of Class Struggle' (1986) examines the uses of photography and film for agitational and propaganda purposes in Weimar, Germany, during 1922 to 1932. In so doing, it also articulates Spence's aspiration to seek alternative uses for photography, and questions 'the dominant practices of documentary photography' in two respects (Spence et al 1986: 105): first, in analysing John Heartfield's photomontages, she shifts focus from the customary appraisal of artistic authorship or formal aesthetics to the semiological processes that describe women in a class society as products of capitalism. Second, in signalling the efforts of the *AIZ* (Workers' Illustrated Press) to engage working people in the politics of visual imagery and to counter the norms of photojournalism, she points to the covert agenda inherent in any claim of 'documentary truth'. She emphasizes that the several layers of signification in photomontage can reference a range of contradictory historical and material information, as well as forcing the viewer to consider the reality that lays *outside* the image (Spence et al 1986: 181).

Influenced by the dialectical methods of Heartfield, Russian *avant-garde* film and the writings and theatre practice of Augusto Boal, Spence suggests that, to photograph people responsibly and to work with photography politically, the non-naturalistic methods of staged photography might be the best way to subvert established photographic traditions.

Her conference paper 'Questioning Documentary Practice' (1987) controversially refers to the 'impenetrable theory' that fails to reference photography in practice, and to those whose address to 'race, disablement, gender' amounts to another form of oppression (Spence 1995: 102–103). It demands a debate in which everybody can speak across cultural perspectives, and a use of photography that encompasses a broader spectrum of practice. Spence contests the pursuit of objectivity and the privileged position of the author by suggesting that before photographers comment on the condition of others, they need first to ask how to represent themselves. In typical candid fashion, 'The Picture of Health?' (Spence 1986b) offers a self-scrutiny of her experience as a cancer patient in a way that exposes hierarchies and prejudices embedded in the health industry. It addresses representations of the body, illness and subjectivity 'not just as a bloody sign' but from the various positions she adopts – as cultural critic, artist and phototherapist (Spence 1995: 122). Her interdisciplinary stance borrowed methods from different discourses that were alien to the academic world, such as psychotherapy and oral history, and contributed to emerging changes of approach to theoretical discourse and the analysis of visual culture. For example, 'Phototherapy: The Potential for a Benevolent and Healing Eye' (1987) not only explores the political and therapeutic power of personal story-telling, but also the psychoanalytical processes of subject construction and the recurrent concepts of Western culture such as 'romantic love', which she had explored in *Fairy Tales* (1982).

Influenced by feminist debate, and echoing the shift in thinking from the idea of a unitary subject to one in continual process, Spence's scrutiny of the construction of identity introduces an immersive subjective dimension to understanding what's happening in photographs. Adopting a method used in psychotherapy to describe a photograph of herself, she speaks in the first person and in the present tense: 'I am sitting at a dressing table and it's got three mirrors. I love sitting there because I can see both sides of my face and when I tip the mirrors in certain directions I go on for ever' (Spence 1986a: 143–148). This subjective process of analysis forces recollections of unspoken shame or conflict, and evocative metaphoric chains of association, such as the many identities involved in looking and being looked at. *The Politics of Transformation: The Female Gaze* (1986) incorporates an implicitly critical response to debates at the time concerned with the 'male gaze' and Jacques Lacan's psychoanalytic theories, such as Laura Mulvey's influential essay 'Visual Pleasure and Narrative Cinema' (1975). *The Daughter's Gaze: Blaming, Shaming, Renaming and Letting Go* (1990) states: 'Subjectivity is neither ahistorical nor universal [but] a web of psychic

processes, uneven, split, contradictory and potentially antagonistic to itself, formed and articulated within specific historical moments and contexts' (Spence 1995: 196). Putting theory into practice, she advocates phototherapy as a means to visualize psychic process, social history and the structure and pattern of relationships and behaviour by presenting a series of perspectives from which to observe how, as 'split subjects', we inhabit 'contradictory positions' with different people, within different discourses and at different times (Spence 1995: 147). It is a process that challenges the traditional power relationship between photographer and sitter, promoting use of the photograph as catalyst rather than aesthetic artefact.

Her approach has validated many of the themes of feminist practice – the consideration of 'identity' as a central issue, the associated concerns of embodiment and the disruption of hierarchical divisions between the thinking mind and material body, between reason and feeling, and between public and private. Her assumption that photography is political and must engage with theory is radically significant as an early example of theoretical analysis that *uses* practice, demonstrating an alternative process of acquiring knowledge to that of abstract discourse. Her attitude challenges the hierarchies of theoretical debate in its manifestation as photography. For example, her promotion of phototherapy contributes to arguments with patriarchal theory and to the development of aspects of feminism in relation to the theory and practice of psychotherapy (Spence 1986a: 198), and her use of the family album (*Reworking the Family Album*, 1990) contributes a more demonstrable understanding of the social function of popular photography, theorized by Pierre Bourdieu (1990).

The significance of Spence's writing is best understood alongside her practical engagement with how photography works – in taking photographs, in looking at photographs and being photographed; her writing and photographic practice critically determine each other. Referring to herself as 'cultural sniper', the iconic cover image of her book, showing her daubed with paint, in stocking mask, drawing a catapult at the viewer and bearing her teeth, embodies that description (Spence 1995). Her attitude was consistently subversive in her concern to re-present the contradictions and absences presented by photographic representation, to disrupt the assumptions of tasteful or privileged photography. And always ambivalent in her relation to art, she states in an interview with John Roberts: 'art should be a living process' and 'put in a social context' (Spence 2005: 102). Her work encouraged the launching of photography as the 'alternative' medium with which to engage with subject matters not considered appropriate

for the dominant discourses of art theory, such as the 'merely' personal or distasteful, class/power relations and humour. Spence's most provocative contribution is perhaps her advocacy of democratic documentary, through the use of 'amateur' and 'personal' photography, which introduce a type of narrative that subsequently becomes common in mainstream photography practice. She calls on the photographic community to scrutinize 'amateur photography' which, in not being taken seriously, perpetuates the 'real problems' of representation – those of the 'institutional, the family and self-censorship' (Spence 1995: 104). In 'The Walking Wounded' she promotes photography as a political instrument that possesses an essential radicality because it can be produced, possessed and circulated by everyone (Spence 1986a: 214). Her advocacy of photography for educational and community purposes, together with her collaborative photographic practices, undermine the basis of modernist auteur photography. In asserting 'amateurism', Spence's polemic went some way to changing subsequent practice – superficially in terms of the adoption of staged photography and informal record as photographic styles, and more fundamentally in terms of the development of an informed awareness of visual representation and the need for ethical, responsible uses of photography.

Biography

Jo Spence was born in London to working-class parents in 1934. Her experience working in the world of commercial photography in various capacities (1951–1974) was crucial in shaping her subsequent career and influence. She founded the *Photography Workshop* in 1974 with Terry Dennett as a socially committed resource for research, community action and education. She worked collaboratively throughout her life (*Hackney Flashers*, *Polysnappers*, David Roberts), developing the practice of phototherapy with Rosy Martin from 1983. Her many exhibitions included *Beyond the Family Album*, Hayward Gallery, 1979; her BBC broadcasts included *Putting Ourselves in the Picture*, 1987. Diagnosed with cancer in 1982 and with leukaemia in 1990, she made use of photography to change attitudes towards health and illness, and was working on *Scenes of the Crime* and *The Final Project* until the time of her death in June 1992.

Primary texts

Spence, J. (1983) 'Using Family Photos in Therapy', Transcript of therapy session with P. Clarke, in J. Spence (1986) *Putting Myself in the Picture: A Political, Personal and Photographic Autobiography*, London: Camden Press, pp143–148.

——(1986a) *Putting Myself in the Picture: A Political, Personal and Photographic Autobiography*, London: Camden Press.

——(1986b) 'The Picture of Health? Parts 1 & 2', *Spare Rib*, issue 163, pp19–24; issue 165, pp20–25.

——(1995) *Cultural Sniping: The Art of Transgression*, New York and London: Routledge.

Spence, J. and Dennett, T. (eds) (1979) *Photography/Politics: One*, Photography Workshop.

Spence, J. and Holland, P. (1991) *Family Snaps: Meanings of Domestic Photography*, London: Virago.

Spence, J. and Martin, R. (1988) 'Phototherapy: Psychic Realism as Healing Art?', *Ten.8*, no 30, pp2–17.

Spence, J. and Solomon, J. (eds) (1995) *What Can a Woman Do with a Camera? Photography for Women*, London: Scarlet Press.

Spence, J., Holland, P. and Watney, S. (eds) (1986) *Photography/Politics: Two*, Photography Workshop, Comedia, London.

Secondary texts

Boal, A. (1974) *Theatre of the Oppressed*, London: Pluto Press.

Bourdieu, P. (1990 [1965]) *Photography: A Middlebrow Art*, Cambridge, MA: Polity Press.

Burgin, V. (1982 [1977]) 'Looking at Photographs', in V. Burgin (ed) *Thinking Photography*, Basingstoke, UK: Macmillan Press.

Hevey, D. (1992) *The Creatures Time Forgot: Photography and Disability Imagery*, additional texts by J. Spence and J. Evans, London: Routledge.

Martin, R. (2009) 'Inhabiting the Image: Photography, Therapy and Re-enactment Phototherapy', *European Journal of Psychotherapy & Counselling*, vol 11, no 1, pp35–49.

Radley, A. (2009) *Works of Illness: Narrative, Picturing and the Social Response to Serious Disease*, Camden, UK: InkerMen Press.

Sekula, A. (1982 [1975]) 'On the Invention of Photographic Meaning', in V. Burgin (ed) *Thinking Photography*, Basingstoke, UK: Macmillan Press.

Spence, J. (2005) *Beyond the Perfect Image: Photography, Subjectivity, Antagonism*, Barcelona: Museu d'Art Contemporani de Barcelona.

Weiser, J. (2005) 'Remembering Jo Spence: A Brief Personal and Professional Memoir', PhotoTherapy Centre, http://www.phototherapy-centre.com/articles/2005_Weiser_Memoir_on_Spence.pdf.

Jane Tormey

DAVID LEVI STRAUSS (1953–)

In his introduction to David Levi Strauss's *Between the Eyes: Essays on Photography and Politics*, John Berger describes the author as 'a poet and storyteller as well as being a renowned commentator on

photography (I reject the designation *critic*)' who 'looks at images very hard' (Strauss 2003: vii). This account aptly captures Strauss's approach to writing as well as to politics. He is someone for whom the complex and even contradictory relationship between language and images or, more particularly, between politics and aesthetics has been critical.

Strauss first began to think explicitly about the conflicted relation between these two realms in a collection of essays entitled *Between Dog & Wolf: Essays on Art and Politics*, which was published in 1999 and contains ten essays (originally published between 1988 and 1998) that range in focus from Desert Storm propaganda, to new art in post-Soviet Russia, to artists as various as Jean Genet, Joseph Beuys, Carolee Schneemann and Daniel Joseph Martinez, among others. It is in the book's first essay, 'Aesthetics and Anaesthetics', however, that he makes his most lasting contribution. In this essay, which first appeared in *Art Issues* in 1993, Strauss, staying true to his poetic background, begins by tracing the etymological roots of the words aesthetics and anaesthetics. He then goes on to discuss the relationship of these terms to postmodernism and the Culture Wars through the examples of Hal Foster's influential 1983 anthology *The Anti-Aesthetic*, as well as the attempt by conservative cultural critics to censure 'obscene' art. According to Strauss, these individuals, both on the left and the right, support an anaesthetic position, by which he means that they both believe that the primary function of art is anaesthetic, or to alleviate pain. Strauss finds this position exceedingly problematic since, as he maintains: 'As with all other parts of the allopathic complex, the anaesthetic only masks symptoms; it does nothing to treat the root causes of pain, to trace it back to its source, give it meaning, or counter it with pleasure.' It is for this reason, then, as Strauss further argues, that 'the anaesthetic is usually discussed in purely utilitarian terms, like propaganda: if it stops the pain, it is successful, no further questions. But the aesthetic is all questions, disequilibrium, and disturbance' (Strauss 1999: 12). For Strauss, it is the uncertainty and even irritation produced by the aesthetic that helps him begin to map out why beauty – and especially the visual pleasure that viewers derive from its depiction – cannot be separated from politics.

Strauss continues to develop his thinking about the relationship between aesthetics and anaesthetics in his 2003 book *Between the Eyes*. This volume includes 18 essays that he published between 1986 and 2002 on a rather disparate group of contemporary photographers who range from photojournalists Richard Cross, John Hoagland and

Sebastião Salgado to artists Joel-Peter Witkin, Francesca Woodman and Alfredo Jaar, among others, as well as on topics that vary from the events of 11 September 2001 to the bombing of Afghanistan. The most influential essays in the collection are those on Salgado and Jaar. Interestingly, these are two photographers who are usually pitted against each other, since Salgado is a photojournalist who works in the humanist tradition of concerned photography, while Jaar is an artist whose often conceptually driven works address issues of representation in a highly critical and self-reflexive manner. Yet, it is precisely Strauss's interest in bridging the divide between aesthetics and politics that allows him to address their seemingly divergent practices within the same collection.

Strauss most convincingly outlines the false distinctions that mainstream photography criticism and writing have made between aesthetics and politics in the book's first essay, entitled 'The Documentary Debate: Aesthetic or Anaesthetic? Or, What's So Funny About Peace, Love, Understanding and Social Documentary Photography?'. First published in 1992 in *Camerawork* in a longer and slightly different form, in this essay, he traces the roots of the 'aestheticization of tragedy' argument to Walter Benjamin's famous 1934 essay 'The Author as Producer'. He further explains that whereas Benjamin wrote this critique explicitly in reference to the New Objectivity photography of Albert Renger-Patzsch, beginning in the 1980s, mainstream photography critics and writers such as Martha Rosler, Allan Sekula, Abigail Solomon-Godeau and John Tagg have improperly borrowed his historically specific conclusions to deny the role that aesthetics might play in current social documentary photography practices. Over time, as Strauss further explains, this critique of aesthetics has been so absorbed into mainstream photography criticism and writing that its conclusions have become widespread and definitive. He uses the trenchant critique that Ingrid Sischy made against Sebastião Salgado in a 1991 article in the *New Yorker* entitled 'Good Intentions', in which she accuses Salgado of being more interested in the aesthetics of his images than in the plight of his famine-stricken African subjects, as evidence of the continuation of this line of thinking. For Strauss, the persistence of this critique is not only troubling but, more importantly, futile, since it fails to acknowledge that, as a form of representation, photography cannot function without aesthetic properties, given that, as he cogently states, 'to represent is to aestheticize; that is, to transform' (Strauss 2003: 9).

In establishing the implicit role that aestheticization plays in any form of representation, Strauss then goes on in other essays to argue

that aesthetics and, more specifically, beauty can function as a form of resistance. For him, given the current state of the 'technologies of communication' in the global world, this recognition of the political weight and subversive potential of aesthetics is necessary more than ever. Strauss makes this point clear in his essay 'Can You Hear Me? Re-Imagining Audience under the Pandaemonium', first published in 1999. He explains that because of recent advances in speed and interconnectivity, the 'technologies of communication have proliferated and accelerated' so that an 'all-consuming Pandaemonium of sound and image' has 'swept across the globe' and 'it has become more and more difficult for any one voice to be heard above the collective din' (Strauss 2003: 156). To deal with this situation and the inundation of images that it has brought, Strauss further maintains that contemporary photographers have to find a different means with which to engage viewers. It is precisely within this media 'Pandaemonium' that issues of aesthetics, then, become indispensable, since they give photographers, as he elucidates in his essay from 2000 entitled 'A Ferocious Philosophy: The Image of Democracy and Democracy of Images', the means to 'reduce the speed and frequency of images' and thus make it possible for viewers 'to see images differently' (Strauss 2003: 179). But, as political scientist Mark Reinhardt points out in his 2007 essay 'Picturing Violence: Aesthetics and the Anxiety of Critique', in making this argument about the necessity of aestheticization, Strauss never adequately explains what kinds of effects aestheticization actually produce in viewers. For instance, is aestheticization necessarily always beautiful and, hence, pleasurable or can it also be problematical and, moreover, are all forms of aestheticization, in fact, equally productive in getting viewers to slow down and think?

Strauss's third and most recent book, *From Head to Hand: Art and the Manual*, published in 2010, gathers 20 of Strauss's essays – all but two were previously published between 1993 and 2009 – on artists ranging from sculptors Martin Puryear, Donald Lipski and Ursula von Rydingsvard, to painters Terry Winters, Ron Gorchov and Leon Golub, to writers Robert Duncan, John Berger and Leo Steinberg, among others. In contrast to his previous better-known writings on photography and politics, the subject of this book is more narrowly defined on the artistic process itself, or what he calls 'the passage from idea to object in the plastic arts' (Strauss 2010: iv). By this statement, Strauss alludes to the reciprocal relationship that occurs between the hand, the eye and the mind when ideas and objects are materialized. This interest in how things are made, however, is not

new for Strauss; it is one that can be traced back to his studies during the early 1980s with Robert Duncan and others at the Poetics Program at the New College in San Francisco, California. This retrospective, as well as introspective feature of the book, is quite fitting since the collection in many ways also functions as a kind of memorial, especially essays such as the one written in remembrance of artist Leon Golub as well as the ones written in honour of those who have been influential to Strauss's own development as a writer and critic, including Duncan, John Berger and Leo Steinberg. What Strauss values most about these men and, especially, Steinberg, on whom he ends the collection with an essay from 1997 entitled 'It Has To Be Danced To Be Known: On Leo Steinberg', is their willingness and even insistency to look closely and compassionately at what is actually in front of them. It is this important guidance that has and continues to inform Strauss's deep, thorough and compelling engagement with photography, art, politics and the world around him.

Biography

David Levi Strauss was born in Junction City, Kansas, in 1953. He initially studied history, philosophy and political science at Kansas State University and then went on to receive a BA in 1976 from Goddard College in Vermont, where he studied photography. He subsequently studied 'photography as language' with Nathan Lyons at the Visual Studies Workshop in Rochester, New York, and poetics with Robert Duncan and the other poets who formed the Poetics Program at New College of California in San Francisco from 1980 to 1983. Strauss is currently Chair of the MFA Program in Art Criticism and Writing at the School of Visual Arts in New York City. Strauss has written on art, film and photography for *The Nation*, *Artforum*, *Art in America*, *Art Journal* and *Cabinet*. He is the founding editor of *ACTS: A Journal of New Writing* (1982–1990), and is also a contributing editor at *Aperture* and *The Brooklyn Rail*. Strauss has received numerous awards that include, among others, a Guggenheim Foundation Fellowship in writing; an Infinity Award for Writing from the International Center of Photography; a Reva and David Logan Grant in Support of New Writing on Photography from the Photographic Resource Center at Boston University; and a Visiting Scholar Research Fellowship from the Center for Creative Photography at the University of Arizona.

Primary texts

Strauss, D. L. (1980) *Manoeuvres: Poems 1977–1979*, San Francisco, CA: Aleph Press/Eidolon Editions.

——(1999) *Between Dog & Wolf: Essays on Art and Politics*, New York, NY: Autonomedia.

——(2003) *Between the Eyes: Essays on Photography and Politics*, New York, NY: Aperture.

——(2004) 'Breakdown in the Gray Room: Recent Turns in the Image War', in *Abu Ghraib: The Politics of Torture*, Berkeley, CA: North Atlantic Books.

——(2010) *From Head to Hand: Art and the Manual*, New York, NY: Oxford University Press.

Secondary texts

Baird, D. (2003–2004) 'Book Review: *Between the Eyes: Essays on Photography and Politics*', *The Brooklyn Rail: Critical Perspectives on Arts, Politics, and Culture*, December–January, http://www.brooklynrail.org/2004/01/art/between-the-eyes-essays-on-photography-and-politics, accessed 16 January 2011.

Bey, H. (2004) 'David Levi Strauss', *Bomb*, Fall, pp74–80.

Haworth-Booth, M. (2006) 'The Poet as Critic and Political Observer', *Art Newspaper*, vol 15, p48.

Johnson, J. (2004) 'Book Review: *Between the Eyes*', *Afterimage*, vol 31, no 5, March/April, p17.

Reinhardt, M. (2007) 'Picturing Violence: Aesthetics and the Anxiety of Critique', in *Beautiful Suffering: Photography and the Traffic in Pain*, Chicago, IL: University of Chicago Press.

Sholis, B. (2010) 'Book Review: *From Head to Hand: Art and the Manual*', *Bookforum*, February/March, http://www.bookforum.com/inprint/016_05/5040, accessed 16 January 2011.

Waltemath, J. (2003–2004) 'In Conversation: David Levi Strauss with Joan Waltemath', *The Brooklyn Rail: Critical Perspectives on Arts, Politics, and Culture*, December–January, http://www.brooklynrail.org/2004/01/art/david-levi-strauss, accessed 16 January 2011.

Erina Duganne

JOHN SZARKOWSKI (1925–2007)

John Szarkowski writes on photography with the understanding of a photographer, attentive and sensitive to what is unique to photography itself. He was an established and successful photographer, with two acclaimed publications to his name, when he became director of the

photography department at New York's Museum of Modern Art
(MoMA) in 1962; and while the demands of this position meant he
had no time to seriously continue his photography, he took it up
again when he retired from the museum in 1991.

Primarily taking the form of a series of essays in catalogues accom-
panying shows he curated for MoMA, his writing has often been
identified as modernist and formalist. But this is complicated by the
fact that when he says he is interested in showing what is unique to
photography, its identity is inseparable from its realism.

Szarkowski's aesthetic response to photography drew upon two key
figures: Louis Sullivan and John Kouwenhoven. Sullivan's architecture
and writings had formed the subject of Szarkowski's first book,
The Idea of Louis Sullivan, published in 1956. Kouwenhoven's account of
the vernacular in his 1948 book *Made in America* was acknowledged in
the introduction to Szarkowski's first statement about photography in
The Photographer's Eye (1966). Kouwenhoven insisted on a uniquely
American vernacular culture in its technological design and arts,
characterized by simplicity and economy (Kouwenhoven 1948): his
examples include the Model-T Ford, grain elevators, shaker furniture,
skyscrapers and, in terms of painting, the precise realist work of
Thomas Eakins, Winslow Homer and Charles Sheeler. Together with
Sullivan's credo of form following function and his disdain for unne-
cessary ornament, Kouwenhoven's thesis begins to explain Szarkowski's
consistent preference for a certain kind of photography: fit for
purpose, matter of fact, plain, unembellished and non-arty.

In the catalogue accompanying one of his first important shows,
The Photographer and the American Landscape (1963), Szarkowski began
to establish the benchmark for this kind of photography. Interestingly
it was identified with the work of photographers who did not
consider themselves artists. The standard was set by the photographer-
explorers who worked with the geological and geographic Government
Surveys during 1867 to 1879, especially Timothy O'Sullivan –
photographers who 'were simultaneously exploring a new subject and
a new medium' and who 'made new pictures which were objective,
non-anecdotal, and radically photographic' (Szarkowski 1963: 3). At
the turn of the century, as Szarkowski notes, photography was
revolutionized by a new school of photographers, including Alvin
Langdon Coburn, Edward Steichen, Clarence White and Alfred
Stieglitz, characterized by 'a conscious concern for aesthetic state-
ment' (Szarkowski 1963: 4). This, of course, broke with the formal
qualities established by the early explorer-photographers and one
had to look to the more modest work of relatively anonymous

workers for its continuation, the work of Darius Kinsey, for example, who, from the early 1890s to 1940, worked in near isolation, photographing the logging industry and its men in the Washington woods.

This argument was developed further in the book *The Photographer's Eye*. Here Szarkowski identified photography's distinctive aesthetic in its capacity to give import to the everyday and ordinary in counterpoint to the hierarchies and cultural distinctions which he associated with painting:

> Painting was difficult, expensive, and precious, and it recorded what was known to be important. Photography was easy, cheap and ubiquitous, and it recorded anything: shop windows and sod houses and family pets and steam engines and unimportant people. And once made objective and permanent, immortalized in a picture, these trivial things took on importance.
>
> (Szarkowski 1966: 7)

Szarkowski's interest in functional and vernacular photography was particularly evident in this book and exhibition. Photographs by the journeyman worker or Sunday hobbyist became important since because such practitioners, very often artistically ignorant, had no allegiance to traditional pictorial standards, they more readily demonstrated characteristics and problems inherent in the medium of photography itself. For Szarkowski, the photographer learned in two ways, 'from an intimate understanding of his tools and materials' and from 'other photographs' (Szarkowski 1966: 11).

A key American photographer in terms of the vernacular for Szarkowski was Walker Evans. Indeed, his reticent and impersonal work was so far from art photography in a fine art sense, that Szarkowski, in the catalogue essay for his 1971 retrospective, proposed that it 'seemed almost the antithesis of art' (Szarkowski 1971: 11). Evans's photographic subject matter was described in terms of a particular vernacular 'American sensibility' attached to the humble and amateur practitioner:

> As Le Corbusier had attempted to reject the models of the grand tradition, and gone to the grain elevator and the airplane and hardware catalogue for the beginning of a new architectural vocabulary, so Evans rejected the accepted successes of picture making, and began again instinctively with nourishment that he could find in handpainted signs, amateur buildings, the humbler

varieties of commercial art, automobiles, and the people's sense of posture, costume and design.

(Szarkowski 1971: 16)

Vernacular analogies recur in Szarkowski's definition of value in his writing. Jacob Riis, as he points out, 'had no interest in "artistic" photography'. Yet, the reason he made so many great pictures was because he was 'intuitively interested in form as a bridgebuilder makes intuitive judgement concerning scale, proportion and line without thinking of his work as architecture' (Szarkowski 1973: 48). In his essay on the fashion and portrait photographer, Irving Penn, what interested Szarkowski was the 'modesty and simplicity of his approach' (Szarkowski 1984: 25). In many of Penn's early portraits the 'presence of the studio is insistent … . The studio presents itself as the functional workroom of an honest craftsman who is clearly unaware of the requirements of high elegance' (Szarkowski 1984: 26). Robert Frank was said to have 'forged a new style like a weapon that was as clean and functional and American as a double-bitted axe' (Szarkowski 1973: 176). Describing Garry Winogrand's pictures, he says how 'Superficially casual, like a good fieldstone wall, they prove with familiarity to be irreducible and ordered' (Szarkowski 1969).

Another key aspect of Szarkowski's writing on photography was his critical stance towards the documentary tradition. As he put it in a 1984 interview, by the 1960s this tradition had 'gotten so leaden, tired, boring' (Grundberg 1984: 13). In the midst of the political turmoil of the 1960s, his 1967 show *New Documents* advocated a new generation of photographers – Lee Friedlander, Diane Arbus and Winogrand – who were seen to direct documentary to more personal ends.

Szarkowski felt that photography failed to explain larger public issues. In the book for his exhibition *Mirrors and Windows* (1978), he claimed that no photographs from the Vietnam War served either as 'explication or symbol for that enormity' (Szarkowski 1978: 13). Instead, Arbus's photographs were seen to best 'memorialize' the psychological shock of the new knowledge of 'moral frailty and failure' that he felt was the meaning of the Vietnam War for most Americans (Szarkowski 1978: 13). For him, 'most issues of importance cannot be photographed' (Szarkowski 1978: 14).

In *Mirrors and Windows*, Szarkowski established a binary to distinguish between two tendencies that he saw as characterizing American photography since the 1950s. It was a distinction between photographers who 'think of photography as a means of self-expression and those who think of it as a method of exploration', between the

'romantic' Minor White and the 'realist' Robert Frank (Szarkowski 1978: 11). Szarkowski's aesthetic allegiance, of course, has remained with the latter, the idea of photography as window rather than mirror of the artist.

He has described formalism 'as trying to explore the intrinsic or prejudicial capacities of the medium' (Stange 1978: 702). In this respect, for Szarkowski, Winogrand was 'the most outrageously and thoroughgoing formalist' that he knew, with his way of photographing understood as being about 'trying to figure out ... what that machine will do by putting it to the extreme tests under the greatest possible pressure' (Stange 1978: 702).

The book for his final major show at the MoMA, *Photography Until Now* (1989) ended with a quotation about William Eggleston's photographs from the writer, Eudora Welty. It reiterates the import of the everyday and commonplace as an abiding subject matter for photography. Welty's words, Szarkowski says, 'might be taken more broadly, and stand for the deepest of photography's ambitions now, and for our present apprehension of its mysterious powers: "He sets forth what makes up our ordinary world. What is there, however strange, can be accepted without question; familiarity will be what overwhelms us"' (Szarkowski 1989: 293). But by this time Szarkowski's influence and power was on the wane; he had been subject to increasing criticism during the late 1970s and 1980s, a period marked by a politicized and self-consciously artistic postmodern photography. *Photography Until Now* was met with a particularly damning review by Abigail Solomon-Godeau in *Art in America*, who claimed it 'presented a curious spectacle, reaffirming a certain type of modernist orthodoxy at the moment of its historical exhaustion' (Solomon-Godeau 1990: 141). She highlighted how Szarkowski's version of the history of photography in the book and exhibition failed to address the wider ideological implications of photography, its involvement in 'issues of spectacle, voyeurism, and the visual appropriation of the world that followed in the wake of colonialism and imperialism' (Solomon-Godeau 1990: 145).

In a 2005 US television interview, Szarkowski was asked if there was one photograph that 'knocked your socks off' (http://www. charlierose.com/view/interview/1055). He said almost everything Walker Evans did, and then added: Eugène Atget. This was because they were 'like good bread and good water ... as clear as good water and as nourishing as good bread.' It might strike us as an odd throwaway remark, spoken not written, but it nevertheless beautifully accords with the central emphases of his aesthetic evaluation of

photography – the repeated accent upon clarity, simplicity, honesty and the commonplace.

Szarkowski's writings did much to establish and define photography as a modernist *avant-garde* art; but it was a photography that largely remained separate from the artistic uses of the medium that took place during the time he was at the MoMA. Szarkowski showed scant interest in photography's import within Pop, Conceptual, Performance and Land Art. Nor was he interested in the Appropriationist work of postmodern artists that dominated the 1980s: for him, Barbara Kruger and Victor Burgin's work never transcended being 'superior illustration' (Szarkowski quoted in Durden 2006: 89).

The appreciation of photography as a collectible art was virtually non-existent when he took up his post in 1962. Occupying, as one critic called it, 'The Judgment Seat of Photography', Szarkowski certainly played a key role in photography's subsequent acceptance and value as art (Phillips 1989). But, despite his claims to the contrary, it was really only one kind of photography he ultimately valued, one that remained close to the set of qualities integral to Kouwenhoven's vernacular and far from the artiness that characterized more overt aesthetic uses of the medium.

Biography

John Szarkowski was born on 18 December 1925 in Ashland, Wisconsin. He majored in art history at the University of Wisconsin, graduating in 1948, having interrupted his studies to serve in the US army. Working as a museum photographer at the Walker Art Center in Minneapolis, and as a teacher of photography at Albright Art School in Buffalo, he then resigned to move to Chicago to work on a book on Louis Sullivan. In Chicago he worked on the staff of two advertising firms until a Guggenheim fund allowed him to complete the Sullivan project, with the book published in 1956. In 1958 he published *The Face of Minnesota*, a picture book on the state of Minnesota for its centennial celebration. In 1961 he was offered and accepted the position of director of the Department of Photography at the MoMA, assuming the role in July 1962. During the 29 years he was director, the department produced 160 exhibitions: those directed by Szarkowski included *Five Unrelated Photographs*, *The Photographer and the American Landscape*, *The Photographer's Eye*, *Dorothea Lange*, *New Documents*, *Walker Evans*, *Diane Arbus*, *William Eggleston*, *Mirrors and Windows*, *Ansel Adams and the West*, *The Work of Atget*, *Irving Penn*, *Garry Winogrand* and *Photography Until Now*. Following his

retirement in 1991, Szarkowski returned to photography, publishing, in 1997, *Mr Bristol's Barn*; during 2005 to 2006, a substantial retrospective exhibition of his photography toured major venues in the US, opening at the San Francisco Museum of Modern Art. He also continued to write on photography and to curate, though less frequently. One of his last major exhibitions and publications was *Ansel Adams at 100* (2001). He died of a stroke on 7 July 2007.

Primary texts

Szarkowski, J. (1963) *The Photographer and the American Landscape*, New York, NY: Museum of Modern Art.

——(1966) *The Photographer's Eye*, New York, NY: Museum of Modern Art.

——(1969) *Animals*, New York, NY: Museum of Modern Art.

——(1971) *Walker Evans*, New York, NY: Museum of Modern Art.

——(1973) *Looking at Photographs*, New York, NY: Museum of Modern Art.

——(1976) *William Eggleston's Guide*, New York, NY: Museum of Modern Art.

——(1978) *Mirrors and Windows: American Photography Since 1960*, New York, NY: Museum of Modern Art.

——(1984) *Irving Penn*, New York, NY: Museum of Modern Art.

——(1989) *Photography Until Now,* New York, NY: Museum of Modern Art.

——(2000) *The Idea of Louis Sullivan*, London: Thames & Hudson.

Secondary texts

Durden, M. (2006) 'Eyes Wide Open: Interview with John Szarkowski', *Art In America*, May, pp83–87, 89.

Eisinger, J. (1999) *Trace and Transformation: American Criticism of Photography in the Modernist Period*, Albuquerque: University of New Mexico Press.

Grundberg, A. (1984) 'An Interview with John Szarkowski', *Afterimage*, October, pp12–13.

Kouwenhoven, J. A. (1948) *Made in America*, New York, NY: Doubleday and Company, Inc.

Phillips, C. (1989) 'The Judgment Seat of Photography', in R. Bolton (ed) *The Contest of Meaning*, Cambridge MA: MIT Press, pp15–47.

Solomon-Godeau, A. (1990) 'Mandarin Modernism: "Photography Until Now"', *Art in America*, December, pp140–149, 183.

Stange, M. (1978) 'Photography and the Institution: Szarkowski at the Modern', *The Massachusetts Review*, vol 19, no 4, Winter, pp693–709.

Sullivan, L. H. (1980) *Kindergarten Chats*, New York, NY: Dover Publications.

Websites

'A Conversation with Photographer John Szarkowski', http://www.charlierose.com/view/interview/1055, accessed December 2010.

Mark Durden

JOHN TAGG (1949–)

British-born scholar John Tagg's most influential contribution to a critical discourse on photography has been the notion that there is no such thing as photography in and of itself. This idea, drawn from French philosophy and a key element of postmodern thinking about the photograph, was best articulated in an essay Tagg published in 1984:

> Photography as such has no identity. Its status as a technology varies with the power relations which invest it. Its nature as a practice depends on the institutions and agents which define it and set it to work. Its function as a mode of cultural production is tied to definite conditions of existence, and its products are meaningful and legible only within the particular currencies they have. Its history has no unity. It is a flickering across a field of institutional spaces. It is this field we must study, not photography as such.
>
> (Tagg 1988: 63)

This paragraph, with its short crisp sentences, repetitive rhythms, intellectual density and declarative certainty, offers a useful summation of Tagg's qualities as a writer about photography. In it, he combines insights taken from his study of the structuralist Marxism of French philosopher Louis Althusser with rhetoric borrowed from the work of another French philosopher, Michel Foucault. The end result is an argument that presents photography as an apparatus of ideological control, a vehicle all too readily available for transmitting ruling class values and the oppressive power of the state. Photography is capable of this transmission because the meanings of any individual photograph are entirely dependent upon the context in which that photograph finds itself at any given moment. Photographs, Tagg argues, are empty signs, a mere field of possibilities, until they are filled with significance by outside discourses or infrastructures.

Tagg's central claim, that there is no 'photography as such', was a direct counter to the prevailing emphasis by American critics and curators on the need to define the essence of the photographic medium. Derived from the art criticism of Clement Greenberg and the idealist philosophy of Immanuel Kant, this view was conveyed most cogently in the exhibitions and catalogue essays of John Szarkowski, the director of photography at New York's Museum of Modern Art from 1962 to 1991. Stressing the revelation of 'photography itself' as the measure of aesthetic achievement, Szarkowski privileged those art photographers who showed a 'progressive awareness of characteristics

and problems that have seemed inherent in the medium' (Szarkowski, 1964). This privileging deflected attention from the meanings and functions of photographs and focused instead on their formal pictorial attributes. It was an approach to photography that was, in short, both politically conservative and historically inaccurate.

It was also an approach that was anathema to Tagg, as evidenced in his provocative contribution – entitled 'A Socialist Perspective on Photographic Practice' – to the 1979 exhibition at the Hayward Gallery in London, *Three Perspectives on Photography: Recent British Photography*. Tagg's catalogue essay called for 'a new politics of truth', and the relationship of these two terms – 'politics' and 'truth' – has continued to be a central concern of his writing. The following year, for example, Tagg published an edited volume of essays by the German Marxist art theorist and historian Max Raphael, and in 1982 had an essay, 'The Currency of the Photograph' (first published in 1978), appear in *Thinking Photography*, an important anthology edited by Victor Burgin. By this stage, Tagg had also joined the editorial board of *Screen Education*, a British journal dedicated to forging a 'politics of representation', looking in particular at the realms of art, education, film, TV, photography and the law. In keeping with this broad mission, Tagg's own writing soon incorporated elements of psychoanalysis, feminism and semiotics, as well as Marxism.

In 1980 Tagg published a two-part essay in *Screen Education* that has remained perhaps his most influential example of this kind of discourse. Entitled 'Power and Photography', this extended commentary offers a pioneering effort to relate the work of Foucault to a history of photography, tracing the way in which disciplinary power circulates and has its effects within various photographic practices aimed at fixing identity. These effects, Tagg suggests, are sometimes embodied in the photographs themselves:

> We have begun to see a repetitive pattern: the body isolated; the narrow space; the subjection to an unreturnable gaze; the scrutiny of gestures, faces and features; the clarity of illumination and sharpness of focus; the names and number boards. These are the traces of power, repeated countless times, whenever the photographer prepared an exposure, in police cell, prison, consultation room, asylum, Home or school.
>
> (Tagg 1988: 85)

Although his analysis concentrates on the use of photography within prisons, asylums and other institutions of incarceration, Tagg rejects

an association of power with prohibition alone. 'We must cease once and for all to describe the effects of power in negative terms – as exclusion, repression, censorship, concealment, eradication. In fact, power produces. It produces reality. It produces domains of objects, institutions of language, rituals of truth' (Tagg 1988: 87). Indeed, Tagg, quoting Foucault, describes power as a 'name given to a complex strategic situation in a given society' and suggests that only by understanding it in these terms can we develop a countervailing resistance. This resistance, he says, 'exists in dispersed, local, multiplex forms' (Tagg 1988: 92–93). His own essay might be taken as an instance of one such resistant act, offering a model for an engaged academic scholarship that cuts across the usual modernist art history then dominating the field.

In 1985 Tagg moved from the UK, where he had helped to develop a social history of art programme at the University of Leeds, to the US, eventually taking up a teaching position at the State University of New York at Binghamton. From there he has continued to exert influence over debates about photography in the West, and also, through his students, on photographic scholarship in places such as Korea. A book of his essays appeared in 1988 as *The Burden of Representation: Essays on Photographies and Histories* (the book was also issued in Spanish in 2005). Both the title and the pluralizations in his subtitle have become common elements of the lexicon of photographic discourse. The book brought together seven essays, six of them previously published in magazines such as *Screen Education* and *Ten.8*, along with an extensive and often self-critical 'Introduction'.

These essays, which included both parts of 'Power and Photography', focused on the instrumental uses of photography by the modern state, situating particular photographic practices in the historical contexts that gave them their evidentiary force. The final essay reproduced in the book, 'Contact/Worksheets: Photography, History, Representation' (1979), was also the most experimental. Although still calling for a '*new politics of truth*' (Tagg 1988: 188) and declaring a commitment to 'the tradition of Marxist thought' (Tagg 1988: 197), Tagg here adopts a more personal voice and fragmented narrative style, mimicking, as he tells us, the discontinuous nature of his own historical researches.

The Burden of Representation attracted some substantial reviews. David Phillips, for example, praised the book even while pointing to an insufficiently developed notion of photography's production of subjects, a result of what Phillips calls Tagg's discomfort with 'the potentially unsettling implications of psychoanalysis' (Phillips 1989: 120).

But he also concluded that 'John Tagg's writings undoubtedly provide some of the most sophisticated analyses of photography currently available' (Phillips 1989: 118), having 'put on the agenda a complex range of questions to be asked when writing about photography, questions which have transformed what a history of photography might look like' (Phillips 1989: 121).

This questioning has continued in Tagg's subsequent essays, which have been collected in two books so far, *Grounds of Dispute: Art History, Cultural Politics and the Discursive Field* (1992) and *The Disciplinary Frame: Photographic Truths and the Capture of Meaning* (2009). The work of Jacques Derrida has become a prominent presence in Tagg's writing over the past 20 years and the writing itself has taken on a more distinctly literary character. These essays nevertheless address some familiar themes, including the politics invested in the construction of photography's apparent realism and the relationship of documentary (for him an ethical as much as a pictoral practice) to regimes of power and coercion. Indeed, Tagg now extends that regime to include the very practice of history writing in which he is engaged, 'whose protocols of evidence and argument are also shown to turn on a kind of violence: the violence of meaning' (Tagg 2009a: xvi).

In trying to describe how power is conveyed by, and perhaps even inscribed within, certain photographic practices, John Tagg has offered a key example of how one might think critically about a range of genres of photography that previously received little attention, such as criminal and medical photography. He has also made cultural work of this kind seem to matter to academic scholarship, even while helping to bring the study of photography's history into the heart of what came to be called postmodernism. Most important, his work insists that photography – like writing – is productive, not simply reflective; it does things to the entities it represents. This is the continuing challenge he highlights for all other writers on the photographic experience.

Biography

John Tagg is Professor of Art History and Comparative Literature at the State University of New York (SUNY) at Binghamton in the US. Born in 1949 in North Shields, a shipbuilding and fishing town at the mouth of the River Tyne, in what was then Northumberland, England, he studied fine art and art history at the University of Nottingham, England, before attending the Royal College of Art, London, where he graduated in 1973. In 1976, following his appointment as the first Arts Council of Great Britain Fellow in Photographic History and Theory at the Polytechnic of

Central London, Tagg began to concentrate on the history of photography and the analysis of visual culture. He then taught for three years at the University of London, Goldsmiths College, before moving to take up a position at the University of Leeds. In 1984 he moved to the US, teaching first at the University of California at Los Angeles and then, after two years, at SUNY Binghamton. He has been publishing scholarly essays and art criticism since 1970.

Primary texts

Hill, P., Kelly, A. and Tagg, J. (1979) *Three Perspectives on Photography*, London: Arts Council of Great Britain.

Tagg, J. (1977) 'The World of Photography or Photography of the World?', *Camerawork*, no 6 (April), pp8–9.

——(ed) (1980a) *Proudhon, Marx, Picasso: Three Studies in the Sociology of Art*, by Max Raphael, translated, by I. Marcuse, New Jersey and London: Humanities Press and Lawrence and Wishart; translated into Korean by K. Lee, Seoul: Noonbit, 1991.

——(1980b) 'Power and Photography – Part I. A Means of Surveillance: The Photograph as Evidence in Law', *Screen Education*, no 36, Autumn, pp17–55.

——(1981) 'Power and Photography – Part II. A Legal Reality: The Photograph as Property in Law', *Screen Education*, no 37, Winter, pp17–27.

——(1988) *The Burden of Representation: Essays on Photographies and Histories*, London and Amherst, MA: Macmillan and University of Massachusetts Press; republished by Minneapolis, MN: University of Minnesota Press, 1993.

——(ed) (1989) The Cultural Politics of 'Postmodernism.' *Current Debates in Art History: One*, Binghamton, NY: State University of New York at Binghamton.

——(1992) *Grounds of Dispute: Art History, Cultural Politics and the Discursive Field*, London and Minneapolis, MN: Macmillan and University of Minnesota Press.

——(2005) *El peso de la representación: Ensayos sobre fotografías e historias*, translated by A. Fernández Lera, Barcelona: Editorial Gustavo Gili.

——(2008) 'In the Valley of the Blind', in R. Kelsey and B. Stimson (eds) *The Meaning of Photography*, Williamstown, MA, and New Haven, CT: Clark Art Institute and Yale University Press, pp118–129.

——(2009a) *The Disciplinary Frame: Photographic Truths and the Capture of Meaning*, Minneapolis, MN: University of Minnesota Press.

——(2009b) 'Mindless Photography', in J. J. Long, A. Noble and E. Welch (eds) *Photography: Theoretical Snapshots*, London and New York: Routledge, pp16–30.

——(2009c) 'Crime Story: Walker Evans, Cuba and the Corpse in a Pool of Blood', *Photographies*, vol 2, no 1, March, pp79–102.

Secondary texts

Batchen, G. (1988) 'Photography, Power, and Representation', *Afterimage*, vol 16, no 4, November, pp7–9.

Harris, J. (1989) 'The Uses of the Real', *Art History*, vol 12, no 2, June, pp247–254.

Hugunin, J. (1993) 'Disputing Grounds', *Views*, vol 13–14, no 14–1, Winter, p17.

Phillips, D. (1989) 'The Subject of Photography', *Oxford Art Journal*, vol 12, no 2, pp115–121.

Ribalta, J. (2010) 'Review: *The Civil Contract of Photography* and *The Disciplinary Frame*', *CAA.reviews*, http://www.caareviews.org/reviews/1446.

Szarkowski, J. (1966) *The Photographer's Eye*, New York, NY: Museum of Modern Art.

Wexler, L. (1989) 'Photographies and Histories/Coming into Being', *Exposure*, vol 27, no 2, pp38–44.

Geoffrey Batchen

WILLIAM HENRY FOX TALBOT (1800–1877)

For many, the significance of William Henry Fox Talbot has resided primarily in his being one of the inventors of the two photographic processes announced to the world in 1839. Many established histories of photography (Newhall 1937 and Gernsheim 1955), speak of his contribution in terms of technical matters alone and with the occasional acknowledgement of his subject matter when it sits comfortably within a conventional art historical framework. Talbot indeed laid the foundations of modern photography; but his intellectual world was far-ranging, making him a distinctive figure within nineteenth-century science.

What Talbot has to say about photography in his writing offers a fascinating reflection on what photography *was* and *could be*, rather than just a simple account of its development and use. His research into philology, optics, chemistry and mathematics, supported by other interests in botany, art and classical history, was the intellectual matrix against which photography is formed. Talbot's writings on photography in notebooks, letters and published works reveal a methodical and occasionally romantic character suggesting both the eighteenth-century influences of natural philosophy and the thinking of modern science as it emerged during the early 1830s. Talbot's photography and writing is caught between 'old' and 'new' worlds of thought. This is particularly evident in his seminal book *The Pencil of Nature* (1844–1846), but present in his other published accounts of the genesis and evolution of photography.

On 7 January 1839, news of Louis-Jacques-Mandé Daguerre's process of fixing the camera image 'by the spontaneous action of light' reached Talbot, thus encouraging him to set out his own related experiments

from the early 1830s as described in a hand-written paper entitled 'Some Account of the Art of Photogenic Drawing', read out to the Royal Society on 31 January and printed shortly after. This was preceded by an announcement of his process to the Society by Michael Faraday on 25 January where a selection of specimens of his process were available for inspection.

In the early texts accompanying the announcement, terms and ideas such as 'natural magic', 'shadows', 'nature's marvels', 'words of light', 'a wonder of modern necromancy', the 'black art' and 'fairy pictures' appear. Talbot's use of language was as rich in references to alchemy and hidden natural forces as it was in its matter of fact observation and the reasoning of modern science. Some of these terms would appear again in *The Pencil of Nature* but this time accompanied by photographically illustrated plates, which marks it with a special significance.

In addition to the better-known experiments described in journal articles published in *The Athenaeum*, *The Royal Society*, *Literary Gazette* and *Philosophical Magazine* (Weaver 1992), Talbot, like many of his social class, was a prolific letter-writer. It is here as much as in his published work that his thinking on and around photography can be found (Talbot Correspondence Project – http://foxtalbot.dmu.ac.uk/). To present him as an important writer on photography as well as its significant inventor is to open up his vital contribution to the analysis of both images and their uses, to gain greater insight into what has been described as the 'dawn of photography' (Schaaf 1992). On receiving examples of Talbot's latest experiments, the scientist John F. W. Herschel wrote a letter to Talbot, declaring that he had some kind of Faustian pact with the devil, that 'surely you deal with the naughty one' (TCP, 16 March 1841). Photography at that point, then, is of the world but instils a strong sense of otherworldliness in those who encountered it.

Herschel is important to Talbot's work and thinking in other ways. It was Herschel who coined several important terms as part of his own researches and Talbot's, including the word 'photography' and others such as 'negative', 'positive' and 'snapshot'. In the naming of Talbot's version of photography, the act of writing is inscribed etymologically into its very character, into its very name. Arguably, Talbot chose to anchor the naming of his invention in more familiar graphic terms as a way of grappling with the modernity of his invention.

Variations of the name photography (writing with light) are to be found in Talbot's earliest experiments – 'secret writing' in 1831 (a parlour room game where invisible handwriting could be chemically revealed), 'sciagraphy' (shadow writing) in 1834, photogenic drawing

in 1839, and the Calotype process formulated in 1840. So we have nuances and literal references to the qualities of photography that incorporate the invisible made visible, shadows or traces of the physical world, images originating in light and finally a more sophisticated and commercial naming with the Calotype (derived from the Greek word '*Calos*' for 'beautiful'). The Calotype utilized chemistry, by which, following a brief exposure in camera, a latent image could be chemically developed out of the light sensitive paper. Here was a more effective foundation for Talbot's negative-positive process that was announced in 1841 and went on to form the backbone of his commercial work and subsequently all photography prior to the digital age.

In *The Pencil of Nature* (Talbot 1844–1846), Talbot introduces other allusions to writing where photography is seen as an automatic process, an inscription by the sun, an image 'Impressed by Nature's Hand'. It is also where Talbot provides us with a past, present and future for photography. Tensions between the hand and the machine (between the artist and mass production) were not a cultural concern for Talbot; he saw photography as an artist's aid and the basis for new forms of creativity and commerce. *The Pencil of Nature* is Talbot's primary vehicle for this, a luxuriously bound series of six volumes, published over two years, emerging from his attempt to industrialize photographic reproduction in his small factory workshop established at Reading.

In his writing, Talbot begins to make much of photography's distinctive optical, material, spatial and temporal qualities that underline its difference from existing forms of representation. Analogies with 'the pencil' or with 'painting' are there as pointers, a means of locating the new art; and through the pages of his book photography's difference becomes clearer. In this respect, he anticipates the criteria that the curator and writer John Szarkowski would turn to in his Museum of Modern Art (MoMA) exhibition and book *The Photographer's Eye* (1966); but Talbot's nascent modernism is all the more compelling and contradictory for his preoccupation with themes that connect more readily with later revisionist approaches to modernism concerning the original and the copy.

All of the photographic plates from *The Pencil of Nature*, made as salt paper prints mostly using the Calotype process, are deliberately chosen to extol the virtues of the new process. In terms of photography's rendering of detail, Talbot writes carefully about the excess of information so beautifully captured in prints such as 'The Haystack' and in details previously unseen, such as the clock face on the tower of 'Queens College', noting the time at which the photograph was taken. Discussions on time and detail permeate other commentaries

for plates ranging from the effects of weather on brickwork to historical narratives relating to the architectural heritage of Lacock Abbey or the trials of Patroclus in the Trojan Wars.

Several plates introduce ideas of evidence and copying that are, for Talbot, unequivocal. The plate 'Articles of China', speaks of photography as a new legalistic truth where the contents of a collector's cabinet could be rendered in minutes and provide hard visual evidence: 'And should a thief afterwards purloin the treasures – if the mute testimony of the picture were to be produced against him in court – it would certainly be evidence of a novel kind' (Talbot 1844). Facsimiles of drawings and engravings also figure where photography can change the scale of works of art and the original 'preserved from loss and multiplied to any extent'. More surprisingly are plates such as 'A Scene in a Library' where Talbot speculates about the possibility of photography 'seeing in the dark'. Knowing that there are parts of the spectrum that cause changes in photographic paper by trials with a prism, in a strangely unnerving but profound way Talbot suggest that a room could be flooded with infrared light rays and thus reveal the occupants inside: 'For, to use a metaphor we have already employed, the eye of the camera would see plainly where the human eye would find nothing but darkness' (Talbot 1845: Part II).

Talbot's sensibility was also bound up with a deep sense of history embodied in his other writings, such as *Hermes, or Classical and Antiquarian Researches* (1838) and in his *The Antiquity of the Book of Genesis* (1939). The extent of Talbot's written output and interests were not outside of his photographic experiments but offered a network of sensibilities and ways of thinking about photography. The contents of his family home at Lacock Abbey, many of which express both social class but also the material pursuit of knowledge, such as statuary and books, figure in many of his early tableaux in *The Pencil of Nature*.

The Pencil of Nature is key to understanding ideas that became associated with the early currencies of photography, as well anticipating many of its later uses and critical interpretation by other writers. It is not only the proximity of Talbot's writing to a new phase in visual culture that underscores his importance as a key writer on photography, but also that his writing shows an interest in the photograph as a space of alternative inscription beyond appearances. In his analysis of certain pictures, Mike Weaver has argued for a conscious metaphysical construction of Talbot's pictures that speak clearly to his disciplinary interests, pictures that reveal a pictorial sophistication that extols the virtues of the pursuit of knowledge and human frailty (Weaver 1992).

Talbot as a writer speaks back to his photographic experiments in ways that enrich the dynamic between word and image, and that are revealing of his time but also evocative when we look back at how photography played out. By recognizing the role his texts have to play in defining what photography *was* or *might be* and in anticipating future applications of the medium, Talbot's contemporary relevance should never be overlooked.

Biography

William Henry Fox Talbot was born on 11 February 1800 in Melbury, Dorset, England, the only child of William Davenport Talbot (1764–1800) of Lacock Abbey and Elisabeth Theresa (1773–1846), daughter of the second Earl of Ilchester. When he was only five months old, his father died and his mother was faced with the Lacock country estate that was failing and in need of repair. The boy and his mother subsequently lived in a series of family homes until Lady Elisabeth remarried in 1804. Throughout this period his mother remained a potent force in his academic development, encouraging the young Talbot to advance his intellectual interests beyond his early years. Through the family's social circles he met influential political and scientific figures who would later extend to an impressive scientific network that included John F. W. Herschel, Charles Babbage, Thomas Young, J.-B. Biot and David Brewster. After an education at Harrow and then Cambridge, where he graduated in mathematics in 1822, Talbot's intellectual trajectory was still heavily influenced by his classical education and on-going interests in early civilizations, but from the 1830s would include important work on spectroscopy, calculus and crystallography. He died in 1877 at Lacock, having set out some of the leading practical conditions for a workable photographic process in the 1840s, devised methods of reproduction that anticipated the half-tone process and illustrated press (photoglyphic engraving during the 1850s), and contributed papers to the development of many fields in science and humanities.

Primary texts

Talbot, W. H. F. (1839) *Some Account of the Art of Photogenic Drawing, or the Process by which Natural Objects May Be Made to Delineate Themselves without the Aid of the Artist's Pencil*, Read before the Royal Society, 31 January 1939, and printed privately: London: R. & J. E. Taylor, 1839. Reprinted in B. Newhall (ed) (1980) *Photography: Essays and Images*, London: Secker and Warburg.
——(June 1844–April 1846) *The Pencil of Nature*, London: Longman, Brown & Longmans, issued in fascicles, un-paginated, including 24 salted-paper

prints. (A facsimile copy of *The Pencil of Nature* was published in 2011 by Chicago and London: KWS Publishers.)

Weaver, M. (ed) (1992) *Henry Fox Talbot: Selected Texts and Bibliography*, Oxford: Clio Press.

Secondary texts

Arnold, H. J. P. (1977) *William Henry Fox Talbot; Pioneer of Photography and Man of Science*, London: Hutchinson Benham Ltd.

Batchen, G. (1997) *Burning with Desire: The Conception of Photography*, Cambridge, MA: MIT Press.

——(2008) *William Henry Fox Talbot*, London: Phaidon.

Buckland, G. (1980) *Fox Talbot and the Invention of Photography*, Boston, MA: David R. Godine.

Edwards, S. (2006) *The Making of English Photography – Allegories*, Pennsylvania: Penn State University Press.

Gernsheim, Helmut (with Alison Gernsheim) (1955) *The History of Photography from the Earliest Use of the Camera Obscura in the Eleventh Century up to 1914*, London, New York: Oxford University Press.

Herschel, Sr. J. F. W. (1839) 'Note on the Art of Photography, or the Application of the Chemical Rays of Light to the Purposes of Pictorial Representation', Lecture given to the Royal Society on 14 March 1839; printed in *The Athenæum*, 23 March, p223.

Newhall, B. (1937) *Photography 1839–1937*, New York, NY: Museum of Modern Art.

Roberts, R. (2000) *Specimens and Marvels: The Art and Science of W. H. F. Talbot*, New York, NY: Aperture.

——(2004) 'Images and Artefacts: William Henry Fox Talbot and "The Museum"', in B. Finn (ed) *Artefact*, vol 4, London: Science Museum, pp4–20.

Roberts, R., Batchen, G., Schaaf, L. et al (2001) *El Arte y los Experimentos de William Henry Fox Talbot*, Madrid: Museo Nacional Centro de Arte Reina Sofia & Aldeasa.

Schaaf, L. J. (1992) *Out of the Shadows; Herschel, Talbot and the Invention of Photography*, London: Yale University Press.

——(1996) *Records of the Dawn of Photography; Talbot's Notebooks P & Q*, Cambridge: Cambridge University Press.

——(2000) *The Photographic Art of William Henry Fox Talbot*, Princeton, NJ: Princeton University Press.

Websites

Schaaf L. J. et al, *Talbot Correspondence Project*, http://foxtalbot.dmu.ac.uk/, accessed April 2012.

Russell Roberts

HENRI VAN LIER (1921–2009)

The Belgian philosopher Henri Van Lier started writing on photography during the late 1970s. His thinking, expressed in unusually poetic and literary terms, is closely indebted to the very structure of the French language, vocabulary and syntax. Although precision and meticulousness are always his final aims, it is through words and wordplay that Van Lier develops his theories. His writing is best characterized by the combination of the search for the most precise description and the most expressive way of saying it.

Henri Van Lier's core writing on photography is contained in his *Philosophy of Photography*, which originally appeared in French in the *Cahiers de la Photographie* in 1983 but was not translated into English until 2007. The book is primarily interested in the notion of medium-specificity. While he attempts to disclose what is unique about the photographic image and its manifold uses, he always defines photography in relationship to what it means for humankind. Photography is considered in relationships to the discipline he terms 'anthropogeny', which studies the gradual emergence of what makes us human through the history of the species.

Given the semiotic and linguistic paradigms that were dominating photographic theory when he started writing on the medium, it is no surprise that the notion of the photograph as index is central to Van Lier's work. However, he introduces a fundamental distinction between 'indices' and 'indexes'. According to Van Lier, this basic distinction is clouded in Charles Sanders Peirce's work by the fact that the English language, unlike French, does not have two different words to shape the two ways of thinking about the index. What Peirce calls an 'index', Van Lier calls 'indices'. For Van Lier, indices are 'the physical effects of a cause they physically *signalize*, either through *monstration* – as when the imprint of a boar's paw shows this same paw – or *demonstration*, as when an unusual disarrangement of objects might reveal a thief's route to a detective' (Van Lier 2007: 17). 'Indices' are described as 'non-intentional signs' while 'indexes' are intentional signs and 'indicate objects much in the same way the index finger or an arrow might point to an object' (Van Lier 2007: 17). Indexes refer to the ways in which a photograph points towards certain elements in the picture in order to emphasize them; they are tools to say 'look at this!'. For this reason, Van Lier defines photographs as 'possibly indexed indices' (Van Lier 2007: 118). They are indices in that they are the result of photonic imprints, and in this sense they reveal their causes; but they can also be indexes, provided we pay attention to the fact that the

photographer has chosen 'his frame, film, lens, developers and prints' in order to highlight certain aspects of reality (Van Lier 2007: 118). For Van Lier, the photograph is both a trace, according to the traditional sense of Peirce, and an arrow pointing to a certain object that can be seen or read within the picture itself, but whose status, contrary to that of the indices, is intentional and man-made.

Van Lier defines the basic features of our human interaction with the world through the terms 'frontality' and 'angularity' (Van Lier 2009: 14–15). We interact with our environment through a frontal view; we are not 'immersed' in our environment but we face it. And this 'frontality' proceeds through the introduction of rectangular frames, of which photography offers a technically developed version. By introducing a mechanical device that combines frontality and angularity, photography not only multiplies the kind of images that make more explicit what Van Lier argues are typical human aspects of vision, but it changes this vision as well. Van Lier proposes that human vision has 'internalized' the cropping and square-angled look of photography, and we now look at the world as if our eyes behaved like a camera. Photography, as a result, is understood as a technology that changes humankind. As he states in his *Philosophy of Photography*: 'The photograph radically changed […] the entire system of traditional culture. […] Man as creator of images, formerly so important and fundamental, has been subordinated and is now often only facultative' (Van Lier 2007: 53). By facultative he means we have become discretionary or optional. What photography discloses is that the production of reality is no longer solely dependent upon our intentions and skills, but that reality can be expanded as well as enhanced by technologies that transform us. What Van Lier is looking for is the 'cosmological' dimension of photography, what it can teach us about the transformations of humankind as a whole (Van Lier 2007: 60).

In Van Lier's 'anthropogeny', history can roughly be divided into three major periods or worlds. In World 1, we were still part of our natural environment, while in World 2, we managed, thanks to language and culture, to organize our environment, transforming what he calls the 'real' into 'reality'. The 'real', for Van Lier, is that which 'is not yet domesticated by our technical, scientific and social relations', while 'reality' is 'the real in so far as it is already seized and organized in sign systems' (Van Lier 2007: 36). In World 3, which Van Lier relates to the realm of digital culture, the production of sign systems becomes a production of new forms of the real (Van Lier 2009: 289–301). Here, as well, the place of photography is crucial: classic (analogue) photography fascinates Van Lier because it is at the crossroads of the 'real' and 'reality' (it organizes the

real, yet at the same time we cannot control it completely); contemporary (digital) photography enables the shift of photography's frontality and orthogonality to the real-transforming capacities of World 3 structures and devices. Van Lier's future-orientated thinking is interested not in the being of humankind, but its becoming, its endless transformation.

For Van Lier, photography is not just a special category of sign, it is also a social practice and a way of world-making: hence, for instance, in his reflections on the transformations of the medium, the strong emphasis on the creative dialogue between the image (with its own style and content) and image-taking (with its multiple relationships to the technology of the camera, printing, distribution, etc.) What drives photographic history is the dynamic interaction between subject matter (which subjects can be pictured), photographic technology (which machines are being used) and individual subjectivity (what people know about photography and how that influences their looking at a photograph). New technologies make room for new subjects and new styles, not in the sense that they mechanically open windows upon previously unseen things, but in the sense that the photographer tends to find and to invent the subject matter and the accompanying style that best fits the technology in question, and vice versa. A simple example of this principle is the 'convergence' between content, style and technology in Van Lier's analysis of the negative-positive technology of the Calotype, which in comparison to the exclusively positive technology of the Daguerreotype, introduced a subject matter that was looking for a balance between light and dark zones in the picture, whose effect was the same in both versions, negative as well as positive (see http://henrivanlier.com/anthropogeny/al_semiotique_hpp_an.html).

Given the fact that a photographic picture is much more than an object, but has to be seen in its dynamic function as a sign, it is no longer relevant to make a fundamental distinction between amateur art and professional art, between art and non-art, between personal and anonymous work. Van Lier was not only very sympathetic to often despised forms of photography, but also to such under-researched uses of photography as pornography, making interesting remarks on such photography as a form of social behaviour. And, as always, Van Lier is aware of cultural difference. Just as photography changes through time, it changes between cultures. There is no single master narrative of photography.

Biography

Henri Van Lier was born in Rio de Janeiro in 1921 and died in Brussels in 2009. A trained philosopher, he was for many decades a

lecturer of philosophy and the theory of culture at the IAD (Institut des Arts de Diffusion, or School of Audiovisual Production), affiliated with the University of Louvain-la-Neuve. Best known for his books on aesthetics – for instance, *Les arts de l'espace* (1959) and *Le nouvel âge* (1962), a pioneering work in the field of arts and science studies – he became, during the 1970s and the 1980s, a regular contributor to the French public radio station *France Culture*. During these years he also contributed numerous articles to the *Encyclopedia Universalis*, a French-language general encyclopaedia. His *Philosophy of Photography* was published in 1983 but not translated into English until 2007. Between 1982 and 2002, he spent most of his time writing his *Anthropogeny* (2010), strongly influenced by the thinking of Stephen Jay Gould and considered an exceptional example of cross-disciplinary reflection on the transformation of human nature through time.

Primary texts

Van Lier, H. (1959) *Les arts de l'espace*, Tournai: Casterman.
——(1962) *Le nouvel âge*, Tournai: Casterman.
——(1968) *L'Intention sexuelle*, Paris: Casterman.
——(1980) *L'Animal signé*, Brussels: Vander.
——(2004a [1992]) *Histoire photographique de la photographie*, Bruxelles: Les Impressions Nouvelles; English translation available at http://henrivanlier. com/anthropogeny/al_semiotique_hpp_an.html.
——(2004b) *Le tour de l'Homme en quatre-vingts theses*, Brussels: Musée de la Maison d'Erasme; English version available at http://www.anthropogenie. com/anthropogeny/around.html.
——(2007 [1983]) *Philosophy of Photography*, translated by A. Rommens, Leuven: Leuven University Press, Lieven Gevaert Series, http://www. anthropogenie.com/anthropogeny/an_semiotique_philo.html.
——(2009) *Anthropogénie*, Bruxelles: Les Impressions Nouvelles.

Secondary texts

Maes H. (2008) 'A New Philosophy of Photography?', *History of Photography*, vol 32, no 4, pp380–383.
Peirce, C. S. (1940) 'Logic as Semiotic: The Theory of Signs', in J. Buchler (ed) *The Philosophy of Peirce*, New York, NY, Dover Press.

Websites

The website Anthropogeny gathers most of Van Lier's writings, with some translated into English: http://www.anthropogenie.com/main_en.html.
Van Lier, H. (2010) 'Anthropogénie (2002)', *YouTube*: http://www.youtube. com/watch?v=TUTYAWq7frk.

Jan Baetens

MIKE WEAVER (1937–)

Mike Weaver's interest in photography seems to have been kindled around 1965 by Peter Bunnell, the pioneering American curator of photography at Princeton. An article on 'Ansel Adams: Interstate Luminist', published in *Creative Camera* in December 1975, was his first published text on the subject. Previously, from 1964 onwards, he had written mostly about Concrete Poetry, with an especial reference to Ian Hamilton Finlay, the Scottish artist/poet who was just then beginning to go public. In September 1977 he contributed 'Walker Evans: Magic Realist' to *Creative Camera*, but put most of his efforts into comprehensive research rather than periodical literature.

The switch from Ian Hamilton Finlay to Julia Margaret Cameron looks, at first sight, surprising. Nonetheless, there are affinities. Finlay's poems and lettered artworks take a certain amount of deciphering for they allude here and there to other words, items and systems of thought. The poems, sometimes arranged in columns and series, reveal themselves through time and as part of a deliberated process. Weaver, reflecting on Cameron's interest in types, saw a similarity: sequences or chains of meaning connecting figures from the Old and New Testaments with her contemporaries. If Christ's typological forebears were King David, for example, and John the Baptist, He was at the same time closely involved with his betrayer, Judas. The idea of trust and betrayal points then, to Shakespeare's Othello and Iago – and thence to any number of contemporary dealings.

Cameron, as recounted by Weaver, practised her art in contentious times. She was a traditionalist and an idealist making pictures against the naturalistic grain of the period – she took up photography in 1863. She had to negotiate between classical and Christian options and simultaneously 'to sublimate desire and to make desire sublime' (Weaver 1984a: 23). She had to accommodate the classicism of Raphael and the expressive chiaroscuro of Rembrandt. A more conventional writer than Weaver would have stressed such salient points; but in the Cameron book they appear spontaneously as he recounts her cultural and personal context. He has always been curious about how art arises. In her case, it emerges in a culture preoccupied by theology in relation to aesthetics, and one widely read in classical and romantic literature. Weaver insists on the richness of this background, less because that is what it was really like than to warn off beguiling simplifications.

Although the Cameron texts are a scholarly study of an artist and her circle, they allowed the writer to touch on his own sense of

photography. In a poem of 1875 she writes of an artist searching 'the key-note' in order to get to the heart of a tragic tale. Weaver identifies this key-note with certain stopping gestures represented by Cameron and her contemporaries. The major event itself might lie beyond expression, but preliminary and consequent states of mind and of body could be noted. A picture made with these terms of reference would be, by implication, part of a series, real or imagined. In his next major essay, 'The Metamorphic Tradition in Modern Photography', written for the catalogue of the exhibition *Creation: Modern Art and Nature* in the late summer of 1984, he applies his theory of the series to landscape photography – all of it from the twentieth century. The theory is entertained, no more than that, in pictures which suggest continuities and imagined narratives: a Stonehenge montage, for example, by Jerry Uelsmann in which a writhing knot of snakes recall Medusa and the possibility that those giant slabs were once living creatures turned to stone.

The series theory depends upon informed reverie. The photograph triggers a response which leads further. A simple scene with evidence of movement might feature as a fragment from a continuum, or as part of a whole. In a more complex scene, a cloud might look like a mountain range, and a mountain range might appear as a set of trees, and the trees as a haycock – from one of Weaver's readings of a landscape by Paul Strand, who became one of his special interests. There is nothing fixed about these readings, and the writer subsequently rewrote his interpretation on Strand's landscape (*Haying, Haut-Rhin, France*, 1950–1951). But a great deal depends, in the operation of the series theory (which might also be called a theory of reverberations), upon the viewer's capacity to follow pointers and to make connections. Any viewer who is assertive and learned can indulge a substantial train of thought – best controlled, if it is to be other than arbitrary.

Weaver was particularly active during the mid-1980s, endlessly curious and resourceful. In 1986 his book *The Photographic Art* was published by the Scottish Arts Council to go with an exhibition of the same title. It is photography's most tantalizing text: 21 short essays in support of 100 pictures. His idea was that we might try to understand photographs less as the work of individuals responding to impulse than as determined by tradition, made up of aesthetic systems so assimilated as to have become second nature. These aesthetic systems to which he refers are almost beyond comprehension: the Bible, the writings of John Ruskin (39 volumes), the works of John Milton, of medieval alchemists, as well as that of *post-facto* analysts, such as Weaver himself, who have identified American, British and European

traditions and their aesthetic properties. The photographer working within this amplified context is, to some degree, an agent, volunteering topics which look promising. The viewer makes the best of the picture, using whatever interpretive materials come to hand. There may be reliable readings when, for example, a biblical specialist such as Francis Frith photographs a biblical topic; but in many instances context gives out and Weaver shows himself trying to make sense of an intractable image. One inescapable implication of *The Photographic Art* is that pictures have been taken principally to allow us to investigate our cultural inheritance, that they might almost be considered as puzzles to be worked out. The idea of an inexhaustible cultural matrix also helps to account for the way in which photographic careers move by fits and starts, sometimes in touch with the culture and then detached and at a loss.

William Henry Fox Talbot, the great inventor of the negative-positive process, interested him in 1986 and thereafter. It is due to his efforts alone that Talbot ever came to be thought of as an artist rather than as a technical innovator who took pictures for demonstration purposes. Weaver considered Talbot's *English Etymologies*, published in 1847 and just short of 500 pages, as the longest artist's statement ever penned, and in *The Photographic Art* he made much use of it. His proposals regarding Talbot's iconography of wheels and ladders could be debated but not disregarded. It was different in the case of Roger Fenton whose art, although just as open to analysis, has almost no supporting texts. Fenton, a religious man working in a religious age, would have understood landscape and its staffage theologically: trees, for instance, as invoking the Crucifixion and the original tree in the Garden of Eden. The theory, spelled out by Weaver, fits in parts and is a challenge to anyone who has ever looked at Fenton's hetero-geneous output. Weaver's theory is the most likely, indeed the only, theory ever to have been applied to pictures which do look as if they have been taken by a photographer with something in mind: a sche-matic outlook, certainly, in which one item is related to another in a meaningful way.

Weaver's practice, as it unfolded during the 1980s, was to carry out exploratory writings: his studies in *The Photographic Art*, especially, and also in his essay 'The Metamorphic Tradition'. Promising topics were taken further; Fenton was one of these, although Fenton proved unyielding. Paul Strand was a different sort of problem. Talbot had been largely misunderstood, despite a wealth of textual evidence. Fenton was an enigma. Paul Strand, however, had lived a well-documented life and had explained himself throughout. Weaver

chose, in an essay of 1990, 'Dynamic Realist', to recount Strand's life in politics before his departure for France in 1949. Weaver's intention, as in the case of Julia Margaret Cameron, was to give an urgent account of the artist's creative ambience and of thinking carried out under pressure. The 'dynamic realism', which in the essay's subject had to take account of movement as a fact of life, had to amount to more than mere description. Photography carried out under these terms had to be at the same time both recognizable and exemplary. Strand's terms were 'dimensional' and 'specific'. Like Mrs Cameron, Strand was a dialectician, needing to mediate differences in his picture-making. Weaver's gift has always been to identify his artist as having in the end, or in action, to transcend their own thinking, their dogmas and ideas about how art should be carried out. In Strand's case, after elaborate preliminaries, Weaver turns, maybe with relief, to explications which allow him to forage in his favourite ground: the cultural matrix.

The new photography of the 1960s and after was a different matter. Garry Winogrand, whose art he reviewed in 1991, exemplified the new, relatively ungrounded, mode. In the end he decided that Winogrand dealt in contingency, in objects that cropped up in significant clusters. These contiguous or contingent objects might mean something to the photographer, but for anyone else their meanings were opaque. To come to terms with this new photography, not unlike that of Talbot more than a century before, images had to be identified, named and spelled out. Metonymy, the rhetorical term for the application of a word to a thing, is the term he uses. The metonymic act stabilizes understanding for long enough to give some sense to the picture or to open up possibilities. Weaver identifies the Freudian as Winogrand's preferred typology on the strength of a picture of a father with a blinded or dazzled child, but can go no further than approximations.

His ambition was always to put in place a reliable meta-language, even if it took several attempts. In 1993, in conjunction with Anne Hammond, his co-editor at *History of Photography*, he tried again to make sense of recent photography, this time exemplified by William Eggleston. Their researches took them via existentialism to Karl Jaspers's use of the term cipher. Symbols and metaphors stood in a direct relationship with their subjects, but ciphers were somewhat askew. They seemed to stand, in Jaspers's eyes, for existence where mistakes might be made and doubts creep in. Ciphers were makeshift signs leading to no definite readings. In real life, of course, a cipher is the zero which multiplies preceding numbers by ten and divides

succeeding numbers also by ten. In itself it is valueless. The cipher is, in other words, part of an activating process with some of the same properties which mark the typological idea, so important in the reading of Cameron.

Biography

Mike Weaver, born in Cornwall in 1937, is best known for his ground-breaking work on Julia Margaret Cameron, published as an exhibition catalogue in 1984. His educational trajectory was remarkable: a double first class honours degree in English from Magdalene College, Cambridge, where he was appointed a research fellow in 1963. In 1969 he was awarded a doctorate for a study of the poetry of William Carlos Williams, the subject of his first book in 1971. Institutional development always interested him: he was, for instance, the founder of the Department of American and Commonwealth Arts and of the Audio-Visual Library at the University of Exeter, where he taught between 1967 and 1978. In 1978 he became chairman of the Photography Advisory Group of the Arts Council of Great Britain, at a time when British photography was in process of a creative surge. That appointment lasted until 1983. In 1991 he became co-editor, with Anne Hammond, of the scholarly magazine *History of Photography* until 2000.

Primary texts

Weaver, M. (1984a) *Julia Margaret Cameron 1815–1879*, London and Boston, MA: Herbert Press and New York Graphic Society.

——(1984b) 'The Metamorphic Tradition in Modern Photography', in *Creation: Modern Art and Nature*, Edinburgh: National Gallery of Modern Art, pp84–94.

——(1985) 'Robert Mapplethorpe's Human Geometry: A Whole Other Realm', *Aperture 101*, Winter, pp42–51.

——(1986a) *The Photographic Art: Pictorial Traditions in Britain and America*, London and New York: Scottish Arts Council and the Herbert Press, and Harper and Row.

——(1986b) 'Curves of Art', in *EW 100: Centennial Essays in Honor of Edward Weston, Untitled*, vol 41, pp80–91.

——(1986c) *Alvin Langdon Coburn: Symbolist Photographer*, New York, NY: Aperture.

——(ed) (1989a) *British Photography in the Nineteenth Century: The Fine Art Tradition*, New York, NY: Cambridge University Press.

——(ed) (1989b) *The Art of Photography 1839–1989*, London: Yale University Press.

——(1990a) 'Paul Strand: Native Land', *The Archive*, University of Arizona, vol 27, pp5–15.

——(1990b) 'Paul Strand: Dynamic Realist', in M. Stange (ed) *Paul Strand: Essays on his Life and Work*, New York, NY: Aperture, pp197–207.

——(1991) 'Facts for the Imagination (Garry Winogrand)', *History of Photography*, vol XV, no 4, Winter, pp310–312.

——(ed) (1993) *William Henry Fox Talbot: Selected Texts and Bibliography*, Oxford and Boston, MA: Clio Press and G. K. Hall.

Weaver, M. and Hammond, A. (1993) 'William Eggleston: Treating Things Existentially', *History of Photography*, vol XVIII, no 1, Spring, pp54–61.

Secondary texts

Jameson, Mrs A. (1848) *The Poetry of Sacred and Legendary Art* (2 vols), London: Longman, Brown, Green, and Longmans.

Jaspers, K. (1959) *Truth and Symbol*, London: Vision Press.

Panofsky, E. (1945) *The Life and Art of Albrecht Dürer*, Princeton, NJ: Princeton University Press (2nd edition).

Ian Jeffrey

GLOSSARY

Abject/abjection – the term is often used to describe photographs showing death, states of physical decay or general waste matter. It also has a psychoanalytic meaning, introduced by the Bulgarian-French philosopher and psychoanalyst Julia Kristeva in her 1982 book *Powers of Horror*. Abjection is 'what disturbs identity, system, order'. For her: 'The corpse, seen without God and outside of science, is the utmost of abjection' (Kristeva 1982: 4).

Aesthetic/aesthetics – concerns the pictorial and formal qualities of photography that are to do with beauty and judgements of taste. Aesthetics becomes a particularly contested issue in relation to documentary photography. David Levi Strauss, for example, has argued against the '"anti-aesthetic" branch of postmodern criticism', identified with Hal Foster, and the theory and criticism of photography by Martha Rosler, John Tagg and Abigail Solomon-Godeau, among others (Strauss 2003: 9). Defending Sebastião Salgado's photography from its detractors, Strauss argues that aesthetics can be linked with politics and that beauty can be a call for action.

Analogue/analogical – a term now commonly used to describe chemical-based photography, but was used within semiology to describe photography's close resemblance to its subject. Roland Barthes, for example, speaks of photography's 'analogical plenitude' in 'The Photographic Message' (Barthes 1977: 18).

Aura – a complex term, primarily linked with photography and art through a series of essays by Walter Benjamin. The aura of an artwork was said to be lost through photographic reproduction, with the aura associated with the uniqueness and the cult value of an original artwork. Benjamin nevertheless still refers to the aura of early portrait photographs, associated with the 'fullness and security' of the gaze of their subjects, in his essay 'A Small History of Photography' (Benjamin 1979: 247).

Elizabeth A. McCauley in her study of Second Empire commercial photography, has said how avid purchase of photographic prints after engravings and copies of oil paintings did not diminish the aura of original artworks, but often 'created the desire to experience such works in the flesh' (McCauley 1994: 300). The early reproduction of artworks was about the adaptation of high art to capitalist societies, centring it within the art market.

Aura has a more general use to do with a ritualized or cultic response to things. One might even go so far as to say that analogue photography takes on an aura as it is replaced by digital photography.

Calotype – the name that Talbot gave to the paper negatives he used to make salt paper prints in 1840. Using paper negatives his prints were not as sharp as the Daguerreotype; but from an original negative image, multiple positives could be made by simple contact printing.

Camera Lucida – patented in 1807 by William Hyde Wollaston, a drawing aid that created an optical superimposition of the subject being viewed upon the surface upon which the artist was drawing. Its principle was based on light being refracted through a prism.

Cartes-de-visites – commercially produced visiting cards bearing studio portraits, mostly of individuals and couples. The format was patented by a Parisian photographer, André-Adolphe-Eugène Disdéri, in 1854.

Collodion process – also known as the wet-plate process, was introduced in 1851 by Frederick Scott Archer. It involved coating a glass plate with a solution of collodion mixed with light sensitive silver salts. The process was inconvenient as plates were exposed while wet and needed to be developed immediately afterwards. Producing detailed and easily reproducible prints, it nevertheless became the most popular form of photography until superseded by the 'Dry-plate' process that was mass-marketed during the 1880s.

Connotation – in a general sense this refers to the realm of interpretation; what we can read from photographs. Roland Barthes uses this term to refer to a photograph's cultural codes and, as he says in relation to the press photograph, connotation 'is realized at the different levels of the production of the photograph (choice, technical treatment, framing, layout)' (Barthes 1977: 20).

Daguerreotype – a direct positive image made in the camera on a silvered-copper plate. The process was discovered by Louis-Jacques-Mandé Daguerre in 1835 and announced in 1839. Daguerreotypes were irreplicable and generally encased in a box like an item of jewellery. The images flickered between a positive and negative image as one turned the plate in the light. Alan Trachtenberg describes its special qualities well: 'Flipping from negative to positive and back … the daguerreotype seems not only alive but dead and alive at once. An image which bears an already-visible trace of its own extinction within its living form, and does so in a portable and intimate physical form: what better *memento mori* for a time when people died at home, often from epidemic disease, and more often in infancy or childhood?' (Trachtenberg 1992: 176).

Denotation – for Roland Barthes this term is used to refer to what is recorded by the photograph and concerns 'the perfection and plenitude of its analogy' (Barthes 1977: 19). It is what appears natural in a photographic

image, a message without a code and is in contrast to connotation, which involves the ways in which a photograph is coded.

Digital – William J. Mitchell defined digital representation as 'a digitally encoded, computer processible image' (Michell 1992: 4). In contrast to analogue photography, it holds a discontinuous relationship to the real.

Empathy/empathic – a relationship of identification, often used to describe a viewer's relationship to the subject portrayed within photographs. When subjects in photographs look back to the lens and us, they are often seen to invite or cue empathy and identification.

En-abyme – in his discussion of the pictorial significance of mirroring in photographs by Brassaï and Lady Clementina Hawarden, Craig Owens adopts this phrase from literary criticism which 'describes any fragment of a text that reproduces in miniature the structure of the text in its entirety' (Owens 1992: 17). *En-abyme* in terms of photography concerns how photographs can reflect upon themselves by containing image within image. The inclusion of mirrors in photographs offers an ideal means to do this.

Fetish/fetishism – The *Oxford English Dictionary* gives one useful definition as 'Something irrationally reverenced'. A fetish is, then, something given a value in excess to that which it is. Certain photographs of loved ones can then become fetishes. Connoisseurship of the fine photographic print can also be seen as a form of fetishism.

Victor Burgin proposes that the photographic is like the fetish because it 'is the result of a look which has, instantaneously and forever, isolated, frozen, a fragment of the spatio-temporal continuum' (Burgin 1982: 190). He draws a relationship between this quality and Freud's psychoanalytic account of fetishism – seeing for the first time his mother's body lacks a penis and terrified that human beings are permanently in danger of castration, the child disavows this lack by stopping the look on an object, the fetish, that compensates for this lack. Christian Metz has further developed this psychoanalytic relationship with photography in his essay 'Photography and Fetish' (Metz 1985).

The gaze – generally used to refer to the different kinds of looks and exchanges of gazes that take place when we encounter photographs. We can be positioned by photographs to identify with certain gazes. It is in this respect we can speak of a male gaze or a colonial gaze in relationship to certain photographs, for example.

In his essay, 'Looking at Photographs', Victor Burgin, offers a useful distinction between four types of gaze or look in his reading of James Jarché's 1941 'General Wavell Watches his Gardener at Work':

1 the look of the camera;
2 the look of the viewer as she or he looks at the photograph;
3 the looks exchanged between the people depicted in the photograph;
4 the look the actor may direct to the camera.

For Burgin, the 'full-frontal gaze' of the general to the camera and viewer is a gaze we are invited to identify with. In his reading, the photograph is about a colonial power relationship: with the gardener, his face hidden in shadow, cutting between our look towards the general, portrayed as 'out-of-place' (Burgin 1982: 150).

Haptic – related to touch, often used in discussions of photographs when they are physically handled or when the photograph's subject matter concerns physical contact.

Hegemony/hegemonic – best understood as the way in which ruling groups maintain leadership and control through the active consent of major groups in society. It is often connected with the social theory developed by the Italian Marxist Antonio Gramsci (1891–1937). The writer bell hooks, valuing certain art practices for the way in which they challenge cultural stereotypes, speaks about them being 'counterhegemonic' (hooks 1995).

Humanism – a philosophical concept centred upon human values and concerns. In terms of photography, a key understanding of this term comes from Edward Steichen's curated 1955 exhibition *The Family of Man* and Roland Barthes's critical essay in response, following its display in Paris (Barthes 1982a). Humanism is predicated upon the sense of a universal human nature. Barthes criticizes this idea by saying that while birth and death are 'universal facts', economic and historical forces determine how we are born and die. What he objects to in Steichen's exhibition is how it elides the differences between first and third world countries and how labour itself is portrayed as 'natural' as birth and death. Barthes was influential on a lot of postmodern critiques of humanist traditions within photography.

Ideology – a set of ideas or system of beliefs that characterize a particular group or class, but also their embodiment in such cultural institutes as churches, schools and art galleries, as well as cultural artefacts: paintings, texts and photographs. Photography is ideological in the sense that it conveys and enforces certain belief systems.

Traditional Marxist thought saw ideology as the way in which the dominant class furthered its economic and political interests by concealing the exploitative nature of class relations. Louis Althusser's reworking of Marx's theory was especially influential on photography theory because of his description of ideology as 'a system (possessing its own logic and rigor) of representation (images, myths, ideas or concepts, as the case may be) existing and having a historical role within a given society' (Althusser 1970: 233).

Index – Charles Sanders Peirce (1839–1914) uses this term to refer to a sign that is caused by its object. All analogical photographs are in this respect indexes. Talbot describes the photograph as an index when he says photographs are 'Impressed by Nature's hand'. This identity of the photograph runs through its history and can lead to quite poetic reflections. For example,

when Oliver Wendell Holmes describes three photographs of Ann Hathaway's cottage, he says how he can see marks left by the rubbing of hands and shoulders on an open door and wonders whether 'scales from the epidermis' of Shakespeare's hand 'are still adherent about the old latch and door, and that they contribute to the stains we see in our picture' (Holmes 1980: 80). André Bazin, Susan Sontag, Rosalind E. Krauss and Roland Barthes all describe photographs as having been caused by their subjects.

Medium – describes the material used in an artistic activity. Debates about an art's medium and medium-specificity are integral to modernism and a formalist account of art. The photograph's identity as a medium is awkward because it is seen as transparent: we see through it. A medium-specific account of photography could concentrate on the surface of the print, the type of paper, etc., or the differing characteristics of a Polaroid, colour slides, etc. On the other hand, it can also be used to speak about the intrinsic characteristics by which photography represents the world: its detail, framing, its relationship to time, etc.

Memento mori – often used to indicate how photographs serve as reminders of death. Susan Sontag says all photographs are *memento mori* in *On Photography*.

Modernism/modernist – an approach to an artwork that is concerned primarily with its aesthetic and formal qualities rather than its historical and political contexts. Modernism is given a specific meaning within Clement Greenberg's account of abstract painting, in which, as Victor Burgin put it, 'The art work was to become a totally autonomous material *object* which made no gesture beyond its own boundaries, the surface itself – its colour, its consistency, its edge' (Burgin 1982: 11). Greenberg's writing is also used to highlight modernism's cultural distinction and elitism since in his account of *avant-garde* art it is opposed to kitsch and popular art forms. In terms of photography, modernism is generally allied with the writings of John Szarkowski because he insists on considering qualities integral to photography itself. However, because of the dominance of content, photography cannot approach the autonomy of the artwork in Greenberg's account of modernism.

Myth – for Roland Barthes, myth is 'a type of speech', but one which has been 'depoliticised' (Barthes 1982a: 142). He includes as an example of myth a photograph on the cover of *Paris Match*, viewed at the time of the country's war with Algeria, in which a black soldier salutes the French flag. Photography's appearance as a natural sign with 'a sensory reality' (Barthes 1982a: 117) disguises or rather 'purifies' the historical reality of colonialism, creates a false innocent picture and message: 'I see very well what it signifies to me: that France is a great Empire, that all her sons without any colour discrimination, faithfully serve under her flag' (Barthes 1982a: 116). As he later says: 'myth acts economically: it abolishes the complexity of human acts ... it organizes a world which is without contradictions' (Barthes 1982a: 143).

Narcissism – self-love. Charles Baudelaire uses the Daguerreotype's mirrored surface to say how photography makes narcissists of us all. Victor Burgin proposes our relationship to photography can entail a narcissistic identification with the camera position and the subject depicted (Burgin 1982: 148).

Naturalism/naturalistic – Peter Henry Emerson uses this term to describe his technique of softening photography's depiction to bring it closer to the way in which the human eye perceives the phenomenal world. Emerson contrasted naturalism with realism, which he connected with the all-over clarity provided by photographic representation.

Ontology – concerned with the essence of something: its being. For example, in *Camera Lucida*, Barthes says he 'was overcome by an 'ontological' desire: I wanted to learn at all costs what Photography was "in itself," by what essential feature it was to be distinguished from the community of images' (Barthes 1982b: 3).

Phenomenology/phenomenological – phenomenology is the study of 'phenomena': things as they appear in our experience, or the ways we experience things. Roland Barthes refers to his *Camera Lucida* as 'a phenomenology of photography' (Barthes 1985: 357).

Pictorialism – a photographic movement, dominant in the late nineteenth to early twentieth centuries, that sought to make photography artistic by bringing it closer to painting. It included such photographers as Alvin Langdon Coburn, Edward Steichen and Clarence White. This tradition is generally opposed to the straight photography, championed by Beaumont Newhall and John Szarkowski.

Postmodernism – has a particular significance for photography in describing a body of criticism critical of aesthetic and formalist accounts of photography that failed to address its wider historical, political and cultural contexts. Among others, it is allied with the writings of Abigail Solomon-Godeau, Victor Burgin, John Tagg, Allan Sekula and Martha Rosler.

Punctum – a term coined by Roland Barthes in *Camera Lucida* to describe a subjective response to photographs. There are two *punctums*: one of detail and one of time. The first concerns details that do not make sense, that are excessive to the message of the photograph and not intended by the photographer. The second concerns the illogical temporal conjunction we experience before certain photographs – Barthes's famous example is the portrait of a prisoner in his cell just before being executed: 'the *punctum* is: *He is going to die*. I read at the same time: *This will be and this has been*' (Barthes 1982b: 96).

Referent/referentiality – the thing being referred to, which in the case of photography is another way of saying its subject matter.

Scopophilia – from the Greek 'love of looking', often used to refer to sexual pleasure in looking and allied with voyeurism.

Semiology/semiological – connected with the Swiss linguist Ferdinand de Saussure and refers to the study of signs. A semiology of photography sees it as a language and analogous to text.

Signifier/signified – according to Ferdinand de Saussure (1857–1913), a sign is composed of the signifier and signified. Signifiers are the letters or sounds of words and signifieds their meaning. Barthes refers to the plane of the signifiers as 'the plane of expression' and that of the signifieds as the 'plane of content' in his *Elements of Semiology* (Barthes 1964: 39).

Simulation/simulacra – linked with postmodernism and used by Jean Baudrillard to describe a situation where representations are seen to have replaced reality. Baudrillard is offering a response to the pervasive dominance of images in Western culture and is describing their effect and impact. He goes so far as to speak of 'the precession of the simulacra', referring to how simulacra precede, come before, reality (Baudrillard 1983).

Stereoscope/stereograph – invented in 1838 by Charles Wheatstone, an instrument that creates a 3D illusion by giving us two images of the same object, with a minor deviation exactly equal to the perspectives that both eyes naturally receive in binocular vision.

Studium – Roland Barthes's term for a cultural response to photographs, what we can understand collectively, and to be set against the singular subjective encounter associated with the *punctum*.

Tableau/x – a picture, but often associated with a constructed and staged photograph.

Taxonomy – a system of classification of specimens that has been seen to characterize a key use of photography in its systematic cataloguing and individualizing of things and people.

Trompe l'oeil – a French term meaning 'deceive the eye'; it is used to describe an optical illusion in painting but has a clear relationship to photography's illusionistic effects.

Vernacular – the everyday language spoken by people and often used to describe common and everyday subject matter within photographs. Vernacular photography is often used to refer to anonymous or amateur 'non-art' photographs: family album photography, postcards, ID photographs.

Voyeurism – sexual pleasure in looking.

References

Althusser, L. (1970) *For Marx*, New York, NY: Vintage Books.
Barthes, R. (1964) *Elements of Semiology*, New York, NY: Hill and Wang.
——(1977) *Image-Music-Text*, Glasgow: Fontana.

——(1982a) *Mythologies*, London: Paladin.

——(1982b) *Camera Lucida: Reflections on Photography*, London: Jonathan Cape.

——(1985) *The Grain of the Voice*, New York, NY: Hill and Wang.

——(1986) *Elements of Semiology*, New York, NY: Hill and Wang.

Baudrillard, J. (1983) *Simulations*, New York, NY: Semiotext(e).

Benjamin, W. (1979) 'A Small History of Photography', in *One Way Street*, London: NLB.

Burgin, V. (ed) (1982) *Thinking Photography*, London: Macmillan.

Holmes, O. W. (1980) 'The Stereoscope and the Stereograph', in A. Trachtenberg (ed) *Classic Essays in Photography*, New Haven, CT: Leete's Island Books, pp71–82.

hooks, b. (1995) *Art on My Mind: Visual Politics*, New York, NY: New Press.

Kristeva, J. (1982) *Powers of Horror: An Essay on Abjection*, New York, NY: Columbia University Press.

McCauley, E. A. (1994) *Industrial Madness: Commercial Photography in Paris 1848–1871*, New Haven and London: Yale University Press.

Metz, C. (1985) 'Photography and Fetish', *October*, vol 34 (Autumn), pp81–90.

Mitchell, W. J. (1992) *The Reconfigured Eye*, Cambridge, MA, and London: MIT Press.

Owens, C. (1992) 'Photography *en abyme*', in S. Bryson, B. Kruger, L. Tillman and J. Weinstock (eds) *Beyond Recognition*, Berkeley and Los Angeles: University of California Press.

Strauss, D. L. (2003) *Between the Eyes*, New York, NY: Aperture.

Trachtenberg, A. (1992) 'Reflections on the Daguerrean Mystique', in G. Clarke (ed) *The Portrait in Photography*, London: Reaktion, pp173–192.

INDEX